ARCHIVING AN EPIDEMIC

SEXUAL CULTURES

General Editors: Ann Pellegrini, Tavia Nyong'o, and Joshua Chambers-Letson
Founding Editors: José Esteban Muñoz and Ann Pellegrini

Archiving an Epidemic

Art, AIDS, and the Queer Chicanx Avant-Garde

Robb Hernández

NEW YORK UNIVERSITY PRESS

New York

Publication of this book has been aided by a grant from the Millard Meiss Publication Fund of CAA.

NEW YORK UNIVERSITY PRESS
New York
www.nyupress.org

References to Internet websites (URLs) were accurate at the time of writing. Neither the author nor New York University Press is responsible for URLs that may have expired or changed since the manuscript was prepared.

Library of Congress Cataloging-in-Publication Data
Names: Hernández, Robb, author.
Title: Archiving an epidemic : art, AIDS, and the queer Chicanx avant-garde / Robb Hernández.
Description: New York : New York University Press, [2019] | Series: Sexual cultures | Includes bibliographical references and index.
Identifiers: LCCN 2018059692| ISBN 9781479845309 (hbk : alk. paper) | ISBN 9781479820832 (pbk : alk. paper)
Subjects: LCSH: Mexican American gays. | Gay men—Sexual behavior.
Classification: LCC HQ76.2.U5 H475 2019 | DDC 306.77086/642—dc23
LC record available at https://lccn.loc.gov/2018059692

New York University Press books are printed on acid-free paper, and their binding materials are chosen for strength and durability. We strive to use environmentally responsible suppliers and materials to the greatest extent possible in publishing our books.

Manufactured in the United States of America

10 9 8 7 6 5 4 3 2 1

Also available as an ebook

CONTENTS

Color photos appear as an insert following page 68.

LIST OF FIGURES

Introduction

How AZT Changed Aztlán

I throw away your oxygen mask
Empty pills bottles and favorite hats
Remove the lint from the dryer
Thinking if I get rid of your death, Mi Amor
(Your Denim Shirt)
Then the virus that killed you
Won't live in my clothes
(Your Denim Shirt)
In my house, our house
Anymore
—Samuel Rodríguez, *Your Denim Shirt*

Your Denim Shirt (1998) is a visual elegy on tape.[1] Samuel Rodríguez's experimental video short opens with handwritten poetry on parchment paper lit under the glow of candlelight. Text dissolves into a denim shirt haunted by the narrator's lyrical verse. The camera follows behind the young man gliding through the tight corridors of his San Francisco apartment as he performs a daily ritual of attending to floral arrangements, personal possessions, and clothing left behind in the ruins of AIDS.[2] Haunted by his lover, he seeks to "get rid of your death."[3] However, intrusive memories frustrate his impulse to lay waste to pill bottles, clothes, lint, and an oxygen mask. The bedroom closet opens, transporting the narrator to another time. He holds an ordinary felt fedora and fits it on his head. The video emits the soundtrack of the couple's first meeting set to the Chicano nationalist anthem "Suavecito" (1972) by the Bay Area rock band Malo. Photobooth snapshots document the shirt and the lovers' chance encounter, bittersweet keepsakes that suggest a future that was imagined but never arrived. The young man washes and

irons the denim shirt, and as the iron glides down the smooth fabric, Rodríguez intersperses erotic images conjuring visions of the lost lover with flashes of his bare back. Finally, the narrator returns the shirt to the closet.

Juxtaposing denim with skin and artifact with body, Rodríguez reveals that the shirt is more than a souvenir approximating "the virus that killed you."[4] The narrator empties the closet, erasing viral traces from his home. His hands press against the closet doors sealing it like a tomb. However, the shadow of his lover lingers. Cast in silhouette, the dead lover places the denim shirt over his bare chest like the "ephemeral trace" of queerness that "matter[s] more than many traditional modes of evidencing lives and politics" as José Esteban Muñoz suggests.[5] Like a specter, the lover lingers as "pieces of cloud dissolved in sunlight."[6] Rodríguez's lament closes over a Mexican American home altar with its constellation of photos, iridescent prayer candles, and sticks of incense. Loss becomes tangible through visual and material substitutions, a commemorative display that refuses to give up the ghost.

Whereas Rodríguez's video is fictional, Cecilia Aldarondo's vérité-style *Memories of a Penitent Heart* (2016) takes a documentary approach to metaphorically correlate a physical body with AIDS and material remains. Released nearly twenty years after *Your Denim Shirt*, Aldarondo's film confronts family secrets surrounding the loss of her uncle Miguel Dieppa, a Puerto Rican actor and playwright who died from a mysterious form of "cancer" in 1987. Social media plays a consequential role in the film by helping her make contact with "Robert," the man her uncle loved and lived with until his death. Now a Franciscan monk in Southern California, Robert helps Aldarondo uncover the "material remains of Miguel's other life."[7] Aldarondo interrogates Robert's personal archive, examining each fragment of her uncle's body of record as though conducting an autopsy. She lovingly pores over Polaroid snapshots, business cards, found film footage, and a wallet. Three unpublished plays create tension in the film when Robert offers her these works *if* she promises to publish them. Aldarondo responds with uncertainty, which provokes Robert: "Did you not see how beautifully he wrote? Look at his writing!"[8] For Robert, Miguel's stories are more than the dramaturgical benchmarks of his MFA in playwriting. These are the last of his creative output, the last of him.

Extending body and memory through the remains of AIDS outbreak is why "Queering the Archive, Or Archiving the Queer," hosted by the UCLA Chicano Studies Research Center (CSRC), holds paramount importance for the queer Chicanx artists who are central to this book. Attendees of this September 25, 2006 symposium found a portrait of Chicano avant-gardist Edmundo "Mundo" Meza projected on a screen, greeting them as they entered. Meza appeared in half-male and half-female clothing, a parlor gag indebted to nineteenth-century freak shows and circus theatrics (see figure 2.2).[9] His photo was no ordinary snapshot. It was mined from the scrapbook of East LA visual provocateur Robert "Cyclona" Legorreta. In its original form, Meza's portrait is extracted from a page consisting of photography, collage, and performance art documentation. It reveals a scene of Chicanx masquerade, traces of carnivalesque play in glittering garments first rehearsed on Whittier Boulevard in the late 1960s. The UCLA event came on the heels of the CSRC library's 2004 acquisition of Legorreta's archive, a large, eclectic, and unruly assembly.[10] Legorreta's archive pervaded the discourse and the scholarship at the symposium and appeared most prominently in Meza's appropriation, a new becoming as a promotional image advertising the event.

Meza appears as a specter, a visual embodiment of erasure. "When [Meza] passed away a great portion of his materials were then destroyed by family," CSRC Director Chon Noriega observed, reflecting on the young man who died at twenty-nine on February 11, 1985.[11] The avant-garde aesthetics of Meza and the wider contours of his biography begin and end here. We are given little explanation of how he died, what circumstances contributed to the apparent destruction of his art, and what consequence that violent act has for the way contemporary Chicanx art is defined. Overlooking symposium participants as a digital projection, Meza is a cautionary tale of vulnerability, his body of record known only because of its ruin.

Noriega makes no mention of AIDS in the context of Meza's life or the physical conditions shaping his archive. He enters the discourse of Chicanx art history and criticism of Southern California excised from the plague much as his visual image is extracted from Legorreta's scrapbook. The critical events surrounding the disappearance of his "materials" are equally obscure. Attendees are left to wonder: "Why is 1985 the last time

his things were publicly observed?" "What happened afterward?" For many of Meza's peers and artistic collaborators, his death was their first encounter with AIDS, but it certainly was not their last.

Missing from the symposium is what Muñoz calls "the key to queering evidence": to "think of ephemera as trace, the remains, the things that are left, hanging in the air like a rumor."[12] Meza hangs in just that way. The whereabouts of his paintings are unknown. Stories about his archive linger as speculation, bits of information expropriated from Legorreta's documentation of East LA's raucous performance statements. Queers of color encounter archiving differently, as the examples of a denim shirt, a box of unpublished plays, and a scrapbook reveal. This difference occurs because of the general neglect of queer ethnic and feminist records in repositories with conservative acquisition policies, egregious histories of colonial appropriation by cultural heritage institutions, the fugitive state of artworks, and physically degraded materials pulverized in the fallout from AIDS.

These fractures and occlusions demand alternative archival understandings of that which is left "hanging," ways of interpreting queer archives outside institutional recordkeeping practices where the marginal places occupied by these archival bodies are dispersed and remote.[13] Lingering in domestic undergrounds and subterranean archival spaces, art like Meza's dwells elsewhere. Another methodology is needed to understand (1) how in the trauma of the AIDS plague archival and custodial practices have been alternatively constituted outside traditional recordkeeping nomenclatures; (2) how these constellations reveal queer epistemologies of the archive and challenge the foundations on which Chicanx art history is written; and (3), most important, how institutional mediation can upset the entanglements of space, loss, and memory that give these fields their shape.

Archiving an Epidemic: Art, AIDS, and the Queer Chicanx Avant-Garde reimagines the story of Chicano avant-gardism in post-1960s Southern California. This book contests the pervasive heteronormative vision of Chicano art by elucidating a queer genealogy of artists and artistic practices that yielded other avant-gardisms through gender nonconformity, sexual difference, and alternative kinships. This era's queer creative agents were notorious for their garish performance personas, provocative visual spectacles, and "living art" statements. Storming LA

and agitating against predominant political ideologies and heteropatri-archal social norms, they shared an ethos of sexual alienation, a bolster-ing spirit of political dissent, and a philosophical aim to "open people's minds" through "structures of feeling."[14] With an iconoclastic verve, they voiced an empowering language of the *maricón* and delighted in every "berserk" outburst they incited from barrio street corners to luxury storefronts on the west side of the city.[15] Despite their signifi-cant creative activities, they remain largely unknown in the narrative of contemporary Chicano avant-garde art, which is centered on the East LA collective named Asco (Spanish for "nausea"), founded in 1972 by Harry Gamboa Jr., Gronk, Willie Herrón, and Patssi Valdez. Only a few provocative exceptions disrupt the institutionally-sanctioned accounts of Asco, which did in fact have collaborations with the more brazen and unapologetically queer actors focused on in this book.[16] The con-sequence of these historiographic decisions for Chicano art and perfor-mance are canon defining, while omitting a more complex picture of Chicanx avant-gardisms in Los Angeles.

Rather than forming a singular entity, queer creative circuits are vast and represent a multinodal composition of Chicanx avant-gardes. Al-though some art historians and cultural critics will consider "Chicanx" an erroneous descriptor because of its contemporary currency, I use it here to diffuse cisgender binary language and emphasize the gender and sexually nonconforming expressions proliferating in Southern Cali-fornia. Thus, I challenge the ostensibly progressive linearity of Chicano art history in "straight time."[17] By refusing the hegemonic norms of life maturation and destabilizing the "natural" attainments of the hetero-normative Western human subject oriented through "reproductive" life cycles, a queer temporality urges a critical reappraisal of how much of what Chicana and Chicano art *is* is based on a chronological model of complete records, social lives of objects in uninterrupted chains of custody, and clear claims to copyright transfer and artwork owner-ship. Rather than base our understandings of how "official" and textu-ally authenticated reservoirs of cultural knowledge historicize Chicana and Chicano art, I take a queer of color turn by embracing the same-sex desires and gender transgressive impulses of Chicanx art and move to consider what it could have been, though it is "not quite here."[18] The blind spots that surround this queer vestige exists, in part, because

AIDS devastated the field. The impact of this plague was grave: artist oeuvres, artistic practices, creative communities, discerning aesthetes, and, in particular, material records disappeared.

AIDS's *near* obliteration of Chicanx avant-gardisms' queerer exponents yielded other modes of recordkeeping, custodial interventions, vernacular preservation, and storage technologies for these posthumous oeuvres and pulverized fragments. My investigation elucidates this response to human loss by formulating a methodological intervention that I term "archival body/archival space."

Queer Turns in Archival Theory and Evidence

Before I thoroughly explain this study model, allow me to add that "the archive" is an imperfect project. It is important not to presume that all institutional collections are "complete" bodies of record. Redactions, omissions, editorial revisions, and serendipitous rediscoveries prevail. Caught somewhere between completion and oblivion, public archives assemble remainders. Researchers hardly know what record administrators have jettisoned under the subjective measures of cultural significance and historical value. Thus, "evidence" as an information organizing structure is a hermeneutic taken at face value. As Michael O'Driscoll and Edward Bishop stress, "The space of the archive is never neutral, never empty."[19]

However, an evidentiary paradigm like the document has been imbued in heterosexual terms as records are born in acquisition and die through deaccessioning. The life cycle of archival documents has provoked literary, cultural, and information theorists and in no small way, bestowed print materials with agency. Consider the views of one figure from the golden age of archive theory, Sir Hilary Jenkinson: he espouses "unbiased" and "objective" record administration defined by unbroken chains of custody.[20] His approach largely privileges document generation from "official" state-sanctioned and corporate bodies. Such documents belong to a collection "untainted" by threats of mismanagement, inauthenticity, incompletion, or processual error. In nineteenth-century England, provenance or the history of record ownership followed a clear chain of possession, resulting in the mere transference of organizational papers through the unbiased stewardship of

a record administrator.[21] The French archival idea of *respect des fonds* follows a similar principle: "All documents which come from a body, an establishment, a family, or an individual form a fonds, and must be kept together."[22] Drawing on varied record categories, including those organized by heterosexual familial units, original order is carefully delineated, which ensures that the collection remains deposited into a singular institutional repository. This practice guarantees that the "archival bond" between records seals the "organic linkage generated between agency and record group."[23] In this sense, the body of record remains stable and authentic through an emphasis on its documentary wholeness. Historical truth is commanded through administrative custody, an adage with clear colonial underlays.

Following the polemical work of Jacques Derrida in *Archive Fever*, postmodern archive theorists' suspicions and redefinitions of the archive led with an eye on "form" and "power."[24] They sought ways to expose the sociocultural politics of archives and to demonstrate that the bond or "organic linkage" was built on Eurocentric, colonialist, and, I might add, heteropatriarchal ideologies that favor progressive teleology and what Lee Edelman calls "reproductive futurism."[25] Critical archive scholars such as Joy Atherton, Frank Upward, and Sue McKemmish similarly steered away from life cycle approaches in record management to better account for those interstitial evidentiary acts, whereby multilateral transactions unfix contextual attributions in favor of a "records continuum model." According to Michelle Caswell, "In this view, the archives [were] not a stable entity to be tapped for facts but, rather, a constantly shifting process of recontextualization."[26] In such a model, "the life cycle stages that records supposedly underwent were in fact a series of recurring and reverberating activities within both archives and records management. The underlying unifying or linking factor in the continuum was the service function to the records' creators and all users."[27] Jay Kennedy and Cherryl Schauder have called the continuum model's recontextualized record groupings "families."[28] Doing so, they nonetheless "linked" record interactions into discourses of biological normativity and naturalized belonging.

Though advocates for this model radically challenged the terms of record life cycles from a passive and fixed autonomous body to an active one, a heteronormative preoccupation with progeny persists.

This propensity had profound consequence amid the AIDS outbreak. Transparency in record transfer or deeds of gift was futile particularly for queers of color. Biological families oftentimes dissolved, trashed, or looted the deceased's private collections. These artists' "queer kinships," the alternative semblances of nonprocreative desires organizing life, art, and memory, were routinely denied claims to their personal effects.[29] As floating signifiers for infection, material ties to a lifestyle rich in queer creativity, same-sex domesticity, and sexual risk were broken. As Aldarondo reveals in her reencounter with the "official" history her grandmother Carmen constructs in the family scrapbook, the album is a carefully curated presentation of clippings and cutouts displaying "the son my grandmother wanted. Not the one she had."[30] In a "records continuum model," it is difficult to understand what is to become of those orphaned collections, those parcels of paper with no recognizable "family" to belong to. Thinking about these complicated traumas in the archive is a frustrating endeavor. It also magnifies the compulsory heterosexuality pervading not only institutional recordkeeping methods but also the emergent field of archival affect theory.

Heteronormativity foregrounds emotive responses to records in what Richard Cox calls "The Romance of the Document."[31] He theorizes that "the pull of the document can be an all absorbing one. . . . Rather than feeling guilty about such emotions, records professionals need to realize that the romance of the document is a powerful means of understanding why our records are important in society."[32] His position is quite radical for empiricist factions in information studies, because, according to Anne Gilliland and Marika Cifor, "many practitioners and theorists continue to evince a profound distrust of stances that seem less than objective and of aspects relating to records and archives that invoke affective responses."[33] Despite this, Cox's nascent theorization of archival affect is restrained, conservative even. He illuminates the "general fascination" of publics engaging with various forms of documentation such as journals, letters, diaries, oral storytelling, and websites.[34] Each record type requires a different approach that "convey[s] something about this romantic attraction."[35] And yet, what this "something" *is* is never quite explicated in Cox's assessment. Just what desire drives this "romantic attraction" to the document? Moreover, if "romantic appeal"

is engendered not by documentary records but rather by the debris that *fails* to meet the barometer of authenticity, how do we account for other "romantic attraction[s]" that deviate from the document's normative and appropriate allure?[36] How do we rectify those strange appeals for evidence consisting not of "untainted" romantic papers but rather of the "taint" of documents' failure—their decay, shattering, disappearance or visual obstructions? Queer archival bodies require pivoting from these heteronormative archival epistemes with a view toward other methodological possibilities.

Because an "evidentiary logic of heteronormativity" perpetuates what Mathias Danbolt sees as the "institutional ideology of 'hard facts' that dominates the humanities—an ideology that excludes the temporary and performative knowledges of queerness,"[37] performance theory is consequential for understanding queer archives and affects. Ann Cvetkovich's "radical archive of emotion," José Muñoz's "ephemera as evidence," Rebecca Schneider's "performance remains," and David Román's "archival drag" undercut the heteronormative document "romance" in Cox's purview and affairs with text. They emphasize the eclipses of movement and ephemerality of queer desire.[38] My approach continues in this register by resisting traditional historiographic prescriptions of record wholeness and preferring to "get lost . . . from the evidentiary logic of heterosexuality."[39] Muñoz shares an important critique of queers' "vexed relationship to evidence," a relationship that can no longer rely on the stable document in institutional custody but rather must explore queer acts of cultural transfer in slips of time.[40]

In light of growing attention to queer archives of feelings, it may be surprising that I want to consider other material states of documentation that seek meaning not solely through the sutures of ephemerality so central to Muñoz but also through the ware of time and decrepitude devastating AIDS' physical evidence.[41] However, because bodies, technology, and writing mediate performance, as Philip Auslander argues, we must "perceiv[e] the document itself *as a performance* that directly reflects an artist's aesthetic project or sensibility and for which we are the present audience."[42] Amelia Jones echoes his sentiment, redrawing the dichotomous relationship between the perceptual body and the archival body as "a kind of material embodiment."[43] Reading the archive, "we

cling to scraps from the past, *re-embodying them* through projection, interpretation, restaging them in writing art histories or performative art work, in order to try to claim infinite futures."[44]

"Re-embodying" the scraps left in AIDS's ruin is a performance of inordinate difficulty.[45] Neither ephemeral nor entirely concrete, the queer archival constellations central to this study lie somewhere in between, expanding the terms of affect and archive. Queer evidence makes "re-embodying them" a lesson in failure (a frustrating endeavor) as an archival body decays to the point of *near* absence.[46] These gradients pose ways to read queer lives through a reenvisioning of the wreckage. Like Muñoz, I suggest that "the ephemeral does not equal unmateriality," and so my thinking about these remains shares much with the fluctuating state of the material record in its wasted state.[47]

Because of AIDS's disastrous aftereffects, archival bodies eschew completion and systematic retrieval for public consumption in accessible repositories. My aim is not to overlook the ways in which record collections—institutional or otherwise—are "notoriously difficult, disorderly, impenetrable spaces, prone to produce multiple and conflicting narratives."[48] Nor do I assert that private recordkeeping is not disorganized or an affectively rich assembly in domestic space. Rather, I seek to look at the ways in which a virus engenders material worlds that Chicanx cultural carriers of loss and memory know all too well.

Lost Bodies/Lost Spaces

The basis of these alternative archival formations is found in the resilient memorial practices of Mexican American material culture. *Santos* (saints), *fotoesculturas* (photo-object sculptures), *nichos* (boxes), *recuerdos* (prayer cards), *repisas* (display shelving), *farolitos* (luminous miniature lanterns), *papelitos* (paper bits), *nacimientos* (nativity scenes), *capillas* (yard shrines), *descansos* (roadside memorials), and *El Dia de los Muertos* (Day of the Dead) folk art traditions produce functional portals to the divine, deceased, and diseased.[49] *Ofrendas* (altars) memorialize through tangible/intangible juxtapositions of photography, plant life, ceramics, religious paraphernalia, ornate frames, fragrant atmospherics, and candle incandescence. The dynamic interplay of semiotic and sensorial cues perform the intimate "touch" of display acting upon the self

and home. In her critical study of altar vernacular practices, Kay Turner suggests that the physical body "is a central metaphor for relation. . . . That the home altars are populated primarily with body images is an indication of the essential desire to bring spiritual and physical, sacred and profane realms together through incarnation."[50] Turner's move here is instructional insofar as it translates the body through interlopers of object and picture, a surrogacy of human loss and suffering in artifactual stand-ins.

These constellations parlay discursive tethers tying memories to anachronistic teleologies, mnemonic aids, and historical reencounters. Strategic assemblages of accumulated objects, parts, and unfinished wholes map what Jennifer González calls "autotopographies"—memory landscapes of the self.[51] Much like the archival process of institutional transfer where one record forms a bond with the next, the vernacular language of autotopographies invests Chicana and Latina homemaking with radical possibilities. Amalia Mesa-Bains calls this a "domesticana Chicana" sensibility, a feminist language for domestic arts and labor, which explicates women's "techniques of subversion through play with traditional imagery and cultural material."[52] Chicanas' "exterior worlds are ultimately made sensible through . . . particular system of signs" in González's view, with the body of record concretized in artful associations and tactful combinations.[53] This exteriorization of the "transmutation of social and personal suffering into penetrating visions of the present and brave sightings of hopeful, better futures" establishes sensorial and corporeal relations in these commemorative sites.[54] Domesticana aesthetics and collecting practices "turn dominant narratives and relations upside down" according to Karen Mary Davalos, in ways beneficial to understanding feminist custodial interventions beyond the Anglophone discourses privileged in collection/collector studies.[55] Chicanas and Latinas have historically re-membered and re-placed their circumstances with alternative memory technologies that are conversant with the dead and challenge evidentiary regimes of printed records in "homage to the unseen but felt presences in our lives," as Laura Pérez argues.[56]

Certainly, Chicana and Latina stewardship intercedes and redefines public and private archiving, enriching Tomás Ybarra-Frausto's oft-cited "rasquachismo" sensibility, that perspective of the underdog improvising

new worlds with what is "tattered, shattered and broken."[57] Despite their resilient craftwork, these domestic art practices sometimes recommitted the very acts of trauma and violence on the material record at the precipice of viral outbreak. As Turner explains about the home altar, "because the family is a profoundly concrete manifestation of the power of connection, no one knows the importance of this power as the one who makes it possible: the mother."[58] Matriarchal domestic arts create dire consequences for queers of color when enacted only to scrub clean family histories from the stain of homosexuality and AIDS, as Aldarondo portrays in *Memories of a Penitent Heart.*

The fragments and occlusions tracing a life like Miguel Dieppa's are no ordinary omission. Pérez's "hopeful, better futures" recedes, giving way to zones of wreckage.[59] Searching for queer evidence intensifies fugitive sources of knowledge in their incomplete forms. The resulting shards become a recurrent aesthetic, a powerful way to allegorize AIDS among what is "tattered, shattered and broken," as Ybarra-Frausto says.[60] AIDS breaks down all that it touches—bodies, social ties, material culture, archival bonds, record wholes. Powerful is its human devastation; wide is its field of debris. An incident that Alice Foley, a lesbian restaurateur, recalls is telling: "An entertainer here in town who was obviously sick came in the restaurant and ate. . . . We didn't know what to do with his dishes, so we threw them out. That's when I said I've got to get more information on this shit—I can't keep throwing dishes away!"[61] Foley's shattered dishes occupy no ordinary position in the archival record; they are haunting reflections of AIDS's lethal charge. Not surprisingly, anxiety over the toxicity of material remnants shape queer artist responses. A pile of shattered dishware in a derelict kitchen gives voice to human pulverization in Peter Hujar's *Broken Dishes, Newark* (1985) (figure I.1). A disturbing and destructive pathos is articulated by his photograph. Matter breaks down, upturns, and grounds into dust. Monochromatic tones capture human destruction in fractures. HIV's taint is made palpable in an obliterated home site.

Barton Benes's mixed-media practice casts a lost civilization in archaeological ruins. In *Shards* (1989–2012), Benes decoupages bisque pottery fragments with photos of dead friends (figure I.2). Giving three-dimensional scale to vernacular snapshots, he refuses the terms of straight photography and whole ceramic forms. Rather, fifty shards

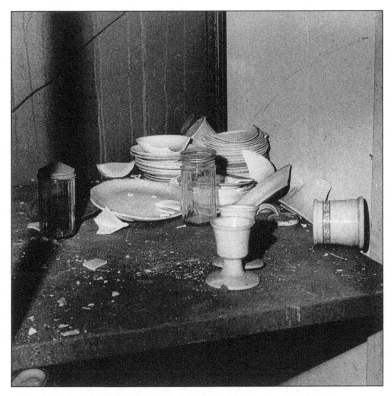

Figure I.1. Peter Hujar, *Broken Dishes, Newark* (1985), gelatin silver print. Photograph courtesy of The Peter Hujar Archive LLC.

concretize AIDS's material consequence, giving gravity to lives lived and memories shattered. The advent of protease inhibitors ended this practice. "After my health improved, a friend told me that Barton had made a shard for me in anticipation of my death," wrote AIDS activist Sean Strub in an eerie revelation from his memoir, *Body Counts* (2014).[62] Left on Benes's workbench, his photo and ceramic fragment lingers in timely uncertainty detached from the deathly closure that was certain to come but did not come to pass.

Strub's incompletion in Benes's project upended AIDS imagery predicated on impending death. The advance of anti-retroviral drug therapies prolonged lives like Strub's and thus tore a temporal rip between those who were and who were not counted in Benes's accruing shards archiving

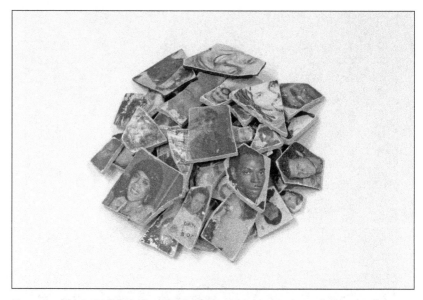

Figure I.2. Barton Lidice Benes, *Shards* (1989–2012), bisque clay and photographs, dimensions variable. Photograph by Pavel Zoubok Gallery, New York. Collection of Kevin O'Leary and Brian Esser. Permission provided by Warren Benes on behalf of the Barton Lidice Benes Estate.

the dead. "I haven't had to make a new one in a long time," Benes said to a reporter from *POZ Magazine* in 1999. "Isn't that nice?"[63] However, the inequities of health care, medication affordability, and the severity of HIV transmission for queers of color, in particular, frustrate narratives that AIDS is over. Shards have racialized and gendered implications and convey unending medical disparity, new infections, and persistent dying. Clusters of cracked dishware, fashion rags, and paper airplanes crowd the corners of David Antonio Cruz's *playdeadreprised* (2013), giving transnational and immigrant meanings to this work from a younger Puerto Rican artist (figure I.3). Flecks of gold leaf, costume jewelry, and oil enamel cast a luminous finish over his mixed-media panel, an assemblage built into a high-relief surface. Decadent stains of brownness pool like melted chocolate bars. Amorphous white splatter flows into the swirl to create discordant colors and shapes in the composition.

Cruz's chocolate blots demand a reenvisioning of brownness' function and purpose. The work's political undertones allude to what José Muñoz

calls "feeling brown," a way of retaliating against invisibility and anti-immigrant stigma, of understanding "feeling like a problem [as] a mode of belonging, a belonging through [the] recognition" of brownness's collective resistance.[64] Cruz's chocolate stains and Muñoz's brown project both protest US xenophobic and colonial tensions that have pervaded the Americas and the Hispanophone Caribbean, in particular. Paper airplanes that are sculpted from archival records documenting Puerto Rican migration histories through Ellis Island and affixed to Cruz's paneling upend a romanticized national origin story of European foundations. These voluminous layers widen to indexing state-sponsored migrations of exploitable Puerto Ricans in the 1950s to remedy mainland labor shortfalls.[65] A rhetorical history of the "American Dream" melts down into indescribable but omnipresent brown blobs struggling for definition.

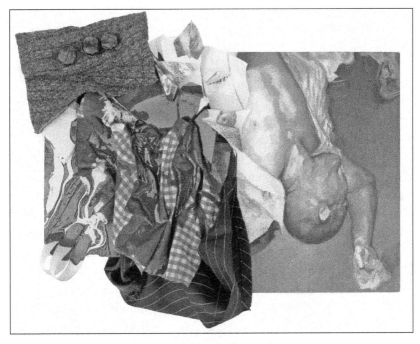

Figure I.3. David Antonio Cruz, *playdeadreprised* (2013), enamel, oil, gold leaf, fabric, broken plates, and paper planes on wood panel, 6" × 12". Permission and photography provided by the artist.

Cruz's self-portrait depicts his back arched and body splayed, chest and taunt torso exposed, creating conflictual desires, driving illicit thoughts, and raising necrotic allusions. Brown skin bristles against a cascade of dish shards and rags at the ends of the board paneling, signaling his death through the remains of things. Cruz revisits the wreckage portrayed in Hujar's and Benes's AIDS elegies by "playing dead" on veritable registers—from deathly erasures of his sexuality to the social death of his citizen subjectivity and legality.[66] Emulating what Michael Moon calls "memorial rags," the fabrics draping the painting and draping his body suggest the wound dressings Walt Whitman eroticized in his Civil War battlefield poems.[67] That is, Cruz's composition is "not only about literally shattered flesh but also about the shatterings—not least of all erotic shatterings—one can experience in response to flashes of flesh, the unexpected uncoverings and re-coverings of desired or beloved flesh that are as much a part of the everyday of the sick as they are of numerous other quotidian practices."[68] Peeking out beneath the debris is a queer Latinx body breaking away from strictures of social recognizability in flashes of skin, drippings of brownness, and fractures of things. The resulting permutation enunciates other "discursive spaces" from which queer Latinidad's AIDS devastation is discernable and perhaps overwhelmingly weighing his body beneath the shards.[69]

AIDS's jagged edges become a platform whereby queer Chicanx artists record and domesticate HIV, as in Laura Aguilar's mixed-media assemblage, *Gilbert's Altar* (ca. 2001).[70] In it, she revisits past artistic practices "convey[ing] a sense of shifting and layered individual and collective identities that contests an ideal subject or body of cultural or national identity."[71] Her photo-text work, a visual process of layering that, according to Yvonne Yarbro-Bejarano, elucidates a new baseline for domesticana aesthetics, infusing a domestic arts vocabulary with an equally powerful axiom of bodily exposure beyond Aguilar's archetypical nudes: HIV infection.[72]

Gilbert's Altar, an *ofrenda* for her close friend and confidant, Gil Cuadros, refers to an American modernist language predicated on ready-mades, bricolage, junk art, and rasquachismo in Southern California. Installed in a worn leather suitcase, her portable virtual museum has all the itinerant possibilities of Duchamp's *Boîte-en-valise* (box in a suitcase) and exacts the careful memory work of González's

autotopography. Creating a rare three-dimensional entry in her photo repertoire, Aguilar presents viral citations in the crashings of remnants. When opened, the case exposes the viewer to Cuadros. His body lies in state as a layered collage of body signifiers, material keepsakes, and emotive accents of anguish. Campy depictions of the pair in kitschy Cisco Kid sombreros and ponchos combine bittersweet recollections with photography of his ailing body. Like a coffin, the leather case presents ritualizing portraits of Cuadros in health and physical decline. Pieces of him reverse the violent incisions ghosting Meza's unattached visage in public spectacle or the strategic cutouts in the Aldarondo family scrapbook. *Gilbert's Altar* gives a deeper look into Cuadros's interiority; it is a study of queer of color intimate knowledge generated inside this leathery brown chasm. His photo fragments convey a life of whimsy and fantasy, of fastidious prose, a poet's life cut short at the age of thirty-four.

Aguilar's startling image of Cuadros near death inters his body into the collaged visual field mapping him in times of pleasure, play, indulgence, and demise. Like Cruz's lifeless performance draped on his bed, Cuadros's similarly limp body breaks away from the circuitry of circadian rhythms and neurological stimuli. He is in her care now. Aguilar's photo assemblage echoes the intimate relations cast in other AIDS pre- and postmortem photographs by A. A. Bronson, Rosalind Solomon, and William Yang. According to Jennifer Doyle, David Wojnarowicz's depiction of Peter Hujar's corpse in *Untitled (Hujar Dead)* (1988–1989), "navigates the dual capacity of photography to function as a continuation of the care one extends to the dying and as a mechanism that abstracts death, turning it into a consumable object."[73] I would also stress that it reproduces that infected body's consumptive entanglement in a pharmaceutical nexus of corporate capital.

A cookie tin in the case's bottom compartment is stuffed with drug trimmings, AZT, HIVID, and Difulcan. Its patterned design presents a viral meditation in domesticana terms, an *ofrenda* made with biomedical compounds, citations of sickness, and health industry profiteering. Cuadros's medications add one more "cocktail" to an archival body punctuated by bureaucratic indifference. An oral syringe bisects the gingerbread-man cookie-cutter making deft allusions to a Judeo-Christian cross and, coincidentally, signaling his seropositive status. The syringe is more than a prop; it conjures a body diseased, fatigued, and

bedridden. Shards here are of cellular proportion as the pills literally inside the gingerbread man are pollutants fostering viral replication, the breaking down of T cells, and crippling of human immunity. And like the classic children's tale, try as he may, the gingerbread man cannot outrun his fate. For Aguilar, no one is immune, least of all those in the vulnerable bastions of queer Chicanx LA. She intervenes in Chicana heteromatriarchal worldmaking by caring for an ailing queer brown body reapproximated in a domestic arts vocabulary and modernist tradition. More than testifying to the ways that Chicanas and Latinas also confronted the AIDS crisis with bold acts of recovery and care, Aguilar's assemblage-*ofrenda* stages another kind of attachment through alternative kinship, a claim to queer familia that bonds Cuadros and Aguilar together through the fallout, in the shards.

Like the dead littering the Civil War battlefield in Whitman's poetry or an expiring timeline approximated inside a leather suitcase, cultural obliteration was happening all around 1980s Southern California and making new demands on art and archive, record and remembrance. The AIDS crisis surrounded Chicanx avant-gardists such as Meza, Teddy Sandoval, Jack Vargas, Robert "Cyclona" Legorreta, and Joey Terrill (though the latter two are still alive). It is not surprising that they exist in art history's flotsam, in the shards of Chicanx art's entrée into US and Latin American contemporary art, and beyond art museums' delayed recognition of this heterogeneous community's boundless creativity.

Chicana and Chicano art is a critical discourse and, as classically defined by Shifra Goldman, imparts "statements of a conquered and oppressed people countering oppression and determining their own destiny, though not all the producers of these images necessarily saw their production in the political way."[74] As the cultural arm of the Chicano civil rights struggle, it grows from the convergence of political mobilization, antiwar demonstrations, and third world protest movements in the 1960s. Given the disproportionate Chicano presence in the Vietnam War draft, corporate agribusiness's abuses of farmworker labor, and increasing economic, health, and educational disparity, cultural workers fashion images to resist their material circumstances.

At this time, a visual vocabulary coalesced loosely based on Mexican postrevolutionary modes of public activism. These include street murals,

poster art, and political ephemera predicated on historically revision-
ist iconographies, anti-assimilationist cultural nationalism, and a sex-
gender politic lauding "La Familia."[75] Chicanx artists practiced visually
promiscuous "level[s] of deliberation, active engagement or agency . . .
in the choices they made in their creative processes," as Holly Barnet-
Sanchez argues.[76] Because Los Angeles has been a major epicenter for
different creative factions and artistic movements ranging from the early
bohemia of Edendale in the 1910s to the postwar "Cool School" on the
west side in the 1950s, the city's urban character shapes Chicano creative
expression, infusing it with socialist, narrative-based, and experimental
idioms and media critique.[77] Early on, however, Chicano art's enuncia-
tion as a category was propagated by public museums throughout the
Southland in ways that favor representational images, street sensibility,
and urban flair in shows such as *Chicano Graffiti* (1970) at Pomona Col-
lege Gallery or the *Los Four* (1974) exhibition at the LA County Museum
of Art.[78] Chicanx avant-gardes' dematerialized practices in conceptual-
ism and performance remained outside histories of American art, con-
temporary art, post-Stonewall visibilities, and aesthetics of the New Left
in the United States until the 1990s, when these omissions were recti-
fied to some degree by landmark national exhibitions, traveling shows,
catalogues, art media discussants, documentaries, and art historical
scholarship. However, such resurgence was occurring against an AIDS
backdrop as it ravaged queer Chicanx audiences. In turn, much of this
curatorial activity boosted the formative work of Asco, the East LA art
collective, in ways unexpected. I detail this discursive shift in the next
chapter.

Chicano historiography and art criticism leave queer amoebic avant-
gardes unevenly regarded, misattributed, or removed from an authorial
line of sight that privileges pristine whole documents, fine art objects,
and untarnished matter preferring discernible "hard facts."[79] Chicano art
history struggles to grasp Meza and his illusory visage projected above
symposium panelists, ghosting the archive of Chicanx avant-gardisms as
"lost art," that rare category traditionally used to define the systemic era-
sure of "degenerate art" in 1930s Germany where "Nazis' vilification of
modernist art . . . saw thousands of artworks destroyed, artists prevented
from working, and they and their supporters imprisoned or killed."[80]

Related human atrocities such as AIDS, coupled with government indifference, pharmaceutical greed, and inadequate healthcare for people of color and immigrants is an ongoing problem that must be confronted.

Chicanx visual and cultural critics have yet to assess the consequence of AIDS's devastation. As this book shows, the post-traumatic aftermath of human loss crystalizes what this plague has meant for art historical interpretation, formal considerations, public memory, and historical retrieval. The irony of Meza's illusory image is that the extant cannot exert its cultural authority without the nonextant. As curator Jennifer Mundy reminds us, "Lost art . . . should be seen rather as part of a broader continuum of thought and activity that can give meaning to the works even when they no longer exist physically (or, indeed, have never done so). . . . Not all works that are lost are forgotten, and even forgetting is part of art's broader histories."[81] Using this as my cue, I advance a methodology for thinking about how "the disarticulation of the object may lead to the articulation of other histories, and other geographies" as Caitlin DeSilvey argues.[82] Investigating the aftermath of AIDS demands "get[ting] lost" in Muñoz's sense by turning to subterranean loci: the ceramic graveyard, window trimmings, disparate trails of artworks, and cutouts layered in suitcases and scrapbooks.[83] Queer archival analysis resists privileging particular modes of heteronormative documentary authority and thus seeks out queer remnants reformulated in alternative ways because, as Cvetkovich reminds us, "creating history from absences, so evident in queer documentary and other cultural genres, demands creative and *alternative* archives."[84] This book retraces those alternative archival formations generated around and through a virus. These overlapping contexts are the basis from which an archival body/ archival space methodology emerges.

Toward an Archival Body/Archival Space Methodology

Queer avant-gardists' omission from histories of Chicano art and performance requires a complex set of analytics if one is to grapple with *what*, *where*, and *how* queerness remains in alternative forms. Although the public/private divide is certainly a leaky one in archive studies, Rob Fisher explains that personal recordkeeping is not only "embryonic" in archival theory but also "borrow[s] concepts from [its] government

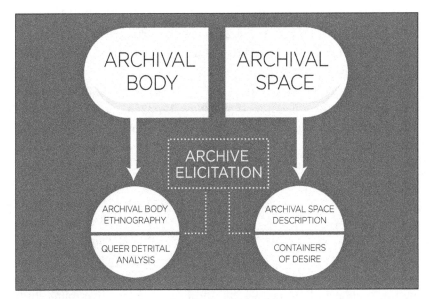

Figure I.4. The archival body/archival space study model.

colleagues" to the detriment of ascertaining its own language.[85] Archival body/archival space confronts this by introducing a study model with a set of five operators. This schema offers another lexicon for alternative archiving conversant with practices current to queer homemaking, Chicanx domestic arts, and memory fields of wreckage and loss.

Rendered through a metaphorical pill capsule, this book's methodology is visualized in a graphic arts style that is mindful of AIDS activist creative expression (see figure I.4).[86] Its design shares a confrontational spirit like that of the brazen art tactics of Gran Fury and General Idea in *One Day of AZT/One Year of AZT* (1991) and *Playing Doctor* (1992), which interrogate the disease and its pharmaceutical imagery.[87] Consistent with Aguilar's AIDS cocktail trimmings and what Rodríguez so desperately wants to extinguish in *Your Denim Shirt*, the resulting diagram's spatialization reoccupies this visual past and thus points to the viral shapes of things found in the field.

"Archive elicitation" centers the diagram; it is an oral history–based technique that influences all aspects of this research design. The custodian is interviewed during an archive-centered activity. This activity takes the shape of an in-house collection survey or object-centered

inventory about the works' disparate habitats. Preliminary fieldwork research with artist Joey Terrill in 2007, the subject of chapter 4, inspired the basis for this multifaceted technique. His reflections about his late friend Teddy Sandoval prompted him to announce mid-interview, "You know, I got some of Teddy's stuff up here, I got all kinds of stuff."[88] Breaking from the video interview and walking out of the frame, Terrill rummaged through kitchen cabinets. AIDS memory "fossils" populated his tabletop. The archival activity materialized a temporary portal to Sandoval, his extinguished oeuvre, and a queer Chicanx past of avant-garde collaboration.

Terrill's ceramics charge an otherwise static interior with political purpose. They cast insight into the creative process of alternative archive production "somewhere beyond" institutional arrest. Unlike object biography methods focused on one object of "deeply held values and source of meaning" detached from spatial contexts or domestic environments, such as in Kathleen Cairns and Eliane Leslau Silverman's study of women's treasuring practices, the compound layers of queer custodial interventions at home are vital.[89] Carefully analyzing the physical and visual properties of this constellation illuminates the devastation of AIDS more deeply.

Archive elicitation informs "archival body ethnography," which broadly considers the queer afterlife for Chicanx art and archive in its fugitive state. Through a descriptive overview of the body of record, we evaluate the recordkeeping constellation in its textual, visual, and artifactual appearance. If physical objects can "give us a personal archive or museum that allows us to reflect on our histories," in what Russell Belk has classically termed "the extended self," then "all human-made material things have the potential to convey information—and in some cases, they even convey viewers to another world or state of being," as Laurel Thatcher Ulrich and colleagues contend.[90]

The archival body convinces us of another state of *being, an approximation of human loss* in the articulation of accumulated records. By granting agency to this alternative archive form, we confront this assembly's fleshy or what Jennifer González calls "epidermalized" surfaces. These are no ordinary physical objects; rather, they "come to stand in for subjects not merely in the form of the commodity fetish, but as part of a larger system of material and image culture that circulates as

a prosthesis of race discourse through practices of collection, exchange, and exhibition. . . . Just as living humans can be conflated with material culture, so material culture can acquire the racial status of humans."[91] The archival body extends identitarian ligatures with insight into AIDS loss at the intersection of race, gender, sexuality, and, in particular, a disease. A line of questioning emerges about the "creation of another archival structure" in a multidimensional assembly of this surrogate anatomy.[92] By drawing specific observations from the sometimes conflicting or obscure relationships in the record formulation, the archival body congeals in a deluge of printed and artifactual "life tissue" or in literal ways like tins of post crematorium remains disguised as objet d'art accenting discreet corners of the home.[93] These parts offer an unusual resource from which physical remainders of queer Chicanx lives and deaths cohere in subterranean grounds.

A closely aligned area of inquiry, "queer detrital analysis," makes AIDS losses tangible through physical substitutions and reproductions of nonextant works to augment or resolve missing pieces with unknown or inaccessible whereabouts. Doing so challenges the terms of document preservation such as those relayed by historian David Lowenthal when he argues that "however venerated a relic, its decay is seldom admired."[94] Under his premise, archivists and historians should abhor decay because it "also symbolizes failure."[95] Conflating a decaying relic with failure, Lowenthal's thinking perpetuates heteronormative views predicated on "success" of the new. As J. Jack Halberstam notes, "Failing is something queers do and have always done exceptionally well."[96] Using detritus as an episteme to rethink archive as failure, we embrace the archival body's degradation and incompletion and recognize that it suggests "ways of being and knowing that stand outside conventional understanding of success."[97] By assessing the collection's ruinous state, queer detrital analysis circumvents systemic preservationist practices that strive for permanence and instead questions what discernments are possible through fragments, bit parts, substitutions, or glimpses that depart from institutional preferences for wholeness, authentic originals, unencumbered views, and historical precision.

The next operation in the schema, "archival space description" (see figure I.4), understands that the "history of any archive is a history of space," as Cvetkovich stresses.[98] Refusing "house arrest" in Westernized

memory palaces, in Derrida's terms, archival bodies experience a deviated life course. As Halberstam suggests, "Queer subcultures produce *alternative* temporalities by allowing their participants to believe that their futures can be imagined according to logics that lie outside of those paradigmatic markers of life experience."[99] By diverging from institutional ascension, the constellation is "outside of all places," according to Foucault, a type of countersite reserved for calamities happening "elsewhere" in "forbidden places" that are "persistently disappearing, though a few remnants can still be found."[100]

The archival body's spatialization is a study in diffusion or what postcolonial archive theorist Ricardo Punzalan calls a "dispersion narrative" that "captur[es] the complex and layered paths of dispersion [which] present profound challenges in any attempts at consolidation."[101] By undercutting singular and complete institutional holdings, the subterranean ground acquires new importance and requires descriptions that take note of the archival body's material-space ecology. Fields of wreckage and the environmental conditions are meaningful entanglements that impart place-based knowledge about where the record body is interred.

Doyle presents an instructional example in discussing her accidental discovery of Andy Warhol's print *Sex Parts* (1978) at MJ's, a historic gay bar in the Silver Lake neighborhood of Los Angeles (the bar closed in 2014). As "queer wallpaper," the framed work on paper accents other homoerotic décor and suggests a different, perhaps *queerer* architecture activating the sexually transgressive surroundings. The print's queer spatial position—in this case, a queer nightlife environment—demands a baseline inquiry into "not what it depicts, but where it hangs—and what its location makes visible."[102] As such, an "archival space description" interrogates not only a network of cast-offs but also the immersive atmosphere for the remnant, and thus creates a retelling of the ways in which AIDS debris is located, (dis)assembled, and displayed.

The housing of these fugitive sources of queer of color knowledge requires closer consideration of queer modes of care. The intimate channels of custodianship enabled by alternative kinship challenges discourses of provenance based on individual histories of ownership among genteel European aristocrats or affluent connoisseurs. Rather, the vernacular technologies and preservationist practices generated in response to human loss empower an adjoining spatial analysis of

"containers of desire." In chasms and compartments, these archival bodies take shelter sometimes to prolong record longevity and other times not. Interior cracks and crevices charge domestic landscapes with Chicanx art's sexual agency, because, as Victoria Newhouse suggests, the power of art's placement "affect[s] perception and meaning."[103] Thus, the preservationist technologies composing the micro-architecture shrouding the archival body and the sensorial experience of it are key to understanding its sexualized knowledge.

Containing personal keepsakes in shoeboxes or desk drawers is not extraordinary in and of itself. The private keeping of entrusted papers or heirlooms is part and parcel of much of material culture and collection studies.[104] However, drawers, furnishings, and other containers are not inherently passive and benign. According to Gaston Bachelard, these "inner space[s]" structure the "veritable organs of the secret psychological life. . . . They are hybrid objects, subject objects. Like us, through us and for us, they have a quality of intimacy."[105] Bachelard observes "an entity of depth" inside the object environment and suggests that even in the excavation of a casket, "We open it and discover that it is a dwelling-place, that a house is hidden in it."[106] This hidden house is rife with secrecy and discretion; the archival body's "intimate space . . . is not open to just anybody."[107]

Bachelard is useful here. He speaks to the enclosures/disclosures of domestic archival technologies in preservation, keeping, and care. Queer racial, gender, and sexual difference is more pointedly confronted in *Telling to Live*. The Latina Feminist Group recounts the production of *papelitos guardados* (guarded papers), an intimate collection of private confessions "tucked away [and] hidden from inquiring eyes."[108] The materiality of Latina feminist archival storage is subtly suggested but unexamined. What meaning might be derived from the everyday performance of "tucking away" Latina writing and, more important, from the cavity swallowing this literary production at the edges of domestic architecture? Most pressing is the threat *papelitos* pose when the chasm withholding the writing is suspected and unearthed. It is not solely the paper scraps but the container, that in-between-ness of floorboards and domestic surface, which has the power to expose.

As the Latina Feminist Group attests, when *papelitos* shed light on the person's erotic life, the threat of self-exposure stimulates sexually

charged interior spaces and behaviors. The nightstand, chest of drawers, closet, or headboard compartment threaten to expose erotic paraphernalia, pornography, sex toys, little black books, or other explicit ephemera. Discreetly placed "nudie" magazines or fetish gear hidden in a garment bag disturb the home setting. Alison Bechdel recounts in her illustrated graphic memoir *Fun Home* (2006) the discovery of a suggestive snapshot of her male babysitter; the semi-nude photo was taken by her father during a family vacation and found "in an envelope labeled 'family' in Dad's handwriting."[109] In *Prospero's Son* (2013), Seth Lerer descends upon his late father's San Francisco apartment and finds in the closet, amid belts and suits, a rack of leather bondage paraphernalia. Describing his shock, Lerer writes, "I sliced through the papers: threatening letters from a spurned lover, a restraining order against someone else. Rough magic, robes, utensils, things of darkness."[110]

By darkening the domestic landscape with daily reminders of taboo sexual relationships, these containers emit ghostly possibilities of unspeakable desires, a haunting of that which lurks in the "dark cracks" of the furnishings and on the surface of envelopes.[111] And these reminders grant ordinary containers with extraordinary abilities to possess sexualized meaning and queer evidence. These specific microspatial placements—and not just the things in them—potentially shape experiences of the home through sexual subjectivities germinating in wall cavities and behind closet doors.

Containers of desire exude a sexual agency that extends its reach far beyond the cohabitation with furnishings. A trip to the emergency room, for example, may set into motion a backup plan between friends where the armoire is "cleaned" of illicit contents before it can be seen by the prying eyes of anxious family relations. Other times these object environments are manipulated before the housekeeper, out-of-town guest, or moving company enters, rupturing (even temporarily) the way in which these things have routinely been lived with. The presentation and archival placement of these containers queerly catalyze certain actions in the everyday. They present an unsaid yet profound spatial organization of our sexual lives.

Another possible property to consider is the interplay of light and dark. Mikkel Bille and Tim Flohr Sorensen propose an "anthropology of luminosity," arguing that "the study of luminosity and *lightscapes* is

about attributing agency to light in the relationship between thing and person, through the illuminations and shadows this creates, and the meaning invested in these relationships."[112] Queer remains housed in cold dark shadow or exposed to the day show how sources of luminosity are important properties used to treat and present archival body/archival space on meaningful occasions or in quotidian household operations. An emphasis on containers' interiority demands a rethinking of the neutral grounds of storage, especially in lieu of a custodian's care, object safeguards, and staged encounters with different light sources to embellish or shield. After all, in the early years of the AIDS crisis, gay bars and public sex environments bathed patrons in blush hues to deflect physical evidence of bodily waste. The work of painter Roger Brown shows how lighting camouflaged diseased complexions under grim realities.[113]

Overall, this study model explicates the visual and material consequence of AIDS for the story of Chicanx art and its queer avant-garde facets. The creative archival constellations roused by this plague demand an archival body/archival space methodology and its related neologisms. My intention is not to revel in stories of rescue or to overstate the distinctiveness of disorderly private recordkeeping. Rather, it is to confront how AIDS devastation and its traumatic aftermath created conditions unlike any other, for some queers, the stockpiling of wares amid persistent deaths and for Chicanxs—a culture fashioned with a rich repertoire of domestic arts and border craftworks infused with the dead—material worlds demanding a set of analytics that eschew the heteronormative logics of progeny, ordered systems of record retrieval, and the violence wrought by administrative controls.

The Structure of This Study

My efforts to discern the posthumous art practices and scenes central to queer Chicanx lives and deaths take me from a living room in the mid-century architecture of Palm Springs, California, to a mountain ranch high atop Crested Butte, Colorado; from an artist studio in Downtown LA to a train station in Highland Park. What I discover are unusual recordkeeping formulations re-membering lost artists, demarcating a disease through artifactual stand-ins, visual surrogacies, object networks, and dispersed fragments.

Aiding in this investigation are other artists, family members, friends, collaborators, and, in particular, former lovers, who facilitate my entry into some of the most intimate and private areas of the home. Custodians meet my phone calls or emails with suggestions of other possible stewards of artworks, fragments, and stories. The case studies anchoring this study begin with "Cyclona's East LA Circle of Friends" as curator Cirilo Domine dubbed the group in the *Beyond Memorials and Symbols* show at the LA Gay and Lesbian Center's Advocate Gallery in 1998.[114] Robert "Cyclona" Legorreta's circuitous queer art faction dovetails with other informal collaborators, nebulous collectives, and fellow provocateurs and appears, for example, in an innocuous scrapbook of his performance art documentation (a subject of chapter 1).

The book foregrounds the nascent visual vocabularies of creative actors at the precipice of Chicanx queer aesthetics—artists who were besieged by widespread illness and in some cases erased. Three crucial yet little noticed avant-gardists—namely, Mundo Meza, Teddy Sandoval, and Joey Terrill—are the focus of case study chapters. Each illuminates a different vector of an archival body/archival space study model and instrumentalize the disparate constellations shaping the afterlife for queer Chicanx art "somewhere beyond" systemic forms of preservation and professional protocols. An archival body/archival space approach reveals a more complex picture of not only the experimental language of queer Chicanx representation but also the custodial responses to AIDS, the resulting degradation of physical records, and material losses of artworks and artists.

In chapter 1, "The Iconoclasts of Queer Aztlán," I draw on Cherríe Moraga's classic essay to introduce defiant remappings of art history through queer Chicanx avant-gardes formed in post-1960s Southern California. Rarely acknowledged in the prevailing narrative of LA Chicanx art and performance, artists like Legorreta, the central figure in this chapter, is typically seen as having a peripheral relationship to a singular Chicano avant-garde, with Asco at its core. In this chapter, I question and upend such a historical framing of curated exhibitions by describing how a queer iconoclasm interlinks and emboldens the art practices of the Escandalosa Circle, Butch Gardens School of Art, Pursuits of the Penis, and Le Club for Boys (among others). These salacious artistic endeavors invariably stop short in the face of the AIDS outbreak,

making the institutional disciplining of archival bodies/archival spaces difficult if not impossible to achieve in traditional museum settings. Thus, queerer epistemologies of archive and evidence are crucial to understanding another definition of Chicanx avant-gardisms, which unfurl in the forthcoming case studies.

In chapter 2, "Looking for Mundo Meza," I detail my efforts to locate Meza's "vanished art" and challenge the prevailing belief that his family destroyed his oeuvre following his AIDS-related death in 1985. Through a mobilization of queer detrital analysis, I propose how partial visions of Meza in mannequin anatomic fragments offer another way to understand an alternative archive. Meza's access to creative upstarts in the city unveils a rarely seen infusion of Chicanx and English aesthetics in the fashion trends and burgeoning retail scene of LA in the 1980s. Looking for Mundo means glimpsing him at the stylish filmic and literary margins of queer custodianship enacted by fashionista Simon Doonan.

Several friends and artistic collaborators bore witness to the dissolution of Meza's collection, including his contemporary, Teddy Sandoval. In chapter 3, "A Roll/Role of the Dice: The Butch Gardens and Queer Guardians of Teddy Sandoval," I consider the relationships between two distinct archival spaces: Palm Springs and the Highland Park neighborhood of LA. I pair the sediment of Sandoval's queer detritus with the sentiment of his posthumously completed public art commission, *The Gateway to Highland Park* on the Metro Transit Gold Line. By retracing the ceramic trails, object networks, and specks of sand and sequins, I uncover the artist's largely concealed corpus harbored within an alternative archive formation that interlinks house with urban landscape and city with desert in what amounted to a daring contribution to the city's public art history: the first Chicanx AIDS memorial in LA.

Seeing Sandoval's work for the first time at the *Chicanarte* exhibition at Barnsdall Park in 1975, Joey Terrill would later embark on a series of artistic collaborations with him, envisioning abject masculinities in the barrio. In chapter 4, "Viral Delay/Viral Display: The Domestic Para-Sites of Joey Terrill," I examine how his considerable attention to photorealism, American scene painting, and portraiture created and, indeed, archived intimate tableaus of same-sex desire, fantasy, heartache, and loss. By focusing on two works finished in 1989, the same year that Terrill tested positive for HIV, I unfetter an archival body/archival space

approximated by seroconversion. These "queer visual testimonios," as I term them, furnish domestic display environments with viral meaning. Terrill's collectors such as Michael Nava and Eddie Vela forge home bodies with "para-sites," households tethered through Terrill's retrospective documentation of AIDS incursion and introspective timestamps about HIV infection.

The fifth chapter, "Conclusion: Making AIDS Matter," forwards a sixth precept to the archival body/archival space study model: the virtual queer archival laboratory. Taking a page from feminist art history and AIDS art activism's institutional critique of museums, I present and rearrange a series of vignettes in speculative form. Returning to a failed nineteenth-century museum project predicated on casts, I "jostle" scenes from an art book fair, men's fashion boutique, and travel document of a Mexican voyage to Chichén Iztá.[115] Using duplication and revisitation as a means to make AIDS *matter*, I offer many possible afterlives for alternative archival forms to reimagine what Chicanx art could have been. Queer of color futures break from discourses of wholesale preservation and thus invite creative and virtual interventions.[116]

By considering queer Latinidad within an archival body/archival space methodology, this book explicates the alternative ways these artists remain in visual compounds and material constellations. Given attitudes toward the authority of empirical records, documentary wholeness, and neutral repositories, it is not surprising that these subterranean sites are overlooked or circumvented. In remedying this omission, these memory fields air the long-standing silences and invisibilities surrounding AIDS in the literature and criticism of Chicanx art history, performance studies, and contemporary art, more broadly. In the proceeding investigation, I generously apply this study model to reconcile distorted views of sexual and gender transgression in Chicanx avant-garde histories, elucidate the unexplained yet undeniable presence of these artists in Southern California, and propose other ways of being and seeing Chicanx culture.

1

The Iconoclasts of Queer Aztlán

On January 30, 2008, *Arte No Es Vida: Actions by Artists of the Americas, 1960–2000* opened at El Museo del Barrio, a cultural nexus for contemporary Latin American and Caribbean art in the corridor of New York's museum mile, a stretch of ornate memory palaces including the Guggenheim, the Smithsonian Cooper-Hewitt, and the Metropolitan Museum of Art. Commemorating the forty-year anniversary of El Museo, Deborah Cullen curated an ambitious survey that examined divergent performance expressions and political actions across transnational and regional contexts. Among the hundred artists who "prefigure, link to, and differ from the received history of 'performance art'" was a rather obscure figure from East Los Angeles, Robert "Cyclona" Legorreta.[1] Combining the salacious term for World War II–era zoot suit Chicanas with the destructive force of a natural disaster, his alter ego Cyclona harnessed the chaos engulfing Southern California with draggy rage.

Visitors to El Museo on that opening day saw Legorreta's "live art" statements in selections from a twenty-eight-page scrapbook, a profound anthology of queer Chicanx artistic collaborations and performances from 1969 to 1974. The book consists of collage arrangements on the front and back of paperboard and glycerin paper. They are strangely disjointed; snapshots are tilted or cropped for a frenetic effect amid taped and glued scraps. Each frame animates Cyclona's disruptive performance work in compressed temporal structures and sometimes distressed materials (see figure 2.2). His reviled persona pervades the collage like a cinematic sequence. Jump cuts are mimed on paper. The scrapbook's disassembled pages are recombined in the vitrine, creating a plane of four panels that feature Legorreta in restaged photos and texts. An accompanying label reads:

CYCLONA

(1952 El Paso, Texas, lives-works Whittier, California)
Cockroaches have no friends, 1969
Scrapbook with color photographs

The Marriage of Maria Conchita Teresa and Chingón, 1971
Scrapbook with color photographs
The Fire of Life: The Robert Legorreta–Cyclona Collection,
The UCLA Chicano Studies Research Center Library and
Archive

Knowing how to generate a public reaction using his body
and attire, Cyclona based his performance art pieces on
homoerotic overtones that contrasted with the Chicano's
cultural nationalist ideology, which affirmed traditional
conceptions of gender and family structures.[2]

The heading on the label gives his alter ego's rather than his own name. Legorreta's foundational influence in queer Chicanx performance is positioned in "contrast" to "the Chicano's" family, opposite its nationalism. The text speaks with a didactic, nearly ethnological tone and constitutes his art practice in dichotomous terms. What is not described is his propensity for stirring publics with caustic tantrums and fulminating outcries. Legorreta's inclusion in the exhibit section entitled "Border-Crossers/Franqueadores de Fronteras" is also telling in that it groups him with work "evoking and challenging the delineations and existence of borders through conceptual practices, performance actions, interventions, and even street theatre."[3] Arte No Es Vida is the first public exhibition of his scrapbook. Despite its showing to a mainly New York audience, Cullen sutures the remnants of Cyclona's insurgent acts to a corpus of border-crossing conceptual artists in the Americas. But the boldness of such curatorial translation was undercut by the conditions in which Legorreta's "ethnographic fragment," in Barbara Kirshenblatt-Gimblett's terms, was presented.[4] After all, the New York Times lauded the "urban interventions of Asco" in its review of the show.[5] Such art

media discourse distances Legorreta's instructional role in Chicano conceptualism, neutralizes his significance as a precursor to avant-garde and experimental art vocabularies in East LA, and thus intensifies the symbolism of his body of record placed in a glass box.

If the art gallery is a narrative organization of museum space and the metonymic fragment is "an art of excision, of detachment, an art of the excerpt," then the scrapbook's placement is telling: placed in a vitrine beneath the Asco photos mounted on the wall, Legorreta is literally positioned under the feet of the Asco collective, a group that scholars such as Dianna Marisol Santillano argue "redefined contemporary Chicano art and challenged its artistic canons, thus *launching* the Chicano avant-garde."[6] Her comments are profound and speak to a cultural moment when "postethnic art exhibitions that questioned Chicana/o identification . . . emerg[ed] in Los Angeles and elsewhere since the beginning of the millennium."[7] Conceptualism and performance strategies are central to the post-identitarian discourses in *Phantom Sightings: Art after the Chicano Movement*, which opened at Los Angeles County Museum of Art (LACMA). Coincidentally, *Phantom Sightings* premiered the same year, making these exhibitions dialogic in effect and indicating that they should be understood as such (*Phantom Sightings* even makes its way to El Museo del Barrio in 2010). Asco is featured in both shows and located "as a starting point" in *Phantom Sightings'* curatorial framework and exhibition design.[8] Resting its argument on the collective's visual genealogy of conceptual artworks between 1972 and 1976, co-curator Chon Noriega suggests, "Since the 1990s, Asco has influenced or provided a point of reference for a new generation of artists and artist groups whose work explores . . . public space."[9]

Whether as a starting point in Karen Mary Davalos's terms or point of reference in Noriega's, Asco is central to its curatorial presentation, a substratum for the Chicano avant-garde's experimental language. The reciprocity between these two shows, one on the East Coast and the other on the West, cannot be emphasized enough. A selection of Asco digital prints from the mid-1970s appeared in both exhibitions, repeating a narrative about the collective under the guise of its four founders: Harry Gamboa Jr., Gronk, Willie Herrón, and Patssi Valdez. Despite the group's rotating cast of collaborators, especially in its later iteration in the 1980s (the Asco B period), what was seen at *Arte No Es Vida* were

seven works from Asco's early performance oeuvre, which included *Walking Mural* (1972), *Spraypaint LACMA (or Project Pie in De/Face)* (1972), and, in particular, *Asshole Mural* (1976).[10] Beneath this institutionally sanctioned display of Chicano conceptualism, Legorreta was flattened under the group that "launch[ed] the Chicano avant-garde," begging the question: What are we to make of the queer grounds from which Asco stands?[11]

Growing up in East LA in the 1960s, Legorreta attended Garfield High School. The lives of Asco founding members entangled with his. However, Legorreta's relationship with queer creative upstart and "soul mate" Mundo Meza, a painting prodigy, proved foundational. Recalling the last conversation he had with Meza before he died, Legorreta remembers that Meza said, 'Do you remember the first time we met, Robert? And I said, 'No.' And he said, 'I was a little kid and was on top of my father's shoulders, and your father and my father were drinking friends."[12] Legorreta explained: "The first time we met, it was when he was almost a baby."[13] His story bordered on a prophetic nearly psychic journey for the pair. Legorreta's final exchange with Meza, who died from AIDS-related complications in 1985, illuminated the incidental body traffic of East LA happening through the urban sprawl, the "hit and run" collisions that Gamboa imagined occurring between artist, concept, and media in banal barrio life.[14] Chicano conceptualism was created out of these conditions rife with creative possibility.

In fact, one of these collisions occurred between these "psychedelic glitter queens" and a classmate calling himself Gronk.[15] He would meander in and out of doorways of retail shops "[seeing] what Mundo and I were doing," Legorreta remembered.[16] Described as a "barbarian/beatnik," Gronk wore "wingtips and these old shiny pants from the fifties—the ones that would glitter."[17] Looking beyond the urban decay in East LA, Gronk sought something glitzier, more flamboyant than himself. "He came up to us one day," Legorreta added, and "said he was putting a play together and he wanted us to be involved."[18] That play turned out to be *Caca-Roaches Have No Friends* (1969). Such "run-ins" permeated the social landscape and stimulated a series of transgressive experimentations in Chicanx gender and sexual expression.[19] Adorned in swaths of fabric, this trifecta became twinkling subversions of Chicano masculinity.

As living art personas, they repudiated *machista* body disciplining, which dominated the barrio. Their garish self-images intrepidly commandeered urban landscapes and agitated complacent Mexican and Mexican American publics. Recalling his early performance work in 1994, Legorreta concluded, "We were trying to shock people into believing that they could do anything they wanted to do. . . . I always [said] East L.A. was like a giant rubber that was ready to explode."[20] And explode it did.

Despite advancing what are arguably the first queer Chicanx performance art actions in Southern California, the formative works of Legorreta and Meza in androgynous self-imagery have yet to be evaluated in any substantive way in Chicanx art history, performance studies, and contemporary art. If acknowledged, these artists are cited mainly in relationship to Asco. In fact, Cyclona's living art performance in *Caca-Roaches Have No Friends* is "proto-Asco," according to Amelia Jones, in her catalog essay from the LACMA retrospective exhibition, *Asco: Elite of the Obscure* (2011).[21] Being historicized in a more linear teleology of the collective, Legorreta, Meza, and Gronk are precursory addendums lapsing into that amorphous queer Chicanx avant-garde that is unknown.

In this chapter, I distinguish these visual provocateurs not to restore a more complete picture of Chicano avant-gardism alone but to reframe their discomforting function as iconoclasts of queer Aztlán. In revisiting "queer Aztlán," I recalibrate Cherríe Moraga's radical reimagining of the symbolic homeland for dispossessed Mexican Americans in the US Southwest. Queer Aztlán represents a liminal site for these sexual outlaws, "a Chicano homeland that . . . embrace[s] *all* its people, including its *jotería*."[22] I want to consider how these artists' intimate knowledge and rehearsals of disturbance rouses queer experimentation in Chicanx art, making it potentially explosive. Performance actions, print media art digests, and alter personae teeter on the edge of destruction, deliciously upsetting heterosexual propriety and inciting outrage. I argue that these artists understand that iconoclasm is not unilateral but multidirectional, and that they channel its reactive power in ways previously unseen. By illuminating how creative collaborators—Ronnie Carrillo/Jack Vargas, Joey Terrill/Teddy Sandoval, and Robert Legorreta/Mundo Meza—interject a queer iconoclastic vocabulary into an ostensibly static object-centered

Chicano visual field, I unfurl how ethnic and sexual marginalia agitate any straight linearity of Chicano art history with their destabilizing and detonating effects.

Flammable Machos

In art historical terms, iconoclasm is the physical or sometimes symbolic destruction of icons deemed ideologically or politically objectionable. Works of art, monuments, statuary, sacred icons, and even archival repositories are susceptible. They are desecrated and targeted in times of war, regime change, protest, and political struggle. These retaliatory acts are by no means anchored in the distant past, however. According to Erika Doss, iconoclasts (literally, "image breakers") assault public art projects "considered offensive and inappropriate" because shifting ideological and symbolic beliefs conflict with the "processual frame" of public memory.[23] Loss caused by vandalism undercuts a popular presumption that "contemporary works are somehow immune to . . . disasters" and protected within in a hypermedia digital culture.[24] Portable media technologies are thought to recontextualize difficult artwork and at the very least prevent visual materials from disappearing. However, technoculture's utopian practices are contradictory, sometimes deleting documentation or bypassing cultural texts deemed historically unimportant or not worthy of conversion or public access.

In any online records of the early years of the AIDS crisis, cohorts of queer artists of color in the 1980s are noticeably absent. As a result, accusations of "whitewashing" AIDS pervade contemporary reevaluations of the 1980s. An exhibition such as *Art AIDS America*, presented at the Tacoma Art Museum in 2016, brought this cultural tension into stark focus. On December 17, 2015, the Tacoma Action Collective, a multiethnic activist coalition, crowded inside the museum to stage a "die-in," reinvigorating that insurgent nonviolent action from the theatrical arsenal of ACT-UP. Their performance seconded the group's "brilliant and savvy media-friendly soundbites, graphics, and theatrics [which] relied, to a large degree, on the operatives of visibility politics," as David Román argues.[25] "The documentation of visibility politics and its tactics—in both mainstream and alternative media—served multiple and specific purposes that varied according to who held the camera and for what end."[26]

Román's summation of ACT-UP's effectiveness circa 1998 predates the advent of Web 2.0 and social networking software, though his observations are prescient vis-à-vis the Tacoma Action Collective's activism nearly twenty years later. Catalyzing political participation on a wide scale, these shrewd high-tech queer millennials empowered the archival capacity of cellphone technologies to document and in turn, more immediately incite change by going viral with mobile data.

AIDS devastation frustrates research processes predicated on digital retrieval and online sleuthing. Moreover, because queer visual artists frequently experience their creative expression through what Richard Meyer calls "outlaw representation," their collections spur reactions from museum curatorial divisions or more traditional archive repositories resistant to affective, experimental, or combative art histories and paradigms of evidence. With corpuses stirring outrage and provoking "the avowed mission of censorship, the mission of making these images disappear" from the privileged sight of heterosexual visibility, the resulting conditions facing queer Chicanx artists are akin to iconoclastic retaliation.[27] Again, iconoclasm is multidirectional and for the remainder of this section I ruminate on not only the censorious and reactionary responses to artists of queer Aztlán but also, how such destruction is repurposed undergirding Chicanx avant-gardes explosive interventions.

Examples of public outrage over queer Chicanx and Latinx visual art are manifold. In 1975, Jack Vargas, a mixed-media conceptual artist from Santa Paula, California, showed new work at *Chicanarte*, a historic exhibition featuring more than 100 artists organized and juried by Al Frente Communications, Inc., and the UCLA Chicano Arts Council at Barnsdall Park.[28] Vargas's entry, *New Language for a New Society—28 Samples* (1975), was Duchampian in its approach. Using a found-object Rolodex, Vargas interrogated the indexical function of the device by disordering strings of language through sexually suggestive innuendo and jumbles of wordplay. Calligraphic handwritten envelopes sampled his radical poetic, a patois spoken within his inner circle of queer Chicanx artists and mail art correspondents. In addition to "Trash—eek," "Mexi-Queen," and "Jiffy Beanzales," words such as "la-la's" referenced an aura of "boring" uniformity, of young gay men in a phase of hedonistic frivolity.[29] "Public Hairs" named the hypervisible and audacious behavior of gay nationalists making their private parts public parts, much to

Vargas's disdain.[30] His cylindrical index presented a Chicano poetics at its most experimental, hybridizing linguistic structures, creating perversions of language, a mishmash of Spanglish accented with a gay urban vernacular.

Vargas's bold submission provoked hostile responses. In a 1999 interview with art critic Jeffrey Rangel, Harry Gamboa Jr. reflected on the public's caustic reception: "People wanted to toss him into the [La Brea] tar pits basically. . . . I remember that that particular piece, the way he played with the words had an effect on the way I think from that point on the way I would use words."[31] A decade after the Rangel interview, Gamboa was more explicit about the volatile reactions to *28 Samples*, pointing to one individual culprit, who was part of a broader marauding horde: "A man grabbed hold of the Rolodex file and was about to toss it to the floor when several artists intervened and talked to the men while Jack Vargas was escorted to safety," he recalled.[32] "It is possible that his exhibited work was the first to encompass Chicano and expansive gender roles during a transformative period when other artists would be amendable to collective influence and group efforts."[33] The collectivist possibility yielded by his poetic machinery—and, for that matter, a portable archive—suggests a rarely considered outcome of queer Chicanx visibility: its destructive powers. In his art memory, Gamboa completes the work by showing how Vargas's queer wordplay and its repercussions effectively incited social transformation with reverberating aftereffects. The force of Vargas's conceptual piece resonated with Gamboa, whose later photo-text pieces, experimental prose, and public access media broadcasts and video productions have jarring traces of Vargas that must not be underestimated.

Around 1975, Vargas met Ronnie Carrillo, a former classmate of Joey Terrill and friend of Jef Huereque. Writing under the guise of fictitious handles and cheeky monikers, they emulated the subversive traditions of mail art, a proto–social media network interlinking art, performance, and epistolary literature through federally governed postal channels. According to Michael Crane, "In a subjective sense, these media are used to create the psychological constructs of contact and support necessary for the existence of the network. Some letters and envelopes are used to create fiction, legends, and other attitudes of the mind."[34] Vargas's and Carrillo's resulting personae demonstrated another queer creative

faction organized around a mail art-literary exchange. The result catalyzed image-text junctures and proved yet another paper-generated queer Chicanx expression in "epistolary performance."[35]

Through fictitious art handles, collaged envelopes, and innovative salutations, Carrillo and Vargas used the post office to perform new identities. With a poet's penchant to test the page and restructure the literary body, Carrillo used biblical verse, poems, diary entry duplications, and salacious teasers in his "Pursuits of the Penis" letters. Postscripts forecasted "coming attractions" in his erotic pursuits. Carrillo's writings were sent in nondescript mailers. He covertly placed more emphasis on the interior expression, on the principal act of what his words were capable of showing in paper and ink. Vargas's print productions, however, inverted Carrillo's discreet treatment.

Vargas's "Judeo Christian Ethic Universal" letters adapt the salutary formatting and "outs" it from the trapped space of letter enclosure. By exteriorizing the epistolary device on the envelope surface, Vargas calls attention to mail art's rebuke of institutional art gallery systems, revised Carrillo's innovation taking his salutatory format on the inside and turning it outside. One might imagine how this envelope may have activated the mailroom. Listed are categorical entries with satirical and witty retorts to "Worst Commercials," "Best Commercial," "Best Product of the Year," and "Best Company of the Year." Vargas logs a record of popular culture, and melds a simultaneous documentation of his media tastes and preferences. His attention to flamboyant sticker embellishments of flora and fauna, dinosaur specimens, lunar motifs, and crowns convey a satirical outlook with a pop-art spin. His envelope surfaces a campy décor imitating an official notice dispatched from an Orange County "queen on the scene." Sticker seals marked "confidential" draw ironic attention to what's inside. Vargas exteriorizes what Carrillo interiorizes in a mailed epistolary performance.

The men's geographic distance of just under thirty miles from one another intensifies their feelings, which emerge in confessional moments in their letters. Vargas admits, "I wish I lived in closer proximity to where you live—I too think of you after—actually, being very honest, I do need you (I think you and I feel a need but we don't understand it yet enjoy it,) and miss you, Ronnie, and I don't know why but I do."[36] Carrillo is similarly confused, feeling inexplicably elated after receiving

Vargas's letter. "Jack . . . received your letter several days ago—what a joy! I was uplifted so much and pleased with your letter that I temporarily forgot about tricking. For you see I was going to the Park when your letter came and after experiencing it I felt too good to go assault myself."[37] The mail disrupts his carnal urges to trick with other men. Instead, he finds "joy" in Vargas's handwritten pages.[38] The corporeality instilled through the writing enhances the performative capabilities of paper as it acts on and acts through sender and receiver. As Alison Piepmeier espouses, "paper facilitates affection," and for Carrillo and Vargas nothing could be more true.[39] In their struggle to overcome distances created by urban sprawl, allay parental suspicions over their sexualities, and mediate federal postal carriage with queer Chicanx confessionals and diaristic divulgement, the two letter writers catalyze a temporary domicile away from "fleshy debris," escaping the "ancient yet familiar beasts" tantalizing them in the dalliance of boys, bars, and parks.[40]

Their epistolary writing came before the AIDS onslaught intensified a personal awareness of loss and almost certain death. Carrillo tested positive for HIV in 1989, and Vargas died from AIDS complications in 1995, at forty-two. His name is now etched into tile, which forms the central partitions of *The Wall-Las Memorias* in Lincoln Heights in East LA. Cited as the "only memorial of its kind dedicated to Latino/a victims of AIDS," the civic project was conceived by Richard Zaldivar, a Cathedral High School alumnus who was two years Carrillo's senior.[41] Designed by architect David Angelo and artist Robin Brailsford with six murals painted on steel panels and a chrome arched gateway, *Las Memorias* was a promising yet fraught endeavor.

Installed in Lincoln Park, a recreational site of historic consequence for Chicanx art and civil rights history, *Las Memorias* activated a place for Latinx AIDS public memory in the barrio, broadly.[42] But despite its hyperbole, it was not the first AIDS memorial in LA nor was it exclusively organized and created by HIV+ Latinx artists, a distinction I make clearer in chapter 3. However, in its elegiac attention to and emphasis on materializing AIDS's egregious devastation, *Las Memorias* presents a queer of color expression of the disease. In this way, its placement tells a social narrative of Latinx bereavement from the unusual standpoint of barrio urbanism. As a site of reflection and meditation, *Las Memorias* adds another political dimension to the physical fixtures of East LA

recreation: a skate park, playground, and Plaza de la Raza, a lakefront center for Chicanx art established in 1970.

The ten-year campaign to fund the memorial faced vocal opposition from progressive and conservative power brokers, however. Members of the Sierra Club publicly opposed the work for its imposition on limited green space.[43] A group of neighborhood boosters called Friends of the Lincoln Park LA Committee seconded this stance, arguing, "This is about green space for us. It is not an issue about gays or sexual orientation."[44] But for the Christian Right it was. A website administered by Abiding Truth Ministries under the pseudonym Pinkpork.com rallied residents against *Las Memorias* because of its proximity to a children's playground.[45] Online propaganda such as "Parks are for Families and Recreation!" incited irrational responses to perceived predators trafficking around the memorial, itself seen as a validation of the supposed immorality of a queer lifestyle—even as a tax-financed endorsement of "filthy" sexual behaviors that were blamed for spreading HIV.[46] By cleverly tying its argument to wasteful city spending, Pinkpork.com rallied fiscal conservatives to the cause. "This is a ridiculously premature waste of my hard-earned tax dollars and I hope the ridiculous AIDS Wall doesn't get built. Zaldivar has achieved his goal of keeping AIDS in the news in our area. We don't need a wall for that," wrote one opponent in the *Observer*.[47]

Attacks on *Las Memorias* also criticized its design and imagery. Proposed mural panels were selected from a cadre of recognized public artists. Six partitions stood opposite each other, lining a concrete pathway accentuated by the park's natural shrubbery. The concourse fostered a sense of a serene and peaceful retreat. A meditative pathway unfolded Latinx AIDS vignettes freestanding on staggered panels. Alex Alferov's *Spirituality and AIDS* (2003) portrays the Madonna in pensive repose, shrouded by roses and skulls that resonate with Day of the Dead iconography. An immigrant from Yugoslavia, Alferov had extensive exposure to Chicanx cultural production through Self-Help Graphics, another East LA Chicanx artistic hub. His submission was an infusion of Byzantine, Mexican, and barrio visual elements.[48] His concerted attention to virgin iconography incensed zealots from the religious Right, who argued, "It appears that the Las Memorias project is attempting to a paint a tax-funded picture that suggests that the Mother of Christ would support

the homosexual lifestyle. Nothing could be more offensive to the First Amendment."[49] Removal of Alferov's painting alarmed the artist, who appealed to a titan of Chicanx art history, Shifra Goldman.

As an esteemed champion of Chicanx visual criticism, she must have held considerable hope and appeal for Alferov, who was reeling from the death of Self-Help Graphics stalwart Sister Karen Boccalero in 1997.[50] Goldman's scholarship had branched out into Latin American AIDS criticism in 1994 with an essay for the exhibition *Mexican Art: Images in the Age of AIDS* at the University of Colorado at Boulder Art Galleries: "I have deliberately chosen to detach AIDS as a disease from the practices of sexuality by connecting it to the long history of human plagues, epidemics, and pandemics—where it properly belongs, in my opinion."[51] Goldman's drive to extricate AIDS from queer of color visibility and bodies of desire errs on the side of caution if not repression, a position gleaned from her correspondence with Alferov. After evaluating the combating factions in the *Las Memorias* controversy, she concluded: "I repeat: this whole process is political—not even aesthetic. . . . I might have no objection to the murals themselves. But I would be very uneasy at the placement over the grassy space where children can play—and must play because so few parks exist in East Los Angeles. I raised a young child there, and am fully familiar with the terrain, as I told you. We MUST consider a different placement of the murals—and NO OTHER ground-destroying additions. This is quintessential."[52]

In this way, Goldman contested not the imagery necessarily but the spatial appropriateness of queer of color AIDS visibility.[53] Her contention seconds the notion that the installation of *Las Memorias* in the green space of Lincoln Park compromises sites for family activities. As a place, *Las Memorias* is symbolically if not spatially destructive, violating a recreational landscape in service of heterosexual families and the nearby Plaza de la Raza. The backlash to the project from progressive, conservative, and even Chicanx art advocates demonstrates how queer of color reclamation of barrio urban space in service of AIDS public mourning threatens stirring upset and anger.

Alferov's work survived these censorious attempts and was rejoined to the other mural panels that crossed ethnic, gender, and generational categories. In recent years, *The Wall–Las Memorias* has fallen into severe disrepair and, a favorite of taggers, is frequently vandalized.

Slang-infused homophobic slurs such as "Miyones de jotones" (roughly "millions of faggots") are scribbled on the installation's archway. As caustic forms of barrio writing, these continue a practice of defacement that ironically bolstered creative responses by queer Chicanx avant-gardists like Legorreta's battered art books and Terrill and Sandoval's performance exercises, as we shall see. Of course, Alferov's Byzantine Virgin was not the first public exhibition to stir religious zealots. The struggle over cultural reclamation, feminist iconography, and the limits of queer racialized imagery affected Chicana artist Alma López early in her career. Opposition from museum administration, government, and Catholic leaders came together at the International Museum of Folk Art in Santa Fe in 2001. López faced death threats for *Our Lady*, a digital collage print that depicted the sacred mother of Christ in a floral bikini with obvious lesbian allusions. As Alicia Gaspar de Alba notes, "For months after the opening, protest rallies and prayer vigils were organized outside the museum, spearheaded by a community activist cum volunteer chaplain for the city's police department, a deacon of Guadalupe Parish, and the archbishop of the Santa Fe Archdiocese."[54] López's work does not stand alone, but enters a larger Chicanx lineage of queer artistic reappropriation of sacred iconography.

Since the 1970s, Chicana artists Amalia Mesa-Bains, Yolanda López, and Ester Hernández "were threatened and attacked for portraying La Virgen in a feminist and liberating perspective," Alma López observes, and in so doing affiliates her work with a radical feminist genealogy.[55] "Yolanda M. López received bomb threats," she notes.[56] Scholar Laura Pérez also reports that Hernández received a life-threatening phone call after her silkscreen *La Ofrenda* appeared on the cover of Carla Trujillo's *Chicana Lesbians: The Girls Our Mothers Warned Us About* (1991).[57] In the early 1990s, artists Bill Rangel and Mike Moreno infused La Virgen de Guadalupe within culturally specific safer sex imagery for VIVA, the first lesbian and gay Latino artist organization in LA. Moreno's drawing *El Virgen Del Rey* (1993) replaces the traditional halo surrounding La Virgen with a condom wrapping an erect phallus. The prophylactic radiates with divine intervention, sealing ejaculate behind the protective barrier of latex.[58]

Another VIVA member, Alex Donis, an LA-based Guatemalan artist, showed *My Cathedral* in 1997 at Galería de la Raza in San Francisco's

Mission district, a largely immigrant ethnic neighborhood buttressing the Castro, a historically queer epicenter and cultural artery. Donis's site-specific installation debuted in street-facing windows. His paintings on light boxes illuminated same-sex kisses between political or religious figures, including Mary Magdalene's passionate embrace of La Virgen de Guadalupe.[59] Less than two weeks after the opening, a thrown brick shattered the plexiglass panes, destroying his pieces. The surviving artworks were moved into the protective shelter of the Galería. Reflecting on the attack in 2015, Donis remembered, "Out on the street a makeshift altar was constructed where the works had been vandalized, pedestrians wrote comments of tolerance on the sidewalk outside the gallery. . . . After this incident in San Francisco occurred, I continued to think a great deal about this whole dynamic of what happens when queerness collides within the realm of public space."[60] Clearly, artworks by the queerer iconoclastic vestiges of Aztlán met with a reception that was quite different from the highly lauded public space interventions of an Asco-defined avant-garde resonating for Noriega at the outset of *Phantom Sightings* in 2008.

The destructive anger roused by Donis's *besos peligrosos* (dangerous kisses) was reignited nearly fifteen years later by *Por Vida*, a public art digital mural commissioned by the Galería de la Raza. (see figure 1.1). Designed by Manuel Paul in conjunction with the exhibition *The Q Sides* on queer representation in low-rider culture, and on behalf of the Maricón Collective, a queer quartet of Chicanx creative innovators and DJ upstarts based in LA (see the concluding chapter for more on this group), *Por Vida* is a forthright depiction of same-sex couples, as well as a portrait of a postoperative transgender man replete with the surgical lines accordant with trans contemporary artworks of Jenny Saville and Cassils. Rupturing the pervasive image of cisgender machistas in Chicanx public art, *Por Vida* was defaced three times over the summer of 2015 and was trolled and maligned on social media. "Keep that bullshit in the Castro," one angry reactionary demanded.[61] The work was even firebombed, sending waves of alarm throughout Chicanx queer art activist communities. With their intimate knowledge of iconoclasm and its ramifications, queer visual artists confront the limits of barrio publics, test the cutting edge of queer ethnic visibility, and challenge an oppressive regime of heterosexual sight—often with explosive ends.

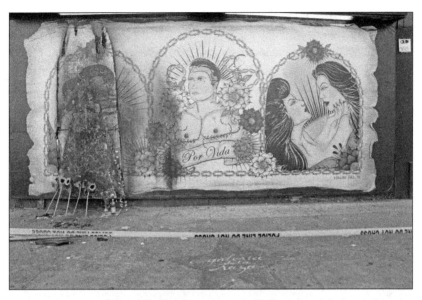

Figure 1.1. Manuel Paul (on behalf of the Maricón Collective), *Por Vida* (2015), digital mural on billboard, Galería de la Raza, San Francisco, CA. Permission courtesy of Manuel Paul. Photograph by Gilda Posada.

The verve by which the iconoclast destroys signals more than incendiary reactions over public space; it also represents an aesthetic strategy central to European and Latin American avant-garde practices. Contesting social mores, upsetting museum categories of fine art, or creating imagery to effect social change, Chicanx art can thus be "a transgressive act aimed at unveiling and destabilizing official narrative and practices of dominant political power and authority."[62] In the 1960s, the Chicanx art movement was in accord with nationalist ideology and the radical Left. The monolithic "Chicano artist" as dictated in movement manifestos, or *planes*, was an instrument of anti-assimilation, a symbolic weapon for asserting cultural pride. According to George Vargas, "Historically, most Chicano art has been made in the name of the people's art movement, outside the museum structure and hierarchy, so the establishment continues to associate it with radical or protest art."[63] He adds, "most Chicano art of this period predictably expressed an anti-establishment or militant perspective. Chicano artists

identified with the revolutionary art of France, Russia and especially postrevolutionary Mexico."[64]

Artist Carlos Almaraz seconds Vargas in his classic manifesto arguing for art's "function as a revolutionary weapon."[65] Through the artillery of Chicanx political imagery, he contends, "a person becomes an artist because he has some insatiable iconoclastic need inside himself. Perhaps that's a bit romantic. However, destroying art in order to create new art appears to have this iconoclastic characteristic. I supposed that this is one reason for the great appeal of avant-garde art."[66] Interlinking Chicanx art with avant-gardism's "insatiable" desire to destroy, Almaraz correlates Chicanx cultural practice with an inherent "iconoclastic need."[67] Chicanx art opens a space for mutual vocabularies of destruction within a broader genealogy of avant-garde practice. However, Almaraz's insistent masculine language hints that transgressive gender and sexual visualities are upsetting in their own right.[68] Sexual marginalia destroys in other ways, disturbing the unifying dictates of nation and family prescribed under a Chicanx art liberationist ideology. Queer avant-gardists brazenly confront pervasive heterosexuality, upending a dominant Chicanx sex-gender system.

Consider Willie Herrón's *The Wall that Cracked Open* (1972), an iconic mural in the urban landscape of LA's east side. Herrón created it after his brother was knifed to death in an alleyway behind Alvarez Bakery in an act of gang violence. *Carnalismo*, or Chicano brotherhood, marks this moment of loss, thus concretizing fraternity in the barrio built environment. Herrón's work is on par with Chicanx visual imagery that imbues the city's urban landscape with hypermasculine archetypes. For instance, in 1974, Wayne Alaniz Healy, a famed member of East Los Streetscapers, painted *Ghosts of the Barrio* at Ramona Gardens, a housing project in East LA. The Spanish conquistador, Aztec warrior, and armed Mexican revolutionary construct a phantasmal frame around Chicanx urban youth standing guard over el barrio. Carefully delineated body distances, looking arrangements, and chiseled athletic bodies compose a virile and rather impenetrable brotherhood. In this pantheon of revolutionary tropes, Chicanx masculinity inherits a divine birthright to defend land, home, and family, eyeing trespassers and disciplining the streets. Healy's work, which anticipated Almaraz's manifesto by two years, arms these foot soldiers for art and revolution. His work speaks in

fraternal terms to a mural like Herrón's. Both Healy and Herrón present a semiotics of Chicano heteromasculinity that reinforces a machista discourse and delegitimizes a post-op transgender man's entry into a visual field constituted by a rigid cisgender system. In this context, *Por Vida*'s destruction becomes necessary.[69]

Nevertheless, the Maricón Collective's mural narrative is indebted to the figurative organization of *Ghosts of the Barrio* and the disorienting imagery of *The Wall that Cracked Open*, which uses the grotesque to sharpen East LA gang violence and death toll. *Por Vida* thus links to a broader public art dialogue in a barrio urban space permeated by transgender violence. And yet, the trans Chicanx subject's visibility is absent even from the disturbing pathos of Herrón's representation of barrio social upheaval. An all-pervasive heteronormativity makes contemporary queer Chicanx mural practice an anomaly, especially as queer iconoclasts have clashed with these public monuments to cisgender male fraternity. Long before the Maricón Collective, heterosexual macho archetypes were put into sharp relief through actions of queer terror.

For instance, Herrón's *The Wall that Cracked Open* appeared on the cover of the second issue of *Homeboy Beautiful*, Joey Terrill's self-published art performance digest (1977–1979). His serial feigned investigative journalism to subvert traditional portraits of Chicanx masculinity, East LA street culture, and *carnalismo* with "homo-homeboy" satire. In the style of a fotonovela, *Homeboy Beautiful* staged photo performances creating an apocryphal queer Cholo underground. Thus, a fictive lead exposé on "E.L.A. Terrorism" featured an ensemble of flamboyant players he affectionately termed the "Escandalosa Circle" (or "Scans" for short), a formation I take up more thoroughly in chapter 4.[70] Performing as an investigative journalist he called "Santo," Terrill portrayed a "Saint" turned "Sinner" as his namesake in Spanish suggests. Infiltrating the perverse underbelly of a homo-homeboy underground, Santo exposed a terrifying reality: clandestine queers infiltrating East LA's toughest gangs.

As the face of *Homeboy Beautiful*, Terrill embodied this particular reality. He posed on the cover in a white bandana and black jacket with "East Los Angeles" splayed across his back. His stylish accouterments offset a collaged scrap from a road atlas, making the barrio geography central to the viewer's reading. Turned slightly to the left, Santo holds a spherical mortar bomb styled in cartoonish exaggeration. In terrorist

performance, Santo fit awkwardly against Herrón's symbol of *carnal-ismo*, Cholo gang violence, and Chicano avant-garde mural experimentation. Posing with a bomb ready to explode, Terrill literally stood apart from Herrón's mural, a mural otherwise converted and discursively reformed within the Asco corpus despite its asymmetry.[71] As a queer saboteur, Terrill upset a significant symbol of Chicanx masculinity, a monument to a fallen homeboy and Herrón's *hermano* no less, charging the City Terrace landscape with a "disidentifying" recircuitry of queer racialized demolition.[72]

Anticipating what Jasbir Puar terms "terrorist assemblage"—that discursive production of nonnormative terrorist bodies that emerged in the post-9/11 context of Islamophobia and "homonationalism"—Santo exemplifies "this disjuncture of the regulating and regulated queer, homosexual, gay disciplinary subjects and the queered darkening of terrorists," though nuanced from the standpoint of queer Chicanx liminality—a sexual iconoclast at the margins of the city and Aztlán nation.[73] As an incongruent "assemblage" within East LA cultural geography and Chicanx public art, *Homeboy Beautiful* threatens to attack the normative subjects and symbols of a US nation-state, sabotage a racially and sexually stratified urbanity, and perhaps bomb LA's more progressive avant-garde auxiliary, Asco. A noncompliant destructive force, Terrill refuses the heteronormative terms of Chicanx nationalist discourse, subverts the visual codes of Chicanx heteromasculinity, and thus embodies Almaraz's call to "destroy . . . art in order to create new art."[74]

The queer avant-garde aesthetics of Terrill and the Escandalosa Circle featured in *Homeboy Beautiful* reveal the ways in which queer Chicanx performance could be scandalous in the context of heterosexual models of masculinity in the barrio and even terrorize the racialized and straight barriers of urban space. The queer iconoclastic ethos of an artist like Terrill echoes Richard Meyer's contention that state and legal oppression inspired gay artists to "rework . . . the phobic construction of homosexuality so as to counter that construction within the space of their art."[75] My interest thus lies in how queer Chicanxs respond to "subtle forms of silencing" as well as "to acts of open hostility and harassment" and the creative disobedience that that hostility engenders.[76] In this way, I am moved by José Muñoz's profound call to reoccupy "the toxic language of shame" in a "mapping of the social" through genera-

tive uses of "stigmatizing speech."[77] These queerer iterations of Chicanx avant-gardisms surfacing in 1970s Los Angeles adapted iconoclasm as a creative resource to destabilize the sex/gender systems and heterosexual propriety upholding certain Chicanx art underpinnings at that time. More than the affective structures of "nausea," these queer avant-gardes sought vocabularies through the offensive limits of hate speech, repulsive power of language, and repellant detection of same-sex desires. The disturbing sight of the *maricón*, the abject reversal of the heteromasculine machista, energizes these iconoclastic structures of art production.

Theorizing Mariconógraphy

At the time that Almaraz was considering the destructive power of Chicanx art inlaid within European avant-garde pasts, a queer creative circle was dressing for the revolution. On July 4, 1976, Joey Terrill attended the annual Christopher Street West pride parade in Hollywood with the Scans.[78] Like an offensive line, they marched shoulder to shoulder in matching t-shirts, blue jeans, and tan chinos (see figure 1.2). Their clothing was a semiotic play of subversive gay codes, which recalled gay liberationist campaigns using the popularity of denim as public statements supporting gay and lesbian civil rights so that "straights might wear blue jeans and thus be harassed . . . help[ing] them see the world from a gay's point of view."[79]

The chinos they donned were a familiar staple of Cholo urban streetwear offsetting Eurocentric queer surroundings with barrio urban aesthetics. The handwritten word "Maricon" [sic] meaning "faggot" on the cotton T-shirts imitates the gang *placa* (tag). Traces of the vandal's criminal hand rewrites the social landscape, making these brown bodies legible for a Spanish-literate public. Similar to the offensive graffiti found in Teddy Sandoval's barrio landscape photo documentation, *maricón*, like *puto*, a comparable anti-gay slur, is breathed in, giving homophobic text brown flesh (see figure 1.3). (I describe Sandoval's art practices with language more completely in chapter 3.) Marked with the stigmatizing "puto" etched onto the walls of East LA, they embody a violent vernacular spoken in their transnational ethnic enclave.

In their defiant self-fashioning, the Scans empowered a specific Spanish slur humiliating effeminacy under a machista regime of

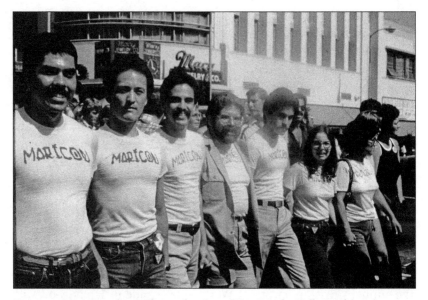

Figure 1.2. Maricón t-shirts, Christopher Street West Parade, Hollywood (1976). Photograph by Teddy Sandoval.

heteromasculine domination. Centering the photo is Terrill, standing between Danny Rodriguez and Efren Valadez; his grin is a cheeky recognition of having mobilized a queer guard under the maricón guise. Though Terrill's project is oftentimes associated with Chicanx gay male self-definition, it is important not to overlook the female foot soldiers in the line. Marching under the pseudonym of *malfloras*, these ugly flowers demonstrate Terrill's artistic attentions to Chicana lesbian political legibility.

An additional photograph from that day makes a coordinating art statement with women embodying another facet of mariconógraphy (see figure 1.4). In the image, Chicanas crowd the foreground as perceptual agents surveilling the body traffic. Young men adorned in "Maricón" t-shirts scatter behind them, pressed into a textual jumble forming the background. Martha Diaz confidently surveys the surrounds with a penetrating stare. To her right, her lover Pat Silva is in harmonious stance. Pat exchanges Martha's hand in figure 1.2 for a camera slung around her neck. With her finger close to the shutter release, Pat is armed with that piece of visual machinery preparing to subdue the Mulvian "male gaze"

and hegemonic fields of patriarchal scopophilia.⁸⁰ Each photograph shot and unloaded from her camera undercuts Almaraz's propensity to see the presumably male artist "act[ing] as a camera for society."⁸¹ More than acting, the snapshots coming from Pat's camera are incursions into LA's queer visual economy, inching closer to a Chicana lesbian visuality taking shape against a Californian camera culture dominated

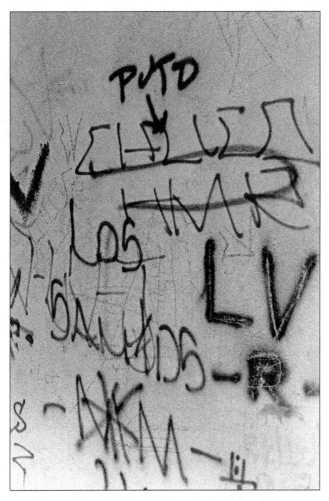

Figure 1.3. Teddy Sandoval, "Puto Graffiti," barrio landscape study (mid-1970s). Photograph courtesy of the Estate of Teddy Sandoval/ Paul Polubinskas.

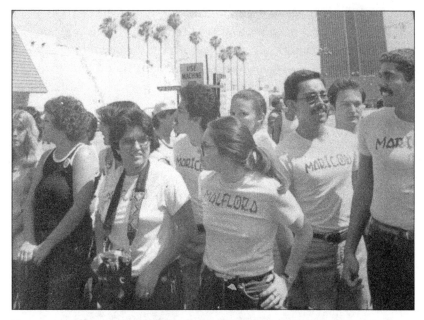

Figure 1.4. Malflora t-shirts, Christopher Street West Parade, Hollywood (1976), photo documentation. Image courtesy of the Estate of Teddy Sandoval/Paul Polubinskas and Joey Terrill.

by men: Slim Aarons, Lee Friedlander, Bob Mizer, and Bob Willoughby. Mirroring Diaz's scrutinizing look, Pat also has the capacity to reverse the lens, suggesting the way Chicana lesbians were practicing a studied feminist optic and simultaneously working as interlocutors for Terrill's conceptual project on the streets and in their skins.

After all, Silva was no stranger to this collaborative process. She was Terrill's cousin, and she assisted him with an earlier woman-centered photo-text piece, *30 Lesbian Photos* (1975), a book art project archiving lesbian self-documentary records behind a salacious title promising "Explicit!" images. Each page layout reflects the participatory art activity since women submitted different recordings of lesbian everyday life. The book's explicitness relieves in the humorous depiction of lesbians caught in the act: attending college, lounging at home, and partying with friends. Much like Vargas's ironic attention to the "confidential" contents behind ornate envelopes, Terrill's creative network of queer Chicana

image-makers teases heteropatriarchal attentions and disguises a covert feminist project behind the cover. Terrill's intellectual and creative foundations intertwine with Chicana lesbian pursuits of visibility. As details of *30 Lesbian Photos* indicate, malfloras who experienced an ethos of rejection could respond with the potential to slyly detonate patriarchy.[82] Partaking in the related experience of queer racialized abjection, malfloras intermingle in Terrill's work and widen the relational possibilities happening through the camera and text. Such vocabularies were a consequential element of Terrill's overall practice.

In something of an apotheosis for Terrill and Sandoval, this maricón/malflora public intervention was part of a larger artistic project that underscored the ways in which the offensive Spanish text generated a representational politic for these figures at the intersection of conceptual portraiture, photography, and performance art. From the outset, defining *maricón* was a difficult undertaking. The meaning derived from a culturally specific slippage of social, geographic, linguistic, and historical contexts that offer inconsistent but related associations with emasculation, effeminacy, penetrability, and homosexual inferiority.[83] According to Jaime Manrique, "maricón is a person not to be taken seriously, an object of derision. Without exception, maricón is used as a way to dismiss a gay man as an incomplete and worthless kind of person."[84] As a slur, *maricón* evokes a vehement rejection of same-sex desire and, in particular, the humiliating vulnerabilities of the penetrated sexual subject. As a rhetorical term, it joins a broader misogynistic project of eradicating men's fragility and perceived predispositions of emotion: read, weakness. Its physical manifestation policed the social landscape like the marauding homeboys in Healy's mural eyeing feminine mannerisms, behaviors, and gesticulations with punishable consequences.

Terrill and Sandoval's artistic engagements resulted in attempts to name Chicanx sexual difference from a decidedly working-class barrio and immigrant viewpoint. The maricón thus served to rebuke hypermasculine limitations of Chicano political imagery and disturbed the heterosexism undergirding nationalist discourses. By laying claim to the hostile and offensive force of abject masculinity, Terrill and Sandoval reinvested the stigmatization of the "faggot" with empowering possibilities because, as Manrique recalled, "Maricones . . . can be the fiercest people."[85]

Just one year before marching down Hollywood Boulevard, where Terrill and Sandoval embodied what Richard Meyer called "defiant visibility for the camera," the pair shot *The Maricón Series* at Terrill's Highland Park apartment.[86] In this collection of conceptual portraits Terrill, with his heavy dark brow, moustache, and slicked-back hair, indexes a familiar racialized masculinity resonant among young Chicanx men in the 1970s (see figure 1.5). The textual self-descriptor "Maricón" appears branded across Terrill's chest. Because the old English style of this typography was omitted from the early iteration, the pair relied on other visual signifiers and portrait conventions. Terrill's eyes close in a passive retreat that can be seen as an alluring display. The positioning of his solid masculine body in a fragile repose subverts the intimidating posture typical of Chicano hypermasculine bravado. Lounging across a Mexican *serape* (folk blanket), which his mother purchased in Mexico City, he offsets a cross-border prop with the reprehensible figure of the penetrated masculine subject. Posed on his back, Terrill suggests lurid sexual behaviors with other men against a symbolic backdrop of ethnic artifacts in a way that makes Chicano nationalism and his motherland quite literally complicit in maricón visibility. What Terrill and Sandoval restage is a co-constitutional relationship, which, according to Daniel Enrique Pérez, exemplifies the "maricón paradigm," a dialectic in which "all Chicanos embody some elements of machismo irrespective of their sexual identity. A direct correlative would be that all Chicanos also embody some elements of mariconismo."[87]

As image-makers, Terrill and Sandoval showed in visual terms machismo's interdependent relationship to mariconismo. At its foundation, mariconógraphy exploited the maricón's preeminent threat to an image system in which Chicanx and Latinx heteromasculine visibility was made most vulnerable. With a delicious subversiveness, Terrill and Sandoval's t-shirt enterprise tactically negotiated Chicanx sexual difference and undercut the macho façade by redrawing new relational structures through the iconoclastic power of the maricón signature. Proof of this unfailing queer Chicanx collaborative ethos even came through their sharing of the visual field, as a bit of Sandoval's shoe is observable left of the frame. Thus, their process of self-display makes an audacious collective statement adapting photography, fashion, and performance to

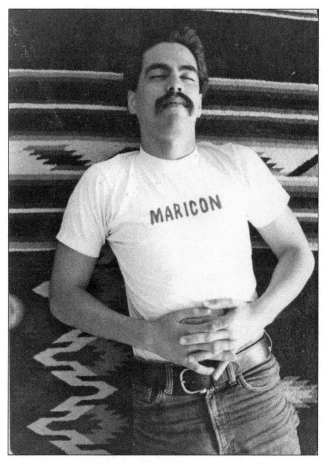

Figure 1.5. Joey Terrill and Teddy Sandoval, *The Maricón Series*
(1975), black and white photograph, image courtesy of the Estate
of Teddy Sandoval/Paul Polubinskas and Joey Terrill.

imbue the politics of Chicanx cultural representation with unapologetic
presentations of a stigmatized social body.

Mariconógraphy's iconoclastic power agitates a broader visual econ-
omy by emboldening an archive of offensive images because, as Shawn
Michelle Smith notes, "archives train, support, and disrupt racialized
gazes, infusing race into the very structures of how we see and what
we know."[88] Those "racialized cultural prerogatives of the gaze" are also

sexualized modes of looking, and they signify within a chain of photographic pasts.[89] Caricatures, mocking illustrations, and sensationalist photojournalist exposés shape maricones' pictorial definition in ways that resonate with early twentieth-century work.

Consider, for example, revered Mexican printmaker José Guadalupe Posada's portrayal of the infamous "Los 41" ball. On November 17, 1901, *El Diario del Hogar* reported a police raid at a private home, which led to the arrests of forty-one men, nineteen of whom were reportedly clothed in satin gowns, jeweled earrings, silk fabrics, and corsets. In four lithographs published in *El Diario del Hogar*, Posada propagated a salacious image of homosexuality at the Baile de los Hombres (Men Only Ball) in Porfiriato Mexico City.[90] *Caballeros* (gentlemen) dressed in elegant attire lead their jubilant *damas* (ladies) in ball gowns that swing and billow. The visual field is a clash of gendered signifiers—exaggerated silhouettes, voluminous hips, bulging breasts, genteel mustaches, wide brows, and shorn hair. Posada's is a laughable caricature of Mexican effeminates and buffoons. In these illustrations, maricones appear obedient, frivolous, docile, and ultimately contained in a disciplining heteromasculine depiction of a decadent gender-transgressive world.

Maricón passivity fostered chaos nearly seventy years later. The headline reading "Los 41 Maricones" ghosted an equally scandalous avantgarde performance action unleashed upon an unwitting audience in East LA's Belvedere Park in 1969.

A Cyclone in Aztlán

On November 20, 1969, self-proclaimed "live art artist" Robert Legorreta descends on a crowd of unsuspecting spectators in East LA.[91] Few watching the performance know how to interpret the seventeen-year-old Chicano youth's attire of a black slip and fur. While they study Legorreta's lipstick-stained mouth and alabaster-white complexion, he emerges as his alter ego Cyclona. Like the crimson hue bloodying the ends of his fingernails, Cyclona is a chameleon of shock, rage, and sexual aggression. As *Caca-Roaches Have No Friends* begins, viewers peer at an eclectic backdrop of draped fabric and props, which suggest an otherwise private domestic domain unsealed for the audience's voyeuristic consumption. From the outset, the production's reclusive young

playwright, Gronk, mixes metaphor with sarcastic pun by pairing the double meaning of "cockroach," a more insidious racialized discourse of Mexicans as LA's unwanted pests, with *caca*, Spanish for human excrement.[92] In effect, the presentation positions East LA viewers themselves in shit, confronted by the socially repulsive Caca-Roaches and pressed against the symbolic asshole of the fraught Chicano cultural condition.[93]

Inhabiting this scatological wasteland is Legorreta, who marshals over the filth and orchestrates the salacious performance. Agitating the public, he defiantly lifts his slip, exposes his furry armpit casting odorous wafts, and simulates a public orgy in what he calls "a protest against gerontocracy."[94] In the climactic "cock scene," he unveils his boyfriend Billy, shirtless and bound with knotted fabrics. Revealing a proxy phallus and two dangling eggs hidden beneath a cloth flap appended to his shorts, Cyclona bites the water balloon, smashes the symbolic *huevo*-testicles to the ground, and ignites the crowd.

Families were lured to the performance under false pretenses of *floricanto teatro* and rioted as a result. According to Legorreta's legendary retelling, crowds set trash cans ablaze, and the police were called. His cohort of unruly caca-roaches escaped with their lives.[95] This performance confirmed for Gronk much of what Legorreta already knew from his transgressive gender experimentations down Whittier Boulevard. Political liberation requires shocking embodiments, confrontational actions, and disruptive appearances. The parallels between Mexico City's clandestine "maricones" in 1901 and East LA's raucous "caca-roaches" in 1969 are uncanny. They conjoin in a transnational queer visual lineage, one defined by the incendiary vision of a Mexican man in a dress.

Legorreta, along with Meza and Gronk, created a variety of influential photo-based performances and public actions, including *Piglick* (1969), *Madman Butterfly* (1970), *God the Nuturin' Mother* (1971), *La Loca en Laguna, Liberation of Laguna Beach* (1971), and *The Wedding of Maria Theresa Conchita Con Chin Gow* (1971). In his Cyclona persona, Legorreta became a living art piece whereby artists literally drew from and on his body in paints, fabrics, found materials, and urban detritus. Consuming his publics, taking them hostage, he became an unlikely muse, entering collaborative works imbibing the distasteful palate of the strange and bizarre. Take, for instance, photographic documentation from the performance *God the Nuturin' Mother* (see figure 1.6). Exercising an "un-

Figure 1.6. *God the Nurturin' Mother* (1971), Robert "Cyclona" Legorreta (center) with Gronk and Mundo Meza, color photograph. From The Fire of Life: The Robert Legorreta–Cyclona Collection, Chicano Studies Research Center Library, University of California, Los Angeles.

natural disunity" in Southern California's sublime coastal landscapes and natural ecology, the action set against desert and rock was source photography for *Cyclorama* (1972), set in the library basement of California State University, Los Angeles.[96]

In performance documentation of *Cyclorama*, Cyclona and Meza appear in glitter rock androgynous getups, activating the riotous backdrop of Gronk's neo-expressionist mural in exaggerated gestures (see figure 1.7). Caked in white powder, Cyclona throws his head back in an orgiastic howl as he grasps Gronk's mutant interpretation of the barren wilderness. In silvery tinsel and *papel de flor* ornamentation,

he and Meza animate the static work. They pose with Meza's painting like a performance prosthesis, a plasticized extension of chaos in their hands. The triad juxtaposes genre and media in a "performative collage": portraiture, photography, muralism, self-display, and reembodiment of actions past resolve into a visual patchwork.[97] The triad's innovation anticipated later Asco conceptual approaches to absurd street theater that similarly contested muralism's stasis; these include such works as *Walking Mural* (1972) and *Instant Mural* (1974), which evidenced a process that Gronk described as "using a narrative approach to painting, giving

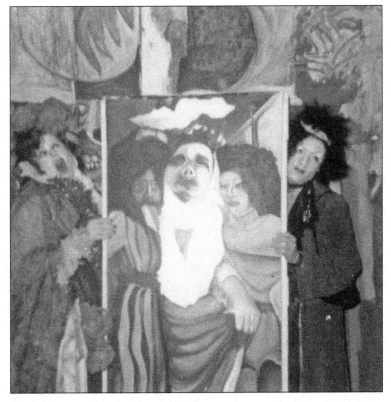

Figure 1.7. *Cyclorama* (1972), Robert "Cyclona" Legorreta (left) with Mundo Meza, color photograph. From The Fire of Life: The Robert Legorreta–Cyclona Collection, Chicano Studies Research Center Library, University of California, Los Angeles.

it a theatrical sensibility. . . . It's part wall, part set, part characters who have come alive."[98]

Gronk departed from the Cyclona/Meza queer trinity to collaborate with fellow Garfield High School graduates Gamboa, Herrón, and Valdez, who together formed Asco in 1972. Gronk recalled in an interview with art critic Max Benavidez that "all of a sudden I think, you know, 'This is where I think I belong.' And the drugs and the chaos of the other group [that included Cyclona and Mundo Meza], it just was not something that I thought I could stay with. So I think Cyclona thought that was a rejection and so did, perhaps, the other artists in the group. 'Oh, look at it. He's going with those straight kids, and it's like he's denouncing us.' And that's not the case."[99]

Gronk's reference to the "other group" in contradistinction to "those straight kids" is critical.[100] He saw Legorreta as a recognizable creative force in a shared but perhaps more destructive language of "the drugs and the chaos."[101] He hinted at the formation of different yet related avant-gardes predicated on sexual definitions and not necessarily on aesthetic terms. One, defined by Cyclona, was imbued by disorderly behavior laced with drug experimentation and mania. In the late 1960s and early 1970s, the very bohemian and counterculture demand for higher states of metaphysical consciousness through recreational marijuana use drove Legorreta's search for social liberation in amorphous androgynous shapes and outrageous performance expressions. For Meza, Orange Sunshine LSD hallucinogens manifested in his psychedelic pen and ink work and optical illusionism redolent of Dutch printmaker M. C. Escher, a major influence on his practice. Legorreta's East LA circle was a more unhinged avant-garde formation closer to that altered state of being in the madness of Cyclona's dark matter.

Asco was ostensibly less chaotic, less euphoric, and, according to Gronk, more "straight." Whereas scholars make a persuasive case for Asco's queer gestalt, I do not regard them as "launching the Chicano avant-garde." Rather, it is my contention that queerer artistic collaborations, collisions, and run-ins forwarded their and other creative structures. These avant-gardists' queer liminality intercedes, separates, and oftentimes breaks away independent of Asco. Like the explosive energy generated by nucleoid fission, these other cells' radioactivity destroys tenuous sex-gender systems, Catholic dogmatic teachings, familial dis-

courses, and appropriate expressions of desire and self-imagery. They must also be evaluated in their own way and on their own terms.

We need only consider Asco's *Asshole Mural* (1975) for guidance. In a no-movie performance "site visit," the four members adorned in business wear attire juxtapose Chicano embodiments of social affluence with a storm drain, a vacuous wasteland of negative space.[102] As Amelia Jones notes, "Effectively, they perform their dandy-esque urban (and urbane) bodies against a backdrop of metropolitan abjection. LA is literally opening its asshole to the 'no movie' camera."[103] Gronk is flanked on one side of the hole, sharing a horizontal parallel with Willie Herrón to the right. Leaning on one leg, he diverges from the authoritative and masculine postures of Herrón and Gamboa. Their shoulders squared and chests erect, they mirror each other in contrapposto rest, a fashionable posture consistent with classical sculpture.

However, Gronk's body orientation breaks away. Disunified and different, he is literally "slanted," located somewhere in-between Valdez's glamorous excess to the far-left background of the performance and Herrón's and Gamboa's fraternal uniform to his right. Gronk's pelvic positioning pressures the composition's horizontal line tilting upwardly. His gesture against the cavity widens *Asshole Mural* to that toxic hole of negative space, to that dark matter, to that bizarre energy of unseen chaos. His nod beneath that fedora is something contrary to Asco's straight-laced and stylish brethren. In a slanted comportment, he presses himself against the asshole mural, weighed upon the concretized urban anus. His body is a bent referent for divergent sexual transgressions, a recollection of "Caca-Roach" scatology from his past, perhaps an indexing of Cyclona in that vestige of darkness.

Cyclona is antithetical to the fine lines and creased suits of the ensemble. As a muse, his disorderly power manifests in numerous ways— for example, as a whimsical flapper in Anthony Friedkin's gay photo essay printed in a 1973 issue of *Gay Sunshine*; a grotesque hallucination in Gronk's drawing "Cockroaches Have No Friends #3" (1973), published by Loyola Marymount University's art-literary journal *El Playano*; a bearded bride oddity in Asco's political rag, *Regeneración*, in 1974; and a provocative enigma in Gronk's "Accion" series, which described him as embodying "these sometimes secret, sometimes public performances [where] Gronk's life truly becomes art and art becomes life."[104]

Of course, this was not the first time Cyclona was unleashed within Gronk's impromptu showings. In 1972, Gronk was drafted to Fort Ord in Northern California to prepare him for army boot camp. Without the requisite "evidence" to demonstrate his homosexuality (making him mentally "unfit" for war), he circulated the Cyclona image among other infantrymen. His dependence on Legorreta as an agent of sexual difference was evinced in a letter written on toilet paper on April 13, 1972. In it he pled, "I've told them I'm homosexual. But my word alone isn't good enough. I need proof from the outside (Gay Liberation [Front] has a title that may be the proof I need). . . . I hope you'll be able to help me out or I may have to do something drastic!"[105] Symbolically, the "live art" muse assisted Gronk in attaining a psychiatric discharge as a registered homosexual. Together, they ultimately prevailed in stopping his draft into the Vietnam War. In turn, Gronk activated Legorreta as an agent of chaos with the capacity to free him from the US military-industrial complex.

Cyclona's foray as a liberationist symbol is foundational to Chicanx avant-gardisms's penchant to disturb the public. Alas, Legorreta is inaccurately portrayed within official narratives about Chicano art practices in the city. The influence of the "legendary street artist" is a nearly unspoken subject prior to the opening of *Arte No Es Vida*. In 1980, Gronk gave only clues to the accosting performer's whereabouts in his interview with Harry Gamboa Jr. Speaking with his brand of absurd hyperbole, he explained that following the last performance of *Caca-Roaches Have No Friends*, "Cyclona was placed into an asylum and has just recently come back to town. I'm hoping for her to star in a comeback performance for my new No Movie 'Titanic,' like the boat."[106] Indeed, Legorreta appeared sans extravagant adornment in *Titanic* (1980), arranged alongside other Asco collaborators representing variant cycles of the collective's permutations, ranging from its early founders to its more esoteric figures associated with Asco B. Standing far left of the lineup, Legorreta occupies the margins of the visual field, an abject relation to the pantheon of Asco patriarchs centering the photograph.[107] Gronk, Gamboa, Herrón, and Humberto Sandoval give the photo gravitas, penetrating the lens with darkening stares. Art historical references about "Cyclona" seem to end here, leaving him inside Gronk's metaphorical asylum. He is hushed into dormant slumber. The curtain closes.

Writing in the Margins

Cyclona's reawakening occurred decades later. Through an alternative archival form, Legorreta extended his artistic practice in new ways, reformulating "evidence" and art documentation by assembling the visual provocateur in another kind of performance. Legorreta crafted two collections of his personal papers, each a spectacular postmodern archival body: *The Gay, "Chicanismo in El Arte"* (2001) at ONE: National Gay and Lesbian Archive at University of Southern California libraries, perhaps a gay addendum to or alteration of the 1975 show at LACMA with a refocus on records highlighting past collaborations with Gronk, Roberto Gutierrez, Mundo Meza, and Patssi Valdez, and *The Fire of Life/El Fuego de la Vida* (2003) at the UCLA Chicano Studies Research Center Library. Both collections overwhelmed record administrators, who struggled to process his amorphous material remains: paper scraps, nondescript mailers, political circulators, decorative art kitsch, toy collectibles, bric-a-brac, record albums, and, in particular, self-published publicity materials.[108]

Legorreta's archival practice was an institutional intervention, another restaging of the queer muse in plastic and print approximation. Because he resisted key recordkeeping principles such as record appraisal, provenance, and *respect d'fonds* (original order), Legorreta manifested the Cyclona persona through his bulky and redundant submissions. At UCLA, toys and pop-culture collectibles plasticize his performance entity. His paper spills prove a broadly historic if not uncredited influence in queer Chicanx avant-garde practices, contemporary art, and American popular culture. Like the museum interventionist critique of contemporary artists Mark Dion, Andrea Fraiser, Amalia Mesa-Bains, and Fred Wilson before him, Legorreta's take on "evidence" and "historical value" resists systematic order in the archival repository.[109] As an archival body, his eclectic assembly is cumbersome, resists logics, and is susceptible to damage. The inadequacies of institutional storage return his bric-a-brac to an innate state of chaos in which the Cyclona figure exists. Because Legorreta's archival body does not fit easily into traditional archive systems, the resulting administrative decisions over his collection have troubling aftereffects.

University institutions lend pieces of his iconoclastic persona and collectibles to major museum exhibitions. Pieces of Cyclona's archival body populate shows like *MEX/LA: Mexican Modernism(s) in LA* at the Museum of Latin American Art (2011), *Cruising the Archive* at ONE: Lesbian and Gay Archive (2011), *Asco: Elite of the Obscure* at the LA County Museum of Art (2011), and *Asco and Friends: Exiled Portraits* at Triangle France (2014). Just five years after his reintroduction into the Latinx and Latin American performance art corpus in *Arte No Es Vida* at El Museo del Barrio, Legorreta appeared at the "California Pacific Triennial" at the Orange County Museum of Art (OCMA) (2013). At the time, OCMA curator Dan Cameron named Legorreta among thirty-two renowned artists from the United States, Latin America, and the Asian Pacific Islands.[110] OCMA was the first major museum to sample Legorreta's album collection, Mexican-themed toys, and pop-culture memorabilia. In addition, a small installation of sixty-eight vinyl record covers and two vitrines encasing ephemera, drawings, and selections from his oft-cited scrapbook were shown. These offset a three-panel wall text condensing Cyclona in a lengthy rumination of transgender cultural interpretations code switching between "his/her" pronouns. Throughout his oeuvre Legorreta jettisons trans-feminine definition, reminding us that he is a "living art" persona, an embodied visual disturbance. The didactic panels inscribe Legorreta's creative entity contrary to his performance practice. As a result, his iconoclastic powers are bound by display technology, curatorial mistranslation, and the constraints of queer theory.

A handmade photocopied protest poster further indicates the museum's constricting and unaccommodating bounds. A glass vitrine is glamorously lit to illuminate a gold metallic penned text. "Free mi art, free mi people" is written around a color xerox of a Cyclona photo taken by Patssi Valdez in 1983. His scrawl writes against the ONE archive, condemning the renowned gay and lesbian national repository as a "prison" for allegedly mishandling and de-accessioning parts of his collection in 2003.[111] Howling back at the viewer, the iconoclast sounds beneath the barrier of glass casing. Cyclona's call for freedom ironically vilifies the institutional space, making curatorial knowhow complicit with imprisonment, with his unruly archival body's disarmament in an affluent Orange County white box.

Legorreta's actions against an institutionally sanctioned discourse about a homogenous Chicano avant-gardism by curators and scholars have received little acknowledgment. Art publications became targets for his process of social liberation. Essay collections, journal articles, and exhibition catalogs were eviscerated by Cyclona with inflammatory claims. With the gusto of a Mexican *grito* and the style of an urban vandal, the character defaced these glossy keepsakes for fine art audiences. Like a cultural cannibal, Cyclona desecrated books, consuming them with writing in heavy-handed redactions and violent scribbles. Pages were torn away from the binding in retaliation; a type of dismembering that perhaps mirrored the way his scrapbook was ripped from its own book spine and re-placed under luminous glass bulbs and exhibition designs that affirmed Asco as the launching pad for the Chicano avant-garde. His rant between the pages of *Asco: Elite of the Obscure* catalog railed against this misnomer: "This book is a fabricated pice [sic] of SHIT. Where's the court ordered lie detector test? Who will be the first to step up? You?"[112] Pivoting from third person to second person, Legorreta's narrative voice repositioned the passive reader into an anxious accomplice and complicit informant. His editorial assaults raved back at a commercial art-museum complex: art consumer, art historian, and the duplicitous hand of the curator. Antagonized, his desecrated revisions demanded reading the foundations of East LA conceptualism and performance art anew. His pen pointed to the margins, highlighting both his exclusions from the exhibition process and historical errors.

Thus, the inadequacy of institutional frameworks for an iconoclast like Legorreta and an archival body like Cyclona's is cause for other *queerer* epistemologies of alternative archives engendered not necessarily by claims to art celebrity and critical acclaim but rather by the deluge of silence and misattribution resulting from institutional mistranslation. As such, Legorreta asks for "something else" that regards unruly bodies of record, dissonant sounds, and contested spaces; something that can resolve the creative recordkeeping practices formed in the domestic underground, the clutter of rummaging and salvaging of waste; the bits and pieces of a career shadowed by AIDS devastation and moved by loss. Such traditional archive and museum tensions guide Jennifer Flores Sternad and Ricardo Bracho's appraisal of Legorreta's collection: "Museums and art-historical canons are usually not spaces for wild

things, least of all the wildest of things. What's to be done when the object of historical and aesthetic inquiry—and possible inclusion—refuses the rules of engagement?"[113]

This book takes up this challenge guided by an archival body/archival space methodology in search of creative modes of recordkeeping engendered not solely by the presumed mishandling of Chicanx art's queer past but also by AIDS devastation. In fact, reading the field of wreckage following Meza's death offers new meaning for Legorreta's detrital attentions and reoccupation of waste.

Cyclona is a lesson in archival body disciplining. As a collaborative performer who preferred to vandalize books rather than to spray paint the walls of LACMA, Legorreta was a protozoic permutation, one of many queer Chicanx avant-garde variations in Southern California. Rosa de la Montaña, maricones and malfloras, Butch Gardens School of Art, Pursuits of the Penis, Judeo Christian Ethic Universal, and the Escandalosa Circle, as hinted at in this overview of queer Aztlán's iconoclasts, took variant shapes preceding, intermediating, and, at times, evading that nuclear entity called Asco. To understand this creative landscape is to consider the alternative sites and itinerant movements between cities, coasts, streets, backyards, and domestic landscapes. These artists filtered through and fixed around an ethos to "challeng[e] people's minds," and thus iconoclasm became its most unifying force.[114]

Hence, it is necessary to seek out the queer debris, the flotsam and jetsam of AIDS devastation, and apprehend a different picture of Chicanx contemporary art: one showing that its major actors, creative constellations, and intermittent collaborations unhinge the compulsory heteronormativity and cis-gender privileging of Chicano art history and the institutional discourses narrating museums' white cubes. Queerer study operators for Chicanx art's more unruly archival bodies and spaces are necessary to illuminate how the aftereffects of AIDS were endemic to omissions in Chicano avant-garde historicization and thus introduced another way to envisage the purpose and outcome of queer of color recovery. Lingering outside stultifying cultural institutions, the alternative archival formations central to this investigation move Chicanx art and performance criticism closer to those dark places, to the "somewhere beyond" the repository's threshold. It is here where debris

lies, threatening to expose amnesiac gaffes, and upset the foundations of what Chicanx art is, or, rather, what it could have been.

The "vanishing" of Mundo Meza's entire corpus from public view is a critical point of entry into these fugitive sources of queer of color knowledge. While arguably one of the greatest travesties wrought by AIDS in Chicanx art history, Meza's story does not end in destruction but rather begins there. In the next chapter, I detail my efforts of "looking for Mundo," turning to what a glimpse can cast from the scraps.

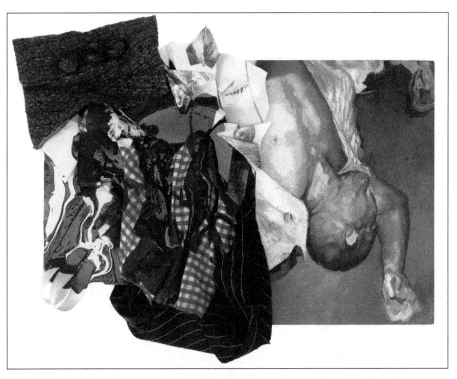

David Antonio Cruz, *playdeadreprised* (2013), enamel, oil, gold leaf, fabric, broken plates, and paper planes on wood panel, 6" × 12. Permission and photograph provided by the artist.

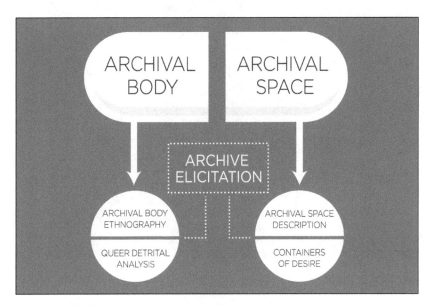

The archival body/archival space study model.

Manuel Paul ("The Maricón Collective"), *Por Vida* (2015), digital mural on billboard, Galería de la Raza, San Francisco, CA. Permission courtesy of Manuel Paul. Photograph by Gilda Posada.

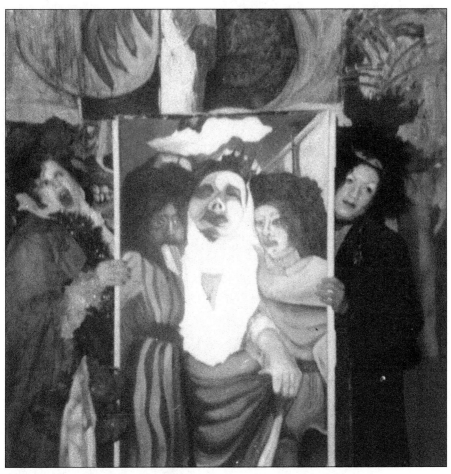

Cyclorama (1972), Robert "Cyclona" Legorreta with Mundo Meza, color photograph. From The Fire of Life: The Robert Legorreta–Cyclona Collection, Chicano Studies Research Center Library, University of California, Los Angeles.

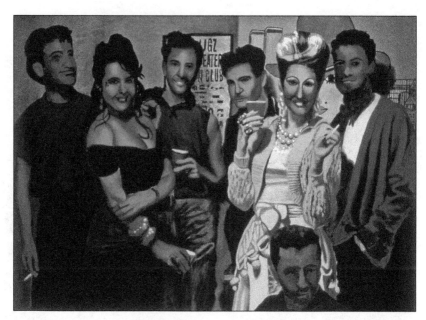

Joey Terrill, *Mundo, Luciana, Robert, Steve, Therese, Jef and Simon* (1983/2004), acrylic and oil on canvas, 40" x 30". Photograph courtesy of the artist.

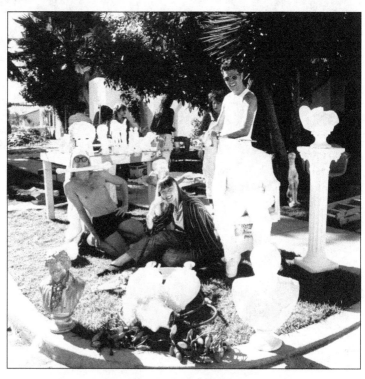

Simon Doonan's yard sale, Los Angeles (1985); from left to right: Simon Doonan, Annie Kelly, and Jef Huereque. Photograph by Tim Street-Porter. © Tim Street-Porter.

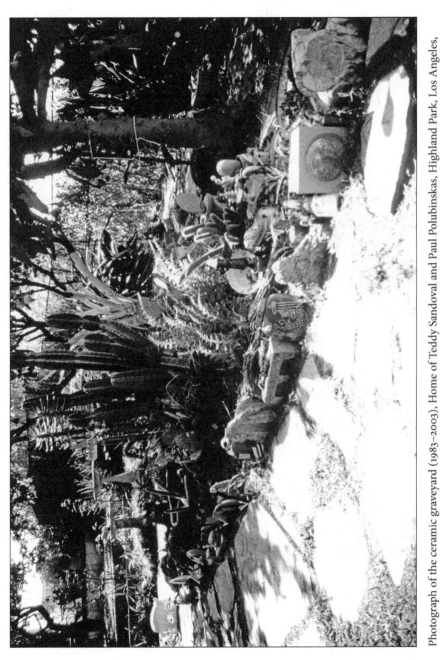

Photograph of the ceramic graveyard (1983–2003), Home of Teddy Sandoval and Paul Polubinskas, Highland Park, Los Angeles, California. Estate of Teddy Sandoval/Paul Polubinskas.

Teddy Sandoval, Macho Mirage (ca. early 1980s), work on Paper. Estate of Teddy Sandoval/Paul Polubinskas.

Joey Terrill, *Chicanos Invade New York*, Windows on White Street, Tribeca (1981), acrylic on canvas; from left to right: *Making Tortillas in Soho* (1981), *Reading the Local Paper* (1981), and *Searching for Burritos* (1981).Photograph courtesy of the artist.

Joey Terrill, *Passion* (ca. 1993), Xerox collage with glitter, print ephemera, and paper cutouts. Image courtesy of the artist.

Joey Terrill, *Remembrance (for Teddy and Arnie)*, study for serigraph (2010), Xerox photocopy, pen and ink, work on paper. Photograph courtesy of the artist.

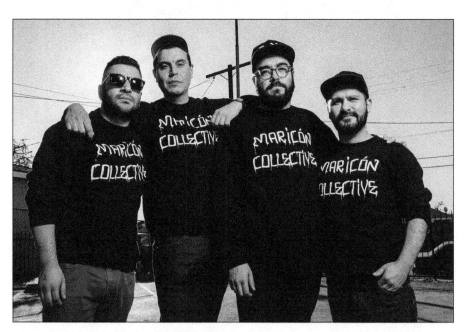

The Maricón Collective (2015); from left to right: Carlos Morales, Michael Rodriguez, Rudi Bleu, and Manuel Paul. © Danny Liao Photograph.

2

Looking for Mundo Meza

His image flickers across the screen. Like an apparition, he appears over the left shoulder of actor Jeff Bridges.[1] In the next frame, he sails across the bar in a discontinuous edit that parses space and time. A silent player occupying the edges of the film, Mundo Meza is one more extra setting the tone for a decadent nightclub scene in Taylor Hackford's film *Against All Odds* (1984), shot in the Palace Theatre on August 6, 1983. In it, the venue swings to a Latin disco–infused R&B number, "My Male Curiosity," performed by the zoot-suit adorned Kid Creole and his shimmering accompaniment, the Coconuts. Meza was no novice to this Hollywood landmark. Flip, the retail "emblem of the New Wave," held its annual ball there, and Meza was its window dresser.[2]

The same year *Against All Odds* was filmed, Meza painted *Portrait Study* (1983) (see figure 2.1), a birthday gift for his friend and collaborator, Simon Doonan. The piece is a delirium of architectural elements—voluminous mass, angular lines, cubic forms, wood grain textures, and neoclassical ruins—encrusting a visage hidden beneath monochrome layers. The suited figure in sleek pinstripes, with a knotted tie and neatly parted hair is a well-pressed contrast. It has a likeness to Meza's image in the motion picture, a male curiosity of another stripe. A gestural stroke of white paint that brushes the left lapel mirrors the knitted cable folds of his sweater jacket from the shoot. Sealing his filmic "bit part" within a composition of geometric fragments, the distorted facial image does not so much pay homage to cubist painters Picasso or Gris as it foreshadows things to come. By 1984, Kaposi's sarcoma, the dark necrotic lesions confirming a depleted immune system, engulfed Meza's body, and by early 1985, this 1970s creative force in queer Chicanx avant-garde aesthetics passed away from AIDS complications. Meza was twenty-nine.

Meza's *Portrait Study* is a stark contrast to his previous paintings in this genre. His record of his self-transformation is quite possibly one of the earliest Chicanx artistic responses to AIDS. Beyond setting a historic

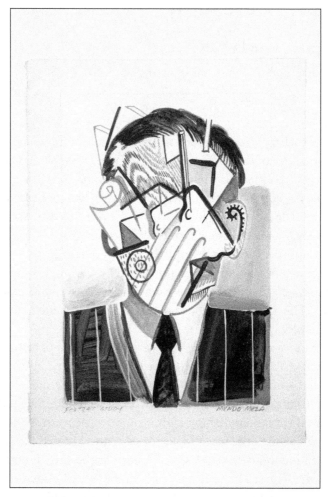

Figure 2.1. Mundo Meza, *Portrait Study* (1983), acrylic on paper, collection of Simon Doonan.

precedent, the work on paper enters AIDS memorializing discourses through an exhibition postcard announcing "Mundo Meza 1955–1985." The four-day posthumous show opened at his alma mater, Otis-Parsons Exhibition Centre, on September 17, 1985. Curated by Meza's artistic collaborator, Simon Doonan, and his ex-lover, Jef Huereque, the show surveyed a period of intense art production from 1975 to 1984, which followed his raucous rendezvous with visual provocateurs Robert

"Cyclona" Legorreta and Gronk from 1969 to 1972 (discussed in the first chapter). Shown were seventeen large-scale paintings, still lifes, pen and ink sketches, mixed-media pieces, window display photo documents, and decorative furnishings, such as the accordion doors he painted with veritable faux finishes, applications perfected during his tenure in visual merchandising. When the show closed, Meza's body of work went with it—removed from public view and all but forgotten from the sights and exhibitions central to Chicano avant-garde history and criticism. Well, almost.

Portrait Study dispersed with Meza's other artworks suggesting another type of movement for an archival body in this devastation. A complex custodial maze of disorganization scatters an oeuvre. These disparate parts lie outside institutional circuits of archive and museum possession, making the whereabouts of his artistic production too elusive to qualify as a recognizable body of record. We are left with a glimpse of an artist engulfed by fractures, distortions, and chaos. His self-portrait on that memorial postcard refuses the viewer access to what hides beneath the layers as the artist seems to ask, How many pieces of me must be gathered to effectively interpret a lost corpus? Looking for Mundo is a frustrating pursuit, an object lesson in obstruction.

Thus, the scraps constituting Meza's archival body/archival space necessitate a more direct analysis of what I term "queer detritus." By enhancing what insight can be ascertained from the glimpse of works no longer extant or shaken from the chain of the collection's assembly, the detrital state of his archive unfastens a historicist pursuit for pristine "uncut" documents, unencumbered objects submitted for "close looking" appraisal. Sifting through the scraps, we find Meza's art "lingering" in a loose constellation of image networks, cultural texts, and stewarding activities.[3] Memoirs, window displays, store interiors, film/video, and reality television expand the "containers of desire" as examined thus far, revealing a profound afterlife for artwork reshaped by AIDS's disastrous hand.

In addition to positioning Meza against the trends, fashion, music, and burgeoning retail spaces coalescing around Melrose Avenue in the 1980s, this chapter captures an unusual synchronicity of commercial opportunities present in Southern California infused with traces of

queer Chicanx avant-garde art and performance. No aesthetic was more important to Meza than the chief agent of fashion decadence and still performance: the mannequin. With a boom in mall culture, Hollywood film, and music television, the custodial practices around the time of Meza's death placed him within a mannequin register. A fractured and pulverized body centering the drama of retail windows, the mannequin's jagged plastic anatomy forwards another detrital form, a plastic remnant subjected to the same ephemerality of the showroom where looks and trends are impermanent and change rapidly.

Glimpses of Meza structure this chapter. Through Doonan's stewardship, his art memories present a complex of minor literary attributions, from *Confessions of a Window Dresser* (1998) and *Beautiful People* (2005) to more vigilant commemorative gestures in film and television like *Beverly Hills Cop* (1984) and *10 Things That Make Me Happy* (2012). Doonan's custodial practices allow for incomplete, partial ways of seeing, which refute overly deterministic arguments that explain the whereabouts of Meza's body of work in terms of destruction. Meza is re-membered in the transformative spaces of shop windows and plastic worlds, a mannequin vocabulary of fracture and irreconcilable pieces. Viewing Meza in glimpses salvages the artist and thus elicits a way of interpreting a queer Chicanx life in "bit parts," like trimmings scattered after a window's close.

Straight Archives, Racial Borders, and Queer Corners

Before looking at Meza's alternative archive formation, we might first consider how his "queer detritus" forces us to rethink evidentiary paradigms. HIV infects not only people but also things. As discussed in the introduction, artworks by Peter Hujar, Barton Benes, David Antonio Cruz, and Laura Aguilar give metaphorical heft to the waste left after the plague's outbreak (see figures I.1, I.2, I.3). Looking for Mundo demands that we use an archival body/archival space method to interpret his dispersed cultural record as material processes and ephemeral remainders.

Consider Meza's appearance in *Against All Odds*. As a background actor, an abbreviated Chicanx image, he is a racialized yet trendy visual accent in a commercial Hollywood film. But what we observe is not only a vestige of queer Chicanx avant-gardisms in seconds of screen

time; we also see a body traced by AIDS—the one indexed in *Portrait Study*, where his terminal illness is relieved in paint. A glimpsed vision emerges from the way splices of film footage and geometric fragments in painting combine, a synergy pervading his creative practice. Looking for Mundo onscreen is looking at another kind of AIDS portrait demanding renewed attention to the way edges of commercial media remediate his body onscreen and on paper.

It is important to consider how views about the fragment have long shaped AIDS moving-image history, though couched in terms particular to independent video and the activist videotape. Randall Hallas's *Reframing Bodies* (2013) examines filmic fractures as narrative and aesthetic devices. Based on a corpus of AIDS guerrilla video, the body appears "in parts": disjointed in image and sound, parceled into distressed clips, or segmented in tightly framed "talking head" shots altering the viewer's affective relationship to this trauma.[4] Hallas's archive aligns the "reframed" body as "a rich, multifaceted metaphor for the dynamics of discursive appropriation and transformation" with the capacity to "bear witness to the simultaneously individual and collective trauma of AIDS."[5] Rather than focus on a "straight-forward representational act" queer AIDS media dialectically "reframed not only the bodies of the witnesses seen and heard on the screen but also the relationship of such represented bodies to the diverse viewing bodies in front of the screen."[6] As a performative act of bodily knowledge, "the optic of witnessing" vis-à-vis film and video allows for a reconnection to social movement activism and transference of collective trauma.[7] However, media images in mainstream Hollywood motion pictures that are not about AIDS are also critical. These texts are otherwise touched by viral outcomes shifting our emphasis from AIDS activist videotapes and avant-garde film to the media's interstitial margins. Meza's "bit parts" do not occupy any ordinary cinematic space. His liminality intensifies what insights can be gained from the borders and corners of film screens where AIDS cultural traces are otherwise commercial vehicles hidden in plain sight.

The seen/unseen ocular relations in AIDS moving image studies are indebted to a growing area of visual culture theory, with Richard Dyer, Martin Berger, and Elizabeth Abel showing how whiteness and colonial ideologies shape looking relations.[8] Considering how the utopian promise of camera technologies in nineteenth-century art and science

influence social relations, Shawn Michelle Smith stresses that "as photographs bring more into view, they also reinforce the invisibility of some things by overtly focusing on others. What is not represented is further obscured."[9] The technological advances in photographic history suggest the ways in which nonprivileged subjects have been culturally relegated to what Smith terms "edge of sight."[10]

Foregrounding nineteenth-century visual culture may seem like an odd detour given the contemporary premises of this study. However, early American and British painting organized around what is termed "critical race art history" has demonstrated how race was moved to the inferior margins of artistic compositions.[11] In the polemic text *The Art of Exclusion*, Albert Boime observes that nineteenth-century painters implemented a triangular composition, "visual[ly] encoding . . . hierarchy and exclusion" of black figures vis-à-vis white subjects[12] Building on Boime's model of racialized imagery and ideology, Michael D. Harris argues that historic visual representations of African Americans "naturalized a social order with black subjects on the periphery doing menial tasks or exhibiting stereotypical behavior so as to emphasize their social and political inferiority."[13] He further explains how this ocular relationship structured the composition of early British portraiture in which slave and animal share the same marginal location as material possessions or pets.[14]

In archive and information studies, these power relations are similarly coded. Archival scholars Barbara Craig and James O'Toole posit an "iconography of archives," narrowing their visual analysis into a semiotics of record expression.[15] Craig and O'Toole interpret the "documentary practices" depicted within early American painting and explain how rare books, deeds, land grants, and legislation elucidate "the settings for reading and writing . . . show[ing], for example, how documentary practices were woven with a physical place."[16] Literary signs appear as writerly or iconographic symbols giving clues about readerly practices and archival contexts from the margins of the canvas. Visual representations of documents demand another level of scrutiny, a process of deciphering records that appear in paintings "ostensibly 'about' something else."[17]

Race and archive share a visual liminality in nineteenth-century painting. Whether as human "property" or literary "possession," both demand a methodological recuperation in order to ascertain how

racialized and printed signs might also disseminate what Foucault terms "subjugated knowledges."[18] A queer detrital analysis grasps at that "something else" in the visual field, as Craig and O'Toole also seek to do, countering the authoritative structures predicated on seeing through Anglocentric and heteronormative lenses privileging the whole unencumbered sight.

Thus, looking for Meza brings critical race art history, queer of color critique, and archive studies to bear on the way AIDS has shaped the record body. As a result, our eye searches the margins, observes human impressions, and invests the corners and edges with new meaning. Meza's fragments are quite different from AIDS activist videotapes. His is a story of "bit parts": bits of art, bits of video, and bits of image. The scraps central to this chapter frustrate vision, and yet are a necessary point of entry. We strain to survey the borders of media marginalia and see their insights.

A page from Robert "Cyclona" Legorreta's scrapbook instructs how to read queer detritus. Collaged photos snapped from Meza's Hollywood apartment document preparations for Cyclona's "comeback" party hosted by Gronk in 1974 (see figure 2.2). Sequentially ordered and thematically aligned, each row arranges Legorreta, Meza, and their circle of friends into a "look book" of performance art documentation. The photographs reveal their physical transformations—alabaster skin, smoky eyes, and glossy lips. In addition to representing queer LA nightlife, the images gesture toward the British fashionista Leigh Bowery and his New Romanticism in London's East End in the late 1970s. As writer Michael Bracewell explains, "New Romanticism was about getting ready, it wasn't about going out. . . . And I think getting ready became an art form. Anybody in their bed set—whether they were out in the suburbs or . . . dingy high rise somewhere—could become this legendary artist making themselves and maybe not even bothering to go out."[19] Legorreta and Meza anticipate Bowery's influence on the British underground, a subcultural trend in "New Wave" post-punk aesthetics that would grow more pronounced in Meza's later work.

In the scrapbook, their masquerade bleeds off their extravagantly adorned bodies and onto the walls of Meza's Hollywood apartment. However, only a partial view remains. One untitled painting hangs over Cyclona's shoulder. Legorreta's swath of overlaid organza and headdress

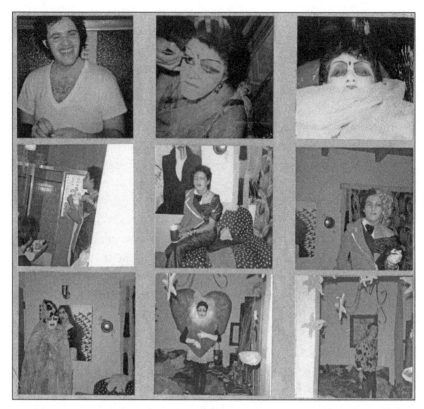

Figure 2.2. Cyclona, Mundo Meza, and Charles Halusca (1973), color photographs mounted on scrapbook page. From The Fire of Life: The Robert Legorreta–Cyclona Collection, Chicano Studies Research Center Library, University of California, Los Angeles.

obstructs the painting. The piece, perhaps a portrait, is a tessellation of black-and-white bird forms alluding to the formative influence of M.C. Escher's woodcut *Sky and Water I* (1938). Ultimately, traces of Meza occupy photographic borders and hinder "complete" visual apprehension. Detoured by the "live art" entity called Cyclona, our skewed view must reconcile Meza's dual paintings—that on Legorreta's skin and the canvas behind him. The bifocal vision cast by competing art pieces also mirrors the artist's own self-display for the occasion, an asymmetry of gender nonconformity and binary rupture of masculine and feminine tropes. The fraught modes of looking at Legorreta's scrapbook hint at

the consequential role of collaborative art-making in Meza's corpus and the fractional ways of looking at his bifurcated self-representation. Thus, both body and canvas "hang" in Legorreta's scrapbook as ephemera in that Muñozian sense, as material incompletion, as queer detritus.[20]

Certainly, their composition and technological limitations affect how these images are assessed. For a certain faction of art historians, these snapshots are "bad photographs." However, they offer an unusual window onto queer Chicanx avant-gardists "getting ready."[21] The scrapbook opens onto the transitional process of becoming, a vacillation between the wardrobe closet and the embodied image statement. Molding the brown façade through the end of a makeup brush, a stain of pink lipstick, and glint of sparkling fabric, Cyclona and Meza's fashion expression is at "the room's edge."[22] They promise a party arrival, which according to Bracewell is a "making" that may end in an incomplete destination. What is behind and between Meza's dual art piece—one alive and the other static—demands another approach for obstructed artworks that never arrive and refuse an unobstructed view. The glimpses of an oeuvre caught on camera question not what an artist archive is, but what its ocular structures can do.

A queer detrital analysis interrogates partially sighted artistic expressions that would otherwise frustrate looking relations and art historical claims. The bit parts glimpsed in the frame undercut a methodological bias to dismiss them, as though only unencumbered sight lines or salvaged art objects are satisfactorily historical and verifiable. More than photos on the page, the scrapbook's alternative recording is "about something else." The way that these fragments disorder our experience of the visual frame allows for queer epistemic understandings of visual evidence to emerge from the scraps.

Show, Tell, and Retail

Although the fragments in Legorreta's scrapbook shed light onto Meza's little-known collection of paintings and performance expressions in Chicanx collaborative art-making, his window displays represent the majority of his creative output around 1979 to 1983. Remnants of his plastic tableaus and shock spectacles are gleaned from various sources, with the memoirs of design and fashion personality Simon Doonan

being the most critical. Published by commercial presses, these books cultivate a dynamic custodial context for Meza, a literary ground in which bits of him lie.

Doonan's first book, *Confessions of a Window Dresser: Tales from a Life in Fashion* (1998), describes his move to LA in 1978. Tommy Perse offered Doonan the opportunity to window dress at his new boutique, Maxfield Bleu, a Hollywood stronghold for "avant-garde clothes."[23] Doonan accepted the offer and headed to a city he knew little about, having grown up in Redding, England.[24] In 1979, he met Meza through a mutual friend and soon developed a special affinity for this enigmatic yet immensely creative Chicanx force.[25] Doonan and Meza could not have seemed more different. Beyond their obvious ethnic contrasts, Doonan was an extrovert and world traveler. Meza was an introvert, yet burst with a contradictory brazenness, having grown up in Huntington Park and nourished by the political uproar of the Chicano movement. What both men did share was an appreciation for the satirical, flamboyant, and macabre.

By 1980, Meza and Doonan had reached new levels of notoriety. Their subscription to the "radical shock" school of window design staged tableaus with absurd crimes and salacious events.[26] In one vignette, hyperpowered children in Maxfield brand t-shirts hurled boulders in the air, crushing a fashion victim in a magnificent stoning (see figure 2.3). This window caught public attention when it appeared as B-roll footage in an episode of *2 on the Town*, a news program about the "famous and infamous" streets of Southern California circa 1980.[27] Meza and Doonan's window epitomized "the look of a hipper Rodeo Drive," crafting a creative retail space ironically positioned relative to West Hollywood's more popular men's fashion attractions: International Male and Ah Men.[28] In another window Meza installed a coffin, closing a six-week storyline about a socialite's rise and downfall. His idea—*telenovela* with a bit of retail showmanship—achieved something that fellow window dresser Bob Currie had proposed but could never complete at Bendel's department store on the East Coast. In a *New York Magazine* article from 1976, Currie alluded to more conservative conditions working under Bendel's president, Geraldine Stutz. What he cultivated was a shopping experience for the department store giant, taking "chances,

Figure 2.3. Mundo Meza and Simon Doonan, "March 6, 1980: Is That a Mannequin under That Boulder?" Photograph by Bob Chamberlin for *Los Angeles Times*, March 6, 1980. Copyright © 2017. Los Angeles Times. Used with Permission.

but I never shock or offend."[29] That was hardly Doonan's mantra, and certainly not Meza's.

By the early 1980s, Meza had honed skills and creative energies promulgated by queer Chicanx avant-gardisms in East LA. Though he briefly attended Garfield High School alongside Legorreta and Asco co-founders Gronk, Harry Gamboa Jr., Willie Herrón, and Patssi Valdez, Meza declined an invitation to join this group of provocateurs in 1972.[30] Instead, he paired with Legorreta in provocative live art performances and embarked on a professional art career. He applied for admission to the esteemed California art school CalARTS in Valencia, moved to Hollywood, and completed formal studio art classes at Otis-Parsons Art Institute in the spring and summer of 1974.[31] His tuition was paid with scholarship money awarded after he placed first in a juried LA District Unified art contest in his senior year at Huntington Park High School. Of course, Meza was no fashion novice. He painted satin-laced platform shoes during a brief apprenticeship with Fred Slatten in the mid-1970s,

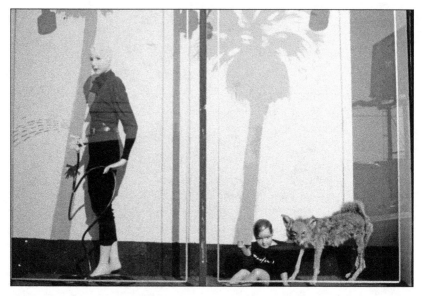

Figure 2.4. Mundo Meza and Simon Doonan, Coyote Abduction Window (1982), Maxfield, Los Angeles, California. Photograph courtesy of Simon Doonan.

adding to the celebrity looks of Sonny and Cher, Sally Struthers, and Elton John.[32]

In joining forces, Doonan and Meza's partnership led to wildly "insane" window treatments, as the innumerable photo reproductions of Maxfield windows in *Confessions* show.[33] Working with a budget of less than a hundred dollars, they ransacked Hollywood prop houses, plundered taxidermy collections, and exploited Meza's capacity to generate backdrops with photo-realist accuracy. Although Doonan's eight-year-long stint at Maxfield led to his turn as a celebrity window dresser at Barneys New York, Meza's influence has escaped the California art and fashion discourses about this period.

A poignant example of Meza's uncredited collaboration is found in a central spread for *Confessions*. In the window, a young mother in a casual denim ensemble waters her lawn; her back is turned carelessly from the tragedy behind her (see figure 2.4).[34] A coyote attacks her equally fashionable toddler, who is adorned in a Maxfield t-shirt. The beast's jaws lock, pulling at the fabric. Child and animal give equally chilling stares directly at the street traffic. The woman's pose suggests privileging

her lawn over her child, and exposes her indifference if not possible col-
lusion with this urban beast. In the other window, a coyote leaps toward
a suburban husband mowing his lawn.[35] The window tableau reimagines
an infamous animal attack in Glendale, California, in August 1981, when
a three-year-old who wandered outside to a driveway was dragged away
by a coyote. This was the first of seven documented coyote attacks on
children in LA County between 1978 and 1981.[36] It generated outrage as
well as hunting, trapping, and killing of coyotes—with as many as fifty-
seven killed within a mile of the first attack.[37]

Meza's wild imagination gave the headline plastic flesh and satirized
the media's sensationalism and the absurd horrors of animal-child ab-
duction. His display exploited unknown terrors in the city's mountain-
ous landscape in a way that may not have ensured higher sales, but as
Maxfield owner Susan Epstein acknowledged, "People have come to
expect something different from our windows."[38] And different it was.
Arguably a subversive exercise in public outrage, Meza refashioned the
confrontational actions of Cyclona ten years prior in pieces like those
discussed in chapter 1.[39] Queer Chicanx avant-garde performance stim-
ulated him, and the results upset lackadaisical shoppers passing by.

The public effect of Meza's perverse frozen tableaus recalls that of the
work of fellow LA artist Ed Kienholz. Kienholz's inflammatory found-
material installations ranged from the racist brutality of lynching in
Five Car Stud (1969–1972), to gun violence in *Still Live* (1974), to the
"pornographic" tones of *Back Seat Dodge '38* (1966). The last angered
the LA County Board of Commissioners, which charged the LA County
Museum of Art with displaying sexually prurient work. In response,
the sculptural car door was closed to protect the public from viewing
the copulating wire and fiberglass figures inside. According to art critic
Hunter Drohojowska-Philp, "As a result of all the publicity, the exhibi-
tion drew record attendance."[40]

Kienholz's found-object montages had a "peculiar social dimen-
sion."[41] The tableaus created "living pictures" that transported viewers
to simulated environments that grew from proto-photographic origins
of museum display. According to Mark Sandberg, "Unlike photography's
'reality one no longer can touch,' . . . late nineteenth-century museum
practice teased spectators with games of voyeurism that could quite
conceivably become games of immersion instead."[42] Still environments

like ethnographic panoramas and waxwork vignettes edified this optical trickery and curiously dovetailed with the feminizing feet of window dressing. Kienholz's macho bravado is put into dangerous proximity with the flouncy decorator, a corollary that Jorn Merkert makes in his exhibition essay for *The Art Show* (1973) in Berlin. He speculates that Kienholz "is stimulated by the confrontation of the two political systems on display here as if in a shop window with all their respective artificial decoration."[43] With tableaus that amuse and disturb, Kienholz envelops the viewer in experiences of spatio-temporality that challenge passive spectatorships and thus animate involvement in scenes parceled and segmented from other places. The distances between the hulking plastic worlds of Kienholz and Meza close. Both create narratives about social upset that arouse emotion and viewers' culpability in frozen theaters of public agitation.

Ironically, Kienholz's fluency in a window dresser's vocabulary exists side by side with the homophobia undergirding a work like *The Beanery* (1965), a recreation of the infamous West Hollywood bar in life-size scale replete with the tavern sign declaring, "Faggots stay out." But between Kienholz and Meza, there is also a queerer dialogue occurring at the intersection of stillness, assemblage, display, and the affective structures of visual disturbance at the museum and the storefront window in LA at this time. In built wondrous environments, mannequin actors animate performances, rousing the grotesque, hedonistic, and even parodic in what are otherwise critiques of social realities. More than plastic props, the taxidermist material in windows further bear on the suspension of life and death.

It is difficult to look at Maxfield's coyote attack window and disregard what the animal may have signified for a Tijuanense like Meza. A Spanish pseudonym for a trafficker who smuggles undocumented peoples across the US/Mexico border, the stealthy coyote evades detection and border security. In the window, the menacing animal trespasses on an immaculately manicured lawn. Performing a public indictment of a fraught system of immigration and irrational fears over "illegals" invading LA suburbia, the scene exposes an affluent woman's vain and indifferent remove, making her complicit in this tragedy. Meza plasticized xenophobic anxieties about what wildness is invading from behind her back.

The coyote's principal action in the vignette reads indigenous meaning into the animal-child abduction case. A choreography between settler-colonialist and Native, Meza's window animates a figure emblematic to Southern California's crisscrossed border landscape. Coyotes were regaled as divine beings and Mesoamerican deities in ancient belief systems; First Nation peoples understood the coyote as a trickster who survives through deceit, cunning, and magic. According to Shane Phelan, "Tricksters can adopt the shape of other being for camouflage or to get what they want, though some people recognize or suspect tricksters despite their disguises."[44] For Phelan, the coyote's versatility is an analog for queerness, and thus it can be seen as appropriately reflecting Meza's performance repertoire in which shape-shifting and androgynous illusionism were tactical modes of survival. Its mythic symbolism evokes Chicanx visual art aesthetics and the sculptures of Tejano artist Luis Jiménez.

Jiménez's *Howl* (1986) is built from fiberglass and polyurethane. Based on his 1976 lithograph of the same name, the sculpture is of an animal perched on a solitary boulder, twisting upward and howling into the sky (see figure 2.5). With ribs relieved in a narrowing torso and tail drooping lifelessly down the rock, *Howl* is a metonym for a borderland wasted, an indigenous future being starved. The animal's cry is a last gasp, an irrefutable bellow into the desolate landscape harkening back to *el grito*, the scream that sparked the Mexican Revolution of 1910. As Jiménez recalls, Mexican Americans "are not unlike the coyote, an animal once targeted for extinction by ranchers. . . . It's not gone, though. It has managed through instinct and spirit to survive."[45] Together, Jiménez and Meza repudiated a Westernized perception of an empty idyllic landscape, an open terrain legitimizing nineteenth-century imperialism rationalized as "manifest destiny." Expanding westward, Spanish and Anglo colonial violence against Native people also upset harmonious relations with species and delicate ecologies. In their depictions of coyote starvation—one ravenous, the other emaciated—Meza and Jiménez magnify the anti-Native, anti-Mexican ideology justifying the vast slaughter of coyotes, "their skins strung along fence lines of the US-Mexican border like so many *ristras* [strings of dried chiles] on an adobe wall."[46]

The coyote became a polysemic symbol for the threat of the city's wildness, a queer transgression of sex-gender systems, and a retelling

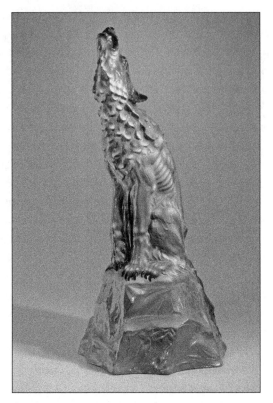

Figure 2.5. Luis Jiménez, *Howl* (1986), fiberglass, acrylic urethane, 60" x 36" x 36". Spencer Museum of Art, University of Kansas, Museum purchase. © 2018 Estate of Luis A. Jimenez, Jr. / Artists Rights Society (ARS), New York.

of Mexican indigenous political subjects invading Southern California's Anglo citizen-body from down below. Predictably, Meza's stylish window caused public uproar. Complaints from family members allegedly related to victims of the animal attacks forced Maxfield to close the window early.[47] While this installation is cited as one of Doonan's most recognizable works—his talk with Jonathan Adler at Casa Italiana Zerilli-Marimó at New York University in 2013 confirms this—Meza's contribution to *Confessions* is unacknowledged.[48] Of late, Doonan has reversed course. "I knew how to rig a bust form," he recalled, "but he pushed me into a creative direction, the coyote abduction was his idea.

He was pushing me to be subversive."[49] Their collaboration and personal involvement reinforced one another in a shared reciprocity between Anglophilic fashion and queer Chicanx avant-gardisms and performance art. Their penchant for shock aesthetics depicting suicide, bondage, anti-Thatcher riots, and stinging commentary on President Carter and the First Lady set the stage for future windows. As Doonan retells, "He was, for some reason, infinitely less risk-averse than even I. This may have been due to the fact that I had a green card and he did not; i.e., he had nothing to lose."[50]

Alas, for a queer Tijuanense working in the ephemeral and anonymous field of window display, there was plenty to lose. Yet on his own terms Meza engaged in a field of design shaped by Chicanx and Latinx creative expression in installation arts directed by merchandise, store marketing agendas, corporate branding campaigns, consumer behaviors, and mannequin manufacturing. In this plastic world of luxury retail, Meza signifies within the contemporary sculptural register of Jiménez, the brazen verve of Kienholz, and a critical genealogy of queer and Latinx artists spirited by window trimming and retail. The pervasive racial myopia in the field of design history little elucidates the Hispanicization of its dressers, which Meza is a part.

It was principally Salvador Dalí who innovated avant-garde approaches to window design. The Spanish surrealist's infamous installation for New York's Bonwit Teller department store in 1934 blurred merchandising devices with the irrational drama of *objet surrealiste* and street theatricality.[51] Hints of nudity, stuffed buffaloes, bloodied pigeons, and dismembered mannequin limbs presented an uproarious scene from the little-seen corners of a bathroom tableau.[52] However, the *piéce de résistance* occurred after Dalí discovered that Bonwit Teller intervened in the showroom. His mannequin had been replaced with a more conventionally dressed body form adorned in retail apparel. Outraged at the store executives' violation, he unleashed what Doonan called his "fabulous rage" against his own installation, tossing the bathtub prop through the window onto the ground, shattering glass, and causing his own arrest.[53] *Confessions* briefly recounted this event, which served as an oft-cited benchmark spurring the "new wave" movement in window dressing. This new wave characterized much of Doonan and Meza's generation in the 1970s, a movement informed by Dalí.

Other Latinx trimmers in New York City like Bloomingdale's Candy Pratts Price, Halston's Victor Hugo Rojas, and Fiorucci's Antonio Lopez and Joey Arias continued in Dali's vein by piloting avant-garde glamour on par with "sight gags," "brutal erotics," and live mannequin shows.[54] Price was born Candida Rosa Theresa Pratts to a Puerto Rican family in Washington Heights, a mainly Afro-Latino neighborhood of Manhattan. Her achievements in window dressing were called "outrageous" and "nonconform[ist]" in the media.[55] Fashion journalists discursively intertwined her practice with an excessive Nuyorican affect, presenting her as "outspoken" with "Puerto Rican flair."[56] Tropicalizing tropes followed the conceptual performance artist Rojas. Born during a military coup d'état in his native Caracas, Venezuela, in the 1950s, he immigrated to New York with his mother in 1973. His good looks, muscularity, and large endowment—he was said to be a model for Warhol's *Sex Parts* (1978) silkscreen series—propelled him up the design ladder.[57] He became a fixture at Studio 54, a Warhol factory apprentice, and highly prized bathhouse conquest. Hugo served as chief window dresser for Halston's showrooms as well as the fashionista's lover. In a 1976 issue of *New York Magazine*, Hugo appears in a diminutive corner of the Halston storefront sipping from a saucer cup next to a pregnant mannequin mid-birth. "Some people thought it was bad taste and vulgar," he said.[58]

Nuyorican fashion illustrator Antonio Lopez, an established draftsman working for major fashion magazines such as *Women's Wear Daily*, *Vogue*, and *Harper's Bazaar* (to name a few), art-directed windows at Fiorucci's, which, in the early 1980s, was "the hippest store in Manhattan" and relished "disco and New Wave clothes."[59] Lopez and his partner, Juan Eugene Ramos, were assisted by recent LA arrival Joey Arias, a graduate of Cathedral High School (attending alongside junior classman Joey Terrill). Arias, who cultivated his career in drag performance, speculative aesthetics, and alongside New Wave vaudeville show staple Klaus Nomi, "freaked out when I saw [Antonio], and stayed behind after the store closed so I could help him with his designs."[60] Though not a window dresser per se, Arias attracted clients as a buyer and shop boy through his otherworldly appearances in outrageously hued hair, thickly powdered pale complexion, and luscious dark lips. Like a living mannequin performing in store windows with Nomi and other new wave

libertines on NBC's *Real People* in 1980, Arias curated the personalities and engineered the social landscape, as well as giving color and pizazz to the store interior.[61] In his Kaprowian "happenings," impromptu performances, and art exhibits, including the paintings of space-bound Cadillacs in Kenny Scharf's show, Arias would "bring the Downtown people Uptown. . . . I used the place as my office, or my gallery, for myself. [Fiorucci's] was a very important place for New York."[62]

Meza expands on a repertoire of Latinx designers, enunciating a display vocabulary indebted to Spanish surrealism, New Wave aesthetics, and perspectives on power and difference culled from the turmoil of ethnic uprising in black and brown social protest movements of LA. His display practice was influenced by his social location as a working-class immigrant and drawn from his queer performance actions on the streets of East LA with Cyclona by his side. Meza's tactics punctuates what Johana Londoño calls the "cognitive space of barrio affinity" in Latinx design.[63] These artists "negotiate their affective and class affiliations of place in order for their designs to be visible in an ever more designed world of consumption."[64] Their shared "affinity" is expressed in a perspective accented by a distinct ethnic location, Latin American sensibility, and barrio urban street sense.

Queer and racialized creative agents pervaded art, commerce, and retail in a way unbeknownst to journalists like *New York Magazine* reporter, Rosemary Kent, who reported that "New Wave" windows at Bloomingdale's, Tiffany's, and Bendel's were ushering "a kind of street theater" and inciting a renewed fervor in the department store.[65] In 1976, she observed "window-hopping," a growing trend among Park Avenue dinner party types, who piled into limousines and toured store façades, equating their excursion as a more democratic alternative to Broadway and opera.[66] New Wave windows were like glass-encased stages, and with each performance, glitzy audiences were attracted to luxuriant tableaus fabricated out of fashion's star players: mannequins.

On the other coast, window displays' minoritarian influences were more pointed. Maxfield windows bear on the performance art emerging in Southern California at the time from the likes of Chris Burden, Suzanne Lacy, Mike Kelley, and Johanna Went.[67] They exuded the city's queer iconoclastic verve. They are also indebted to Chicanx art strategies of public address, such as the street mural. In Sara Schneider's

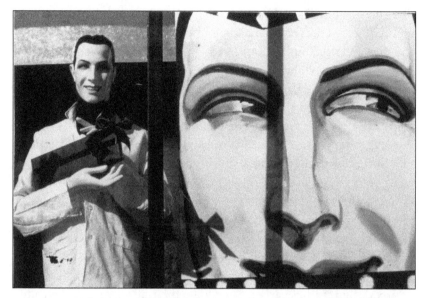

Figure 2.6. Mundo Meza and Simon Doonan, Holiday Window (1982), Maxfield Bleu, Los Angeles, California. Photograph courtesy of Simon Doonan and Sara Schneider.

study of mannequin performance, she foregrounds the unusual emphasis on abstraction in windows with Doonan's signature. Pointing to the large-scale replica of a classic Pierre Iman Parisian mannequin hanging, Schneider stresses that Doonan's "mannequin draws attention to the features of the figure rather than to those of the merchandise. The mannequin itself is the subject of the display" (see figure 2.6).[68]

The artist behind the window backdrop is unattributed, and thus Meza remains anonymous in Schneider's analysis.[69] His obscurity notwithstanding, his work registers a complex design and collaborative art practice behind Maxfield in the 1980s. A recurrent Meza characteristic is to interrogate the mannequin's anatomy and emphasize the plastic parts, a bold gesture indebted to still life painting and, in particular, Chicanx muralism. Meza creates provocative expressions on par with murals done by post-revolutionary Mexican painters such as Diego Rivera and José Clemente Orozco, who worked in the United States. His muralist aesthetic was cultivated under his high school art teacher Margaret Tangie, who was trained in Mexico City and oriented lesson plans around slides gathered from Mexican master painters, pre-Columbian archeo-

logical sites, and modernists.[70] Tangie tuned into her young student's creativity and fostered his promiscuity in Latin American art.

Growing up east of the LA River, Meza experienced variegated approaches to post-1960s Chicanx public art expression. His window display acumen augmented the predominant Marxist principles espoused by Chicano mural ideologue Carlos Almaraz (see chapter 1). Rather than condemn the ills of capital, Meza unapologetically embraced its chief symptom: shopping. His attitude was consonant with scensters on Melrose in the 1980s. "It's sad the kids have nothing to rally behind except fashion," bemoaned one youth movement activist, disaffected by the changing times.[71] Meza beautified mannequin comportment while honoring the mural's capacity to reproduce large-scale colossal icons, generate honorific portraiture, and invent new mythologies from luxury wares. He replaced stone sculpture and indigenous ruins with stationary wax arbiters of French elegance that grabbed passing motorists' attention, ensuring Maxfield's richly layered tableaus were seen "from a car, passing bus or from across the street, especially in LA."[72] Painting an enormous mannequin head in the backdrop of the window, he combines muralism, retail merchandising, Mexican post-revolutionary art, and trendy Melrose residents' thirst for unique shopping experiences.

In *Confessions*, a grainy image shows two wall panels filling Maxfield's main showrooms, apparently representing one-half of a two-part holiday window from January 1982 (see figure 2.7).[73] In it Meza's considerable versatility is visible. His rendition of a mannequin replicates a portion of her face like a pop art reimagining of Olmec colossal heads for Maxfield shoppers, subverting the venerating Meso-American iconography, which predominated Chicanx art at that time. Its facial reproduction bleeds off the wood paneling, an appropriate backdrop for the plastic actor at the windows' focus.[74] For Meza, these static performers populate his tableaus as occupants, subjects, and salespersons. They dominate over the retail products as large scale replicas, dwarfing their meaning. His acuity for mannequin anatomy occurs at its deconstruction, an extraction from the whole perhaps signaling the fractious façades that would dominate his later work, especially as AIDS made its ghastly and deforming marks.[75]

With their shared immigrant reality—Doonan's green card was predicated on lying about being homosexual, which was defined as a

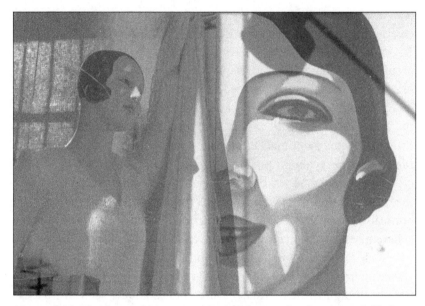

Figure 2.7. Mundo Meza and Simon Doonan, Holiday Window (1982), Maxfield Bleu, Los Angeles, California. Photograph courtesy of Simon Doonan.

mental pathology; Meza was born in Tijuana with an unclear citizen-ship status—both window dressers' lives were profoundly entangled by ethno-sexual marginalia.[76] Such circumstances conditioned their display collaborations and joint travels and made their shop-window tableaus increasingly biographical, ontological, and even archival. An intimate relationship grew from their creative process: a symbiosis best articulated in what Doonan calls "being trendy," a lifestyle infusing art and life with the mannequin repertoire.[77]

Plastic Being/Being Plastic

Meza's liminality broadens in Doonan's follow-up memoir, *Nasty* (2005), which was rereleased in paperback as *Beautiful People* (2009). Writing about his eight years in Southern California, Doonan brings Meza into the text to literalize AIDS for the reader and, more broadly, represent the fashion and art prodigies ravaged by the disease. Meza epitomizes Doonan's pursuit of beauty, a search that goes from the cobwebs of

kitschy LA eateries and cockroach-infested apartments to the "trendy people" of Hollywood's Fontenoy apartments—stylish by design and raucous in attitude.[78]

Chapter 15 centers Meza's photographic portrait on the page, beneath the title "Hollywood."[79] The declaration thrusts Meza's countenance within cinematic history under the guise of Rudolph Valentino, a silent film icon. He appears in a draggy translation of the archetypical Latin lover and sexually ambiguous movie star. Hands on his hips, he strikes a pose in a contrived yet confidant comportment like the mannequin body language that permeated his life.

In choosing this peculiar photo fragment, Doonan seals him in a film vocabulary from the silent era, an alignment of picture and sound not unlike his background work in *Against All Odds*. The photo reprint asks the reader to understand Meza's archive through the fragments of Hollywood's dream factory and its soundless origins. The photograph recalls a history of film performance preoccupied by exaggerated gestures and looks reproduced from film rags like *Photoplay* and *Screenland*. Doonan recounts, "Being trendy was our most intense and satisfying area of commonality."[80] The pair shared a voguish desire to mimic a classic studio star system in "overdressed trendiness."[81] "*Being* trendy" (emphasis mine) is more than a passing phase; it is a social reality, a way of "living fashion" like the mannequins they styled weekly. Huereque recalls this evanescent play of music and art trends in itinerant movement "onto the next—next outfit, next look, next concert."[82] As fashionistas and shop boys in LA's burgeoning fashion and retail epicenter on Melrose, they hungered for the new, relinquishing clothes as quickly as fads passed. They partook in a lifestyle based on the power of self-creation, a way of life captured by a punk shopping at Poseur and divulging his day for the pages of *Los Angeles Magazine*: "[Been] goin' to gigs, getting my hair done, getting my picture taken."[83] Like the temporary window display environment, these scenesters personified a transitional sense of "fashion becoming" as I term it, an ideology by which to live (and die).

Meza's and Doonan's mastery of looks leapt into the art-music scenes on their nightly excursions into Hollywood clubs like The Fake and Club Lingerie. The Veil, a subterranean hotspot hosted by Hollywood's Cathay De Grande, was a "place to see guys with faces painted nearly white, wearing baroque frock coats . . . that extreme androgynous, silent

movie make-up look."[84] Dance clubs like these were breeding grounds for underground trends, gender fluid libertines, and queer sensibilities. As early as 1981, the *LA Herald Examiner* announced the arrival of New Romanticism, a style coming on the heels of Adam and the Ants's show at the Roxy.[85] The English band's appearance broadcasted a new fad—"a nouveau dandy, romantic-decadent aesthetic" for dilettantes trading in torn t-shirts for "waistcoats, great breeches, flounced shirts, brocade jackets and tassel belts."[86] Arguably, this second British invasion hit LA running, growing out of London's post-punk craze.

An English gay bar called Billy's was seminal in birthing the New Romantic look. In 1978, the doorman, Steven Strange, and his flat-mate, Rusty Egan, hosted Bowie Night on Tuesdays, attracting former punks who "started off as Bowie fans and still retained that love of reinventing themselves with their costumes."[87] New Romantics thrilled in being "made up" and combined the rebellious spirit of punk, the economic downturn of Thatcherism, and the fashion extravagance of Berlin cabaret, Hollywood cinema, gothic drama, and circus theatrics. However, unlike punk's predilection for gender conformity—stylizing masculine façades with anarchist accouterments like ripped t-shirts, leather combat boots, and safety pins—the "mannerist" post-punk attitude of New Romanticism was unapologetically effeminate, fueled by that clamor to be *seen* and in the *scene*.[88] As Shaun Cole notes, "Make-up and frills became one of the primary images of the New Romantics, although a number of particular 'looks' were seen—the pierrot, the squire, the eighteenth-century dandy, the toy soldier. . . . [They] plundered, in a magpie fashion, not only post-war fashion but the whole of modern history."[89]

With a ruthless dress policy that turned even Mick Jagger away, Strange and Egan opened the Blitz in 1979, a magnet for a club set that came to be affectionately dubbed "Blitz kids."[90] This cultural nexus was among the central influences for designers Vivienne Westwood and Malcolm MacLaren who found their way to LA. New Wave music acts like Visage, Culture Club, Spandau Ballet, and Duran Duran germinated in Blitz's stylish environment, penetrating the US media markets, including the newly introduced MTV.[91]

British émigrés proliferated in Southern California, creating the foundations from which "New Ro" merged with barrio street fashioning.

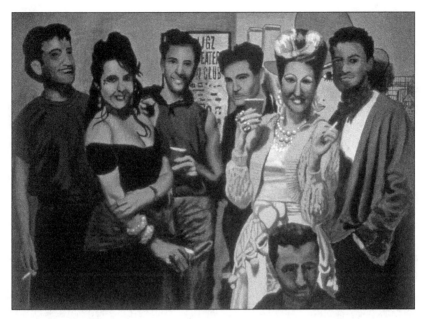

Figure 2.8. Joey Terrill, *Mundo, Luciana, Robert, Steve, Therese, Jef and Simon*
(1983/2004), acrylic and oil on canvas, 40" x 30". Photograph courtesy of the artist.

After Doonan relocated from London to Hollywood in January 1978, he
joined the likes of Westwood, MacLaren, Teresa "Pinkie" Braithwaite,
and musicians Siouxsie Sioux (of Siouxsie and the Banshees fame), Billy
Idol, and Marilyn—fashion icons, designers, and artists inaugurating
a post-punk New Wave sensibility of which Doonan and Meza were a
regular part.[92] A painting by Joey Terrill entitled *Mundo, Luciana, Rob-
ert, Steve, Therese, Jef and Simon* (2004) demonstrates these British and
Mexican American creative circuitries in Southern California (see figure
2.8). Using the subjects' first names in the title, Terrill personalizes the
work. He pieces together a memory of Mundo and recalls past times
culled from another scant snapshot from among his personal keepsakes.
Using a photograph taken in his kitchen in 1983, Terrill captures the
transatlantic and transnational infusions coursing through queer Eng-
lish and Chicano avant-garde factions in LA. It was an extraordianry
cultural mingling coming together in the unexpected ordinariness of
Terrill's barbeque bash in his Alahambra home.

British influences revitalized waning retail shops on Melrose in West LA, creating a glamorous international outlet distinct from the provincialism of the San Fernando Valley, the Sherman Oaks Galleria, and its chief suburban export: Valley Girls. As one eighteen-year-old shopper at Flip's store put it, "Now that I've been to Europe I see how European Melrose is. . . . It's not like Valley clothes at all."[93] Let it Rock!, Flash Feet of London, Retail Slut, Cowboys & Poodles, Poseur, and International Warbabies sold European imports, leather-studded goods, military regalia, spike jewelry, Catholic paraphernalia, and bondage pants. Joseph Brooks and Henry Peck's vintage record shop, Vinyl Fetish, which opened in mid-1980, rang to the beat of an English underground sound.[94] They carried rare and hard to get music from the United Kingdom including obscure acts accented by the New Ro and goth-industrial genre. Brooks and Peck held after-hours parties and in-store record signings while also running The Veil, a nightclub as much about the music as it was about vintage frocks and flowery frills. As Ingram remembers, "An otherwise desolate Melrose Boulevard, at that time lined with second-hand clothing stores and dilapidated repair shops . . . changed in 1981 once London's Flip Jeans moved in; within a year Melrose evolved into a hip, upscale, high fashion mecca."[95]

Founded by Alice Pollock and Paul Wolf in 1978, Flip opened on London's trendy King's Road and featured national and international fashion, recycled clothing, and Flip-brand tie-dyed t-shirts and muscle tanks.[96] As former Flip employee Monica May remembers, Paul Wolf "would go and buy two hundred pound bales of clothing and one would be leather motorcycle jackets, one would be kimonos. . . . A truck would come in and there would be bales of fucking bows all over the parking [lot]. And you would just go through and raid the clothes."[97]

Attracting a mixture of punks, queers, African Americans, and celebrities, Flip became the "rock club of the retail business."[98] With a neon sign animating a rotating record on the building's façade, the store emanated a glowing luminosity and set the trend from which Melrose Avenue was known. "It lights up the darkness," Pollock told an *LA Times* reporter in 1985 about her neon graffiti. "It's magical."[99] After dark, UK fashionistas, "New Ro" sycophants, and British shop boys flooded Melrose and its alleyways, known for drug trafficking and cruising.[100] According to May, "English boys came over with great

imaginings of what California culture was going to be: sunshine and big cars."[101]

According to Huereque, Flip "hired all the cool, interesting people in Hollywood."[102] Meza was one of them. His creative energies flourished in this environment. Moving into Doonan's Fontenoy apartment in 1979, he gained rare access to this English scene.[103] As Huereque remembers, Flip's "was a meeting place and when they threw parties that was the place to go"; "a lot of people from Flip's lived at the Fontenoy."[104] Thus, the retail emporium's social milieu, with its multidimensional queer, ethnic, and English rocker pandemonium was an ideal atmosphere for Meza.[105] Hints of Meza's predilection for mannequin anatomy are glimpsed from a story in the *LA Times* about the store in 1982. Reporter Mary Rourke's lead opens: "The mannequin in the window is minus a hand."[106] While difficult to discern whether this fashion amputation was Meza's doing, the attention to the mannequin's jagged edge makes it hardly outside the realm of possibility.

The duo's stylish extravagance reached what Doonan terms an "apotheosis" in 1981, when they were cast in the music video production of Kim Carnes's Grammy award-winning single "Bette Davis Eyes" (1981).[107] Spotted at the Veil, they matched the gestalt of "Blitz kid" decadence: being trendy in the right place, right crowd, and right time. Meza understood the cultural parlance of the New Romantic movement's stylish semiotics, translating English design into wearable LA duds. Bringing the look of King's Road to East LA, Meza's video performance combines UK and barrio urban influences.[108] Appearing among a group of "trendoids" from the Veil, Meza exists at the margins of videotape.[109] A series of jump cuts and dissolves decenter his body from an unobstructed view. We glimpse him kneeling before Carnes in low-angle camera shots and, later, poised in a dominating wide stance, his head quarter-turned in a dramatic motion.

Outfitted in a stylish pirate ensemble, Meza has strapped a patch over his left eye and lined his right eye in black eyeliner, demarcating a "New Ro" gender-variant androgyny. His boyish visage resonates with the video director, Russell Mulcahy, who grants him a rare but brief close-up. Paired with a neo-Victorian bon vivant, Meza moves through Carnes's smoky lyrics. His body harnesses the sound and adds to a dynamically cross-racial, cross-border, and transatlantic backdrop.

In the mise-en-scène, Meza is a detail gleaned from the broader whole. Similar to the way the mannequin figure populates the void between window and street, Meza performs in the fissures between stage, prop, and recording artist. Accenting the set, he exemplifies Schneider's view that mannequin "body fragments often are simply visually arresting ways of referring to whole selves. . . . They may also suggest that the splinters, shards, and traces of bodies in the window displays are *all there is*, even in the world beyond the window frame."[110] Meza enters this plastic world's interstices as a shard, an accent splintered by a moving camera, a fashion *becoming* in compressed fractions of screen time. In the video edit, what remains is a "bit part," a visual disjunction like that mannequin amputee occupying Flip's window.

His close-up shows a peculiar yet poignant shot that displays a "New Ro" mastery. Meza's eyes rise from the floor as he keeps in step with his dance partner. He turns to look directly into the camera, breaking the fourth wall. His Brechtian gesture calls forth an awareness of modes of film production and the MTV viewer. With a tactical look, he undercuts the optical access to his body. Like a "human backdrop" *placing* the set, he is a fashionable ornament extending his "look" through the nondescript populace. He adds to the mise-en-scène as a trendy Chicanx fashion plate performing what Will Straw observes is the Hollywood extra's ability to express "a more social sense of film as offering images of collectively shared affect."[111] He is the *scene* and *seen*, shaping the feel of "New Ro" with cross-ethnic and fashionable versatility, making the room explicitly LA and Chicanx.

Meza's capacity to create the *feel* of English trend culture with its penchant for kabuki face paint and gothic pale complexions is subtly challenged by his bronze visage. His move further removes himself from a queer Chicanx performance vocabulary as defined by Cyclona's living art pieces or Gronk's pantomiming alter ego, Pontius Pilate, acted in theatrical alabaster façades. Moving among these Melrose scenesters in rhythmic step, Meza refuses to be washed of color difference. Instead, he confronts a performance vocabulary of New Romantic "whiteface" removing his body from the terms of this epidermal recognition. In turn, his disobedience is literally fashion policed as his vernal visage is slapped with exaggerated motion. Each thrash moves him against the electronic beat of the drums and Carnes's raspy vocal.

Meza dances under the stinging hand of his white Victorian counter-part. Flashing blue light radiate her pale skin and cast darkening tones over his. Their choreographed movement automates other couplings in the video field. The gesture is a kitschy homage to Bette Davis's iconic slap in melodrama and period films like *The Private Lives of Elizabeth and Essex* (1939) and *Another Man's Poison* (1952). He faces her disciplin-ing hand, absorbing her blow. She swats at his body, disciplining some-thing that is at once "New Ro," Chicanx, and trendy. With each twist of his head, his attempt to inter*face* with a uniform white body politic is refused under the bon vivant's policing hand. A struggle for visibility is denied, routing him into the video scramble.

Searching for self-definition, Meza returns the gaze by looking pen-etratingly toward the camera in compressed seconds of time. His bronze face shimmers beneath the stage lights. For just a moment, he teasingly acknowledges his recreation, giving his self-image "the right look." And then, his visage lapses into the video void, yielding a televisual glimpse impossible to sustain. In English dress and brown skin, he returns to the crowd and washes away in silence. What remains beyond his enigmatic comportment is a portrait study of another kind. With a look, Meza ex-ercises a tactical countenance, an appeal to the camera's eye, a transgres-sion of design borders traversing the UK and East LA. It was a move that only an undocumented queer Tijuanese adorned in Westwood couture could make. As Doonan notes in *Beautiful People*, "I was intrigued by his Mexicanness, he was enthralled by everything that was trendy and English."[112] Being legible within certain visual fields of British under-ground aesthetics was a "trendy, superficial poseur's" triumph, and Meza did not want to disappoint.[113]

While "Bette Davis Eyes" spent nine weeks on the Billboard Hot 100, Meza embarked on his last collaboration with Legorreta in June 1981. Borrowing on art direction in music video, the stylistics of Hollywood nightlife, and window display, Meza rehearsed the foundations for a photo-based performance in what Legorreta termed "Frozen Art." To-gether, they explored the transmutability of the Cyclona persona and drew on vocabularies indebted to the plastic comportment of manne-quins. Photographing in Kodachrome 16mm shots at his Hollywood apartment, Meza crafted each permutation of the Cyclona character

Figure 2.9. Mundo Meza (with Robert "Cyclona" Legorreta), *Frozen Art* (1981), photograph. From The Fire of Life: The Robert Legorreta–Cyclona Collection, Chicano Studies Research Center Library, University of California, Los Angeles.

from high angles, a technique likely learned through his queer surrealist experiments with LA photographer Steven Arnold at his eclectic fantasy salon, Zanzibar.[114] Legorreta lay prostrate against flat shallow backdrops evocative of retail windows. Like a mannequin actor, Cyclona negotiates the limits of motion and stillness. Fabric swaths, organic/inorganic

materials, and taxidermist scraps suspend him in a lavish yet frozen underworld.

In the frame, the iconoclast is coiled in gilded cord, shrouded in luminous powder and blue cloth, and positioned against a dark crimson backdrop (see figure 2.9). Taking this perverse muse from the persecutory realm of performance assault to the aphonic lull of the mannequin register, Meza depicts Legorreta in a test of stagnation and liveness. In the frame, Cyclona reaches out beyond body restriction and gender discipline as living fashion embodied, activating a window vignette and reenergizing a gender transgressive persona of queer Chicanx avant-gardisms. In suspended animation, his comportment echoes the mannequin's poseur lexicon.

Cyclona gleams from the glittering cord repurposed in Meza's first independent booking at Melon's, a new Melrose boutique. His debut added sadomasochistic allusions to a vignette provoking customers in search of California lifestyle fashions. A collective garrote snaked around mannequin stand-ins, female figures painted onto spherical pillars (see figure 2.10). Bound and gagged with gold rope, these exquisitely

Figure 2.10. Mundo Meza, Melon's Window (1981), 8739 Melrose Ave., Los Angeles, California. Photograph by Elisa Leonelli.

clothed abductees put the imposing mesh of beauty, violence, and social conformity into sharp contrast with the Cyclona figure, a queer muse who pressed against the tangles of rope. Meza's *Frozen Art*, queer Chicanx avant-gardisms, and aesthetic renegotiations of "mannequin body attitudes" yielded an outrageous display vocabulary for the window, one that echoed the tangled brutality in David Alfaro Siqueiros's censored mural *América Tropical* (1932), a work so offensive it was whitewashed from public view in downtown's Olvera Street.[115]

While it is difficult to compare tethered debutantes in luxury apparel and a perverse muse to the brutality of indigenous crucifixion in Siqueiros's condemnation of US imperialism, Meza's rope stirred racist histories, created visual disturbances, and possibly cited these Mexican public art precursors. The photographic legacy of lynching not withstanding, the social anxiety and public dialogue ignited by rope was something Meza was familiar with. This material activates another window from Maxfield shot around April 1981 and printed in the pages of *California Living* magazine, a publication of the *LA Herald Examiner*. The image reveals the suspenseful moments of a well-suited mannequin teetering on a chair before its impending suicide (see figure 2.11). Elegantly dressed, the plastic figure models a suit with a designer noose to match. By 1981, Meza's windows are veritable exercises in the mixed-media intercepts of visual merchandising, site-specific installation, music video, and performance art. His windows are creative outlets of documentation and memory, like a personal archive tying knots between queer Chicano avant-garde pasts in East LA to glitzy English creative circles in his present. In these plastic worlds, he strings timelines together threading edges of media, stunning appearance, vivid visions, and living fashion. Indeed, the early 1980s were "Hollywood," as Doonan pronounces in *Beautiful People*.[116] However, what seemed so promising grew precarious. Meza's future would soon fray in a way that no rope could mend.

Plastic Cinema/Plastic Worlds

Doonan's definitions of beauty are challenged by his elegiac retelling of Meza's illness and the story about his dying. In *Beautiful People*, Doonan mines collections of keepsakes, "boxes of snaps," as he puts it. His queer detrital finds remind him of a time cut short, one accented by wildness,

Figure 2.11. Mundo Meza and Simon Doonan, Maxfield Bleu (1981), 9091 Santa Monica Blvd., Los Angeles, California. Photograph by Elisa Leonelli.

youthful abandon, and Lana Turner impressions at the Fontenoy swimming pool.[117] Sparse photos conjure Doonan's earliest memories of Meza's illness: "When I look at them I think, These were taken the night before our happy, silly, trendy Hollywood lives changed so irrevocably and horribly."[118] After excusing the lump on his friend's throat as an ingrown hair, Doonan confronted Meza's AIDS diagnosis, reminded of an earlier trip to New York where they read about "gay cancer" in the first published report in *New York Native* on May 18, 1981. Meza reportedly told Doonan, "I'll probably get it."[119] As Meza's lover, Jef Huereque remembers, "So few people know how to deal with [AIDS]. It was like, a lot of friends and family, kind of disappeared because it was so unknown, you know? How you caught it, how it was transferred and stuff. Anyways, so I kind of financially nosedived taking care of him, but it's something I had to do."[120] With Huereque, Meza moved to the Brewery arts colony, a renovated Edison Electric steam engine plant in downtown LA and again, found himself on the edges of the city. Like Huereque, Doonan also felt the urgency of the moment and responded

to Meza's terminal diagnosis by investing any remuneration he received from his design work in Meza. The Reagan administration's refusal to publicly address AIDS was something Doonan could not tolerate, and it motivated an unexpected commercial opportunity on the set of *Beverly Hills Cop* (1984).[121]

Starring Eddie Murphy as a streetwise rule-breaking cop investigating the murder of a childhood friend by a ring of drug-dealers masquerading as art brokers, the action-comedy catapulted the comic to hyper-stardom and made *Beverly Hills Cop* one of the top grossing films of the 1980s. Murphy solidified a commercially successful franchise and onscreen identity as "the quick, supple ghetto adventurer living on his smarts."[122] Yet this rogue cop image was contrasted with the derisive yet familiar "sissy" archetype central to Vito Russo's classic film nomenclature of gay representation, "signal[ing] a rank betrayal of the myth of male superiority" in Hollywood film.[123] Flamboyant clowns appear throughout the film, including Murphy's impression of a lisping herpes-infected "friend" of an art dealer named Ramón, Steven Berkoff's portrayal of a slinky venomous art aesthete, and Bronson Pinchot's turn as a swishy gallerist named Serge who speaks in "a Mexican accent as impenetrably thick as the jungles of Yucatán."[124] Although briefly featured, Serge's scene-stealing persona has an equally eye-catching gallery to match, courtesy of designer Simon Doonan.

In the film, the Beverly Hills gallery is a key setting for Foley. His streetwise bravado is a stark contrast to the lavish art world. A kinetic pop sculpture centers the room and is used as a comical gag, a representation of the art market, a condemnation of superfluous art collectors, and exaggeration of Beverly Hills decadent lifestyles. After all, Serge sells a piece for $130,000, to which Foley replies in exasperated disbelief, "Get the fuck outta here," presumably speaking on behalf of the viewing audience as well.[125] Although the film embellishes the "art boom" that characterized the 1980s, *Beverly Hills Cop* also presents an LA art scene populated with racially and sexually transgressive immigrants, "who work in ritzy boutiques and sound as if they could be anything from Middle Eastern to Russian," as one *LA Times* reviewer notes.[126] Serge encapsulates this exotic archetype using an accent that sounds "a little Israeli, a little Arabic and a little something from Pluto."[127] Exuding a

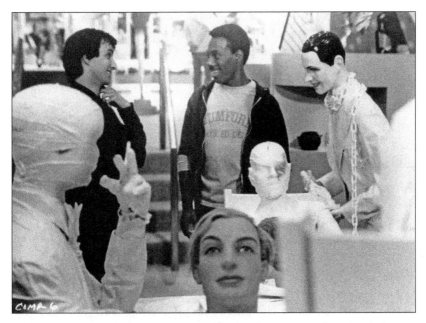

Figure 2.12. Simon Doonan (set designer), *Beverly Hills Cop* Art Gallery (1984); from left to right: Bronson Pinchot (Serge) and Eddie Murphy (Axel Foley).

cross-ethnic queer ambiance, the gallery, a bizarre and embarrassingly decadent art space, prompts Murphy's iconic laughter.

However, his urban wisecracking is subtly undone by the racial contours of the installation. A modish dining room table centers the gallery and holds a mummified court of patricians wrapped in layers of gauze and brandishing white formal wear. Vibrant accents of aerosol spray paint offset the achromatic table settings with fluorescent hues. Dismembered plastic heads rotate along the tabletop, perhaps a self-referential citation to the beheaded mannequin crushed beneath the fashionable stoning staged at Maxfield windows in 1980 (see figure 2.3). A genteel butler appears over Foley's right shoulder, holding a bottle of champagne to satiate the thirst of cannibalizing autocrats (see figure 2.12). The servant, his neck shackled by rings of white chain, occupies the margins of the shot. Director Martin Best's framing is curious, creating tonal contrasts between Murphy's black body and the pale backdrop.

Pictured within a racialized semiotics of what Kirk Savage calls an "iconography of abjection . . . [in] the familiar abolitionist image of the black man in chains," Foley is visually circumscribed against a sculptural vocabulary of slave pasts, a trace of the contemporary art world's pervasive whiteness in the materiality of Beverly Hills in the present.[128] While the mannequin is adorned in white suit and tails, the looping chain remains a pernicious accessory. His styling is a ghastly citation, signifying a contentious history of enslavement—a disturbing enunciation had it not also been masquerading as pop-art kinetic sculpture and sight gag.

However, these plastic actors are no ordinary tribute to contemporary artists such as George Segal with his haunting plaster sculptures and casts of human likeness. A closer look at the installation reveals that the butler in tails is repurposed from Maxfield's mannequin storeroom. Doonan's choice was a personal one, citing a plastic actor consequential to his past collaborations with Meza and central to the young artist's creative repertoire. He and Meza cycle through these recurrent plastic players and generate more than four hundred windows during their tenure.[129] However, Meza favored this particular mannequin, who reappears in different collaborative tableaus including as a mural-influenced window backdrop and Mexican matador frozen in a bullfight (see figures 2.6 and 2.13).

The reconsideration and revisitation of this particular figure in Doonan's set design is in effect an archival space for Meza and quite possibility a reference to Mexicanness. Ultimately, what surrounds Murphy are not extravagant sets designed as punch lines about the Beverly Hills' gallery system, but a carefully codified requiem about Meza and AIDS outbreak. Too sick to share in another Hollywood adventure with Doonan, Meza appears through this particular mannequin approximation. By returning Meza to a symbol of his creativity and stand in for the Mexican bullfighter, Doonan inters him in a visual field of the *torero*, the fighter who must survive the bull's onslaught at any cost. On this movie set, the plastic substitute once again occupies the margins of the motion picture screen, becoming one more "bit part" in Hollywood film. Around that bizarre and extravagant mise-en-scène, Doonan's mannequin recalls a life and death in the symbolic language of the window dresser. With trimmings harvested from the source of Meza's creative powers—retail—Doonan exchanges the gold rope for a monochrome chain. And so, what binds

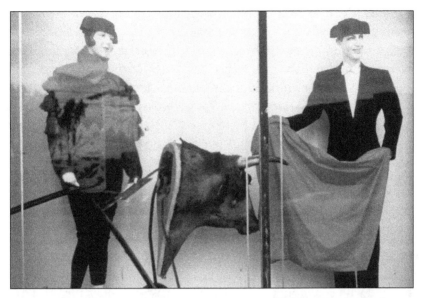

Figure 2.13. Mundo Meza and Simon Doonan, Mexican Bullfighter Window (early 1980s), Maxfield Bleu. Photograph courtesy of Simon Doonan and Sara Schneider.

the mannequin on the set is no ornament, but rather, a shackle anchoring Meza to the failures of the political establishment in refusing to address this disease and, quite possibly, binding reminders of his friend to film.

By remembering Meza in mannequin prosthesis, Doonan gives plastic flesh to the alarming reality that the pair experiences from the isolating corners of Meza's self-quarantine at the edges of the city and the forfeiture of future work together. Doonan's set design represents art gallery extravagance, and yet, it simultaneously stewards Meza through the visual logics of window dressing and, once again, recapitulates the powerful discretion of the glimpse. Doonan's custodial practice illuminates another alternative archival form, using the storefront to engage memory and withstand AIDS's power of dissolution. His practice, thus, establishes the archival possibility of window display in a way realized by AIDS art activists' years later.

Consider the mixed-media installation *Let the Record Show . . .* (1987), a collaboration of ACT-UP, Silence = Death collective, and Gran Fury. Installed in the street-facing windows of the New Museum of Contemporary Art in Manhattan under the curatorial oversight of William

Olander, the display condemns politicians and bureaucrats for their complicit crimes against people dying from the disease with disturbing parallels to the Nuremberg trials.[130] This alarm similarly animates Doonan's intervention as the heads that spin before the shackled servant expose the cannibalizing and gluttonous behaviors of government politicos, pharmaceutical executives, and powerbrokers eating humanity circa 1984. Rather than a rotating tabletop, ACT-UP uses a scrolling LED ticker commanding the public to "Act Up, Fight Back, Fight AIDS." The rolling message crawls under the pink glow of an inverted triangle, which borrows from a retail convention of neon light that evokes the merchandising world.[131] As Silence = Death co-founder Avram Finkelstein recalls, Neon "wasn't simply the commentary on branding I had presumed it might be. . . . It thoughtfully articulated the questions of gender, race, class, and sexual othering situated at the core of the AIDS crisis."[132]

The versatility of window luminosity and its political implications merged with something that writer Simon Watney dubs the "ACT UP lamp shop" on Hudson Street in New York City.[133] Using the power of street display to show "a constantly changing panorama of framed photos, newspaper obituaries, and other mementos of local people who have died of AIDS," these memorial installations convey "etiquettes of mourning" and blur the line between public protest, archival repository, and store merchandising.[134] Although Doonan's Hollywood set design is not a radiant articulation of neon exuberance, his reinvestment in window display's archival possibilities and retail signifiers similarly conveys grief and political urgency in anticipation of ACT-UP's later innovations. However, by using the means of commercial cinema, Doonan is more covert in his intentions rupturing the deafening silence surrounding the disease, mending Meza as a commemorative detail, a plastic remnant, making memory, life (and death) appear on screen if only for a glimpse.

After two months on the *Beverly Hills Cop* set, Doonan accepted his cash commission, which he split with his ailing friend to honor an arrangement existing from their collaborative work together at Maxfield. Although Doonan insisted that Meza use his share to pay for medical procedures or an intensive microbiotic diet to "cure" AIDS, Meza went shopping.[135] He found life-affirming adventures in the luxuriant sanctum of the newly minted Beverly Center, an eight-story fashion paradise

that opened in March of 1982. Even as he battled bouts of pneumonia, he guzzled Thai food, satiating a taste likely garnered from Tommy Tang's in Melrose, and exulted in "the magical, life-affirming power of *shopping*."[136] Their mall adventures trailed off because Meza grew more ill.

Despite Meza's self-seclusion, word of his illness spread. A gift from mannequin historian Marsha Bentley Hale poetically captured Meza's influential yet unsigned signature in the visual merchandising and retail economy stretching across West LA.[137] Her gift, a mannequin's plastic head filled with chocolates, was a harbinger of the impending obliteration of his plastic world. Meza would no longer know "wholeness" in terms of a body of record or coherent art collection. This fragment stood in for what was—a glimpse of an artist torn from the totality of his humanity and lived existence. His search for a future inside the mannequin's core was a sweet indulgence that would empty and become hollow. On February 11, 1985, Meza died at age twenty-nine. With him went pieces of art fractured from an aggregated collection of record. What resulted were different whereabouts for his things taking up the overexposed yet private edges of places including the unexpected corridors of fashion media and reality television.

In the Closet with Chicanx Art

Following its posthumous exhibition at Otis-Parsons in 1985, Meza's collection vanished from public view. As this chapter ruminates, memory of these lost works intensifies the visual and literary sources in which glimpses of his oeuvre remain.[138] Ironically, the sparsity of physical evidence documenting his art and life reveals why commercial media is a critical visual resource for queer detrital analysis and AIDS visual studies. Because of Doonan's celebrity standing, his queer custodial practices inter Meza on a grander scale shaped by national media circuits through an intervention rehearsed decades earlier on a movie set. Looking for Meza in this way redefines the archival body/archival space, redirecting analysis to Doonan's Greenwich Village home and his wardrobe closet, sites attracting media attention from fashion and architectural journalists and yet, traced by AIDS devastation in LA.

On July 1, 2012, *10 Things that Make Me Happy* aired on Bravo TV. In the thirty-minute pilot, furniture designer Jonathan Adler and his

husband, Simon Doonan, grant a behind-the-scenes look at tastemaker lifestyles. By the time this special premieres, the couple's home is already an established destination for fashion disciples. Adler commands an international reputation, having established fifteen US stores (one in London) through his self-titled brand. He has reaped the benefits of fashion celebrity with commissions like the redesign of the Parker Hotel in Palm Springs, California.[139] On his side, Doonan continues to gain prominence in publishing, reality TV, and retail merchandising as Barneys Creative Ambassador.

Before cameras roll, this Greenwich Village home, a renovation of two one-bedroom apartments into a 2,500 square foot abode, is the focus of a *New York Times Magazine* story about stylish décor. Blending a window dresser's penchant for visual stimuli and a potter's proclivity for curios, the interior is what reporter Pilar Viladas describes as "bohemian-preppy glamour with a touch of kitsch."[140] A "monument to their talent," the domestic space personifies Adler's design mantra: "decorating for the way you live."[141] An accompanying photo shoot captures the couple seated next to each other with busts of celebrities and amputated mannequin heads accenting their surroundings and even their laps. The prominence of these fragments illustrates a domestic art of excision, an investment in the fractures and discards that Meza perfected in his short life, rendering parceled mannequin parts into wonderous window tableaus. Such anatomic reminders appear to quote Doonan's time in California. Plastic heads are the principal currency at his yard sale in 1985. These achromatic curios litter the lawn. Doonan appears with Huereque and friend, Annie Kelly, amid headless mannequins, busts, bones, statuary, and neo-classical pedestals clustered on tabletops and lying curbside (see figure 2.14). Accepting an apprenticeship with the legendary Diane Vreeland at the Costume Institute at the Met, Doonan left after Meza's memorial show, making this improvisational yard sale his last display in LA.[142] Dealing in a currency of plastic fragments as the pages of the *New York Times* confirm decades later, Doonan remains conversant in a language of the damaged and discarded. He embraces the bit part, caring for something that cannot be mended. Photographed in this way, the couple makes a home in a playland of mannequin remainders.

Adler correlated this experimental domestic expression with art and living in a September 2013 interview with *Lonny Magazine*. "I make

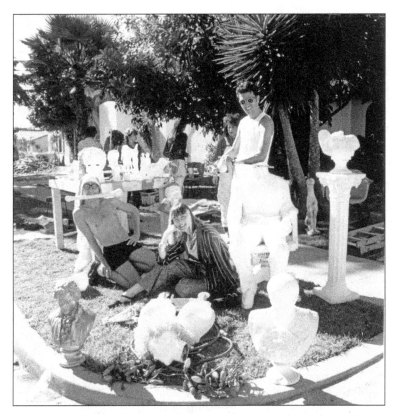

Figure 2.14. Simon Doonan's yard sale, Los Angeles (1985); form left to right: Simon Doonan, Annie Kelly, and Jef Huereque. Photograph by Tim Street-Porter. © Tim Street-Porter.

things consistently and am always bringing new stuff in to road test," he said. "It's sort of like apartment-slash-laboratory-slash-installation space."[143] The home's malleability is evident in the Bravo TV pilot, which features brief vignettes of "happy things," a playful yet not entirely dis-creet game of commercial product placement. Fielding through his daily penchant for prosciutto pizza, Gap skinny jeans, and an Amazon.com Nook reader, Adler also delights in his husband's extensive collection of floral print shirts imported from Liberty of London, something he compares to "Mod Western Victoriana."[144]

A continuous edit turns to Doonan, who greets the camera with a charming, "Hello!" as he comes out from his designer closet.[145] The

tongue-in-cheek transition is fitting for the fashionista with his penchant for sarcasm and puns. The scene forages into the stylist's grandiose storeroom adorned in scalloped hexagonal foil wallpaper, a proper mod atmosphere for a "groovy" collection of 2,961 shirts, a fact he confesses with cheeky indifference. As he flounces before the camera in a pseudo-runway walk and shows off his "charming meadow" of flowery textiles, a collection of artwork offsets the luminous surface opposite the towering racks of floral fabric.[146] Shown for mere seconds over his right shoulder, the art display sets a curious tone for the couple's extravagant surroundings. Inside the window dresser's inner sanctum, a space critical to the fashionista's "overdressed trendiness," *Portrait Study* appears.[147] Unseen since its exhibition in Meza's memorial show, its return thirty years later occupies brief moments of screen time.

Cornered, the work's reappears in a May 2014 issue of *House Beautiful* magazine featuring "tastemakers'" designer closets, which takes a more concerted look inside Doonan's fashion cavity.[148] Hanging opposite racks of clothes, *Portrait Study* animates what Henry Urbach calls "a linguistic and material network of representations that organize the relation between storage and display, secrecy and disclosure."[149] "Closeted" in the permeable structure of the home, Chicanx art negotiates a tenuous dichotomy of exposure/disclosure, robe/disrobe, and conceal/reveal. Doonan's reflections about his closet in *House Beautiful* suggest the intimacy activating his surrounds: "I keep sentimental photos inside so I can see them every day."[150] While his assertion about photography is not entirely accurate—*Portrait Study* is an acrylic painting on paper—the sentiment of Meza's placement within the designer closet encloses this Chicanx artwork with a reminder of the vastly influential young artist whose AIDS-related death lingers in a semi-public/semi-private space that cannot be permanently closed.

Doonan's closet display perceptually "touches" him in the intimate folds of clothing and the daily practice of (un)dressing. Orchestrating "material forms [which] create very different embodied experiences of images and very different affective tones or theatres of consumption," as Elizabeth Edwards and Janice Hart argue, Doonan uses the window of television to reimagine a different face for AIDS and alters the terms of its consumption through ocular obstruction.[151] *Portrait Study* confronts us as an incidental sight, an unsatisfactory glimpse, one omitted from its

place among early AIDS visual representations, which mainly privileged an Anglo male visual corpus, predicated on Keith Haring's barking dogs, Robert Mapplethorpe's flowers, and David Wojnarowicz's fulminations. Meza's alternative archival form consists of jagged edges, obstructed visions, trailing scraps. It is fitting that Doonan re-members him in queer detrital terms: in the corner of his closet, in texts with unattributed yet commemorative origins, in the attachments to plastic bits plotted around his home much like those discards sold curbside on a Hollywood street corner in 1985. Meza's art remnant from this period recirculates again as a familiar calling card, in the form of an artwork that once announced his death on gallery ephemera over thirty years prior. Doonan's media-directed queer custodial practice demonstrates that there are different kinds of queer knowledges to be acquired in the closet. As the return of *Portrait Study* reveals, there is much to be learned from a "bit part." Returned to this inner sanctum of British glamour, Meza is interred in a field of floral textiles where he performs a critical link to a queer Chicanx avant-garde past at the cutting edge of the home space in the present. What escaped Meza in life, no longer escapes him in death as his distorted visage shuns the terms of unburdened visibility to take shelter among the "things that make me happy."

Finding AIDS in a designer closet in the West Village demonstrates the unexpected movements of queer detritus. Escaping the bounds of the institutional archive and the regional barriers of Southern California, Meza's artwork and the obscurity surrounding its whereabouts had consequence for other queer Chicanx artists facing the dire reality of AIDS in the 1980s. As chapter 3 details, the aftermath of Meza's death set into motion a series of efforts by artists facing archival disassembly in other ways. For Teddy Sandoval and Paul Polubinskas, alternative archival interventions were generated around the unusual sediments of dust, sand, and ash.

3

A Roll/Role of the Dice

The Butch Gardens and Queer Guardians of Teddy Sandoval

Gold balloons, lively crowds, and ambient mariachi music filled a Los Angeles neighborhood on April 28, 2003, as local residents celebrated the dedication of the *Gateway to Highland Park* (1994–2003), a new Metro Transit Authority (MTA) station ten years in the making (see figure 3.1).[1] Connecting commuters in nearby Pasadena to the dense financial district of downtown LA, this stop at the feet of a historic LA landmark, the Southwest Museum, represented a momentous occasion not only for local residents but also for public art. A $700 million triumph of urban planning, civic engineering, and political power was equally a triumph for one of its commissioned artists, Teddy Sandoval.[2]

He earned a Spirit of the Southwest Award for his "outstanding contributions to the Southwest Museum Metro Station," a County of Los Angeles Commendation on April 26, 2003, and a City of Los Angeles Certificate of Appreciation.[3] Sandoval, however, was not there to receive these accolades. He had already passed away from AIDS-related complications at the age of forty-five. A resolution in "Memory of Teddy Sandoval" from the Los Angeles City Council on June 7, 1996, confronted this loss, stating that "his station design would become a monument to Highland Park."[4] The city thus celebrated Sandoval's career-defining accomplishment, which almost did not come to pass.

More than creating a future monument for the city, Sandoval's public art piece was enmeshed in the memorializing entanglements of a national health crisis. While he was presented with a unique opportunity to take his ceramic art practice and envision large-scale fabrications with skillful proportion, his death nearly upended a vision born from a Highland Park kitchen window where he glazed his pots and gazed upon the landmark Southwest Museum, LA's first museum.[5] Government bureaucracy and political obstacles threatened to compromise a design concept

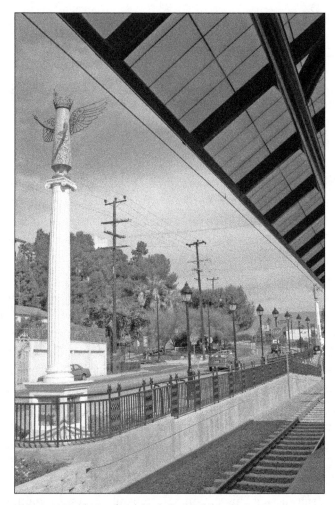

Figure 3.1. Teddy Sandoval (with Paul Polubinskas), *Gateway to Highland Park* (2003), Southwest Museum Station, MTA Gold Line, Los Angeles, California. Estate of Teddy Sandoval/Paul Polubinskas.

approved before his death. The Gateway design is profoundly historical and self-referential, and it discursively codes epidemiological meaning. Embedded in it are recordings synthesizing queer, ethnic, and colonial pasts foundational to Highland Park, a neighborhood rich in Native California history, art and craft design, and Chicanx public art.

Understanding Sandoval's alternative archival formation requires what Ricardo Punzalan terms a "dispersion narrative."[6] Rather than understand Sandoval's body of record in its wholeness and singular location, we look at evidence that "captur[es] the complex and layered paths of dispersion [that] present profound challenges in any attempts at consolidation."[7] Taking this case study's scatterings as a point of entry, I survey archival spaces ranging from Highland Park to Sandoval and Polubinskas' former house on Phillips Way, from the Southwest Museum to a home in Palm Springs. In this way, city and desert combine, demanding a more nuanced understanding of the way Sandoval's archival body/archival space organizes different subterranean grounds outside traditional preservationist controls. Like detrital castoffs, these ceramic pieces reside in artist Joey Terrill's kitchen cabinets in downtown LA. In nearby Montecito Heights, therapist John Ruggles ceremoniously drinks from a coffee mug bearing his own portrait inscribed "for my John" in Sandoval's handwriting dated 1976.[8] A ceramic plate and ornate candlestick occupy the tabletop of Chicanx art collectors' Charles and Martha Abeytia Canales's home in Alhambra, California.[9] Pieces of an oeuvre move across queer domestic environments and private circuits of exchange, and thus, the terms of AIDS memorialization broaden.

In this chapter, I first illuminate the public lexicon of AIDS art memory that Sandoval's partner, Paul Polubinskas, confronted in the immediate aftermath of the artist's death. While activities like the NAMES Project AIDS Memorial Quilt "inspir[ed] the production of cultural memory, the sharing of personal memories to establish a collectivity," the introduction of effective HIV anti-retroviral drug therapy shifted the public arts field and demanded new modes of memorialization in what Paul Butler calls a "future Post-AIDS discourse."[10] For queers of color, however, new HIV infections are hardly "Post-AIDS" and are still being felt acutely. I suggest how Sandoval's *Gateway to Highland Park* advances Latinx AIDS memorial expression at this transformative juncture and in this biomedical context.

More than this, I foreground an archival elicitation activity with Polubinskas, whose private collection represents a custodial intervention protecting Sandoval's irrefutable mark in dual domestic and urban landscapes. Through dispersed sites networked around containers of desire—cabinetry, tabletops, and cardboard boxes—glimmers of Sandoval's

queer Chicano avant-garde practice emerge. In renegade queer graffiti, pictures of macho mirages, mail art personae, and transgender fictions of self, Sandoval is a forerunner of queer cultural currents that span protozoic avant-gardes ranging from the minor, such as the Escandalosa Circle, to the institutionally anointed, such as Asco. His remnants reveal a considerable corpus of creative work generated around gender and sexual transgression in post-1960s LA.

By discerning the way Sandoval confronts AIDS with a visual vocabulary indebted to his early experimentations, Polubinskas orchestrates an alternative archive that plots the landscape with pieces of his deceased partner's archival body. Touches of Sandoval appear in the monumental authority of public art, in the travels of ceramic objects, and in the power of what I term "artifactual performance." Clearly, *Gateway* is more than a monument in tribute of a historic museum. It is a daring entry into LA civic arts—a queer of color innovation about colonialism, sexual risk, HIV transmission and the city's first Chicanx AIDS memorial. For passengers commuting on the gold line, this gateway was anything but ordinary.

Written in Fabric/Written in Stone

After Sandoval passed away on December 18, 1995, Polubinskas—an accountant by profession who handled all of his partner's business affairs—confronted what Christopher Castiglia and Christopher Reed call the "conflicted relations to visibility in the era after AIDS."[11] Spatial forms of remembrance through community-affirming gay and lesbian monument projects of the 1970s were interrupted because of stigmatizing discourses of gay men as "AIDS carriers" and because incipient deaths were too difficult to look back on.[12] The resultant "crisis of memory" as they put it, "call[ed] for a pulling back from spatial visibility."[13] In spite of advances in HIV treatment, public historians and cultural heritage personnel faced a quandary: How do we remember AIDS when its post-traumatic aftermath was "not yet over?"[14] Protease inhibitors delayed the virus's progress and helped to create the first geriatric generation of seropositive individuals. Polubinskas, however, grieved as others had before him: through the NAMES project. The AIDS quilt memorialized the dead on a national scale with handcrafted lamentations.[15]

A project with nearly mythological beginnings, the quilt's origins date to a rally on November 27, 1985, in memory of slain civil rights leader Harvey Milk and Mayor George Moscone.[16] Myriad placards naming the dead were taped to the façade of a government building, resembling a stitched patchwork. As "the wind and rain tore some of the cardboard names loose," San Francisco gay activist Cleve Jones saw "evidence of the human loss of the AIDS epidemic. . . . The majority of gay men who have died of AIDS have been cremated, their ashes scattered. They leave no headstone or physical trace. The AIDS Quilt is the sole testament to their names and their existence."[17]

A three-by-six-foot cloth pallet, the size of a grave plot, gave quilters the blank canvas to sew "would be bits and pieces of a world."[18] Constructed of personal belongings, souvenirs, and cremated ashes, panels became stand-ins for the deceased. Scraps "echoing the body that once filled them" created presence and conversely "restore[d] to the dead the intimate worlds they had lost" with profound meaning for the viewer.[19] Embellished with material accouterments, these "surrogate graveyards" signified in a different way than permanent monuments such as those dominating the national landscape of Washington, DC.[20]

Juxtaposed against palatial white marble sculptures when the NAMES project was rolled out on the National Mall in 1987, the AIDS quilt undermined the authoritative aesthetics of monuments carved from stone.[21] Without requisite models to remember a plague, Jones transformed a commemorative lexicon traditionally venerating national leaders, wars, and historic places through nineteenth-century sewing circles, whereby quilters removed craftworks from the province of the home and translated them in ways unifying publics around shared grief and politics.[22] Doing away with the individual artistic style so prominent in public artworks, the quilt further challenged the terms of memorialization by making the dead and not the artist essential to the viewing experience.[23]

Consider Simon Doonan's quilt for his ex-lover and artistic collaborator, Mundo Meza, as discussed in the previous chapter. In a 2016 Slate.com article excoriating the recently departed First Lady Nancy Reagan for her ineptitude during the height of the AIDS outbreak, Doonan highlighted an illustrative snapshot from that period to complement his criticism.[24] Pictured on the National Mall following the debut of

the NAMES project in October 1987, Doonan kneels next to Meza's fabric swath, his mournful countenance emoting what Charles E. Morris calls an "exhibition of mnemonic world making," a "dialectic and politics of remembering and forgetting . . . [which] raises critical issues of visibility, legitimation, authority and their material privileges and impoverishments."[25] Doonan wears the AIDS activist moniker "SILENCE = DEATH" on a T-shirt, modeling the militant text of the radical collective ACT-UP (or AIDS Coalition to Unleash Power) and its creative auxiliary groups, Silence = Death collective, and Gran Fury. The pink triangle hints at an emerging political consciousness that Doonan initially described as "fatalist," although it simultaneously signified a record of his desires.[26] The quilt puts his erotic life into sharp relief as he experiences his past relationship with Meza and his current one with Avram Finkelstein, the artist credited with designing the logo brandished on Doonan's chest.

His pose suggests a pessimistic turn toward the camera. Doonan's look and activist self-fashioning linger with a textual and audible power, alluding to the chants that Meza could not scream, having died two years before ACT-UP's founding. The rallying cry, "ACT UP, Fight Back, Fight AIDS" traces the shirt making the snapshot a sartorial convoy to fashion's activist voice. By surpassing how traditional civic monuments "commemorat[e] the memorable and embody the myths of beginnings," Meza's internment betrays the illusion of passive silence.[27] In the adjoining panels of Anglophone names, the quilt's pervasive whiteness performs another kind of catharsis for the Slate.com viewer. The juxtaposition of Meza's Hispanophone name with Meso-American pictographic symbols interrupts the memory field and creates another type of readership, one that must contend with his ethnoracial legibility in cloth. Doonan's relationship to the quilt in fashion, creative expression, and even political performance shifts passive "conversations with the dead" to a more polyphonic audibility. His is a transmutable reading at the conjunction of fabric, text, and activist ambience.[28]

Of course, Doonan's snapshot details an earlier period of AIDS commemoration, a time when turning to monuments in queer public heritage was hard to imagine. Doing so would suggest that not only had the virus been defeated but also that the crisis was remembered so it could be forgotten. Any monumental expression for this plague sharply

contrasted with what David Román observed of AIDS: "While certainly different from before, [AIDS] is not yet over."[29] His perception of AIDS's omnipresence in our contemporary moment offsets what Paul Butler conceived as "future post-AIDS discourse" whereby "the ephemeral nature of the quilt makes it different from other potential forms of memorial and, at least on a certain level, calls into question its effectiveness as a permanent site of mourning and memory."[30] Butler's drive to make AIDS remembrance more "effective" amid what Christopher Castiglia and Christopher Reed term "the de-generational unremembering of a diseased lifestyle connected to a shameful history" explains a complex and rather contradictory investment in monuments that serve queer cultural recall.[31] Tangible public memory sites under Butler's purview suggest ways that an AIDS future must be cast in more permanent terms.

What this public heritage discourse elides are the ways in which Chicanx and Latinx artists, in particular, were already negotiating AIDS mnemonic worlds, material remainders, opening gateways to shared grief like the one performed by Doonan's mournful kneeling at Meza's quilt. Consider how VIVA, the first lesbian and gay Latino artist organization in Los Angeles, refashioned the Mexican American home altar. Created in memory of artist and ceramicist Julio Ugay in 1991, the installation on the steps of the Social and Public Art Resource Center (or SPARC) in Venice, California, an organization of critical importance to LA's Chicanx mural movement under the helm of Judith Baca, underscores queer Chicanxs public/private negotiations of a plague.[32] Personal details like food, condoms, and a La Virgen de Guadalupe figurine sculpted from corn *hojas* (husks) memorialize Ugay (see figure 3.2). Xerox flyers of his obituary wallpaper the backdrop of the installation, showing how domestic arts practice were combined with AIDS activism to create gateways to the divine. These practices reappear in Samuel Rodriguez's *Your Denim Shirt*, where the windowsill altar is shadowed by an elusive spectre (see introduction). Observing this phenomenon in San Francisco's Mission District since 1984, Cary Cordova argues that El Dia de los Muertos traditions like *ofrendas* "became a powerful medium to mourn, as well as to demand activism."[33]

Since the early 1980s, before the NAMES project was formed, Chicanx creative communities have found ways to negotiate AIDS loss from

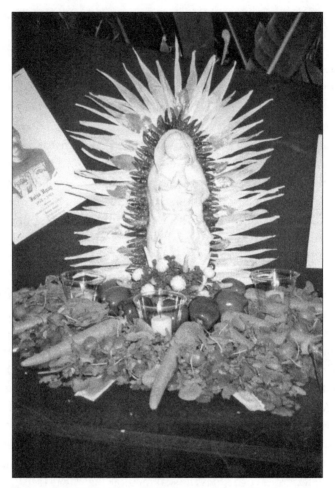

Figure 3.2. VIVA: Lesbian and Gay Latino Artists of Los Angeles, altar installation in memory of Julio Ugay, Venice, California (June 19, 1993). Photograph by Mike Moreno.

a barrio perspective, to render testimonial portraits of the disease, to make the virus tangible, and to think through the itinerant possibility of memorial expression in impressive assemblages of visual, textual, and artifactual remains. As we will see, Sandoval's *Gateway to Highland Park* was at the cusp of these intersections working between material and spiritual worlds.

Walls That Speak

Understanding Sandoval's archival body/archival space in its dispersion requires unfettering two disparate but interlinked sites: Palm Springs and LA urban landscape. These ceramic trails reveal complex networks of object exchange and vernacular preservation practices shaped by AIDS decimation. Through an "archive elicitation" collection-based activity filmed on camera, Polubinskas surveys Sandoval's oeuvre for me as it is articulated in the home site. The walls of Polubinskas's Palm Springs house form the initial grounds of Sandoval's interment. Navigating the domestic environment, Polubinskas's overview of the teal-tinted walls augment the serigraphs by Carlos Almaraz and paintings by Roberto Gil de Montes and Patssi Valdez adorning the interior. These framed works are interspersed with other acquisitions. A treasured pencil study of a male nude by gay American modernist Paul Cadmus hangs above a China cabinet in the dining area. Sandoval, Polubinskas shares, bartered for this nude with a client for Artquake, the lucrative wall glazing and interior design business the couple ran in the late 1980s. In exchange for the Cadmus, Sandoval painted a wall-length marble façade.[34] He perfected other artistic effects as well: Venetian crackle, faux leather, brick-and-mortar treatments. Aged patinas and textured varnishes were drawn from his extensive practice in pottery and glazing, which he also used to resurface his paintings.

Sandoval's ceramic touches are found throughout the house, from the Bob Mizer–inspired physique stencils frosted on the patio doors to the *puto* (Spanish slang for "faggot") mug on the dining room table. The latter reveals Sandoval's wicked sarcasm, a daring entry from an earlier time and recalling his previous documentary photography of puto graffiti on derelict East LA's façades (see chapter 1). The offensive text annotates his ceramics and even set designs for fashion shoots. Sandoval's puto imaginary is consistent with previous collaborations in *The Maricón Series*, which conceptualized abject masculinity through portrait exercises and T-shirts handcrafted by Joey Terrill in 1975 and 1976. Sandoval adds a queer icon of machista aggression within the decorative art register, "queering the homeboy aesthetic" as Richard T. Rodríguez argues, by adopting a "style, circulating within Chicano/Latino gay males spaces, whose visibility emanates from the interplay of materiality

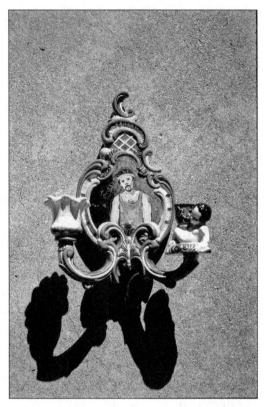

Figure 3.3. Teddy Sandoval (under Artquake), Puto
Candle Wall Sconce (1985), ceramic. Estate of Teddy
Sandoval/Paul Polubinskas.

and fantasy."[35] More than insisting on the stakes of "erotic appeals to
renegade masculinities," as Rodriguez does, Sandoval is interested in the
homeboy's symbolic meaning as a sexually nonconforming motif threat-
ening a heteronormative system of Chicanx imagery in the 1970s.[36]
In the clay medium, the puto is menacing yet fancy, impenetrable yet
fashionable.

Sandoval's puto wares augment a beautifying axiom of precious plates
and delicate dishes. For instance, a regal wall sconce touts an ostenta-
tious baroque revivalist design (see figure 3.3). An East LA homeboy is
revered like a courtly aristocrat, an ornament *par excellence*. Festooned
with decorative scrolls and blossoming flora and fauna, the wall relief

remakes a portly cherub with greased black hair into a suitable companion for a queer homeboy. The sconce is a consummate entry into Sandoval's "barrio baroque" register, a style of wares infusing a lavish eighteenth-century European aesthetic with a Chicanx urban sensibility.[37] A spin on what Tomás Ybarra-Frausto calls "muy rasquache," or high rasquache as explained in the introduction, a style of improvisation that is "brash and hybrid, sending shudders through the ranks of the elite who seek solace in less exuberant, more muted, and purer traditions."[38] Because of their limited production and elaborate construction, puto ceramics must be cautiously treated, placed in wall brackets or glass encasings in the Palm Springs home space. Ironically, the mug's use and reuse accents a morning routine with daily reminders of Sandoval and his iconic archetypes.

Surveying the interior of his home, Polubinskas explains, "I use these pieces in day-to-day living, and these are the ones that I seem to use the most for whatever reason, personal preference. Or when I have people over and we are having cocktails, it would be really nice to have a beautiful one of a kind piece out that's extremely fragile."[39] "But," he warns, "you're one martini away from a broken ceramic in the garden."[40] Sarcastically played, his offhand remark is quite telling. The "broken ceramic in the garden" is no exaggeration (see figure 3.4).[41] Shards from pottery slip-ups or kiln miscalculations were repurposed in the backyard of the house on Phillips Way. The cracks and fractures of ceramic failure queered a garden ecology, reshaping the chemistry of broken objects with the organic materiality of dirt and cacti growing around and through them. Curios posed among cinderblocks. Vases flanked boulders. Winged anthropomorphic figurines topped inverted pots like miniature monuments emulating a prototype for the towering guardians over Sandoval's *Gateway to Highland Park*.

More than decoration, the ceramic graveyard is "plant matter," as Greg Youmans argues, modeling "a philosophy of queer history that asks us to look as closely at unorthodox objects, in this case plants, as we do at papers, but also to treat them differently, creatively."[42] An unorthodox constellation of soil, rock, and ceramic fragments coalesces in an alternative archival formation in the backyard. Strewn with Sandoval's remains, this archival field documents ceramic failure and becomes dead space. This deathly zone intensifies when we consider that Sandoval passed away

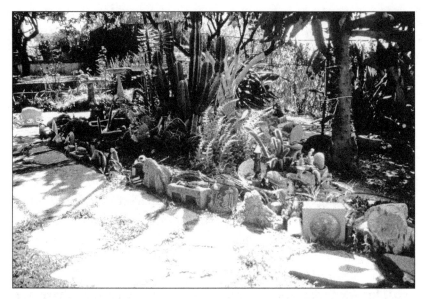

Figure 3.4. Photograph of the ceramic graveyard (2003), Home of Teddy Sandoval and Paul Polubinskas, Highland Park, Los Angeles, California. Estate of Teddy Sandoval/ Paul Polubinskas.

in this backyard in 1995. Some of his ashes symbolically returned to the origins of their making—clay, sand, dirt, and ash. The backyard at Phillips Way is an insightful archival formation, a microcosm of miniature monuments linked to questions of mortality, chance, risk and rebirth. As we will see, these philosophical and existential questions grew more urgent after Sandoval's HIV diagnosis in 1992.

In creating the ceramic graveyard, Sandoval and Polubinskas work in AIDS memorial idioms on a small scale, much like the "painted stones" remembering AIDS in "carefully tended little gardens" at the edges of Chicago's gay beach in Lake Michigan.[43] These miniature commemorations are not limited to the backyard as they surpass the exterior and plot the home where Polubinskas carefully holds pieces of Sandoval close, weary of the lessons from the ceramic graveyard. He is quite aware of the possible destruction wrought by a careless houseguest or the inebriated sleight of hand. The decorative art objects walk an uneasy fault line, testing fate.

Sandoval's ceramics circumvent an institutional approach based on museum principles of ownership and registry. Instead, they circulate in more personalized spaces of care. Some pieces were returnd to Polubinskas in mournful acts of custodial repatriation. These included gold-leaf candlesticks from one of Polubinskas's former clients, which were placed on the glass dining room tabletop like micro pillars, supporting what Jennifer A. González calls a "representation of memory and identity tak[ing] place in the physical sites of domestic and other private spaces where the gathering of artifacts becomes a reconstitution of personal and social history."[44] Unlike González's artifacts, however, these small-scale memory landscapes migrate from one custodian to another. Pieces stand in for Sandoval as networks coagulate in a ceramic register suggesting another way AIDS trauma coalesces in place. These stewards enact correctives to absence and deal with loss through intimate forms of exchange.

During the archive elicitation activity performed on camera, Polubinskas's close friend and fellow Palm Springs resident Greg Kott visits.[45] Polubinskas has loaned some of Sandoval's framed works on paper to Kott, who in return has supplemented Polubinskas's home with pieces from his own small collection of Sandoval artwork. Off screen, Kott notices the display of *Chili Chaps* (1978–1984) in the study, which had been borrowed from him (see figure 3.5). Sandoval's low-relief cardboard wall sculpture is mounted inside a plexiglass shadow box. The paper is embroidered with pinto beans and patches of kitschy siesta-taking hombres and saguaro cacti. Ceramic Serrano chilies imbue the black faux-leathery surface, combining a spicy gestalt with southwestern stylized home décor. Art historian Holly Barnet-Sanchez further notes that Sandoval "plays on the multiple and macho US stereotypes of 'cowboys and Indians,' of Mexican *vaqueros* and pejorative references to them in American literature and cinema, topped by playful and pointed allusions to homo-sociality and homosexuality."[46] Whereas "topped" is a curious choice of words, Barnet-Sanchez's observations accurately describe Sandoval's oscillation between cinematic references to clichés of American Southwest to the gay desires provoked in a pop-art milieu. His mass-media referents are comparable to Andy Warhol's commercial cowboys—none more iconic than Elvis's turn as a gun-slinging sex icon in *Double Elvis* (1963), which debuted not in New York City but

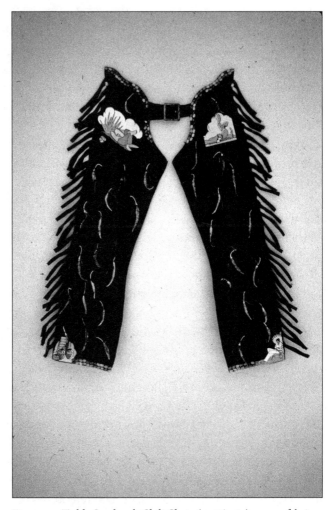

Figure 3.5. Teddy Sandoval, *Chili Chaps* (1978/1984), paper, fabric, ceramic, and pinto beans. Estate of Teddy Sandoval/Paul Polubinskas.

at Walter Hopps' Ferris Gallery in Los Angeles.[47] Sandoval's attentions instill this rugged icon with queer racialized nuance. The resulting infusion of spaghetti westerns, *traje vaquero* (Mexican cowboy regalia), and macho clones in "butch costuming and athletic attire" would signal things to come.[48]

Sandoval's *Chili Chaps* gained a level of national recognition when it was exhibited in the "Chicano Art Resistance and Affirmation" exhibition in 1990, the first major national tour for Chicana and Chicano artists of this size and scope.[49] His sly entry covertly integrated queer fetishism into an ethnoracial curatorial framework. Unbeknownst to audiences is the way Sandoval's artistry had been nurtured by urbanism and clandestine approaches to street art. His renegade graffiti from the late 1970s appealed to an erotic penchant for men's fetish gear. Palm trees, flying underwear, and leather chaps were repeatedly painted on derelict buildings in Silverlake, downtown LA, and Long Beach. As John Ruggles recalls, "Over along Rowena [Avenue], there was a white curved wall as I remember it, like maybe eight feet tall? And [Teddy] went in the dead of night and painted those flying underwear all over it. I don't know how long it lasted, you know? Not a long time!"[50] Expeditiously completed in aerosol paint, with Polubinskas driving the getaway car, Sandoval queered the homeboy street placa with a "nasty" homoerotic handle all his own (see figure 3.6).[51]

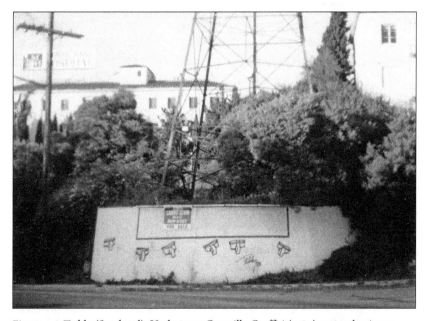

Figure 3.6. Teddy (Sandoval), Underwear Guerrilla Graffiti (1980), aerosol paint on concrete. Estate of Teddy Sandoval/Paul Polubinskas.

Chili Chaps also appeared in the experimental performance *La Historia de Frida Kahlo* (1978) at Los Angeles Contemporary Exhibitions (LACE) in 1978. Embodying the star-crossed love affair of Frida and Diego Rivera, Sandoval and Gronk choreographed an absurd gender fuck tango and dissonant musical reenactment with a show-stopping ostentatious vocal.[52] Theirs was a draggy duet in found fabrics and jeweled accents, replete with Kahlo's signature monobrow. This performance was timely, and, as Rita Gonzalez acknowledges, Chicanx avant-gardists mobilized the modern Mexican painter in queer terms. The celebrity cult of Kahlo was becoming firmly a part of "Chicano artistic consciousness . . . as Gronk and Sandoval staged their own tribute . . . the same year that the Museum of Contemporary Art Chicago organized the first retrospective of Kahlo's work in the United States."[53] Sandoval's *Chili Chaps* performs the backdrop, activating a setting from which to stage their flamboyant debauchery. The *Chaps* are not passive props but rather demand that the viewer consider the macho wearer, a spectral illusion of erotic potential coaxed to fill the fetish wear. In another snapshot taken on the streets of downtown, Harry Gamboa Jr.'s reflection was faintly visible in storefront windows, suggesting his off-camera participation. Thus, Asco members reveled in Sandoval's flamboyance, proving how Chicano avant-garde actors sometimes mingled through more salacious registers of queer expression.

Kott's visit confirms Polubinskas's role as custodian and curator. Polubinskas stresses, "This isn't the museum. If you're going to live with art, then live with it. Don't just look at it. Live with it."[54] In their dialogue, boundaries between walls and custodial responsibilities converge. Polubinskas and Kott open a reconciliatory "contact zone" in art object exchange.[55] Their relationship to Sandoval's artistic record flourishes, refusing to forget him. Seeing *Chili Chaps* in the study, Kott exclaims, "The chaps are great on the wall!" To which, Polubinskas responds, "Thank you for letting me borrow them." Kott retorts, "Well, they're back with you!"[56] Kott's insightful acknowledgment perhaps seconds the repatriated return of Sandoval's candlesticks following his death. Between them an alternative archival arrangement mutually correlates domestic spaces and proves a social response and shared responsibility "[to] live with it."[57] Polubinskas and Kott's lending system circumvents a traditional museum understanding of art collecting as permanent possession.

Instead, they parlay a sense of preservation best practiced in the circuits of gay men and the shared affect over artworks permeating their Palm Springs homes.

Queer Cabinets of Curiosity

Cabinetry represents another significant container of desire for Sandoval's work. Inside the adjoining garage is a wooden flat file elucidating the queer Chicano avant-garde vocabularies he founded and the creative circles to which he belonged. The wood cabinet harbors several pounds of prints, photographs, and ephemera, some crackle-weathered from the smoldering heat of the desert landscape. An archival spatial description demands a consideration of the cabinet itself—engulfed by household clutter, paint cans, and plastic bins. Inside, it holds a vast constellation of material remains and mineral traces, elucidating another creative arrangement of archival body/archival space.

Yellowing paper materials hint at Sandoval's printmaking student days at California State University, Long Beach (CSULB). For him, the studio art department played an important role, parlaying key relationships with emerging Chicanx artist-collaborators, among them Jef Huereque, Marcos Huereque, Gilberto "Magú" Lujan, John Otero, and Jack A. Vargas.[58] There, he formed close friendships with other gay men such as Geoffrey Gratz, Bill Hernandez, and John Ruggles, which proved to be lifelong. CSULB undergraduates from this program responded to these rare yet influential exhibition opportunities for Chicanas and Chicanos in mid-1970s LA with enthusiasm. At the highly lauded *Chicanarte* show at Barnsdall Park in 1975, Sandoval's showing of an intaglio print, *Nude #5 with David* (1975), and mixed-media collage, *Dear Ted* (1975), introduced a provocative homoerotic vocabulary to the mainly Mexican American attendees.[59] Terrill first encountered this artwork here and took note of its unabashed tone as well as the name of the artist brazen enough to exhibit imagery of an engorged phallus: Theodore Sandoval.[60] Exactly twenty years before the day of Sandoval's death, they met at Richard Nieblas's rampageous Escandalosa's Gallery in East LA. That night they formed a friendship that merged Sandoval's queer creative circles from Long Beach with Terrill's group of flamboyant libertines, the Escandalosa Circle (or "Scans" for short) from Highland Park (discussed further in chapter 4).

In the cabinet, pieces of him are coated with sedimentary deposits from the Palm Springs air. The archival body's desert ecology ironically recalls another art practice central to Sandoval's repertoire in the 1970s, something he called, "sand art." Instead of sculptures created beachside, these mixed-media installation works were composed of degrading bags of sand containing miniature works on paper depicting grazing camels, tropical flamingos, and gun-toting cowboys. In small-scale monoprints, male figures tan in swimsuits patterned with miniature chaps imprinted by a rubber stamp. Beach scenes are soiled with granules, giving the surfaces grainy texture.

His early works show not only a regard for the homoerotic mythology of the Western frontier but also a perspectival interest in creating three dimensions for print illustration. Placed behind earthly sediment at the foreground, Sandoval alters the viewer's consumption of flat paper planes. Teasing the boundaries between installation art, printmaking, and collage, he orchestrates fantasy worlds in microcosms of sand. Each bag contains deposits harvested from cruising sites such as Will Rogers State Beach in Santa Monica and 8th Place Palms in Long Beach. Linking sediment with transient male traffic from Navy ships, docks, and cruise liners, his tableaus ossify homoerotic memory, a type of sexual evidence calcified on paper. Sandoval's sand art is queer matter, "a kind of evidence" as José Esteban Muñoz ruminates about expanded "understandings of materiality," which is "interested in following traces, glimmers, residues, and specks of things."[61] Sandoval's queer records archive erotic dalliance in grains. Each bag grounding his desires, fantasy worlds of boys in jockey shorts, swimwear, and cowboy gear.

In the flat file, Sandoval's archival body/archival space is bathed in Palm Springs' desert dust, a queer archival residue coated in "specks of things."[62] Sand in Sandoval's oeuvre necessarily challenges Polubinskas's custodial care by expanding his attention to the finest detail. As a result, he affectionately finds meaning in granules and degrading plastic bags. "He loved sand," Polubinskas says. "He would have loved being out here but he's not, so . . ."[63]

Interspersed in drawers are photographs, one of a handsome, athletic-looking young man. "Who's this kid in the frame?" I asked. "Oh, that's Ron from Ron's Records, my friend from New York," Polubinskas responded.[64] Ron Roth was instrumental in the couple's coincidental first

encounter. Having known Polubinskas through the bar circuit in New York City, Roth invited him to LA when a relationship went bad. Needing a fresh start on the other coast, Polubinskas attended the 1977 Valentine's Day Dance at Circus Disco, where Roth worked as a bartender.[65] Having a handsome bartender as a personal friend had its benefits. Polubinskas's cocktail overconsumption led to a predestined encounter. With the fog of the night's events still in his head, Polubinskas awakened the next morning in Sandoval's bed, which he never left. They were nearly inseparable eighteen years later.[66]

Pieces of Roth pervade the cabinetry in image and artifact. A glossy black and white photograph of him and Veronica Va Voom from Circus Disco is among the paper spill, a keepsake from a time he was named the Emperor of Los Angeles Gay Community at Circus Disco in 1978. He stands proudly in a body-hugging leotard and floor-length red sequin cape like a trapeze performer with Liberace flair. Roth's charismatic smile is charming. His exuberance is contagious, a shard of the sublime. "I have the cape if you want to see it," volunteered Polubinskas. "When the sunlight hits it you're blinded. Ron bequeathed it to me when he died."[67] Physical remnants of Ron reflect the queer social circles to which the couple once belonged.

Inside the closet hang original designer duds from Modern Objects, the men's atelier of Jef Huereque, and shirts from Arnubal, the fashion label of Arnie Araica, a Central American designer and close friend who died from AIDS-related complications in 1993. In this cavity, AIDS decimation is felt in an assortment of fashionable garments from another time, from designers and wearers no longer alive. These clothes second what David Gere observes as a "corporeal fetish" in AIDS choreography wherein empty "clothing serves an intermediary function, an inert replacement for a bodily presence fetishized yet more effectively by the dancer-choreographer himself . . . standing metonymically as they do for the shape and substance of the body."[68] Akin to the shadow cast at the close of Samuel Rodriguez's film *Your Denim Shirt*, clothing haunts with impressions of bodies gone (see introduction).

Roth's cape signifies his critical influence on Sandoval, who extended his art practice into visual merchandising at Ron's Records. Roth's new music store specialized in album trade and rare imports and intermixed art-celebrity with queer sound. When the store expanded from Long

Beach to LA on September 27, 1980, it rented space in a distinctly queer and immigrant corridor in the "new" East Melrose.[69] Flex Bathes, The Zoo, Faultline, Falcon's Lair, and the Ukrainian Cultural Center offered a unique conduit for the music retail house, which benefited from a mixed audience of punkers and cruisy patrons in precoital prelude. Sandoval did not miss these surroundings. An invitation he designed for the shop's grand opening announced an "after hours" party targeting a "21 & over" crowd. With doors opening at 2:30 a.m. "after the bars close," the event accommodated Circus Disco courtesans and Flex bathhouse disciples likely to follow their red-caped gay Emperor. Intuitively, Roth and Sandoval knew their clientele, and they wanted to party.

Producing the commercial graphics, window installations, merchandise displays, and even a promotional float for Long Beach Gay Pride with baseball tees to match, Sandoval was a creative engine devising a stylish gay sensibility for the store. Drawing on the simplicity of asymmetrical lines and patterns redolent of geometric abstraction and the neoconstructivist revival popular in the 1980s, he created a retail look borrowing on the merchandise and its signature sounds. Typography, color palettes, record covers, and vinyl itself fashioned displays, conveying the album's attitude in graphic art renderings and florescent tones.

He rigged increasingly ornate backdrops for artist in-store appearances. His decorative trimmings for the release of Moby Dick Record's up-and-comer, Lisa, included a hot pink high-relief paper sculpture fabricated from promotional posters (see figure 3.7). Sandoval embellished the wall with reproductions of the album cover emphasizing pattern and repetition, a likely import from his Xerox experimentations in mail art and a propensity for postmodern challenges to originality and authorial artistry.

Accents of hearts and phallic rocket ships have sentimentalizing tones, literalizing Lisa's "Rocket to Your Heart" (1983), an techno-infused dance single from her self-titled six-track LP. In hypnotic synthpop tones, she confesses, "I want to love, I want it fast . . . I want to love, dance this night away" in a mantra stoking the emotive registers of lovelorn gay men who consumed her futuristic harmonies on the dance floor.[70] Above her, the wall surface was redrawn with intermingling geometries. A scalene triangle overlaid a rectilinear shape mirroring the advertisements Sandoval established for the store. He responded to the post-disco sound,

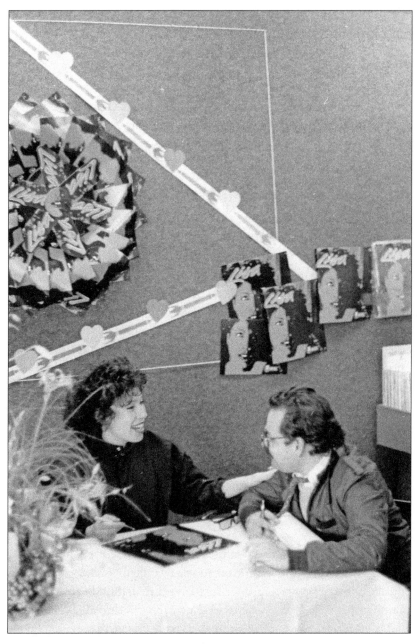

Figure 3.7. Lisa (Fredenthal-Lee) with Teddy Sandoval at Ron's Records Album Signing, Los Angeles, California (ca. 1983). Estate of Teddy Sandoval/Paul Polubinskas.

which influenced everything from his wall signage to props and window design; such ambience became an important sonic resource and audio archive for his gregarious art practices. Lisa was one of the many artists from the independent Bay Area gay music label, Moby Dick Records, who stopped at Ron's Records as part of promotional tours.

Sandoval's practices in window display showed his innovation in male anonymity and macho duplication. For the release of "An American Dream" (1981), a dance single featuring a disco medley of pop cultural western anthems, by another Moby Dick property, Hot Posse, Sandoval painted a backdrop of cowboy clones stenciled onto parcels of paper, revisiting a technique initially used in queer urban street graffiti of underwear and chaps (see figure 3.8). The combination of a stereotypical and mythic story of the American frontier and a contemporary reenvisioning of the disco cowboy is a curious archetype in his oeuvre. Conveyed in black pigment like an elusive shadow, the form is broken down into filmstrips and celluloid parcels littering the window display as a manufactured American replica. Moreover, the cowboy's manifestation signals a "clone" gay male currency of desire. These superfluous masculine types reproduced "macho sign-vehicles as musculature, facial hair, short haircuts, and rugged, functional clothing to express butchness."[71]

An urban wrangler slings a pair of Levi's over a rustic fence propped up in the window's foreground: here, in disrobing the Marlboro man, Sandoval crafts a merchandise display appealing to customers conversant with clone cultural codes. A tease of hypermasculine fantasy, the macho metonym is quite literally a mirage and so, the resultant "macho mirage" comes to the fore and eroticizes the display. The illusory suggestion lures customers in search of not only disco music but also the elusive man behind those blue jeans.

By 1985, with the commercial success of the business, Roth branched out into San Francisco's Castro neighborhood.[72] He brought Sandoval with him to set up shop. The pair took advantage of a burgeoning gay music industry by placing their retail venture distinctly amid a queer soundscape. Bay Area music labels like Moby Dick, Fantasy Records, and Megatone, in particular, produced dance tracks that generated the aptly termed "San Francisco sound," which was deeply indebted to the synthesizer arrangements of Megatone cofounder Patrick Cowley, a DJ and former lighting engineer from City Disco.[73] Cowley's work defined

Figure 3.8. Teddy Sandoval, Hot Posse Window Installation at
Ron's Records Album Signing (ca. 1981). Estate of Teddy Sandoval/
Paul Polubinskas.

a recognizable blend of "up-tempo, high-energy, sexual, drug-friendly,
white and infectious" sounds in a thriving sexual playground. His
dance music pumped through gay clubs, bathhouses, and pornography
soundtracks.[74] Cowley's trendsetting made its way to the East Coast and
became a "rich source of music" at the legendary Saint club in the East
Village in the early 1980s.[75] According to Fire Island DJ Robbie Leslie,

"From 2:00 to 5:00 in the morning, we would play all of these really fast, popular records. . . . They were very masculine and a lot of them came out of San Francisco."[76]

Cowley's synth arrangements revitalized waning disco careers and catapulted a slew of new recording artists onto the Billboard Hot 100 charts. The opportunities presented by independent gay recording studios and queer urban listeners in need of dance records proved irresistible for Roth and Sandoval. By relocating to San Francisco, the pair was bolstered by their unprecedented access to this rising star system and its music sales across coasts.

As I discuss in chapter 2, the creative potency of window display is an overlooked though critical aspect of queer Chicanx artistic expression in the 1980s. Up to this point, Mundo Meza's concerted attention to "shock-theater" mannequin tableaus advanced this aesthetic. Sandoval, too, found expression in these retail forums. However, more than making Ron's Records a visual entity, he also negotiated its sound. His aesthetic thus combined post-disco music and commercial art design with queer innovations in Chicanx avant-garde expressions. Sandoval's greeting cards, suggestively entitled "Hand Jobs," were representative of these image-sound infusions; his creative process was punctuated by sound of the new synth records permeating the store, generated by his state-of-the-art sound design system with reel-to-reel tape player, sound mixer, and dual turntables (see figure 3.9). Given away freely at Ron's Records, "Hand Jobs" edified a "macho mirage" vocabulary through stencils of anonymous leather men, ass-baring party boys, and jockstrap-equipped athletes in a manner evocative of Sandoval's renegade street graffiti. By recirculating the macho under the unusual handle "Butch Gardens School of Art," he extended his reach in new ways amid queer sounds and spaces across LA and the Bay.[77]

Beyond citing a guerrilla public art practice birthed in LA's urban landscape, "Hand Jobs" also quoted a wider conceptual practice predicated on paper and the language of mail art, in particular.[78] A proto-social-media project, mail art connected Sandoval and other queer Chicanx men through avant-garde networks from which alter-egos and fictive personae materialized. Here, Ray Johnson's influence is notable. Drawing on Dada anti-art tendencies, which dematerialized fine

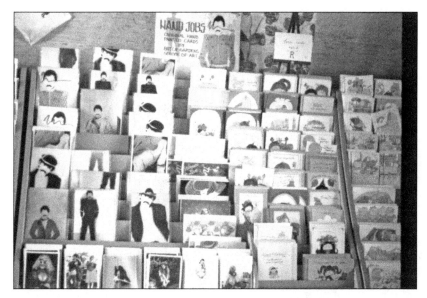

Figure 3.9. Butch Gardens School of Art (Teddy Sandoval), "Hand Jobs" at Ron's Records (early 1980s). Estate of Teddy Sandoval/Paul Polubinskas.

art objects and annihilated formal mechanisms of aesthetic evaluation, he created a mail art network called the "New York Correspondence School." According to Donna Salvo, "Johnson created his own systems of distribution, promotion, and commentary, thus subverting the conventional channels of the gallery and the museum . . . creat[ing] mythical exhibitions at nonexistent galleries that were nevertheless based on factual events."[79] Using the US Postal Service to circulate conceptual works as a networked gallery, mail artists like Johnson performed contrived personas and fictitious organizational monikers in variant mail art expressions: photo-collage, Xerox assemblage, rubber stamp impressions, mass media clippings, and sticker adhesives. As Michael Crane argues, "Some letters and envelopes are used to create fiction, legends, and other attitudes of the mind."[80]

For Sandoval, these "attitudes" stimulated androgynous permutations. His infamous alter ego, Rosa de la Montaña, carried through the post office as an idea, a queer personage, and a drag show on paper. Rosa was a queer iconoclast, a mail art anti-celebrity born from Sandoval's

famed moniker, "Butch Gardens School of Art."[81] Though sometimes called a "bar and performance space operated by Teddy Sandoval . . . [where] emerging Chicano artists and musicians regularly congregated and collaborated," Butch Gardens was not a permanent physical location. More a creative vehicle of Sandoval, the elusive insignia paid homage to the actual gay bar located at 3037 West Sunset Boulevard in Silver Lake. Just as Johnson named his mail art network the "New York Correspondence School" after abstract expressionists' aptly titled "New York School," Sandoval created an imaginary Chicanx "school of art" combining queer racialized possibilities with conceptualism. As Joey Terrill retells, Butch Gardens "was Teddy's signature name for all the mail art that was going out. That was sort of the thing to do. At the same time you were undermining or critiquing the whole concept of the institution like a school of art by doing mail art, which was the total opposite of the precious art object sitting on a pedestal somewhere. You named your whole concept after it."[82]

"Butch Gardens" was an artistic pseudonym, inscribed on works such as the "Hand Jobs" series at Ron's Records. An advertisement for Haberdash and Hill Furs, a Long Beach–based atelier owned by his friend and fellow CSULB alumnus, Bill Hernandez, is similarly inscribed. Sandoval's contribution to "The Daddy Mystique," an article for the pornographic rag *In Touch for Men* that he illustrated, again presented male images without facial definition. Instead, Sandoval emphasized masculine cues: chiseled chests, tufts of body hair, and a preening muscularity (see figure 3.10). His visual attentions to a bountiful harvest of machos reduce maleness to a form, a mystique, a physical essence distinguished by posture and hunky façades. As Martin Levine reflected on the 1970s brut gay self-fashioning, "'Posing' involved standing alone, with a blank expression, in a conspicuous spot. . . . This stance conveyed such butch attributes as asociality, affectlessness, and confidence, and was used to obtain erotic affirmation."[83] Thus, Sandoval's anonymous male shadows literalized the blank illusory visages from which same-sex desires were projected. Like screens, these figurations animate conceptualism's anti-art reaction, supplying an open-ended site of desire in Sandoval's homoerotic milieu. The power of Butch Gardens' *built* environment is perhaps predicated not on the actual space or its occupants but rather on those fantasized projections of virile studs akin to atlantes

Figure 3.10. Teddy Sandoval, Macho Mirage (early 1980s), work on paper. Estate of Teddy Sandoval/Paul Polubinskas.

pillars scaffolding his imaginary art school. Sandoval's machinations like Butch Gardens and items like "Hand Jobs" are indebted to a visual repertoire imported from his musing about sexual anonymity and traces of his commercial work illustrating pornographic stories and one-handed gay pulp fiction.

It is a bit ironic that Sandoval's Rosa de la Montaña contrasted the macho mirage with a hyperfeminine counter. As an extension of Sandoval's cross-dressing alter ego, she epitomized another attitudinal reinvention, a potentially transgender fiction of self in his mail art oeuvre. As Butch Gardens' resident art star, Rosa was an iconic figurehead for a "muy (high) rasquache" art academy based on a lurid gay bar.[84] Mail art exchanges in the pages of Joey Terrill's *Homeboy Beautiful* magazine suggest that she was a widely recognized force among Chicanx avant-gardists, on par with Ray Johnson and Eagle leather bar persona turned editor of *Fanzini*, John Dowd.[85] Queer Chicanx sociality formed around her elusive performance propagated by image and text on paper.[86]

For instance, a flyer for the guerrilla exhibition *Corazón Herido* ("Wounded Heart") invited attendees on behalf of "Ma[dame] Rosa

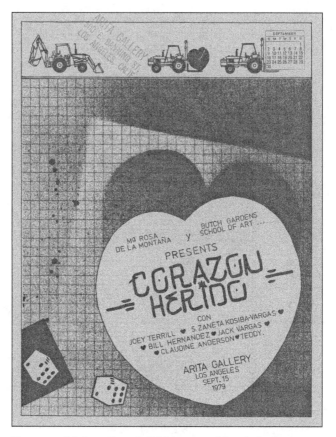

Figure 3.11. Madame Rosa de la Montaña and Butch Gardens
School of Art (Teddy Sandoval), flyer for *Corazón Herido* (1979),
photocopy. Estate of Teddy Sandoval/Paul Polubinskas.

De La Montaña" and the "Butch Gardens School of Art" on Septem-
ber 15, 1979 (see figure 3.11).[87] As an artistic entity, Rosa brought people
together through her textual pronouncement and suggestive sighting.
Like "Nothings"—Johnson's invitation to nonevent situations organized
around empty spaces—Butch Gardens redrew the terms of queer Chi-
canx creative gatherings proffered by this unseen tour de force.[88] At-
tendees are drawn together under the ruse of Rosa de la Montaña and
attend the exhibition like a Kaprowian happening.[89] Seeking a subject
for whom no physiognomic definition is found, gallery goers gener-

ate her persona in their intentions, curiosity, attraction, and complicit search for the evasive hostess. At *Corazón Herido*, she remained in shadow, a textual trace on paper. When she took shape, she was equally unfathomable.

Rosa (1976) is a small-scale print. Anonymous in appearance, she is more essence than drag character. A malleable shape-shifter ensconced in a labial cascade of hyperfeminine power, she rebukes generic conventions of portraiture by erasing the sitter's identifiable traits and, in this way, converses with Sandoval's previous macho mirages. Her opacity is something visitors struggle to know. In a certain sense, Sandoval's alter ego "disidentifies" with a Chicanx ethnic political project, doing away with that culture's capacity to see itself in her.[90] Rather, Sandoval performs a queer iconoclastic counter to a tenuous system of racial and gender coding. Rosa remains an obscure figure, allusive flirt, and shadowy saboteur. And like the gender-defiant Dadaists before her, she undermines a passive feminine portrait, repudiating a heteropatriarchal desire to see, know, and ingest her.[91]

Rosa has clear antecedents in Marcel Duchamp's alter ego, Rrose Sélavy, an image that first emerged in collaborative portrait photography taken by Man Ray in 1921. Duchamp's "feminine masquerade" in fur and darkly stained lip asserts "the radical potential of self-presentational strategies," thereby undoing the male artist's working-class bravado.[92] According to Amelia Jones, "Rrose enables Marcel to eschew the macho worker/painter identity in favour of an ambiguously gendered persona."[93] Analogously, Rosa upsets an East LA public art repertoire fashioned by Chicanx art muralists. Revolutionaries and laborer anti-heroes such as Pancho Villa, César Chavez, and Emiliano Zapata were icons recommitted to concrete in urban address.[94] Rather, Sandoval's excessively femme persona sought a queerer mythos and more explicitly married Dada gender transgressions with Chicanx androgyny. Like Duchamp's, Sandoval's transgender fiction was both a visual and textual personage inscribed onto art pieces. The affinity of "Rosa," a Spanish synonym for the French "Rrose" for Sélavy was not coincidental. At the opening of *Dreva/Gronk 1968–1978: Ten Years of Art/Life at LACE* in downtown LA, he presented himself in a t-shirt reading "Dada" for astute aesthetes to see and decode. As Duchamp's Chicanx descendent, his Dadaist devotion is difficult to deny.

On par with queer contemporary art nods to Sélavy, such as Chris Makos's *Altered Ego (Andy Warhol in Tribute to Rrose Sélavy)* (1960) or Yasumasa Morimura's *Doublonnage Marcel* (1988), Sandoval uses nonconformist gender personae as a central axis in his queer Chicanx avant-garde expression. Rosa de la Montaña joins Robert Legorreta's outrageous live art persona "Cyclona," Mundo Meza's androgynous "glitter queen," the "Mija" *chola* trans femme assassins in Joey Terrill's *Homeboy Beautiful*, and Gronk's later enigmatic icon Tormenta.[95] Sandoval's distinction in Chicanx gender nonconformity comes through in a 1996 interview with San Francisco–based Xerox and correspondent artist Lionel Biron, who recalled that "Teddy . . . was the most Out within the Mail Art movement that I knew. One year I received this marvelous colored Xerox Valentine of himself in full drag."[96]

As such, Sandoval's inescapable transgender visibilities bore on his art and life. In the cabinetry at the Palm Springs home, traces of Rosa imbued prints and envelopes. In sum, paper was a consummate material in the archival space, prolonging and protecting Sandoval's corpus and directing Polubinskas's custodial practice. Packaging and parcels crafted an afterlife for art objects, enabling a future through the interiority of cardboard surrounds. Holding his ceramic remains within degradable miniature spaces like boxes supported another cabinet of personal significance: the utility closet.

In our interview, Polubinskas surveyed Sandoval ceramics interred for "nondaily use." Each vessel is carefully treated and labeled not by its year but by its name. Provenance remains unclear, though Polubinskas recalls each box's contents by title alone. Submerged in plastic wrap, Styrofoam packing chips, tape sealants, and newsprint wrapping, these ceramics retreat inside boxes harvested from everyday household use: Raisin Bran cereal and Kirkland dog biscuits (see figure 3.12).

After his collection overview, Polubinskas repackaged Sandoval's exquisite vase, *Dante's Inferno* (1989), a work based on the fourteenth-century epic poem depicting Dante's passage through the gates of hell. Stylized in a cartoonish rendition, the childlike character of Sandoval's design puts a pop spin on the story. Sandoval takes flat two-dimensional figures and offsets them with handcrafted skull embellishments texturizing the vase's lip. Holding the ceramic toward the camera, Polubinskas uses materials "so [the ceramics] don't get broken because they're ir-

Figure 3.12. Paul Polubinskas with *Dante's Inferno* (1989), screen capture by the author, courtesy of the Estate of Teddy Sandoval/Paul Polubinskas.

replaceable. If Teddy hadn't died they could be replaced."[97] His voice trails, missing a beat, his pause alluding to the unsaid conditions behind the Raisin Bran box. His meticulous set of storage procedures craft containers of desire to manage the post-traumatic consequence of AIDS and impede the destruction of the physical record. Ironically, these ceramics' private spaces reshape the terms of vernacular preservation with the highest of responsibilities, though arranged in the fragility of acidic cardboard shells.

For Polubinskas, ordinary packing materials cast reassurances when, in actuality, they are an unstable object environment. Outside the custodial care of a museum institution, Polubinskas struggles to prolong the life of the artifact against the wear of time, harsh environmental conditions, and the menace of the San Andreas Fault in the greater Coachella Valley. Polubinskas exudes self-confidence despite the hazard. Recalling Sandoval's studio in Highland Park, he boasts that not a singular ceramic was lost during the infamous Northridge earthquake in 1994, which caused over $40 billion in property damage to Southern California.[98] He notes, "The entire ceramics studio [in Highland Park] was open shelving, bisque pieces, just slip wear. It wasn't even fired yet. You could touch [it] with a finger and break it. We lost nothing, nothing, in the earthquake! The art gods were watching us."[99]

His appeals to luck and chance second themes close to Sandoval's aesthetic philosophies as inscribed in the public artwork at the Southwest Museum Station. With ceramics anchoring the cabinetry in one part of Southern California, pieces also settle high atop Mt. Washington in nearby Highland Park. Sandoval's remains surpass the domestic interior engaging Polubinskas into an ambulatory preservationist reaction. Here, Polubinskas would struggle to complete a posthumous art design that not only stood to reshape the urban landscape but also to have important consequences for the place of AIDS in the city.

Creating an Urban Landmark for Highland Park

Fulfilling Sandoval's commission for the Southwest Museum Station was no easy task. Initial costs for the Metro rail system ballooned past early estimates. Construction fees totaled around $6.1 billion in federal, state, and local tax dollars, making the MTA a frequent target of outrage and frustration.[100] One percent of rail construction costs, roughly $10.5 million, were committed to the Art for Rail Transit program; but because the budget remained unchanged, when construction fees spiked, artist concepts and preapproved proposals were frequently readjusted.[101] Sandoval's fellow ceramicist Gil "Magú" Lujan, who designed the Hollywood/Vine metro station on the Red Line, was also unsatisfied, finding that "in projects like this, with the checks and balances that I know are necessary, the bureaucracy gets in the way."[102] Calling the MTA's artist selection process "doomed" from the beginning, LA Times art critic Christopher Knight lambasted the public art program because it was based on the "design" of engineers. By handing artists "empty concrete boxes . . . and blank platforms," Knight argued, the MTA sabotaged public art practitioners early on with physical limitations, material demands, and a provincial take on art talent.[103]

Knight's cantankerous position perpetuates a monocular view of LA art and the built environment, ignoring its transnational relations with Latin America and the Pacific Rim. According to historian Sarah Schrank, as early as the first two decades of the twentieth century, "As Los Angeles grew in geographic size, economic power, and demographic diversity, art became an increasingly volatile site for public debate over what kind of city Los Angeles would be and who would control its cul-

tural terrain."[104] As Knight's comments seem to indicate, contested civic space refused to recede and menaced the MTA's public art initiative through the 1990s and into the next century.

In 1993, the Metro ART program selection panel fielded a short list of five candidates from a pool of eight hundred.[105] Applicants were restricted to California-based artists, and likewise the selection committees were composed of local as opposed to national jurors.[106] Candidates were vetted according to their knowledge of public art, capacity to negotiate with public transit, and demonstrated experience working on team projects. MTA expected commissioned artists to wrangle with stakeholders such as transit urban planners, architectural design firms, structural engineers, construction crews, community leaders, local residents, public historians, and, in Sandoval's case, museum administrators.[107] Due to his aesthetic versatility, ceramic art specialization, and long-term residency in Highland Park, his profile was persuasive.

Sandoval's approval was tasked to a five-member jury that included one local artist, area art consultants, and neighborhood representatives. According to Polubinskas, Sandoval attended exhaustive hearings organized by the MTA. There he convincingly explained his initial public art concept, lobbying local business owners and community leaders. Finding the ceramic medium useful in these venues, Sandoval presented modeling prototypes cast in his kiln at home. In one meeting, he exhibited an Artquake candlestick exemplifying his eclectic postmodern ceramic vision. The decorative object is anthropomorphic in form embedding a science fictional outlook on a palatial Ionic column where a winged peacock has human arms. The figurine melds Frida Kahlo's *The Broken Column* (1944), a self-portrait ruminating on the crippling effects of a bus accident on her body, with classical architecture and caryatid sculpture. While showing his landmark in miniature, he encouraged community members to envision his decorative artwork on large scale. His medium must have resonated with community members anxious over local development. A rousing endorsement from Charles Fisher, a resolute critic, sealed Sandoval's commission. "A lot of sighs of relief [were heard] in the room" reported Alan Nakagawa, project manager for the Art for Rail Transit program.[108]

While the charge of the commission required creative responses to local heritage, Southwest Museum's designation as a "landmark station"

raised the historical importance of the design. Sandoval's art budget was increased to create elements that would be visually distinct from other MTA stations. But could a queer Chicanx ceramicist from East LA transform and appropriately historicize the image of the neighborhood, for the neighborhood? Believing he could, Sandoval turned to an iconic and incomparable cultural resource at his disposal: the Southwest Museum itself.

Established in 1907, LA's first museum is sited high atop Mount Washington. Occupying a breathtaking vista, it is equally a modern temple overlooking the city.[109] Constructed in a Spanish Mission style, with a monumental tower to quote the Cathedral of Mexico's Caracol spiraling staircase, the design solidified "a painterly landscape against which history could be artfully enacted, fostering a nostalgia that did not simply add regional flavor to a tourist trade but institutionalized a celebratory public memory of colonial conquest and acted as a salve in the face of modern urban development."[110] Founder Charles Lummis, a California booster, vagabond, and adventurer from Massachusetts, long touted the museum's romantic vision by espousing the exotic wonders of the Southwest.[111] Anxious over the disappearing Native, Spanish, and Mexican character of an industrializing LA, Lummis "acquired objects as mementoes of occasions in which he participated, amassing souvenirs that held meaning for him."[112] He collected antiquities, textiles, artifacts, and even wax drum cylinder recordings of folk music he termed "catching our archaeology alive." His ceramics relics were especially prized.[113] His curios became the basis of the museum's collection.

"The Southwest Museum attempted to fix Native American cultures through the dominant culture's gaze," as Martin Padget claims, and so it is difficult to imagine what this Spanish colonial temple on the hill might have provoked in Sandoval.[114] The landmark occupied his everyday vision. Polubinskas recalls that as "we sat at the table working on ceramics, we could see [what] turned out to be the ultimate goal . . . the Southwest Museum Station."[115] The stakes for public art couldn't be higher. As the child of Mexican immigrants with a Chicanx political consciousness and queer sense of daring, Sandoval was given the chance to reimagine a rich ethnic landscape and colonial history at the feet of a paternal Anglo institution once seen as the "Future of Los Angeles," a future that looked fraught from his vantage point.[116]

Guardian Tops/Tile Bottoms

Structured around three canopies, a commuter platform, seating, and metal railings, *Gateway to Highland Park* archives the competing pasts of a regional landscape rich with Mexican and Native American cultural histories and heritage landmarks negotiated in Sandoval's signature ceramics and tile material. From the outset, Sandoval presented a directional frame selecting three winged figures, which top white neoclassical Greek columns on tile footings (see figure 3.1). In the eclectic style of anthropomorphic birds, these large-scale ceramic fabrications triangulate the area over the Gold Line train. Each "gate guardian" poses with human hands pointing visitors to nearby and distant locations connected by the railway: Pasadena, Union Station, and the Southwest Museum.

Perched above passersby in crowns and wings made of steel, figures are fabricated in glass mosaic vaulted on top of a column pillar. More than the prototype fired in the kiln at Sandoval's studio, the winged statuary recalls that ceramic graveyard staged in the backyard of the house on Phillips Way (see figure 3.4). In the mid-ground of the photograph, a winged vase with anatomic dimensions is perched on an inverted terracotta pot. The object's rectilinear lines and cylindrical shape in a dark monochromatic palette are reinvented and given life-size proportions on the Gold Line (see figure 3.13). The gateway guardians symbolically correlate a ceramic dead zone with grand-scale realization. Less like caryatids, which guided his candlestick prototype, Sandoval's anthromorphic muses recall the Assyrian Lumassu, a sentient being guarding the gates and entrances of ancient palaces in Babylon.[117] The winged protectors accompany the traveler and akin to *Gateway to Highland Park* they organize cardinal directions. The Assyrian Lumassu walks in side steps, negotiating celestial planes like Xolotl, the Aztec canine who collects the bones of the dead and accompanies the sun to the underworld.[118]

Sandoval's avian guards signify within this ancient archive of mythic beasts. They serve a related function, regenerated from a ceramic graveyard to oversee a transient point of departure or arrival for the work-worn traveler. Coming and going in a movement animating the living and dead, riders experience an itinerant trek guided under the protection of

Figure 3.13. Teddy Sandoval, Southwest Museum Station Gateway
Guardian, Los Angeles, California (2003). Estate of Teddy
Sandoval/Paul Polubinskas.

winged guardians, keepers of another time and space. They hover above
the city skyline symbolically interconnecting ceramic trails from the do-
mestic surrounds of the Sandoval/Polubinskas homestead to a public
domain.

The columns hoisting the gateway guardians into the air embed classi-
cal Greco-Roman references into Highland Park. Sandoval's selection is

curious without a clear architectural reference from the neighborhood's built environment. His columns, however, glean a broader history of LA civic culture influenced by the reproduction of European symbols. As Sarah Schrank observes about a modernizing LA, elitists in the 1920s revived building types "confident that an artificial European architectural landscape or aspirations to Greek classicism were tickets to urbane sophistication."[119] Because LA hosted the Summer Olympics in 1932, this worldview ambition fostered a cosmopolitan preference for Greece. In fact, Corinthian capitals were features of the Mount Washington School with distinct ties to the area (the school was destroyed in the 1920s).[120]

Sandoval's columns reflect on a city entrenched in a European predisposition to modernize public space. This architectural dialogue between neoclassical, Anglo, and Spanish colonial reference is not lost on Sandoval, who confronts these pasts with a bric-a-brac of nineteenth-century cues. For instance, Victorian-inspired ironwork lines the station canopies. Scrolling embellishments shape the crown, wings, and mosaic torsos. Crooked aluminum-cast fern armchairs are quarter-turned on the platform like cast-offs from a period room.

The station points to another landmark in the museums of the Arroyo Seco: the Heritage Square Museum. Founded in 1969 by the LA Cultural Heritage Board, it is a collection of eight restored Queen Anne and Mansard-style homes removed from downtown LA in the late 1960s and preserved as a living history museum in Montecito Heights. Unlike Meza's creative ventures with New Romantic Brits in LA's nascent fashion industry (see chapter 2) and Terrill's flirtations with Englishmen in arts and letters (see chapter 4), Sandoval's relationship to British coloniality engages a language of architecture history. He has an obsessive attention to Victorian garden homes as demonstrated in his copious photo documents and screenprints dating from his studio art classes at CSULB. In fact, reproductions of William Hogarth's eighteenth-century engravings inform his aesthetic influences. These populate the Palm Springs flat file.

Sandoval confronts the area's competing colonial pasts, taking a position hinted by Karen Tongson: "From the . . . recreations of Spanish missionary culture in its downtowns, to the genteel, citrus-era Victorianism still discernible in its oldest houses and civic landmarks—the latter affirm[s] a strange, Brit stranglehold on culture and anarchy even

now, long after the sun has set *beyond* the British Empire."[121] Where commuters find themselves sitting is under guardians pointing to the sources of Indigenous peoples' displacement: England and Spain, as well as American squatters. Does the platform offer MTA commuters a subversive seat to the theft of Native antiquities and archaeological ruins housed in the museum on the hill?

Additional insight is gleaned from Sandoval's tile paintings. Each mosaic guardian hovers above the train platform grounded by a column built on either rectilinear or triangular bases. These footings contain recessed paintings making direct connections to cultural heritage sites, including photographs and fibrous artifacts. One of the bases depicts an indigenous weaving that shows two young Native American men canoeing. The textile quotes the museum's archaeological holdings of Indigenous material culture, rendering soft fabric fibers in cool ceramic tile. By embedding the area's Gabrielino-Tongva people into the structural scaffolding, archival records and Indigenous cultural artifacts combine with the posthumous reproduction of Sandoval's ceramics. Mutual travesties of loss and disappearance in Highland Park undergird the gateway. Polubinskas executes an alternative archival formation stricken by the simultaneous traumas of First Nations, queer men, the AIDS crisis, and artist communities.

Tile is more than a structural consideration; its materiality dominates the platform from the mosaic bodices of the guardian statuaries to the paintings inset in the column mounts. As a genre of ceramic arts, its implementation in the *Gateway to Highland Park* imparts a critical ethnic history of material culture to which Sandoval stakes a claim. Labor and immigration constitute tile production in the Southland since the late nineteenth century. Mexican laborers built LA through a burgeoning mason industry established by Simons Brickyard in Montebello Hills and Southern Pasadena in 1900. As historian William Deverell notes, "The Pasadena operation turned out some forty-five thousand bricks a day at a twenty-acre plant just adjacent to the streetcar line. Mexicans went into deep pits to excavate clay, and mules hauled the heavy loads out from the hole."[122] Simons fostered an ethnic enclave in its company towns maximizing the production of redwares and clayworks to meet renewed demands for Spanish colonial revival design in Southern California, in particular.[123] Brick barons and Mexican workers were re-

sponsible for the vast production of pavers, chimneystacks, roofs, and decorative tiles modernizing the city.

In 1901, California gained another ceramics master when Ernest Batchelder arrived from New Hampshire. A chief figure in the American Arts and Crafts movement, he operated his tile works production company out of a single kiln in his Pasadena backyard; in 1920, he moved to a factory in downtown LA, the iconic 2933 Artesian Street address that operated eleven kilns and supplied the city with "6 tons of material daily."[124] He specialized in decorative and low-relief tiles of Dutch, Italian, and Byzantine patterns; art deco; and even pre-Columbian Mayan reproductions.[125] He innovated new methods to treat, mold, and glaze ceramics, which earned him several commissions in LA, including the Roebling Building (1913), Stowell Hotel (1913), and Dutch Chocolate Shop (1914).[126]

However, one of his most regarded commissions came in 1925 when he designed the lobby for the Fine Arts Building, a major contribution to the Albert Walker and Percy Eisen legacy in downtown LA.[127] Outside, artist Burt William Johnson carved hulking male sculptures to symbolize "architecture" and "sculpture" in stone. The Greco-Roman tradition seemed to combine classical forms and masculine prowess with a modernizing LA built environment. Inside, Batchelder's custom tiles offset the surrounds of feminine art muses kneeling on pedestals, which were fired at his factory. His oversight over their installation proved his accomplishments in large-scale ceramics.[128] Placed atop towering columns in a structure composed of Simons Brick, Batchelder's artistic imprint at the Fine Arts Building prefigures Sandoval's play with vaulted figurines, classical architecture, and tilework germinal to the grounds of the greater Arroyo Seco.[129] Unlike Batchelder, Sandoval's contemporary impetus references a region consequential to his ethnoracial subjectivity, a queer of color reflection of Mexican masonry, European colonialism, and histories of ceramic art and craft.

More than the dead zone of his backyard garden, Sandoval's kiln in the home on Phillips Way partakes in a broader ceramic culture fostered by Simons' brickyards, Batchelder's Arroyo Guild of Fellow Craftsmen, and those Mexican laborers ghosting clay pits.[130] In the 1990s, Sandoval's studio drew interest among the city's Chicanx artists in search of his expertise. Sandoval was instrumental in Gilbert "Magu" Luján's MTA

station at Hollywood/Vine on the Red Line. His kiln fabricated the tiles affixed to the platform's walls. While in residence there, Magu molded a giant erect penis for the couple as a token of friendship and appreciation. Interested in new ornaments for the backyard, Sandoval and Polubinskas welcomed this addition, given its remarkable size and scale.

Artist Roberto Gil de Montes also worked collaboratively with Sandoval to produce ceramics for the gateway transit center at Paseo Cesar Chavez in downtown LA, which required several three-dimensional tiles.[131] Together, Gil de Montes and Sandoval carefully fired each piece individually to avoid the buckling caused by overheating.[132] Like Magu, Gil de Montes gifted a tile study to Sandoval, a low-relief male nude fixed onto a red clay slab like a homoerotic perversion of Batchelder's romantic Dutch décor. This piece stands in Polubinskas's living room among the miniature memorials marking another space and time. The object remembers the history of Artquake in Highland Park, a ceramic studio epicenter for Chicanxs unfastening the pervasive heterosexuality intrinsic to tilework and Mexican masonry in Southern California.

Although Sandoval was not credited directly for his roles in producing these other MTA public art commissions with Luján and Gil de Montes, his studio in Highland Park was a critical nexus for Chicanx ceramic art production in a manner analogous to Batchelder's factory decades before. My contention here is not to conflate Sandoval with a California Arts and Crafts movement figure like Batchelder (though his tile work influenced Sandoval, according to Polubinskas).[133] Rather, Batchelder is a useful lynchpin to think about how Sandoval understood the entanglements of Highland Park with Mexican labor, coloniality, Chicanx art, and, in particular, AIDS representation. His motivations grow clearer in a special feature on Hispanic ceramic artists from LA and Miami in *Studio Potter*, in which he contended that "ceramics as a medium is downplayed by the arts in Los Angeles. It's all right to do ceramics in school but you don't take it seriously. . . . The problem is not with the Hispanics feeling that ceramics is unworthy, because a large part of their culture is ceramic. The problem is with the mainstream."[134]

His offhand remark about "Hispanics *feeling* . . . ceramics" arouses the emotive possibilities of this handcrafted medium, comprehending ethnic and historical definition in clay. He astutely acknowledges the way ceramics have played a consequential role in Latin American art,

whether they be pre-Columbian pottery, Spanish colonial *mayólica*, or *talavera poblana* vessels exchanged in the Americas.[135] Whereas queers of color have noted a lack of archealogical records attesting to historical evidence of sexually transgressive desires in the shaping of the Americas, Sandoval's turn to faux finishes, crackled patinas, and sacks of sand stands to rectify these material absences. His contemporary antiquities conjure evidence of a grand civilization—the ruins of queer Aztlán—and demonstrate the serious corrective work that a non-heteronormative archeological record can do. His kiln thus rebukes prejudicial attitudes that undermine the historical value of his puto mugs and chili Madonna shrines. His objects propose a material register that *feels* a queer Chicanx past ceramically.

For Sandoval, clay had an empowering and a politically consequential role for queer of color world building. In the design of *Gateway to Highland Park*, he enunciates a queer Chicanx art philosophy that contests the LA art establishment's disdain for his medium (unlike his peers Magú or Gil de Montes, he was never represented by a fine art gallery and died without experiencing his own solo exhibition). Although Sandoval's interview in the *Studio Potter* preceded his MTA commission in 1993, it was a fitting signpost that proudly embraced and epitomized all the things that Knight abhorred in his glib assessment of clay works in public transit art projects. Concluding his *LA Times* review of MTA public art, Knight bemoaned, "The most common art material that turns up all over the 50 Metro Rail stations is glazed ceramic tile. Painted, silk-screened, handmade, multicolored ceramic tile. What's up with that?"[136]

It is for these reasons that Sandoval's consummate attention to tile is mindful of the nineteenth-century craft so closely integral to AIDS memorialization and collective grieving as demonstrated by the NAMES project. Sandoval's practice shows how the social and ethnic possibility of tile activates a little-regarded facet of "mnemonic world making" in Chicanx and Latinx AIDS memory landscapes beyond fabric and stitching.[137] Whereas the AIDS quilt made another bold display on the National Mall in 1993, Sandoval was thinking in more tangible terms, not to mourn the finality of death but, as I will discuss momentarily, to negotiate HIV transmission in a public art venue. Venting the viral terms of this national health crisis squarely pitted his plan against its implementation process, which occurred years after his death. Tensions

spiked over retroactive criticism levied at the design and the custodial defense undertaken at the behest of Sandoval's lover and estate executor: Paul Polubinskas.

Ceramic Feeling/Feeling Ceramic

After submitting his proposal for final approval, Sandoval was beleaguered by the ballooning costs for the MTA rail project, which resulted in a "containment period."[138] Sandoval would never live to see the fruition of his design. In the interim, he succumbed to his AIDS-related illness. MTA officials had mixed responses. According to Polubinskas, one was a rumored plan to carry forward with a generic platform void of art. What MTA did not take into account was that, before his death, Sandoval signed over copyright of all images and trademarks to Polubinskas. The artist's resolve was strengthened by what he experienced a decade earlier, witnessing the diffusive aftereffects of AIDS on Meza's art.[139]

On March 8, 1996, Polubinskas issued a formal letter demanding completion of the original design as approved. He stressed, "As Teddy's partner, I was involved in all aspects of his design work for his station, I assisted him in all phases of the work that he performed. . . . The involvement I had with his work on this station certainly qualifies me to carry on with his design plans at this time."[140] Local support was roused from neighborhood boosters and Gabrielino-Shoshone Nation Chief Ya'Anna Vera Rocha. MTA conceded, making what Polubinskas and Sandoval accomplished quite rare. Same-sex couples were rarely afforded legal recognition by a government agency, much less a creative arts partnership.

With the aftereffects of Sandoval's death being felt acutely, a new obstacle endangered the completion of his work. In his approved plan, Sandoval portrayed not only landmarks and museums along the Arroyo River but juxtaposed them with natural forms. The transit platform referenced bodies of water. Sections of the lower railing and gating separating the street from the tracks bent in wave-like curves citing the Arroyo River. In a study for the platform, he placed a fern leaf chair next to a river rock boulder. A pair of buoyant dice broke in the rushing brook. Crushed blue pebble aggregate was poured onto the

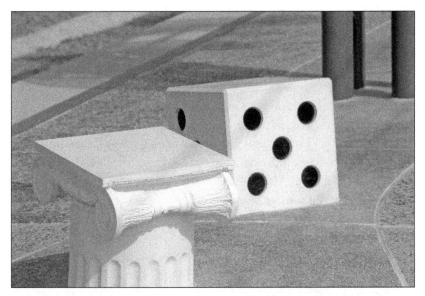

Figure 3.14. Dice and Column Seating in Blue Aggregate River, *The Gateway to Highland Park*, Southwest Museum Station, Los Angeles, California (2003). Estate of Teddy Sandoval/Paul Polubinskas.

standing platform and snaked along the ruins, imitating the movement of a stream. His column capitals resist being swallowed whole by the riverbed (see figure 3.14).

This platform was a flashpoint for Southwest Museum administration. By 2002, the once-thriving museum on Mount Washington faced financial difficulties. Hundreds of thousands of dollars were necessary to maintain the building, whose deterioration due to substantial seismic damage jeopardized the collection.[141] A deal was struck between Southwest Museum administrators and the Pechanga Band of the Luiseño Indians to establish a gallery that borrowed from the collections and exhibited at the Pechanga's resort and casino in San Diego. Southwest Museum adminstrators believed that the appearance of dice in the *Gateway* provoked stereotypical images of Native American gaming and, more important, satirized the museum's dependency on casino dollars.[142] In response, Polubinskas held that any alteration to Sandoval's original design was unacceptable according to the agreement set forth with the MTA and the Highland Park Neighborhood Association. To

preserve Sandoval's work and inoculate the design plan from any alternation based on the appearance of anti–Native American sentiment, Polubinskas needed to retrace the artist's genealogy of dice imagery. Its origins belonged to a visual archive deeply seeped in a queer Chicanx avant-garde past as well as the artist's own declining health.

Clues to Sandoval's AIDS visual repertoire are found in a tile painting recessed inside the column base in Sandoval's Southwest Museum station. The artwork depicts a sea strewn with floating debris. Dice and a heart (which may allude to the sacred heart of Christ) drift in still waters, caught in an indeterminable sense of time. A crescent moon hovers in the night sky like a disembodied eye surveying ruins. The landscape is restless. Waves lap from the watery surface like bubbling geysers. No ordinary tile painting, the artwork is a Sandoval replica and thus signifies within a larger milieu of queer Chicanx art, performance, and gay male collaborations from decades earlier.

One of the earliest permutations of Sandoval's pairing of dice and heart iconography dates to his queer Chicanx conceptual art practices from the late 1970s. The flyer for *Corazón Herido* shows Sandoval's principle attention to heart imagery as an idea and collaborative art practice of which performance was an exemplary expression (see figure 3.11). The flyer's typographical style hints at its exchange in a participatory art dialogue. *Corazón Herido* is written in a Cholo graffiti lettering consistent with Terrill's characteristic penmanship. His writing is identifiable by a distinctly starred "i" and signature dot in the center of the "os." A look at the signage from a closely related Sandoval and Terrill performance piece entitled *Heartbreak Hotel* (c. 1977–78) is further indication of the creative exchange happening through performance, photography, and writing.

In the piece staged in front of a derelict building in downtown LA, Terrill is heartbroken. Terrill crumbles to the ground, drinks himself into a stupor, and pounds on the front door of Heartbreak Hotel where it is time to check in (see figure 3.15). Sandoval consoles him. Their exaggerated comportment sheds self-destruction for a campy mood. A decorative heart prop ornaments the neglected façade. Graffiti rendered in Cholo scrawl undergirds the accompanying sign. A pointed dot in the center of the "o" draw attention to Terrill's hand. This textual inscription is conversant with his personal written material found throughout a

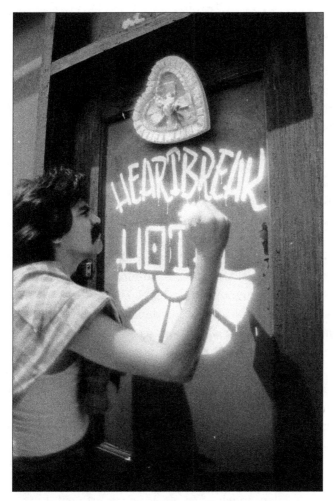

Figure 3.15. Joey Terrill and Teddy Sandoval, *Heartbreak Hotel*
(ca. 1977–78), performance documentation, Los Angeles,
California. Estate of Teddy Sandoval/Paul Polubinskas.

performance repertoire joining the pair, including the t-shirts critical to
the second iteration of *The Maricón Series* (1976) and typographical de-
sign in *Homeboy Beautiful* magazine (1977–1979). Moreover, the urban
landscape itself performs a self-referential backdrop. It is incidentally
recalled in a queer Chicanx performance archive with Terrill's staging
of the "E.L.A. Terrorism" exposé using the same derelict building in the

second issue of *Homeboy Beautiful*. With heartache being the modus operandi of Terrill's oeuvre and wounds being Sandoval's, the pair enunciate a conceptual understanding of the heart's queer imaginary, an articulation closely enmeshed in the collaborative ether of queer Chicanx avant-gardists and their modes of self-representation and desire. More than matters of the heart, dice are symbolic companions in the *Corazón Herido* flyer.

Traces of Sandoval's early avant-garde vocabularies and the composition of the inset tile painting can be found in *VIVA Arts Quarterly*, the principal publication of VIVA: Lesbian and Gay Latino Artists of Los Angeles, and printed the year of his death.[143] His drawing, titled *Passion*, appears on the cover. It portrays a sacred heart wrapped in a crown of thorns and blossoming roses set adrift in the sea. Sandoval's sense of unseen calamity emerges from the darkened sky. VIVA's circulation of *Passion* through its extensive mailing list ruminates on AIDS for the group's multiethnic and immigrant readership. It is a posthumous printing and funerary send-off for its former board member by sea.

In the centerfold, *Passion* is printed again, but in its entirety, revealing a familiar combination of heart, floating dice, and archaeological cast-offs.[144] An Aztec ruin brings indigenous signs into the same aquatic field of vision. Aesthetically, Sandoval's symbiosis is reproduced at the Southwest Museum station, reaffirming the ways in which the experimental language of wounded queer hearts, Native textiles, and the random turn of dice are bedfellows, common travelers in waters. The polyvalent signification of dice doubles as references to artistic collaborators such as Terrill, a citation of VIVA's commemorative issue, and even a regard for a visual vocabulary indebted to queer Latinx art factions in Southern California. Under the shadow of AIDS, this synthesis of hearts, dice, and indigeneity grow in importance.

As the *VIVA Arts Quarterly* centerfold suggests, this intermingled imagery is a self-referential outlet, a confession strewn in wreckage. Sandoval interprets his seroconversion as the arbitrary luck of the draw, a roll/role of the dice. Testing HIV positive was random, a matter of chance, even for the very cautious. In documenting the unpredictability of the virus and consciously interrogating the (un)sustainability of his own immune system, Sandoval's imagery is a creative reengagement of

the archive, bearing on the virus ravaging him, his friends, and other artists of his generation.

Dice serve the gateway design in multiple ways. As multisided sign-posts, they roll in various directions pointing to the intimate and bio-medical records of Sandoval. They point to a print culture of a queer Latinx artist organization catalyzed by human loss. They embed a ceramic lineage that proliferated in the region since the nineteenth cen-tury. They seal a visuality indebted to Chicanx queer avant-gardisms. More important, dice waged a self-revelatory metaphor about infection against a grim life expectancy. Clearly, this was no ordinary gateway. Rather than rehearse a list of the dead in granite engravings or innumer-ate loss in fabric panels, Sandoval interceded with the epidemiological context of AIDS and art activism through a rare rumination about HIV transmission structured around public transit.

However, "the permanence promised by a monument in stone is al-ways built on quicksand," as Andreas Huyssen contends.[145] In this way, this public artwork and its posthumous completion is closer to what Ann Cvetkovich calls "new genres of expression . . . and new forms of monuments, rituals, and performances that can call into being col-lective witnesses and publics."[146] Cvetkovich's pivot toward collective approaches in AIDS memorialization demands another vocabulary, per-haps one that can reconcile a different future for people living with the virus. Her desire for "new forms" need go no farther than what Sandoval had envisaged for Highland Park.

This is perhaps why Sandoval's entry into the AIDS memory land-scape is so significant. By undertaking a public art commission for a neighborhood landmark station, he covertly includes memorializing al-lusions to HIV transmission in a concrete form. Thus, the resulting gate-way dovetails a mixed genre of monument, memorial, and archive into a daring posthumous artwork realized by queer custodial efforts. And consistent with Cvetkovich's appeal to re-member AIDS through ritual or performative means, we might consider how Sandoval's posthumous public artwork may have been imagined decades before.

In the late 1980s, Terrill hosted annual Halloween bashes in his stu-dio loft. Populated by immaculately adorned courtiers, his gatherings were part Chicanx performance, vaudevillian drag show, and "Danse

Figure 3.16. Joey Terrill's Halloween Party (1989), Los Angeles, California; from left to right: Teddy Sandoval, George Robles, Victor Durazo, and Ray Bruce. Photograph by Joey Terrill.

Macabre" masterpiece. Arguably, Sandoval and Polubinskas were the belles of the ball. In 1989, the couple appeared as though they had walked off the shelves from the Highland Park Artquake studio. Polubinskas was a puto cup embodied. His scalp was cast in plaster of paris resin, which created the illusion of a black-varnished pompadour. He posed for party pictures behind a gilded frame breathing life into Sandoval's queer Cholo decorative object. As a puto muse, he paired nicely with his partner, who shimmered in face paint tinted gold.

Sandoval traipsed around in a paper dress emulating a classic Ionic column (see figure 3.16). His head was adorned in a headdress shaped like a decorative vase with gold fabric spilling from its lip. His face was smeared with a gilded veneer mirroring the finishing shellacked onto his pots. Giving flesh to craft, Sandoval enacted an "artifactual performance" that made the potter's skin and the skin of pottery one and the same. By *feeling* ceramic, Sandoval wears the decorative art finishing of his own creation and recasts his epidermis to personify the claywares gestating in a kiln at home. From the column dress to the bulbous vase atop his

head and the serendipitous gold accents, his is a dress rehearsal playing out the sartorial cues that would define the Southwest Museum station design. In this moment, corporality and ceramic co-constitute the fashion statement, redrawing the distinctions between subject/object, stasis/liveness and craft/performance. His HIV positive Chicanx body animates the ceramic idiom, an artifactual performance tracing the future *Gateway to Highland Park*. For Polubinskas, memory of his lover's ceramic dress-up shadows the station high atop Mount Washington.

The premonitory possibilities of this moment expand the terms of what MTA transit commuters experience on their eclectic voyage. In his faithful execution of the design, Polubinskas does more than advocate for public art in an elegiac act of commemoration. Sandoval's archival body extends in the recuperation of records, artwork, avant-garde innovations, and an artifactual performance where ceramics are not only adornments but also the stuff of embodiment. Sandoval's intermingling between the corporeal and the handcrafted brings his seropositive self into the artwork, making art and a virus coterminous. The resulting public art piece that Polubinskas erects re-members Sandoval in a way that no walled museum fortress or theatrical stage could grasp. What persists is a conduit touching Teddy in the ceramic networks trailing a rail line and disparate sites from city to desert.

As luck would have it, the Southwest Museum's deal with the Pechanga Casino fell through, and the dice stayed. On April 28, 2003, local residents celebrated the dedication of Sandoval's *Gateway to Highland Park*. But what would Polubinskas wear to such an occasion? He appeared at the opening in an original design by Jef Huereque's Modern Object fashion line—a black rayon number was fabricated from a textile of twirling dice. In this way, Polubinskas winked back at the Southwest Museum administration, MTA, County of LA, and his undeterred supporters. As the custodian and defender of the dice, Polubinskas preserved Sandoval's final wishes and ultimately executed his partner's vision born from a kitchen window in Highland Park. For one last moment, Teddy and Paul, names synonymous with queer creative couplings in Chicanx art, took a bow and got the last laugh.

According to José Esteban Muñoz, queerness's evidentiary "specks of things" also "reformulate . . . and expand . . . our understandings of materiality."[147] Nothing could be truer than the "specks" of a ceramicist's

archive. Sandoval's alternative archival form subsists of the material processes of residues and fractures like the fine silt of a potter's wheel, granules of sand, broken pots, and dead zones of ceramic experiments gone awry. More than the queer evidence of performance or gesture, the resulting custodial interventions shepherded by Polubinskas demands a reading in the trails of an archival body's dispersion, in vexing interior and exterior domains.

Although Polubinskas's stewarding asks us to understand how AIDS proffered other preservationist responses through materialist constellations of ceramic and sand, the work of Joey Terrill turns our attention to what HIV anti-retroviral therapy has meant for Chicanx artists and collectors living with the virus. In the next chapter, I detail the longest and most enduring series of artistic responses to AIDS from the rare vantage point of a Chicanx seropositive nonprogressor sharing visions across coasts.

4

Viral Delay/Viral Display

The Domestic Para-Sites of Joey Terrill

A piece of stationary from the Renaissance Hollywood Hotel is found folded, scribbled with graphite and ink. In two columns, handwritten names ascend from the bottom footer to the open white space above. Men's Spanish surnames dominate the inventory: Navarro, Castro, Herrera, Ramirez. "Araica" is inserted in triplicate linking "Arnie," "Aaron," and "Abel," suggesting a close union between the three. The referential entries thus resist chronological or alphabetical arrangement: "Mario Tamayo," for instance, is compressed between "VITO—" and "Steven—(Roommate)." A play of hyphens and parentheses suggests a casual, incomplete recording. What is at first "46" becomes "48" and then "49." The numbers refuse to go down as another name and another tear in time transform the page until it halts.

Mined from the personal archive of Joey Terrill, this stationary lists the dead: friends, roommates, co-workers, and lovers all decimated by AIDS. It is sheathed in a private blue laminate folder, an ordinary "container of desire" that compartmentalizes extraordinary contents. His body of record calculates human loss by "naming names."[1] Similar to the mournful "places to speak out loud to the dead . . . as if the name of the deceased itself provide[s] a medium of communication with another world" at sites like the NAMES project memorial quilt and Las Memorias–AIDS Wall, as discussed in this book, other visual and material spaces by which the Latinx dead are accounted for appear in lists such as Terrill's.[2] Conversant with the way Tommy Boatwright collected Rolodex cards for each AIDS-related death in the cinematic adaptation of Larry Kramer's *The Normal Heart* (1985–2014), or how AIDS politico Sean Strub made a "ghoulish roster of the dead" on a cocktail napkin in a New York City gay bar in 1982, or the way writer Brad Gooch added

"checkmark[s] after the names of more and more friends" recently deceased, Terrill also used a method of accounting.[3] Each "body count" added numerical weight to the disease.[4] As a painter and consummate photographer of his everyday, Terrill also unfastened AIDS legibility from textual domains alone.

While the list terminates in 1996 following the death of his close friend and collaborator, Teddy Sandoval, Terrill has never stopped documenting. His corpus is the largest and most consistent visual account of the AIDS crisis in Chicanx art history and, arguably, in American art. Conversant in photorealism, conceptualism, and postmodern aesthetics of appropriation and pop art, Terrill revives genres widely maligned in the mainstream contemporary art establishment: landscape, portraiture, still life, and, most important, American scene painting. What we find are works deeply introspective, representational, and most especially, speculative.

His small-scale acrylic painting *Four Men I Could Have Asked to Marry Me* (2015) is exemplary (see figure 4.1). He depicts a queer quartet of Chicanx men in hues of black and blue. He inscribes their names on canvas, names lifted from his list of the dead. Gold accents add iridescent tones to up light their masculine visages. It is an honorific pantheon of past lovers and friends gone too soon: Craig Brown, Steve Garber, Ray Navarro, and Danny Ramirez.[5] Disrupting the mainstream LGBT civil rights movement, Terrill confronts marriage equality advocates by conjuring the specters of those jettisoned in this discourse. Speaking on behalf of the Chicanx dead, Terrill speculates *if* they were alive, *if* they had lived long enough to see the introduction of HIV anti-retroviral therapy, *if* they were privileged enough to imagine a future together, what could have been experienced together. Appealing to the speculative underpinnings with a past modal tense, Terrill asks: How can same-sex unions authorized by the very neoliberal nation-state complicit in these men's deaths sanctify a future routinely denied to HIV+ and/or serodiscordant couples?

A work like *Four Men I Could Have Asked to Marry Me* encapsulates Terrill's speculative relationship to time, space, and imagery. It underscores what I term is the artist's "queer visual *testimonio*," a readaptation of the Latin American documentary literary genre, which bears witness to human rights atrocities for politically transformative ends.[6] His epi-

Figure 4.1. Joey Terrill, *Four Men I Could Have Asked to Marry Me* (2015), acrylic painting. Photograph courtesy of the artist.

sodic vignettes, diaristic metacommentaries, and confessional revelations on canvas and paper suggest testimonio's pursuit of "setting aright official history."[7] By picturing a tenacious relationship between oral testimony, ephemeral evidence, and what Christopher Reed and Christopher Castiglia call "de-generational unremembering"—the self-amnesia gay men impose around the disease and a stigmatized past—Terrill uses his artworks to extend memory, renegotiate history, and thus underscore testimonio's sense of political "urgency," as John Beverley contends.[8] His paintings regard Chicanx sexual cultures decimated by AIDS and thus, surrogate a body and virus through visual approximations on canvas and paper. By extending an archival body through his mixed-media conjunctions, Terrill's work materializes the perspective of a long-term survivor,

someone who has watched and experienced AIDS's incursion into LA, New York, and the San Francisco Bay over three decades.

More than an analysis of Terrill's alternative archival practices and his creative antecedents, this chapter also unfurls the vital relationship between the artist, archive, collector, and home interior. Rather than enter a familiar collection studies discourse with a penchant for social capital analysis and the discerning eye of elite taste cultures, I expose another area not yet explored in this study: Chicanx collecting practices reformed around historic and contemporary signifiers of same-sex desire and contagion.[9] As gay human geographer Andrew Gorman-Murray suggests, "While home continues to be understood as a site of self-construction, it is no longer seen as a fixed unchanging space which 'stores' traditional values. . . . Home is a constant state of becoming, remade over and over again through processes called homemaking."[10] Producing the "fantasmatic space of homosexuality," as Richard Meyer terms Robert Mapplethorpe's remodeled living space with its sexually charged furnishings often quoted in his oeuvre, queer collectors make home and in turn "construct" the self with Terrill's speculative ruminations on life pre- and post-infection.

This process of domesticating a virus breaks down the distance between collectors, interior space, and the object. Living with the material approximation of a plague is cause for a more nuanced understanding of the home display or what I term "para-site." Chicanx interiors perform "a critical act of witness[ing] to the historic and ongoing institutional violence that continues to push Mexicans and Mexican Americans into marginalized social positions," as Karen Mary Davalos notes.[11] Versatile in what Gérard Genette terms "paratexts"—the anterior and posterior temporal structures of the book's narrative space, editorial logics, and textual transactions—para-sites upend the timely rhythms of domestic architecture's beginnings and ends.[12] Like the Greek etymology of the term, meaning "near, alongside and beyond," the incomplete closures of time in the *para*-site confronts not only ethnoracial resistance to systemic institutional violence, as Davalos argues (after all, these are Chicanx artworks marginalized in an elite US art marketplace) but also the way works imbued by HIV transmit an infectious visual knowledge with the pacing of deathly urgency, of faltering immune systems, of pharmaceutical unknowns, of human crises. Queer Chicanx men

shape these households by playing host to these citations of HIV transmission and, in turn, plot their homes with Terrill's archival body, a body traced by infection, his own and others.

This chapter begins by discerning the archival precepts for Terrill's queer visual testimonio approach, which germinates out of Chicana and Chicano movement activism, gay and lesbian liberation, and queer Chicanx avant-garde practices in the 1970s. I argue that his alternative archivality, a reversal of a compulsory heterosexual Chicano reality, pervades his visual lexicon prior to 1989, the year he tests positive for HIV. Then, by emphasizing the paintings he generated after his diagnosis, I elucidate how seroconversion—the delayed time between initial infection and HIV diagnosis—is visually conveyed in scenic vignettes that depict how he and his raucous cohort, the "Escandalosa Circle," experience a queer brown world waning in the time of AIDS. The opacity of the future and recasting of a new epidemiological self—being HIV positive—reconstituted Terrill's archiving practice as he retrospectively reenvisioned New York City, San Francisco, and Los Angeles with a pathogenic timestamp.

From this spatiotemporal and biomedical scaffold, I shift focus to queer custodial practices at home. Using archive elicitation, I interrogate the domestic settings of Michael Nava and Eddie Vela to show the ways in which Terrill's archival body redomesticates and reorients the interiors. Queer Chicanx men's collecting of the artist's 1989 paintings *Remembrance* and *Untitled* shelter the intimate details and confessions written on canvases like pages from a viral diary. Telling of fractured life cycles and immune systems gone awry, Terrill's canvases charge the home with touches of pathogens. An artist's studio in LA, a dining room in the Bay Area, and a house interior in Highland Park offer a speculative recitation about infection. Walling themselves up with AIDS trauma, these collectors link domestic materialities in a fractious tangle harboring para-sites and thus, keeping reminders of a plague close to home.

Queer Visual Testimonio

Archiving was foundational to Terrill's earliest art practice, a queer reimagining of testimonio, which happened decades before his HIV diagnosis. In a personalized process that Eric Ketelaar calls

"archivalization," or documenting that "moment of truth" where social and cultural conditions determine "something worth archiving," Terrill's visual expressions imbue this archival impulse with new meaning.[13] His alternative archivality lies adjacent to the literary and the visual, allowing for personal narratives to be reimagined in the queer racialized and socioeconomic conditions of his youth.

By making his memories tangible through pictures, Terrill transformed the unstable domestic environment he endured growing up in the Highland Park area northeast of downtown LA during the 1950s. Faced with his parents' broken marriage, his mother's schizophrenia, and an awareness of his same-sex desires, Terrill withdrew into a refuge of images. He immersed himself in a fantasy world of American popular culture, decorating his bedroom with illustrations, photographs, clippings of comic books, Hollywood starlets, and rock and roll icons. Broadcasts from the television set inspired Terrill's creative productions, freehand drawings, and pop-art references. Sitting at the foot of the TV, he exercised his hand, sketching star Dorothy Provine in her glamorous flapper costumes and the revolving mirrored ball in the opening credits of NBC's *The Roaring 20s*. His first "official" photograph is taken with a Polaroid camera in 1970, and its subject is his younger sister Linda. The pair watched with excitement as the film developed before their eyes. From the outset, Terrill linked art, identity, and documentation, synthesizing a self-image through gatherings of found materials, episodic television, interior spaces, and photo recordings of people populating his personal life.[14]

Cathedral High School, an all-boys private Catholic preparatory school, intensified Terrill's initial interest in cultural representation. By the time he matriculated in 1970, he was having sexual experiences with other men and thus confronted the increasingly hostile and ostracizing conditions of his school as a "much-talked about" aberration by students and faculty alike.[15] He recounts being thrown against lockers within the open-air corridors of the campus and assailed by Spanish slurs. *Puto* and *maricón* trailed him down the hallways. Enclosing himself in Father Scanlan's office during lunch breaks, he painted his first mural, *The City*, there between October 1970 and March 1971.

Although Cathedral showed intolerance for sexual difference, the school did provide Terrill with an intensive introduction to Chicanx

VIRAL DELAY/VIRAL DISPLAY | 169

social movement activism. Two politically engaged seminarians, Brothers Gerard Perez and Richard Arrona, screened Luis Valdez's *I am Joaquín* (1969), a cinematic adaptation of political ideologue Corky Gonzales's epic collectivist poem "Yo Soy Joaquín" (1967), in the high school cafeteria. Terrill also witnessed the performances of Teatro Campesino, Valdez's *carpa* (tented) community theater at Lincoln High School's Fiesta de los Barrios in East LA in 1972.[16] As a result of the seminarians' careful stewarding, Terrill became involved in the Chicano Moratorium march against the Vietnam draft on August 29, 1970 and the second wave of East LA high school "walk outs," as well as organizing boycotts of public grocers carrying grapes and lettuce picked by nonunionized workers. According to Richard T. Rodríguez, Terrill "was convinced that doing work for La Huelga might also help him meet guys and thus sustain his inextricably political and sexual desire for community."[17] Ironically, these Chicano seminarians were also responsible for introducing Terrill to San Francisco, bringing him along on excursions of faith up the coast and propagating what he considers among his most significant aesthetic influences.

San Francisco provided Terrill with some relief from a household shaped by his mother's mental illness and a racialized heteropatriarchal environment incongruent with his same-sex identified reality. He fled Highland Park from both a school and a home that grew increasingly intolerant and insufferable. Hitchhiking up the Pacific Coast Highway, he melded into the Bay Area's queer Shangri-La. An incidental stay at a hippy commune fostered his formative introduction to "gender fuck" androgyny, an outrageous cross-dressing aesthetic harnessed by the flamboyant drug-infused exploits of the Cockettes.[18] According to Julia Bryan-Wilson, "The conjunction of alternative cultures and experimentation in art led to a rare openness toward Conceptualism and performance, and the blossoming of feminism and queer lifestyle in California infus[ing] such work with a special awareness of bodily politics. Hence the Cockettes were a defiant San Francisco phenomenon, an outgrowth of its famed gay and lesbian scene" in the 1970s.[19] More than this, the drag troupe's onstage and offstage personae performed queer countercultural worlds with boundless excess. As Joshua Gamson vividly puts it, "The Cockette utopia was one in which the love party erased any differences: we are all freaks under the skin, sisters in glitter."[20]

Terrill's temporary excursions to San Francisco, a city "known as the gathering place of the exiles, the land of milk and honeys," inspired him with that liberationist drive "to make noise," perhaps imbuing the brick and mortar confines of Father Scanlan's office with traces of that other "city" in queer utopian terms.[21] With the "promise [of] less shame, more love, and better sex" in San Francisco, "being suddenly reviled by nearly everyone who had thought you were straight," Terrill grew more defiant, challenging the disciplinary social reproduction of Chicano heteronormativity inside and outside the classroom.[22] He recalls, "My head was full of ideas and possibilities and glitter in my hair and it was just pretty wild and it was sort of an artistic defiance that overtook me and I was like, 'Well, I don't give a fuck about the Cholos and . . . you want to call me names? Call me a Puto? Well, fuck you! I am a Puto! What are YOU going to do about it?'"[23]

This attitude, further reflective of a sexual liberationist call and Chicana and Chicano militant ethos at the time, carried over into Terrill's English literature and philosophy class during his senior year in 1972–1973. Terrill's copy of a 1963 edition of *The Odyssey* shows an expanded sense of "graphic art," a subversive relationship to Catholic dogmatic teachings, and a perverse reenvisioning of Homer's epic poem. In Book IX, Odysseus and his men are trapped inside a cave, where some are devoured by the giant Polyphemus. Odysseus lures the giant into drinking enchanted wine, and he falls asleep, at which point Odysseus impales the Cyclops' eye with a wooden spear. Blinded and disoriented, Polyphemus wrestles horned sheep to the ground searching for Odysseus, who flees the cave tied to the underbelly of a sheep. A vignette by the book's illustrator, Hans Erni, shows the chiseled hero pinned on his back beneath the hooves of the animal and the feet of the monster. Odysseus is caught in the chaotic entanglements of fur, limbs, and frenetic movement.

The homoerotic charge of the scenario and its veneration of ancient Greek masculinity were not lost on Terrill. An illustration on the back of the page omits the sheep from the focal center of the page and instead presents a scene mid-coitus (see figure 4.2). Impaled by Odysseus's other "spear," Polyphemus straddles the hero. His head is thrown back in orgiastic delight. The copulating male bodies visualize an unapologetically homoerotic reworking of Homer. Although these might appear to be the

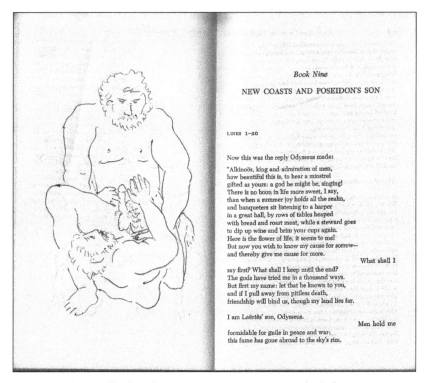

Figure 4.2. Joey Terrill, *The Odyssey* (1969/ca. 1972–73), pen and ink illustration (in verso). Image courtesy of the artist.

scribbles of an apathetic high school teen, Terrill's revisionist intervention permeates the book and demonstrates his burgeoning artistic interest in postmodern appropriation, parody, and an unapologetic visual language of same-sex desire. Such unrepentant behaviors undergird his deepening pursuit to affirm another unseen reality, another reversal of his ethnic and cultural conditions: the image of the maricón.

Terrill's turnabout, a challenge to stigmatizing heteropatriarchal ideologies foundational to church, school, and biological family in something that Shawn Michelle Smith would call "counter archiving," was redolent with Chicana and Latina feminist discourses at the time. [24] Latin American women embroiled in armed movements and interstitial acts of political resistance have been constitutional to redrawing the polemical literary intervention of testimonio outside privileged

authorial male voices. If we concede that "because of the way people of color, especially women, are multiply marginalized in the United States, all autoethnographic expression includes elements of the testimonio," then Terrill's formative artistic practice on the walls of his bedroom, in school office space, and between the pages of a textbook is an analogous intervention—a visual preparation for his later reversals of Chicano avant-garde vocabularies and alternative archiving practices.[25] Testimonio as a feminist of color methodology uses collaborative processes "to create knowledge and theory through our experiences."[26] Terrill's creative efforts to visually detect sexual difference in his work exert a similar collective approach though in the experimental language of contemporary art—conceptualism, performance, intermedia, and participatory art forms—with a Chicanx edge.

Early on, Terrill's knowledge of homosexuals was shaped by the men he sometimes spotted near his aunt's house located down the street from Tyke's, a gay bar in Highland Park. Terrill heard cautionary tales about these so-called sexual deviants. Heeding his tía, he left his tight bell-bottoms at home. Ironically, though, what she did was also to teach Terrill how to attract male attention. The local *lavandería* proved instructional; there he learned how *to see* homosexuals, focusing on a swishy gait, tidy appearance, and clean fingernails alone.[27] However, seeing Chicanx homosexuality was irreconcilable within his particular urban experience, racial geography, and social location. For Terrill and his friends, a cohort of Cathedral alumni, barrio debutantes, and party boys he later dubbed the "Escandalosas" (or "Scans" for short), queer racialized visuality was a cultural nonentity, something hidden and visually undetectable under a white gay ocular regime.

Terrill confronted this visual dearth by providing the means to literalize the very aberration hunted on the grounds of Cathedral's campus and removed from the privileged "eye/I" of Mexican Catholic heteromasculinity. From their mutual experience, the Scans unified as maricones, in a queer avant-garde collaborative project discussed in chapter 1. However, a brief recollection is necessary here to understand Terrill's continuity with testimonio interventions in the overlappings of collaborative art and writing. On July 4, 1976, the Scans were among the 1,500 attendees descending upon Hollywood Boulevard for the annual Christopher Street West pride parade, a festival happening in cities across

the United States celebrating America's bicentennial.[28] Adorned in Terrill's handcrafted stylish canary t-shirts, they took to the streets bearing the slurs *maricón* and, for Chicana lesbian participants, *malflora* (ugly flower) across their chests. "Role model" was playfully stated beneath the neckline on the backside, written in Terrill's thickly lined text, a variation of pop lettering and old English font with the artist's signature dot in the center of the "o."

The entourage walked in ordered step, hands linked, shoulders squared, embodying the avant-garde, a literal advanced line of lesbian and gay Chicanx foot soldiers uniformed in coordinative blue jeans and tan chinos (see figure 1.2). This tactic reinscribed the queer brown body with the mark of a barrio vandal and staked its claim to self-existence in the city by crossing ethnic and sexual urban barriers. Terrill reimagined what artist Chaz Bojorquez calls "Cholo writing" for queer-affirming ends.[29] The resulting "body-placa" unseated the static power of territorializing signage, extracting it from the built environment, and embodying it, showing that, indeed, *maricones y malfloras* were irrefutably visible and their presence must not be denied.[30]

Outside the pictorial frame is Teddy Sandoval snapping photos of this public action. As Terrill's artistic co-conspirator and Scan inductee, his presence at the parade testified to his immersion within a bold and intermedia synthesis naming racialized sexual difference, giving flesh to the signatory placa, and, in José Muñoz's words, "reinhabiting" the offensive.[31] Guerrilla street actions and self-affirming interventions in public space through graffiti tagging were something Sandoval knew well. As noted in the previous chapter, Sandoval practiced "barrio landscape photography" in which "the emphasis of the composition is not merely the graffiti, as occurs when the writings are placed at camera level and isolated from their surroundings. Instead it is the neighborhood, with graffiti as a ubiquitous fixture of the environment," as Colin Gunckel argues.[32]

Growing up in East LA with an attentive awareness of his urban multiethnic space, Sandoval studied "puto" graffiti and documented the erotics of what the barrio told (see figure 1.3). In short, queerness performed the urban landscape, foiling heteromasculine surveillance, testing body disciplining on the street, and confronting Cholos with convincing gender nonconforming ensembles as Legorreta and Meza did in the late

Figure 4.3. Teddy Sandoval in performance action, Los Angeles, California (late 1970s). Estate of Teddy Sandoval/Paul Polubinskas.

1960s (see chapter 1). Queer subversions of Mexican American heteronormative place-making prompted Sandoval's guerrilla stenciling projects that grafted flying underwear, leather chaps, and swinging palm trees onto the skins of derelict buildings, as chapter 3 discusses. Like Terrill, Sandoval negotiated the queer performance potential of "barrio writing" broadly. By expressly using a showy Cholo personage to unsettle a pervasive hypermasculinity associated with graffiti tagging, he undermined antigay slurs mapped onto East LA walls.[33] Scribbling "Barrio Loco WS" beneath signage directed toward "SHIPPING & RECEIVING" in an empty loading dock, he refashioned the Cholo placa with a cruisy and self-soliciting persona. Riffing on a double entendre for gay men's sexual proclivities to ship and receive (see figure 4.3), Sandoval's "Barrio Loco" referenced the derelict corners, abandoned alleyways, and discreet cavities in which same-sex desire's ephemeral existence were made "WS" (on the west side). His "Cholo writing" was a queer iconoclastic rupture reterritorializing barrio urbanity, a palimpsest rewritten with queer desire in a dock to load/unload. His defiant comportment attunes with a cocksure pose.

Terrill and Sandoval share a cheeky subversion of Chicana and Chicano social norms, apparent in their artistic exchanges. These began after a fortuitous meeting at Richard Nieblas's "Escandalosa's Gallery" in East LA on December 18, 1975.[34] The experimental happening that was occurring in Nieblas's living room brought Terrill and Sandoval together with the likes of Jef Huereque, Marcos Huereque, Jim Rivera, and Jack Vargas. The name "Escandalosa" was apt and made its way into a queer Chicanx social vernacular that Terrill retrofitted for his loose constellation of friends and artistic collaborators, another unexpected reversal like the backside page from his *Odyssey* textbook revealing hedonistic behaviors underneath.

The name "Escandalosa" referred to a collective personage, an emergent avant-garde formation like a call and response for queer *carnales*, a gender nonconforming fraternity and sisterhood. "Scan" inducted another visual and linguistic vocabulary that signaled his sexual becoming, a group of Chicanx sexual transgressives seeking ways to collectively name queer racialized difference. Terrill interpreted this collective grouping through another t-shirt enterprise, this time hand-painting "Escandalosa" in typeset that mimicked the Coca-Cola corporate brand. By inserting commercial art advertising into his self-fashioning tactics, he and his friends advertised themselves inside a "pop" repertoire of corporate labeling perhaps evincing the brand's popular slogan sung from Italian hilltops in 1971, "I'd like to buy the world a home and furnish it with love."[35] Their social milieu announced itself at parties and nightlife affairs where attracting attention and mingling among other men activated what Escandalosas did best (see figure 4.4).

These public actions, however, derive from the discreet and experimental exercises in which Terrill and Sandoval pictured maricón abjection a year prior. In *The Maricón Series* (1975), they took a more conceptual approach to photo-performance. Rather than relying on graffiti-influenced typography, they incorporated postural suggestion, textual citation, ethnic-specific cultural props, and photo documentation as modes of expression. The pair strove to depict the abhorrent figure that imbued the walls of the barrio as a pejorative signifier, sounded in the hallways of Cathedral High School in audibly violent tones, and cast shadows stirring heterosexual fears about men loitering in the parks, toilets, and even the local *lavandería*.[36]

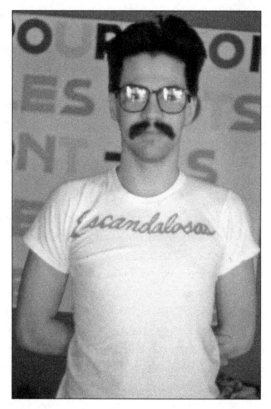

Figure 4.4. Joey Terrill in Escandalosas t-shirt (late
1970s). Photograph courtesy of the artist.

As I discuss in chapter 1, maricón iconography—or, more simply,
mariconógraphy—connects collaborative modes of artistic investiga-
tion with socially transformative outcomes. Maricón as an idea and sub-
versive sign links Terrill and Sandoval's Scan creative expression with a
broader "social practice" vestige whereby the art event catalyzes public
activation in what Nicolas Bourriaud calls "an art form where the sub-
strate is formed by intersubjectivity, and which takes being-together as
a central theme."[37] *Being* maricón in this way practices a creative ex-
pression in anticipation of "the hallmark of an artistic orientation to-
wards the social in the 1990s" as Claire Bishop argues.[38] "A shared set of
desires . . . overturn[s] the traditional relationship between the art ob-
ject, the artist and the audience. To put it simply: the artist is conceived

less as an individual producer of discrete objects than as a collaborator and producer of *situations*; the work . . . is reconceived as an ongoing or long-term project with an unclear beginning and end."[39] Certainly, queer Chicanx avant-gardists rehearsed politically motivated situations with social activist outcomes prior to the 1990s. However, in evaluating Terrill and Sandoval's mariconographic collaborations under the terms of social practice, it is important to heed performance theorist Shannon Jackson's cautionary observation that the "social heterogeneity of social practice" must unsettle "assumptions about the role of aesthetics in social inquiry. While some social art practice seeks to innovate around the concept of collaboration, others seek to ironize it."[40] Thus, any evaluation of Terrill and Sandoval's socially based art-making must not flatten its anti-institutional impulses or how mariconographic vocabularies and different cycles of t-shirt production provoked dissention within the ranks. Not all Scans were unified in this social project of maricón collectivity.

A photograph set in Hollywood's De Longpre Park shows that some participants in the Christopher Street West Parade chose not to appear in maricón/malflora regalia. In particular, one young man in the center of the photograph is without the signature uniform. A fellow Cathedral High School alumnus, Eddie Vela, grew up in East LA in a working-class family of mostly sisters, with the exception of his older brother Louis, who was also gay. Vela spent most of his young life evading the heteromasculine brutality of street-tough Cholos in the city. Vela stood apart from the maricón project, finding its barrio urban character and brazenness irreconcilable with his personal experience: that is, as being "too *elegante*" for the street action.[41] The maricón's "body-placa" was a provocative and ostentatious political performance. For white gay and lesbian spectators at Christopher Street West, it may have reaffirmed stereotypes of Chicanx impoverishment and gang behavior. Vela's appearance in the photograph pricks that Barthesian "punctum," becoming the "poignant" detail in the image.[42] It hints at a "social heterogeneity" among the Scans, as Jackson notes.[43] Vela's grain of experience fits uncomfortably around political realities and visual (mis)statements in the ongoing queer Chicanx struggle for visibility in 1970s LA. Not all maricones partook in the collaborative art statement.

However, Terrill's intervention reversed the atrocities committed by this slur and thus enacted public performances to be read across

variant vectors of social difference. Terrill's milieu proposes a visual and conceptual understanding of testimonio, expanding how "the margins of empire are now 'writing back.'"[44] Although much of the testimonio genre is classically defined as "dependent products" based on "the person bearing witness tell[ing] the story to someone else, who then transcribes, edits, translates, and publishes the text" for social justice, Chicana feminist literary interpretation jettisons this definition, and Terrill does as well.[45] By organizing the collective relation of "being maricón/malflora," Terrill literally writes against invisibility, such that queer and feminist of color cultural productions can "express multiple subjectivities of individual lives, marked by uniqueness as well as shared history and context."[46] Terrill's queer visual testimonio usefully intercedes with collaborative art strategies that string mariconógraphy, participatory engagements, and alternative archiving together amongst the Scans, another queer Chicanx avant-garde formation.

Chicana feminist and queer visual testimonio interrogates institutionalized modes of storytelling and master narratives through a relational critique that is "corrective," collaborative, and sometimes incompatible. And it is through this propensity that the disruptive possibility of *The Maricón Series* outdoes itself. Terrill asserts queer of color narratives otherwise absent from Chicano heteropatriarchy and outside repressive dictates of Chicano nationalism's "la familia." He advances an archive that is as offensive as it is "useful," in the sense in which Ann Cvetkovich understands the term: "A useful archive, especially an archive of sexuality and gay and lesbian life . . . must preserve and produce not just knowledge but feeling" no matter how hard those feelings may be.[47] Terrill affirms this: "When I look at documentation," he says, "I look at a personal narrative, I enjoy looking at pictures of people's lives and so I looked at it as layers, of not seeing enough pictures of Latinos, queer Latinos. . . . And, in fact, with Chicano art, [and the] Chicano power movement being focused on 'la familia' and the narrow ideas of what 'la familia' meant—on the role of men and women—and that propelled me to document an alternative to that [imagery] within a Chicano context."[48]

That "alternative" parlayed a retrospective return to painting in a moment when post-studio and post-object contemporary art practices prevailed. His penchant for photorealism and figuration inspired

new work mired in the gritty urban world of the Ashcan school, the ethnic historical underlays of Eastman Johnson, and lesbian eroticism of Romaine Brooks.[49] However, Terrill's attention to traditional genre painting and portraiture was imbued with contemporary image sources derived from snapshots, slides, architecture, pornography, and magazine found materials about "heartbreak, romance, [and] sex" similar to the comic book melodrama of Roy Lichtenstein and the pop collages of Tom Wesselmann.[50] Terrill's use of acrylic paint and figuration archives the bodies of friends, family, lovers, lesbian compatriots, and, in particular, men, broadening self-portrait conventions and the definitions of a diary. By visually preserving these lives, he allows for a type of historicist corrective, interlaid with collaborative and introspective ligaments. Just as testimonio literature seeks "radically different kinds of representation" through "an alternative form of writing," Terrill's creative practice in image and literary expression does both.[51] Written text strings his paintings together like diary passages confessed over canvas. As the literariness of *The Maricón Series* suggests, this painter writes.

Viral Diaries

Akin to annotations found on photographs or in verse, Terrill's painting titles talk back to viewers, divulging details that refuse open and unencumbered interpretation. The names of his paintings take the titular function of artwork to task. His titles reveal more than they contemplate: *He Used to Untie My Shoes* (1978), *If I Were Rich, I'd Buy My Lover Expensive Gifts* (1980–82), *He Wore Ray Ban Glasses, a Rolex Watch, and He Used to Eat My Ass* (1985), and *I Got Drunk, Called His Machine and Threatened to Punch His Fuckin Face In* (1996). The visual leaks into the textual, an outflow of photographic technology seeps into the written word.

His painting *Yes . . . But It Was a Long Time Ago* (1979) shows this image-text connection by confessing intimate details to the viewer. Based on a photograph of Steven Fregoso taken from inside the young man's bedroom, the portrait captures another time.[52] Fregoso's bronzed body is seen in a partial state of undress—bare chest and toned legs spill from revealing shorts (see figure 4.5). He is positioned to appeal to male desires. With hair disheveled, he reflects the tousled bed linens in the background like a dual erotic portrait of brown body and furniture.

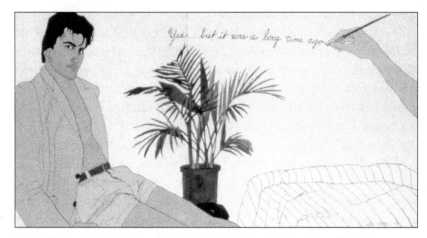

Figure 4.5. Joey Terrill, *Yes . . . But It Was a Long Time Ago* (1979), acrylic on canvas. Image courtesy of the artist.

Quarter-turned, he returns a serious direct stare that cruises Terrill's camera lens with thirsts unquenched. The image is a visual record from a time when Terrill "brought him out" and they had a brief but intense love affair.[53] He offers Fregoso's portrait as a reactive response to general speculation about the nature of their relationship, a rumor that needed correcting especially after Fregoso started dating Terrill's close friend, fellow Scan painter and dancer Victor Durazo.

Terrill confirms, "Yes . . . but it was a long time ago." His metacommentary surrenders an intimate look at the boy in the bedroom, an admission of guilt confirmed by Fregoso's arousal. He is more than a photo source, however. Terrill's hand is visualized entering the composition to the right side of the canvas. Holding a fine-tipped brush, this hand belongs to both painter and writer, annotating the bedroom interior in mnemonic shorthand. He records what Foucault calls the "best moment" between men in that temporal instant of "longing . . . when the lover leaves," resisting the eclipse of time and temporariness of sex.[54] Terrill's painting is a chapter of his sex life now closed—a kiss and tell from the past, recuperated in the present, and redirected for another life course for the pair in the future. Terrill's text and title are crucial to the corroboration of personal details—in it he explicates a queer visual testimonio flattened in the painting's surface, the shallow depth of the

canvas, and evidentiary power of the found photo. Attesting not only to the boy in his bedroom but, most importantly, to the queer Chicanx domestic interior itself, the furnishings tell a story. Like a diary page, the writing is literally on the wall, and it demands consideration.

While many artists use titles of artworks for descriptive and sometime subversive ends—Marcel Duchamp's *Fountain* (1917), signed "R. Mutt," is a classic example of the latter—Terrill's practice is queerly archival. In fact, his spatiotemporal demarcations contain touches of David Hockney, the gay British pop painter who also combines the personal, spatial, and erotic in his work. Like those populating Terrill's oeuvre, Hockney's friends and lovers interpenetrate his canvases and encourage autobiographical reflections and diaristic interpretations. Images of Peter Schlesinger, Gregory Evans, Nick Wilder, Christopher Isherwood, and Don Bachardy construct what Marco Livingstone observes is a "highly personal diary of [Hockney's] life."[55] Similar to Terrill, Hockney's titles work by incorporating names of lovers, like *Peter Getting Out of Nick's Pool* (1966), and Southern California locations, including *Building, Pershing Square, Los Angeles* (1964) and *Mulholland Drive, the Road to the Studio* (1980).[56] However, his approach is predicated on a singular authorial voice, that of a "unitary man-made autobiographer" as Huff claims, which is distinct from Terrill's desire to "document an alternative" through social critique and collective means.[57]

This is not to understate Hockney's place in Terrill's oeuvre. In fact, his role, among gay American and British aesthetes, affected Terrill deeply on personal and creative levels. As a gay Englishman so closely identified with LA, Hockney generated the area's most iconic images of shimmering pools, light-filled desert modern houses, and sun-kissed male nudes basking in the Southland's suburbia. Moving there in 1963, Hockney was driven by an "erotic attraction to the city."[58] And according to art historian Cécile Whiting, he was "engage[d] in a dialogue with subcultural representations of gay life in the city and with midcentury modernism," and was initially attracted to the homoerotic underground of John Rechy's *City of Night* (1963).[59] The Chicanx hustler from El Paso turned avant-garde writer proffered graphic depictions of anonymous sex in downtown LA's Pershing Square, which proved disappointing to Hockney in reality.[60] However, a foray into Isherwood and Bachardy's inner circle redeemed the city for him, albeit on the West Side. He

"integrat[ed] himself into a subculture of gay aesthetes that included an array of artists, writers, and expatriates living in Los Angeles" surrounded by "young and beautiful boys."[61]

One of those "young and beautiful boys" was Terrill.[62] In 1979, he worked as a dispatcher at Metro Dispatch Autoclub, a car tow and repair company on the ground floor of the Prudential Insurance Building on Wilshire Boulevard neighboring the LA County Museum of Art. Terrill worked alongside fellow Scans: Ray Alvarez, Ronnie Carrillo, Louis Vela, and later, Pat Silva. The ordinary hum of another nightshift was interrupted by a panicked call reporting a flat tire on Mulholland Drive. That caller was portraitist Don Bachardy. A follow-up phone conversation from a nervous Isherwood secured Terrill's invitation to the couple's residence for a private dinner party. He attended only to be shaken by the guest list. "I arrive and there was David Hockney and it couldn't have been better if Romaine Brooks had risen from the dead, eight gay men in a range of backgrounds and lifestyle and the thing was Hockney had a sketchbook and it was being passed around and we were having cocktails and it finally came to me for a couple of hours and it was like, it was holiness in my hands . . . [with] his most recent drawings and I look at the sketch of me from across the room."[63]

Terrill's recollection seconds Whiting's claims about Hockney's social circle mingling within this "subculture of gay aesthetes," proving yet another erotic contact zone between gay Englishmen and working-class Chicanxs in LA. Anglophile art, fashion, and architectural styles were similarly influential on these young Chicano avant-gardists' hybrid and promiscuous art vocabularies, as in Mundo Meza's "New Romantic" emulations and Teddy Sandoval's studies of eighteenth-century baroque and later Victorian styles. However, Terrill mingled with a formative generation of postwar British expatriates, gay art and literary modernists living on the West Coast. And although his acquaintance with Hockney was momentary, Terrill's relationship with Isherwood and Bachardy grew. On occasion, he sat for Bachardy, both clothed and nude, testifying to an intimate and participatory art-making process, which matured in his numerous portraits of Isherwood.[64] Bachardy's technique was acknowledged for the way it "record[s] the inner movements of give-and-take between artist and sitter, the subtleties of emotional states at different phases, the never-ending quest to know, and understand, and

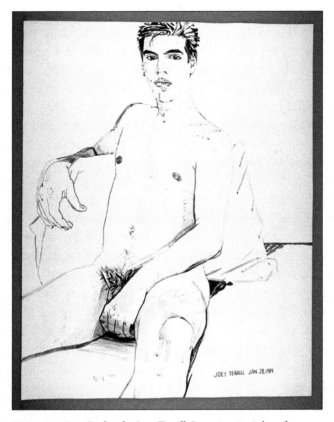

Figure 4.6. Don Bachardy, *Joey Terrill, Jan. 28, 1984*, ink and watercolor on paper. Courtesy of Don Bachardy and Craig Krull Gallery, Santa Monica, California.

have compassion for another human being."[65] Admittedly, Bachardy's attention to Isherwood is unique and defines his corpus between 1953 and 1985.[66] However, his work with Terrill suggests that give-and-take reciprocity, a closeness signaled by his personal inscription in the book *Drawings of the Male Nude* (1986), in which Terrill appears: "For Joey, With my gratitude for his presence in this book, and my love, Don."

Terrill's nude in the opening frontispiece, opposite an introduction written by San Francisco gay novelist Armistead Maupin, is a meditative portrait (see figure 4.6). A guardedness overshadows his youthful exuberance. His left hand is carefully placed over his lap, preventing a

raw unobstructed look at his body—a body time-stamped on the page: January 28, 1984. Twenty-nine in the drawing, he had moved back to LA from New York a few years prior. Unbeknownst to Terrill, this referential image cites a body already infected. Bachardy's drawing operates at a profound moment for the artist, a forecast of the epidemiological categories and slips of time he would soon confront.

His contemporaneous look back on this portrait alters the meaning of artistic collaboration with Bachardy. This image is a turning point for Terrill, a temporal reversal because of its allusions to contagion. Terrill's perceptual shift in space and time was roused by new medical definitions of self. For people of his generation, being "positive" and "negative" reshaped identity, broke it from the linear, causal, and stable "heteronormative time/space constructs" and uncompromised immune systems.[67] AIDS and its visual representations underscore how testimonio literature inadequately writes life cycles in deathly anticipation, in the epidemiological terms of contagion and viral contamination.[68] As Tim Dean notes, "Those who remember the early years of the plague, with its traumatizing images of healthy young people withering and dying, inhabit two temporalities at once: that of HIV as a surefire death sentence and that of HIV as a chronic manageable disease."[69] By occupying "heterogeneous temporalities that overlap without canceling each other," a long-term nonprogressor like Terrill necessarily sees and redefines the spatiotemporal rhythms of the portrait genre.[70] His revisionist attention to self in *Drawings of the Male Nude* upsets progressive timelines in this genre. His anachronistic eye over his Bachardy collaboration finds AIDS with a retroactive look back at an ordinary date on paper—January 28, 1984—that doubles as a timestamp of infection.

As the next section expands, paintings generated after Terrill's diagnosis have consequence for the spaces from which his archival body transmits viral knowledge in domestic display. Terrill's pictures of New York would never be the same.

New York City, 1980–1981

During the summer of 2015, an MSNBC mini-documentary series entitled *Fearless*, hosted by Latina journalist Maria Teresa Kumar, featured Terrill among ten gay and lesbian activists in LA who "made it better."[71]

The episode's title, "Gay, Latino and HIV+: An Artist's Activist Life," contrasts scenes of the dismal outskirts of Santa Fe Arts Colony in the unincorporated city of Vernon with Terrill's studio loft, a vision of Technicolor extravagance.[72] Inside, paintings are stockpiled in layers along the studio's walls and crowding the floor. Sweeping pans juxtapose his off-screen commentary about other spaces, other cities. "Eventually," Terrill retells over the B-roll footage, "because my work was autobiographical, HIV naturally played a role in it as I started to have friends get sick and die, and then, my own HIV status, as well. I was infected in New York in 1980 but didn't know it at the time but I was."[73] Montages of archival photographs cut away to Terrill's commentary. Dramatically lit on a soundstage, his confessions relive in paintings on the wall, telling a story of a different time in a different city. By attuning to the year 1980, we find that Terrill's testimony correlates his abundance of work with AIDS decimation as though the painting stockpile affords artifactual magnitude to this plague's aftereffect on Chicanx queer creative circles. The material proportion of such loss is made possible as the artist looks backward and forward.

For instance, the footage includes glimpses of Terrill's *Self-Portrait* (ca. 1984–1985), a painting based on a photograph sourced from his first visit to New York City in April 1980 and created after his East Coast excursion had ended (see figure 4.7). Brandishing a leather jacket, he folds his arms firmly. His darkening gaze evokes a sense of despair, perhaps wounded after breaking up with his lover, Rick Gildart. A striking man of Mexican and Armenian descent, Gildart was a member of the "West Hollywood 100," a circuit of elite parties organized by affluent older gay men catering to exceptional specimens of male beauty. Terrill's lasting heartbreak is given visual palpability in the stagnant backdrop. A barren vista mirrors the artist's internal state exteriorizing a general malaise. Threatening storm clouds and pools of toxic water carry the dead. His bleak environment is an ominous sign. Though Terrill did not yet know it, his turbulent piece about Gildart was simultaneously a turbulent piece about AIDS in New York. The painting echoes another fight and another breakup. It is further significant because this break-up is cause for Terrill to leave LA and head east in September of 1980.

When he arrived in New York, he had no job, no boyfriend, no place to live. But he wasn't completely alone. His friend Victor Durazo had

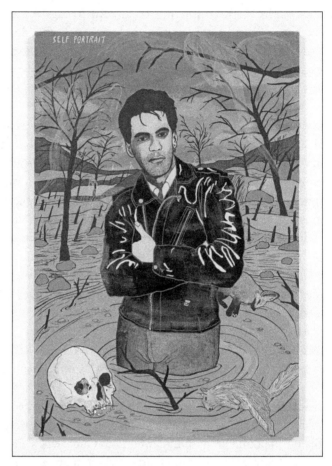

Figure 4.7. Joey Terrill, *Self-Portrait* (1984–1985), acrylic on canvas. Photograph courtesy of the artist.

moved to Midtown where he awaited his lover, Steven Fregoso. Fregoso had secured an apartment sublease from Bill Harris, a gay porn actor whose rise to fame resulted from a starring role in Wakefield Poole's avant-garde adult film *Bijou* (1972). Chicana and Chicano artists Carlos Almaraz, Joey Arias, Elsa Flores, and Dan Guerrero were also among those cultural workers from Terrill's social circles who made their way east. Terrill reunited with his fellow Angelino transplants in an episode little noted in Chicanx art history but one that nonetheless was pivotal

because it demonstrates this art movement's itinerant nature and promiscuous aesthetic influences beyond California.

The temporary exchange of art and ideology between coasts created the right conditions for Terrill's satirical series entitled *Chicanos Invade New York* (1980–81). Titling each painting with barrio-inspired graffiti writing perfected from his maricón conceptual exercises in the 1970s, the typography unites the series in a harmonious textual design. Documenting his group's cultural alienation in three paintings, *Making Tortillas in Soho* (1981), *Reading the Local Paper* (1981), and *In Search of Burritos* (1981), Terrill does so with tongue in cheek. Leaving behind a city saturated with Mexican influences for one where being Mexican American was virtually illegible, Terrill faced his marginalization defiantly by making art and, more important, tortillas. His vignettes record this culture shock, felt despite the opportunities presented by a thriving avant-garde art scene in the East Village and unparalleled access to artworks exhibited in museums dotting Fifth Avenue.

Ironically, the Guggenheim, an iconic Frank Lloyd Wright building, became the satirical backdrop for *In Search of Burritos*. In this composition, set during a snowfall, Terrill portrays the ensemble of Chicanx Angelinos grimacing, smiling, breaking into laughter, and gazing blindly into the snow. Terrill's sister, Linda, centers the tableau. She cups her brow to deflect the glare, resisting her surroundings by turning away from this metaphorical vision of whiteness. This series resulted in Terrill's only exhibition as a recent LA transplant. In 1981, *Chicanos Invade New York* debuted at Windows on White Street with contributions by artists Joy Kreves, Lily Lee, and Naomi Teppich (see figure 4.8). The paintings appeared in storefront window vestibules along a row of buildings in Tribeca, perhaps continuing in the window-decorating tradition central to Meza and Sandoval's corpuses. An alternative exhibition space, artwork changed every month. Despite continuing to generate new satirical work in queer Chicanx painting, Terrill's transition remained a difficult one.

Hindered by poor living accommodations, an inconsolable longing for Rick, and the inexplicable but symptomatic rash on his body, Terrill left New York less than nine months after arriving. However, his co-workers from Conran's Store, a European home furniture retailer,

Figure 4.8. Joey Terrill, *Chicanos Invade New York*, Windows on White Street, Tribeca (1981), acrylic on canvas; from left to right: *Making Tortillas in Soho* (1981), *Reading the Local Paper* (1981), and *Searching for Burritos* (1981). Photograph courtesy of the artist.

insisted that he could not leave the city without first visiting Fire Island, a gay tourist destination popularized in the photography of Tom Bianchi and made infamous in another Wakefield Poole adult film, *Boys in the Sand* (1971). Terrill's one and only trip to Fire Island Pines is captured in a photo taken during a chilly April afternoon in the off-season. The image is an exceptional record depicting his last day in New York, a reminder of his pending departure and another visual record traced by viral infection.

In the course of his MSNBC interview, we see a work-in-progress mounted on an easel in acrylic paint. *Last Day in New York* (2015) returns his archival body to that day in 1981. In a retrospective picture about HIV detection, what was unknown to the artist in *Self-Portrait* (1984–1985) on his first night in the city becomes abundantly clear thirty years later in his *Last Day in New York* (2015): HIV was there all along. Thus, an otherwise pastoral scene of a handsome young man stretched along the beach is recharged as a connective pathway to the disease. An ordinary genre painting fashioning Terrill's home in 2015 "goes viral" in a social media sense, spilling from one timeline to another, when his

first symptoms of HIV seroconversion manifested, an experience he took away with him on that "last day" without the requisite vocabulary to name the signs of his infection.

Although he did not yet know the definition of "gay cancer" on that Fire Island beach in 1981, as Simon Doonan and Mundo Meza may have (see chapter 2), his self-archival depiction charges a familiar artist studio space with retroactive and perhaps "retroviral" knowledge about contagion through a visual re-inhabitation of his body from the past. His paintings' detectable/undetectable modalities complicate an alternative archival formation allowing for another understanding of its memorializing chronicle. Because he retrospectively looks at a tainted immune system in self-portraiture and photographic visual sources, he interrogates the meaning of HIV transmission for himself but also for Escandalosas as they confront their own mortality and indeterminate lifespans under siege.

Up to this point, I have considered queer Chicanx avant-gardists' remains as they have been withheld, concealed, confiscated, cast off, and recirculated beyond institutional ownership and grounded within subterranean domiciles. They are enclosed within dark and withdrawn containers of desire at the ends of domestic cavities and in deep storage. The fact that Terrill is a long-term seropositive nonprogressor allows for a more direct and participatory relationship with his work in exhibition circuits and a self-promoting art marketplace. His search for a commercial gallery dealer has been frustrating. Still, working independently, he continues to make inroads in a way that evaded the careers of most of his contemporaries like Mundo Meza, Ray Navarro, Teddy Sandoval, and Jack Vargas, who are experiencing various resurgences posthumously.

These sociocultural vectors confronting seropositive queer artists of color only intensify the choice collectors make to harbor what Marianne Hirsch and Leo Spitzer call "testimonial objects," which "enabl[e] us to focus crucial questions both about the past itself and about how the past comes down to us in the present."[74] The transfer of the memory of trauma is an *embodied* and, as I will show, *custodial* act of care and display. By broadening the terms of queer visual testimonio, the acquisition of objects that transmit knowledge of a virus and human loss raises important questions rarely addressed in traditional collector

studies. How does internalizing these pathogenic intimations inside the home body reconstitute the household?

How this intimate relationship with viral representation activates the built environment requires further "archival elicitation" of the ways in which private collectors reset the domestic setting with pieces of queer Chicanx lives and deaths and for what purpose. The spatialization of this work echoes not only "how the past comes down to us," as Hirsch and Spitzer note, but also how the acquisition of Terrill's viral diary interconnects a feeling about this health crisis in terms of art custody, home curation, and object positioning.[75] Internalizing Terrill's archival body reorients time-space in households catalyzing para-sites. These disparate homes share a story of Chicanx seroconversion from the San Francisco Bay area to LA.

San Francisco, 1989

Remembrance (1989) portrays Terrill and his lover, Robert Ward, in a lush garden of succulents. Displayed inside the Daly City, California home of gay Chicano novelist Michael Nava and his husband, George Herzog, the painting hangs above a stately modern china cabinet containing Mexican earthenware (see figure 4.9).[76] The painting is a testament to Nava's time as a prosecutor in the City District Attorney's Office in the 1980s. His career in LA's criminal justice system informed his critically acclaimed detective series about a LA-based gay Chicanx criminal defense attorney, Henry Rios. Nava's entry into detective fiction catapulted his career into an elite circle of Chicana and Chicano novelists with successes in queer *and* Latinx literature. As a result of his prosecutorial background, he crossed paths with attorney Roger Horowitz, whose lover, Paul Monette, wrote the moving memoir *Borrowed Time* (1988) describing Horowitz's health decline and death. In it he references a young Joey Terrill, to whom Monette was deeply indebted. Working at the Center for the Partially Sighted in Santa Monica at the time, Terrill was Horowitz's social worker. "The Center turned out to be a haven," Monette writes. "From the very first interview, with a painter named Joey . . . we realized we were in the presence of even more pluck than we could muster on a good day."[77] On a personal level, LA was a gateway to incalculable lows for Nava as he confronted the ravages of

Figure 4.9. Michael Nava Domestic Interior (2014) with *Remembrance* (1989), Daly City, California. Photograph by the author. Image permission courtesy of Joey Terrill.

AIDS there. It is not surprising that he sought a keepsake about that time when the intersection of hope and loss transformed him.

In his Bay Area retreat, pieces from the writer's time in the city come together. Nava's interiors contain a restrained but significant collection of Mexican and Mexican American art, as well as a mélange of paintings, film memorabilia, and relics. The home's glass patio doors open to the foggy embankment blanketing the bay. A dull light casts a gloomy hue over the adjoining dining room space. *Remembrance* forms the focal center of the wall. George and Michael dine beneath it, an elegy for those lost and those still living amidst the plague.

When Nava purchased *Remembrance* after paying a studio visit to Terrill at the Santa Fe Arts Colony loft in 2004, he and George were overwhelmed by the artist's output. "We looked at all his stuff," Nava recalls. "I wanted all of it."[78] His compulsion was perhaps driven by the fact that both he and Terrill faced unparalleled losses. Nava reacted to the work's affective resonance of another time, a "structure of feeling" of

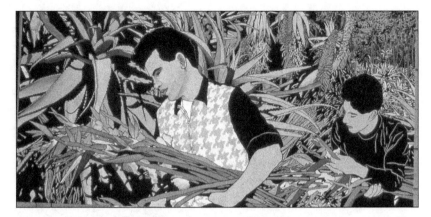

Figure 4.10. Joey Terrill, *Remembrance* (1989), acrylic on canvas. Photograph by the artist.

being "in the trenches."[79] He was lured to the painting because "it was uncharacteristic of what [Terrill] was doing at that time."[80] And indeed, it was. Gone were Terrill's signature tropes—the cheeky social satire, Cholo barrio writing, and textual interventions on canvas. Nava correctly gauged the work's originality, distinguishing it from Terrill's past genre paintings predicated on an individual photo source and confessional reference point.

Remembrance represents a transitional moment for the artist. The work rethinks relationships to time, pathogenic unpredictability, and death. Two men enveloped in a lush overgrown botanical landscape center the tableau (see figure 4.10). Menacing thorns surround them, making any movement risky, possibly fatal. But the men are unaware, not knowing what lurks in the garden. They cradle floral trimmings possibly gathered, mowed down, or shorn from the life giving Earth. The scene conveys an uncertain fate for the pair.

The same-sex couple's vulnerability in the garden makes a startling contrast to Mexican American masculinity traditionally depicted in Chicanx painting. Heroes of revolution and social protest like Emiliano Zapata, Pancho Villa, and César Chávez are familiar representations, echoed in the archetypes depicted in Wayne Alaniz Healy's *Ghosts of*

the Barrio as described in chapter 1. Terrill instead creates sensitive masculine subjects, refusing to represent virile *carnales* and impenetrable machos frequently portrayed at that time. Whether eliciting desire from a *serape* blanket in 1975 or making tortillas in a Soho kitchen in 1981 or delicately caressing floral clippings in a botanical garden in 1989, Terrill's queer visual modalities position Chicano men as homemakers, servile kitchen domestics, self-objectifying hedonists, and bearers of emotion. Despite its mixture of subversion and desire, *Remembrance* succumbs to the uncontrollable plant matter invading the tableau. For these young Chicanos, there is no way out, just a bit of blue sky visible through the foliage. Like *Self-Portrait*, *Remembrance* gives visual potency to that harbinger of devastation, the incursion of AIDS just over the horizon.

After testing positive for HIV in 1989, Terrill was told that the virus would decimate his immune system in a year's time. His outlook grew dire as each new Scan diagnosis mounted, reaching unforeseen proportions. Unlike his previous paintings, which were more facetious in tone and text, *Remembrance* reflects the communal siege he was experiencing. Through the dual portrait of him and his lover, he articulated an epidemiological trauma on a critical scale as another Chicanx and Latinx entered his list of the dead. *Remembrance* is, then, a collective portrait of communal seroconversion, a work anticipating what Hirsch and Spitzer call "untimely deaths in a *near* future."[81] Steven Bruhm deepens this notion in observing that "in the age of AIDS, this distinction between 'anticipation of loss' and 'unabashed grieving' for a loss already experienced" made the perspective for seropositive people and cultural producers such as Terrill difficult to disentangle from the intensity and vastness of human suffering and loss.[82] Never was this urgency to remember so evident than in the alternative experience of spatiotemporality layering Terrill's work.

No longer relying on candid photography that documented "small moments that make up life," Terrill began to advance a performance language that recalled his foundations in queer Chicanx avant-garde practice.[83] With an emphasis on the corporeal knowledge of body statements in posture and gesture—consider a cruisy mode of self-representation discernable from the conceptual rehearsals in *The Maricón Series* and

later *Homeboy Beautiful* magazine—he orchestrated poses for Ward in the Beverly Hills public garden, documenting him among the succulents. Photos from different botanical landscape and floral studies were reassembled to create *Remembrance*'s backdrop. The pair took turns staging themselves against the natural architecture of agave and cacti. The garden's plant life demonstrated the possibility of surviving Southern California's noxious air carcinogens and oppressive heat. And, like the plants, the couple endured. Each snapshot was concisely performed, bringing seropositive statuses, Chicano masculinities, and harsh environments into *Remembrance*'s queer visual testimonio.

For Terrill, this memorial tableau is as much about racial difference as it is about HIV infection. The beautiful yet menacing agave that envelops Terrill and Ward hints at its natural flourishes in Southern California's climate. Its visual citation in the composition invades the pair's body space, suggesting a relationship between Latinidad, labor, and land that connects them to plant life that is nearly indigenous to the region. The succulents' overgrowth interlinks two metaphors in Terrill's work, comparing the menacing tendrils as HIV antibody progression with the immigrant discourses of the city. That correlation between overwhelming plant generation and laboring Mexican American bodies hints at the "lethal" threat of undocumented Mexicans and Central Americans in 1980s LA. As Joshua Takano Chambers-Letson stresses, "In the wake of the Reagan revolution . . . the minority subject [was commonly defined as] a threatening agent of contagion and contamination."[84] By comparing the increase of Latin American immigration and new cases of AIDS, which had killed 30,534 by 1989, Terrill uses these plant matters to bear further insight into nativist, anti-immigrant, and AIDS-phobic anxieties in the city. Unlike the queer ecologies of fractured objects in Sandoval's ceramic graveyard (discussed in chapter 3), Terrill's garden is a commentary on infection as a healthy and Anglo citizen body stands to be poisoned by queer Chicanx men, carriers of viral disease and ethnic incursion in Southern California.[85]

Because Latinidad is deeply embedded in the region, the organic signs of the painting's succulent backdrop also evoke reminders of the alternate healing rituals and myths nurtured in the roots, mud, and nutrient-rich leaf husks of plants like agave, maguey, and tobacco throughout the Americas. Marie Sarita Gaytán notes that agave was fermented and har-

vested in Indigenous ceremony in Mexico for centuries before Spanish colonists distilled it, which galvanized a mezcal industry.[86] According to Patrisia Gonzales, "To Indigenous people, the plants are medicines."[87] "*El poder de las flores*, the healing power of flowers in purification rites," represents a "plant knowledge [that] is so important for Nahua cultures that we literally 'plant' who we are, our *ombligos* (umbilical stubs), placentas, and names."[88] More than seroconversion, Terrill's tableau opens a place for AIDS in plant matter that is distinctively racialized, transnational, and undoubtedly Southern Californian.

LA itself traces the floral bouquets in the pair's arms. Unlike the curative power of plants in *curanderísmo* or Mexican indigenous medicine, the birds of paradise clippings are demure and withdrawn, an iconographic materialization of the young men's emotional work in the garden. This affective site was not lost on Nava, who recalls childhood memories of his Mexican *abuelita* in Sacramento. She gathered flowers from her cutting garden, placing them in rolled newspaper bundles and took two public transit buses to decorate the graves of her parents, a sister, and her son.[89] For him, *Remembrance* evoked this matriarchal memorial practice and intimacy with the dead: "What the two men in the painting are doing is women's work," he reflects.[90] "You know, they're doing the mourning. They're gathering the flowers, which I associate with my grandmother. And in that sense, to me, it is quite subtly transgressive in a certain way of masculinity."[91] Nava's feminization of grief underscores the ways in which spirituality and healing manifest in Chicana feminist emotional and material labor, or what Amalia Mesa-Bains calls "domesticana sensibility." By "reconstruct[ing] aspects of the domestic, the sacred, and the personal," working-class Chicanas "exercise a familial aesthetic . . . characterized by accumulation, display, and abundance . . . allow[ing] a commingling of history, faith, and the personal" to rework "feminine space."[92]

Remembrance and its curated place within the interior of Nava's home participate in a comparable reworking of the dining room as "feminine space."[93] Archiving queer Chicanx memorialization in the domestic display intensifies how the "affective life of [AIDS] politics" rarely documents Mexican men's public performance of emotion in that "emancipatory gesture" of domesticana materiality.[94] That is, Terrill raises an important critique about the ways in which AIDS grief is publicly

enunciated, acted, and ultimately embodied. His tableau ruptures a re-occurring AIDS visual representation of bereaved families agonizing over ailing gay sons. None epitomized this display of human despair more graphically than Therese Frare's bedside photograph of an emaci-ated David Kirby in his final days.[95] Her black and white photograph was infamously repurposed and colorized for a United Colors of Benet-ton advertisement in 1992 to sell clothes.[96] In a crying jag, the father of David Kirby cradles his son's head in a Christ-like scene of self-sacrifice; hence the picture can also be "read as countering images of AIDS pa-tients as alone and without community" as Marita Sturken notes.[97] More than the perpetuation of community, this window on the Kirby clan confronts Terrill's implicit question: Which families get to emote this public health crisis on a national level and, in particular, which men? In this way, *Remembrance* exposes the restrained ways in which Chicano heteropatriarchs perform the affective labor of mourning, and, in turn, unsettles that Mexican American domestic gender economy through the subversive act of flower-gathering by brown male bodies, a floral craft-work closely inlaid with the femininity of home.

Forwarding a visual vocabulary of Chicano manhood with a pen-chant for flowery ornamentation, Terrill brings up the repressed image of the homosexual florist. This romantic, decorative, but reviled figure closely conflates with "sissy" figures in US popular culture. So much so that Mexican masculinity struggles to signify under its sign system, which is predicated on white gay male representations of delicacy and flamboyance.[98] The queer of color potency of *Remembrance* contests this cleavage, finding Chicano legibility and affective expression through a botanical vocabulary. These boys come dangerously close to the femi-ninity of floral craft; rather than engage in the brut labor of *jardineros*, they lament AIDS through the fancywork of flower design.

The stereotype of the floral decorator is further undone in the por-trayal of Ward himself, a working florist. In fact, Ward furnished the bird of paradise bouquets for Terrill's test shoot. His selection is a sig-nificant one. Bird of paradise is the official flower of LA—hence, Ward and Terrill carry delicate symbols of the city cut down. These bundles will wilt, wither, and die. And yet, the bird of paradise is also toxic; it causes nausea, disorientation, and difficulty swallowing when con-sumed, in effect contaminating the citizen body from the inside. Unlike

the thorned succulents symbolizing race and region in the composition's background, these cuttings are tropical specimens not indigenous to Southern California. They are foreign, toxic and sentenced to an abbreviated lifespan. As such, these poisonous beauties are burdens that queer Chicanx men must embrace and carry.

In this way, the floral semiotic—and, by extension, the florist himself—is not only contaminated, but also climatically "unnatural." Terrill and Ward's portrayal of care of the horticultural landscape signals late nineteenth-century "invocations of decadent floriculture" as stand-ins for homosexuality.[99] These are no ordinary Chicanxs evoking what literary critic Christopher Looby calls "the early twentieth-century popular slang terms for flamboyant gay men, 'daisy,' 'buttercup,' and especially 'pansy,' which were then generalized in the term 'horticultural lad.'"[100] With bouquets in hand, Terrill and Ward reconstitute this queer archive enunciating Chicanx men as flowery anomalies, and similar to that abject maricón figure from his early avant-garde practices, this expression of Mexican masculinity does not belong. Not only does the placement of these bouquets magnify the flowers' performance as viral agents in the composition, but they also crystalize the emotional work of performing grief and more importantly, the role of the Chicanx florist little regarded within the creative labor of AIDS cultural memory and the history of Chicanx art and design. *Remembrance* shares other queer traces from Terrill's oeuvre, such as Danny Ramirez, a fellow Scan who distributed flower arrangements to local San Francisco markets before succumbing to AIDS in 1993.[101]

Los Angeles, 1989

Terrill's *Remembrance* was actually the second painting that departed significantly from his signature attributes. *Untitled*, a companion piece, is privately displayed within the quaint Highland Park home of Eddie Vela; like Nava's curation, it appears over the dining room table. Whereas American scene painting inspired *Remembrance*, still life and pop art influence *Untitled* (see figure 4.11). Hard black lines sharpen definition between pottery, petals, and stems in ways reminiscent of Lichtenstein's planar take on floral and kitchenware in still lifes. Budding and blossoming red gladiolus in a black lacquered vase are positioned against

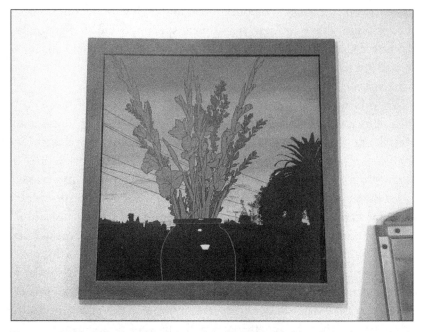

Figure 4.11. Eddie Vela Domestic Interior (2015) with *Untitled* (1989), acrylic on canvas. Photograph by the author. Image permission courtesy of Joey Terrill.

a pink sky at dusk. Creating the view from the West Hollywood window of Eddie's older brother, Louis, Terrill's two-dimensional approach is deceptive, however. It performs Louis's line of sight. The composition asks what his eye might have seen. At the same time, the painting's depiction of the time of transition from day to night alludes to dimming life cycles and the coming of death.

The still life's return to Eddie's dining room echoes the repatriating return of objects after AIDS loss. It is a memento mori for his late brother: the Judy Garland enthusiast, disco queen, and choreographer at La Plaza, the historic Latinx drag bar in Hollywood. The work is adjacent to another wall displaying a framed pen and ink fashion illustration by Efren Valadez, a former high school classmate of Jef Huereque's, a fellow hairdresser of Eddie's, and, like Louis, another Scan stricken by the disease. Terrill's *Woof* (1984–85) hangs in the adjoining living room, a dual portrait of Terrill and Vela in stark black "new wave" couture. Terrill's self-portrait focuses the composition. He peeks out behind a

large black and white headshot of Matt Dillon, a Hollywood heartthrob who could cause gay men to "woof" with dogged excitement. The painting venerates Escandalosa trips up the coast to visit Danny Ramirez in San Francisco and juxtaposes these immaculately attired Scans with the Victorian architectural houses emblematic of the city.

According to Vela, it was he who "planted the seed" stimulating Terrill's aesthetic redirection into the floral still-life genre.[102] He observed caustically: "You know, Joey . . . anybody who's anybody has always done a floral series and nudes."[103] Certainly, Vela's words resonated with the artist, and he was right. Floral still lifes were absent from Terrill's work prior to 1989. More than this, the painting's depiction of a floral bouquet may have been a delayed response to AIDS decimation, a transformation perhaps resulting from an unexpected but influential source.

Terrill's romance with flowers was more than coincidental. The year 1989 marked the passing of Robert Mapplethorpe from AIDS complications. His "Y Portfolio" of floral studies (1978) is a remarkable allegory of life, death, and desire in photography bathed in monochromatic light and shadow. His corpus was a resource for Terrill as it expressed "two kinds of work, using similar frames and visual echoes between the still lifes and what he called his 'sex pictures' to challenge conventions of what is—and is not—beautiful and erotic."[104] Terrill's mixed-media paper collage *Passion* (ca. 1993) is a dialogic addition to this queer language of flowers (see figure 4.12). His wall-length installation mourns Mapplethorpe in layered photocopies collaging male nudes with white calla lilies, leaves, and skulls reappropriated from the deceased artist's oeuvre. Glitter embellishes a low-relief paper surface with a mishmash of timelines, ephemera, snapshots, and avant-garde referents to the past. Street actions like the maricón/malflora march down Hollywood Boulevard in 1976 and cover art from *Homeboy Beautiful* magazine intermingle in a mélange of ephemera. These records point to the subcultural happenings of Theoreticals, anti-clubs Terrill attended in the late 1980s. *Passion*, which happens to share the same title as Sandoval's pen and ink drawing printed in the pages of *VIVA Arts Quarterly* the year of his death (see chapter 3), thus offers a queer Chicanx artistic genealogy in symbolic recognition of and tribute to Mapplethorpe.

Terrill's piece was exhibited in the 1993 *TranscEND AIDS* show at the William Grant Still Art Center and curated by Guillermo Hernandez, a

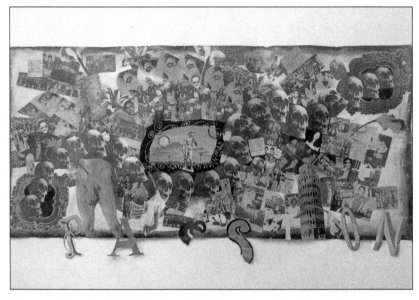

Figure 4.12. Joey Terrill, *Passion* (ca. 1993), Xerox collage with glitter, print ephemera, and paper cutouts. Image courtesy of the artist.

board member of VIVA, the lesbian and gay Latino art organization in LA. Ironically, *Passion* roused arts administrators' anxieties over "the ire of cultural critics who argue for a forceful response to 'the poisoners of culture, the polluters of art.'"[105] Terrill was a consummate offender, a peddler of this so-called poison that needed to be sequestered from an untainted and cultured art public. As a result, his work was placed in a closed-door gallery with a disclaimer forewarning unsuspecting publics of the explicit and potentially offensive imagery. Indeed, LA was embroiled in its own culture wars as VIVA artists and curators like Terrill and Hernandez faced censorship, an art institutional position identified with conservative government demagogues such as North Carolina Senator Jesse Helms, who threatened to withold taxpayer funding for the arts.[106]

Terrill's *Passion* was a combined address acknowledging Mapplethorpe's persecution under pro-family zealots with his own First Amendment suppression at William Grant Still Art Center. More

than this, the loss of Mapplethorpe yielded another commemorative expression, though this time in collage and print duplication. *Passion* ruminated on desired male nudes, recoded Chicano masculinity in a world of horticultural fancywork, and emboldened a queer botanical reimaginary at the cusp of a dwindling Scan queer world. As such, the erotic vocabularies constituting Mapplethorpe's still lifes galvanized an expanded sense of purpose for Terrill's work. In their mutual floral register, Terrill reappropriated the queer representational discourse of flowery bouquets, phallic stamen, and flashes of male physiques to defy neoconservative vitriol and instead visually realign queer Chicanx LA with Mapplethorpe, a figure who, on the surface, could not be more opposite: a professionally trained gay Anglo photographer from Queens. The dialogue between them requires reconsidering Terrill's collaborative art practices with fellow avant-gardist, Sandoval.

While Mapplethorpe's "Y Portfolio" was championed in his 1983 *Flowers* exhibition at the Galerie Watari in Tokyo, Terrill and Sandoval were in LA engaged in another impromptu photo exercise (see figure 4.13).[107]

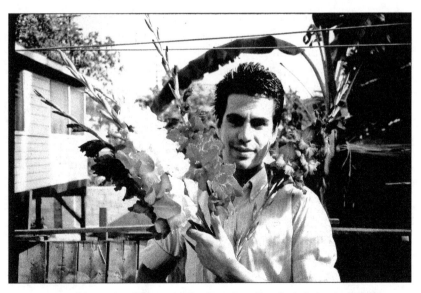

Figure 4.13. Teddy Sandoval, photograph of Joey Terrill with gladiolas (1983), Los Angeles, California. Estate of Teddy Sandoval/Paul Polubinskas and Joey Terrill.

Terrill posed with loosely arranged gladiolas against his body. Flowering spears and delicate blossoms frame his visage and accentuate his masculine facial lines, strong jaw, and furrowed scarred brow. The comparisons of "hard/soft," "masculine/feminine," and "erotic/decorative" advance an aesthetic language consistent with Mapplethorpe's usage of floral props and physical comportment. Richard Meyer writes, "Mapplethorpe proposed [that] homosexuality [was] a space of powerful difference and luxuriant pleasure . . . a space in which the relationship between bodies, objects and surfaces might be dramatically . . . reimagined."[108]

Mapplethorpe's *Dennis with Flowers* (1983) parallels the desirous imaginary of queer Chicano avant-gardes in the restaging of the racialized body through a floral key. Positioned with calla lilies like those in Terrill's installation, *Dennis* is a comparative homoerotic sight where phallus and flowers are hung in correlating reflection. According to Peter Schultz, *Dennis* elucidates "this connection between flowers and the male organ . . . drawing on a tradition in which fruit and flowers have been consistently used within an exclusively homoerotic context."[109] Centering a black male nude for aesthetic and prurient contemplation, Mapplethorpe's *Dennis* "heightens the cryptic dimension of this way of looking. The erotic is not often met with the widespread censure leveled against the pornographic. Yet it nevertheless conveys a sensuous sexuality that is unsettling."[110]

Though Terrill is fully clothed in the gladiola photograph, its staging suggests a comparative corollary with Mapplethorpe's cross-ethnic queerness comparing "flowers to masculine sexuality."[111] Snapshots from Sandoval's camera are equally "unsettling" in the way they interrogate racialized male forms in the sensual relations created in floral arrangement.[112] In the image, Terrill's face brushes against budding spires, expressing his pleasure in the abundance and fancy excesses of homosexuality's phallic delights. Mapplethorpe, Terrill, and Sandoval found mutual joys in lush trimmings and erotic articulations of queer men's bodies. Separated by coasts and ethnic differences, they negotiated the delicacy of racialized masculinities and same-sex desires, a balancing act shadowed by the history of black and brown bodies toiling fields and gardens, a language of flowers spoken queerly.

In this way, Terrill's and Sandoval's collaborative entanglements are impossible to extricate from the gladiola arrangement in *Untitled* and

its placement in Vela's dining room. Vela's drive to collect pieces of Scan lives and fast times brings together queer detrital remnants in an arrangement more commemorative than connoisseurial. His walls tell a story of jaunts up the coast, unrequited lusts for Hollywood hunks, reminders of youthful wilds in Scan fashion. His homemaking incorporates familial loss and traces of queer Chicanx creative designers who, though little known, made inroads in art and dance, hair styling and floral arrangement. Thus, accents of these extinguished oeuvres pervade his Highland Park home, where he re-members lost bodies and better times.

Experiences from the year 1989 reemerged in Terrill's art practice nearly twenty years later. In 2008, Miguel Ángel Reyes, an artist-colleague from VIVA, curated the first gay-male-themed atelier at Self-Help Graphics, a renowned silkscreen studio in the Chicana and Chicano art movement. The show was titled *Homobre L.A.*, a conjunction of "homo" and "hombre," and Reyes had asked Terrill to participate among ten other artists.[113] His lineup brought a more emergent strain of unapologetically queer mixed-media renegades—some self-taught and others art-school trained—with queer iconoclastic stalwarts from sexually transgressive facets of Chicanx avant-gardisms. Maricones, Escandalosas, and VIVAseros alike came together in a mutual pursuit of "homo hombre" visuality in a historic printmaking epicenter.[114]

Among the suite of ten prints is Terrill's serigraph entitled *Remembrance (For Teddy and Arnie)* (2008). With its more elegiac dedication, Terrill's title suggests diaristic reflection and more notably, AIDS political commentary. "For Teddy and Arnie" is a textual maneuver that interjects a retroactive re-vision of the original painting, a literal "remembrance" not only of a community's seroconversion but also of Escandalosas who had since succumbed to the disease. His print creates a visual field reformed by the fog of anti-retroviral drug therapy and post-traumatic fallout on a generation of survivors. Terrill's is a retroactive art strategy, returning to *Remembrance* circa 1989 and rewriting the loss of Sandoval and, in particular, Arnie Araica to it.

The title addendum is not the only change. In the 2008 rendition, more of Terrill's and Ward's bodies appear, but they are positioned farther apart. A study for the silkscreen is particularly instructional in showing how he uses pen and ink illustration to magnify the gap between

Figure 4.14. Joey Terrill, *Remembrance (For Teddy and Arnie)*, study for serigraph (2010), Xerox photocopy, pen and ink, work on paper. Photograph courtesy of the artist.

figures (see figure 4.14). Ward is closer to the print's perimeter, falling off of its edge, in a way that alludes to the couple's breakup in 1992. The claustrophobia of the succulent jungle now makes the landscape's overgrowth in the original painting seem quite tame.[115] In the foreground, exposed earth at their feet makes the spiny plants less foreboding. Using a six-color ink process, Terrill's serigraph further augments the original acrylic palette with blue-black hues, which intensify the distinguishable dark outlines binding Ward to the edges of the paper. The resultant pop finish accentuates details of the textile that Terrill wears.

His attire conveys a classic silhouette borrowed from Pachuco-inspired men's fashion, a post–World War II Chicano vintage look by contemporary designer Arnubal, the signature name of the Salvadoreño-Nicaragüense fashionista, Arnie Araica. Araica was a late addition to the Escandalosa circle; he first mingled with Jef Huereque when both men

lived in San Francisco in the late 1970s. This clothing designer, known for his wild pretense and showy fashions, eventually left the Bay Area for LA, where he sauntered around Huereque's Hollywood pad in eye-catching ensembles and became a perfect addition to the Scan nexus.[116] Araica's love affair with Terrill's friend Curtis Hill segued into social outings with Terrill and Ward until Araica's AIDS-related death on January 4, 1993.[117] Quoting Araica's loud textile in a vibrant chroma, Terrill's shirt resuscitates his friend in the fabric among thorns. Adorned in the material remnants of egregious loss, Terrill wears a reminder of AIDS's catastrophe. Araica's clothing is added to his visual pastiche of broken timelines, a symbol of beautifying art practices that came to an abrupt end. Sandoval and Araica intertwine at the intersection of Chicanidad and Salvadorenidad, Los Angeles and San Francisco, pre- and post-antiretroviral drug therapies. Nearly twenty years later, Terrill recites a fashion statement bearing the sign of unforeseen tragedy in 1989.

Renegotiating *Remembrance* from a contemporary standpoint of post-AIDS drug advancement is an ongoing expression in his work, a story of viral lapse and relapse. His print is not only a reminder of AIDS collateral damage but also of the temporal discord sown in ruptured lifelines. His call for *Remembrance* means something radically different in 2008 than it did in 1989. And it is this temporal dexterity that sharpens his intervention in the original work, revisiting it with a speculative eye. As in *Four Men I Could Have Asked to Marry Me*, he rewrites the past like a palimpsest, confronting the reality of a Scan social scene vanquished. He reconsiders lives that refuse closure because they "could have" pursued other futures, other possibilities. As the recreation of *Remembrance* in 2008 shows, Terrill refutes any static relationship to his work, unsealing closed processes of artistic production to rediscover them anew. In short, nothing is sacred. In his contemporary readaptation of a painting from his past, space and time fray, offering another kind of opening, a way of looking back on a visual record in a way that only a long-term seropositive nonprogressor can actualize on paper and canvas. His retroactive intervention speculates on the meaning of memory and remembrance in an AIDS post-trauma context by reprinting another timeline inside his tableau about a deathly aftermath to come but not epidemiologically defined until the 1980s.

(Un)safe Distance: Hosting Para-Sites

Looking back on Nava's painting, it is difficult to revisit his dining room without thinking about the artwork's future articulation in the *Homobre L.A.* suite. In the print medium, Terrill recommits AIDS's belated yet fatal touch to paper through serigraphy and titular dedication. The retrospective ligature of this work represents another type of movement in need of another vocabulary. After all, Terrill's 1989 works were generated in response to his HIV diagnosis and in turn, realization of certain death. As Steven Bruhm observes, the artist's preparations amid terminal diagnosis "foregrounds the fundamental problem of AIDS art—the future tense creation of a representation in which the subject of that representation is already in the past tense."[118] Because Terrill's immune system has been reinforced, his perilous future is now stalled, allowing for another tense in his artistic creation. Prepped for a retroactive return, he revisits that menacing garden in 2008 only to find its voracious overgrowth kept at bay. HIV's virulent regeneration is evident here—albeit in remission. The question is, for how long? His self-portrait is no ordinary mimetic representation. He recirculates an archival body from 1989, reapproximates his viral self, and thus instills the act of collecting with different implications. The repercussions of cohabitating with tangible representations of Terrill's viral diary redefine the inner workings of the home. Nava and Vela play host to an extension of Terrill traced by pathogenic agents, and paced in an epidemiological lag—that reconstitution of time shaped through delay with specters of AZT drug failures, long-awaited clinical trial permissions, anxiety-inducing medical delays, health insurance debacles, and the paralyzing fear about getting tested at all.

Important still is the way Nava and Vela's household dialogically shares Terrill's chief temporal accord: 1989. They keep time with pieces of Scan seroconversion inside the intimate zones of dining rooms. Because these paintings dwell in spaces intended for entertainment and nourishment, these records of Terrill's viral diary demand a deeper kind of consumptive interaction, a process of transmission echoed in Felix Gonzalez-Torres's candy-spill installations. For example, in *Untitled (Portrait of Ross in L.A.)* (1991), he uses a palatable structure where publics consume and ingest a piece of candy from a mound weighing 175

pounds, the same weight as Gonzalez-Torres's lover. As a conceptual-art stand-in for Ross, the candies eventually dissolve with each visitor's taste, and their vanishing performs AIDS dissolution.[119] According to Chambers-Letson, "Through the encounters with a specific piece, then, a spectator also [comes] into contact with the artist's virus, potentially contracting the virus by engaging with the work and also becoming a carrier of the infection, spreading the virus through the body politic as he or she continue[s] to engage with the political questions posed."[120] Internalizing food and Terrill's companion artwork in the principal site from which meals are eaten augments the house environment as a carrier, a transmitter of viral knowledge in a site of consumption and art display.

Homemaking with a record of Chicanx AIDS devastation contrasts the way gay male domestic fields have historically responded to the disease. According to David Gere, "Many gay men could not fully acknowledge AIDS and the grief associated with it, and it effectively blocked their integration into the shared epistemology of the community of survivors."[121] His point seconds Castiglia and Reed's observation about the amnesiac barriers gay couples imposed to extricate themselves from "risky" and stigmatized public spaces of fantasy and desire. They retreated into domestic fields, exercising "a process of temporal isolation" and "distancing [them]selves from the supposedly excessive generational past in exchange for promises of 'acceptance' in mainstream institutions" in the future.[122]

These blockages underscoring AIDS's *near* amnesia are "an incomplete eradication," however.[123] As Castiglia and Reed note, "The traumatic experience hovers, not forgotten but not remembered, on the edge of consciousness."[124] Under these terms, the process of remembering "hovers" in the built environment like paintings on a dining room wall. More than materializing AIDS memory with a look outward into public acts of collective remembrance, such as civic artworks or monuments, AIDS spatialization also turned inward. A more concise analysis of Chicanx domesticity is necessary because it has empowered alternative modes of cultural memorialization and archivality indoors.[125]

Rarely is AIDS spatialization understood from the context of queer Chicanx homemaking. "Mexican American housescapes," as Daniel Arreola terms them, are "closer to the conception of a historic idealized

landscape partially realized through cultural inheritance and adaptation to different social environments and situations."[126] Arreola's work illuminates the racialized meaning inside structural acts of "enclosure," such as in the home altar, or *nicho* construction, in which containment is empowering.[127] As Arreola suggests, these "housescapes" are no ordinary sites, and if Amalia Mesa-Bains's elucidations of the transformative power of Chicana domesticana practices give any indication, interior withdrawal is as much a metaphor for the preservation of Chicana feminist spiritual and cultural life as it is a response to a health crisis. Walling oneself with visual and material reminders of AIDS devastation activates these enclosures co-habitating with the para-site's epidemiological lag. Thus, Nava's and Vela's willingness to forgo "safe distance" challenges how discourses of AIDS spatialization have historically been predicated on white queer publics either extricated from viral threat indoors or overshadowed by the insistence of what Lucas Hilderbrand calls, AIDS "retroactivism," where mass demonstrations of grief, rage, and social unrest are the sights for intergenerational healthcare advocacy in the present.[128] Not withstanding the critical roles of queers of color in AIDS visibilities on the streets and through public address, remembering AIDS public-facing activities overlooks Chicanx politically and socially resistant interiority. Indoors, containers of desire become crucial micro-spaces from which Chicanx walling, compartmentalizing, and enclosing keeps time with a virus in the rearticulation of home display.

For these reasons, queer Chicanx art and its alternative archivality have the capacity to reveal queer of color biomedical realities with HIV despite being given little agency inside the home. As collection studies scholar Michael Camille notes, "Gender and sexuality tend to be understood as things we see *in* images rather than as inherent in the very structure of relations through which images have been inherited, bought, sold, exchanged and enjoyed."[129] Terrill's retroactive reworkings of contagion pre- and post-infection in housewares reveal something else about these collecting impulses, the way these households *become* in the aftermath of AIDS. According to Andrew Gorman-Murray, "Familial and coupled identities are materialised *in* furniture and decorative objects collected over time."[130] For the long-term seropositive nonprogressor or

the Chicanx steward of AIDS memory, these collectibles punctuate the home with incompleted lifespans and recordings not only of responses to AIDS but also of speculative negotiations of contagion. The resultant domestic interiors confront an intermission of HIV progression and threat of relapse, where remembrance literally "hovers," transmitting reminders of a plague as people with AIDS waned, disappeared, or waded at "the edge of consciousness" as Castigilia and Reed note.[131]

If furnishings materialize an identity, then what does it mean to willfully keep pieces of a virus close to home? The alternative archival formations discussed in this chapter stage a claim to a body, a memory, and a viral diary whereby AIDS becomes an explicit part of the furnishings intended to create comfort and shelter. Inserting Terrill's archival body into these domestic para-sites reimagines the relationship between the testimonio attester and confessor, unseating a passive exchange into a more direct confrontation of a human atrocity told through another kind of AIDS portrait: furniture. A look inside Terrill's home is instructive.

In his Santa Fe Arts Colony studio, Terrill has painted a self-portrait on an ordinary bathroom mirror (see figure 4.15). Like the artworks adorning Nava and Vela's domestic environments, he forwards an image from an earlier time; his youthful visage reconstitutes the vanity, becoming the body-sign from which he gazes routinely. In the photograph, he enters the relation of things constituting the material record of the bathroom: towels stacked above on wire shelving, a shower curtain drawn after a bath, a glass ceramic shelf beneath the mirror. His appearance is a study in contrasts shuttling through time by adding a blueprint of himself. Nonetheless, his body and virus are integral to reshaping his experience of the home-space. In the vanity, an aged Terrill stands in his coordinating blue shirt while brandishing a status symbol of digital advancement, the iPhone. He confronts his younger self with a retrospective look to an earlier period of himself but one that remains connected to his seropositive status. AIDS traces both bodily approximation, and by recasting multiple versions of his countenance at the reflective level of camera, mirror, pose, and self-portrait painting, he presents a mise-en-abyme of timelines, fragile life cycles, and versions of self. In his unidirectional reflection, his portrait and household become carriers, a viral diary of self in things. After all, the visage looking back at him is another

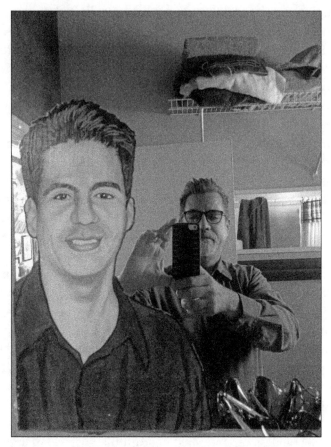

Figure 4.15. Joey Terrill, self-portrait in his bathroom mirror (1989/2015), acrylic paint on mirror, Santa Fe Arts Colony Studio. Photograph courtesy of the artist.

record painted in 1989. By indexing his recently diagnosed HIV-positive self into an archive of furnishing, he proposes another way of *being* in a material world, becoming the interior logics of his domestic space. For Terrill, this is no contemporaneous "selfie." The digital photo articulates a matured perspective, a perception gained from a future otherwise denied to that seropositive young man staring back at him. His mirror is more than vanity. It is an instrument from which he confronts daily reminders of defying the odds and, thus, faces a reminder of possibility and survival amid the devastation.

Living to tell the story of a long-term nonprogressor, Terrill uses the experience in the present to revisit the past for future direction. As I conclude in the next chapter, the afterlives for queer Chicanx avant-gardes require an equally dexterous laboratory for alternative archival forms beyond institutional preservation. By suggesting a return to dormant art practices and terminated oeuvres, I offer virtual ways to make AIDS *matter* in terms of an abandoned project from the museum's nineteenth-century past.

Conclusion

Making AIDS Matter

Archiving an Epidemic tells a story not only about what happened before AIDS but, more important, what happened after. What began as a study of the queer vicissitudes of Chicanx avant-gardisms also became an investigation into the afterlife of records tattered from the whole, confiscated from private archives, and occluded from an "official" accounting of Chicanx art and performance studies and, more specifically, cultural responses to this health crisis. An archival body/archival space study not only demands a redefinition of recovery and the purpose behind it, but also points to "someplace else": the itinerant movement of waste in AIDS's wake, trailings of queer detritus, and dispersals of archival bodies withheld in subterranean remove. Finding AIDS in this way requires queer methods to distinguish the whereabouts of discard and tactical custodial practices that emerge out of trauma and defiance. These divergent and complex afterlives alter object ascendency into institutional spaces, and they encourage a reappraisal of the role of the museum and curation. Thus, my afterthoughts return to the speculative impulses of artists and custodians, which pervade this book and enable the eye to rove across time and space beyond the familiar framework of institutional intervention for preservation's sake. The proposal I offer is what I term a "virtual queer archival lab" in Chicanx art and culture.

By 1989, with 30,534 dead from AIDS and 42,744 infected with HIV in the United States, the AIDS crisis reached new heights.[1] With the Food and Drug Administration's 1987 approval of azidothymidine (AZT) as the first government-sanctioned drug therapy, a generation of gay men was driven to get tested.[2] Queer Chicanx men like Ronnie Carrillo, Jef Huereque, Ray Navarro, and Joey Terrill received the same HIV seropositive diagnosis that year.[3] As David Gere observes, "not only were an extraordinary number of AIDS deaths occurring during this period, but

these were also mostly deaths of young men at the peak of their physical and creative powers."[4]

In 1991, the Estate Project for Artists with AIDS emerged in New York City to help with legal counsel, estate planning, institutional record transfer, and will preparations and other arrangements. With a pale hand focusing the photograph for the cover of its guide, *Future Safe*, the Estate Project warns, "Give yourself time and your work can survive: you are the person who decides how."[5] As *Archiving an Epidemic* reveals, the Estate Project's "future safe" is no guarantee. "Art's present and future" are in the hand of a de-racialized savior who embraces institutional intervention wholesale, without assessing the cultural vulnerabilities of, and uneven assignments of artistic merit to, queer artists of color, particularly seropositive Chicanxs and Latinxs.[6] Articulating the philosophy of the organization, director Patrick Moore espouses, "We believe that an artwork only lives when it is seen."[7] And yet, if the Estate Project's self-definition is predicated on professional stewards, then how do we reconcile artwork that escapes public exhibition arenas? When rescue is refused on behalf of reluctant ethnic heritage purveyors, is the unseen artwork "dead"?

The whereabouts of personal archives and the dispersal of collections defy streamlined modes of record transference and provenance study and frustrate the life cycles of objects and ephemera that feed formal public repositories. The archival bodies/archival spaces assembled in this book stand apart from the colonial guise of rescue and institutional mediation recapitulated in the Estate Project's preservationist discourse. This study moves closer to the strategic omissions that refuse the official channels of systemic preservation, as queer of color artists and custodians self-assert silences challenging institutional cooptation. As historian Deborah Gray White observes about African American women's cultural heritage, "There are, of course, other kinds of records, but they are not always easy to locate" because "black women's reluctance to donate personal papers also stems from the adversarial nature of the relationship that countless black women have had with many public institutions, and the resultant suspicion of anyone seeking private information."[8] Chicana feminist historian Emma Pérez similarly recognizes "the interstitial gaps, the unheard, the unthought, the

unspoken . . . interrupt[ing] the linear model of time . . . in such locations that oppositional, subaltern histories can be found."⁹ Adding an alternative archive's refusal to engage in the colonial terms of lost/found rediscovery (especially when what is "rediscovered" was never lost to begin with), I pivot toward what art historian Bethan Stevens calls "art-memory," suggesting that "artworks whose whereabouts is unknown . . . make rewarding objects of study in their own right. . . . Like memory, lost works can turn disciplinary definitions on their heads."¹⁰ White, Pérez, and Stevens point to an institutional dilemma that upends lost-found discovery in a colonial sense and asks that we find a way to curate in absence, to work on behalf of ghosts—not as an end but as a source of creative opportunity.

In the pages that remain, I propose other directional possibilities for these alternative archival formations. I meander through a book fair, haberdashery, and pre-Columbian monolith in episodic vignettes that suggest their queer afterlives. Because archival bodies/archival spaces shuttle around disparate routes, the future of these zones of wreckage must resist unidirectional, straight modes of recovery. Whereas Jennifer Tyburczy makes a compelling argument for a queer curatorship that can "materialize a spatial and discursive approach to display that utopically imagines new forms of sexual sociality and collectivity between bodies, things, and nations in public institutional display spaces, such as museums," her critique stops short of thinking through the underground trails where the queer of color artists and custodians at the center of this study are located.¹¹ Difficult to access, the alternative archival constellations under consideration in *Archiving an Epidemic* can be damaged by external disturbances. Affective tethers, object networks, vernacular curations, and queer custodial attachments can be unsettled or discarded, even as they are justified in the name of public access, record longevity, and educational good as espoused by traditional agents of archive and museum administration. However, what other afterlives can be reimagined for archival body/archival space if speculative inquiry was principally engaged?

Before contemporary media outlets and high-profile exhibitions such as *Art AIDS America* (2016) revived an AIDS cultural industry predicated on "chosen markers that suit a dominant narrative," AIDS art and performance did not sit well within conventional museums and

archives.[12] Seeing them as sites of antagonism, injury, or suppression at the crux of the culture wars of the 1990s, Silence = Death co-founder Avram Finkelstein met activist-museum collaborations with pessimism or detain, skewing the popular perceptions surrounding his involvement in the site-specific installation, *Let the Record Show . . .* (1987) at the New Museum, as discussed in chapter 2.[13] He recalls, "I had a political antipathy for the art world, based on my long-held belief that the sole function of Western European aesthetics is the consistent reinstatement of whiteness, patriarchy, and class, in support of colonization and hegemony. I had abandoned my art practice and wanted no part of a museum installation."[14]

Scholars such as Alan Wallach concur, arguing that "art museums are profoundly conservative institutions and although some have in recent years made concessions to, or even encouraged, revisionist approaches, the majority continue to resist the implications of revisionist scholarship and critical theory."[15] In opposition to this tendency, I turn to what Griselda Pollock calls the "virtual feminist museum" as alternative, one that acknowledges "a perpetual becoming of what is not yet actual," or in José Esteban Muñoz's words, "something that is not quite here."[16] To curate AIDS' devastation for queers of color necessitates that a sixth operation axiom be added to the archival body/ archival space study model: a speculative activity I term the "virtual queer archival lab."

If, as Pollock suggests, "the dominant social and economic power relations that govern the museum make feminist analysis impossible,"[17] then this also holds for queer of color critique. Hence, I ponder "unexpected pathways through an archive of the image in time and space," pathways that diverge from the institutional disciplining that stripped Robert "Cyclona" Legorreta's scrapbook from its spine, minimized Mundo Meza's historic significance because of his lack of hard evidence, or sentenced Jack Vargas's new language for a new society to the La Brea Tar Pits.[18] Like the "repository" in Chela Sandoval's theory and method of oppositional consciousness whereby "subjugated citizens can either occupy or throw off subjectivities in a process that at once enacts and decolonizes their various relations to their real conditions of existence," the virtual queer archival lab "throws off" institutional confines in search of other possible futures in the "jostle" of timelines.[19] By turning toward those

"leaks beyond the confines of the gallery," we decolonize our curatorial practice and embrace the "more disorderly truths" in AIDS queer of color pasts, even if only virtually.[20]

The episodic vignettes that I unveil in this chapter make a related yet unexpected intervention through a curatorial practice borrowed from the museum's nineteenth-century past: the "cast collection." Casts or copies were central to arts education, visual study, and a national culture where reproductions of architectural and sculptural specimens allowed access to little seen, difficult, and remote locations. While the cast is not the only visual and material vocabulary at work in a virtual queer archival lab—because the phantom nature of AIDS erasure, live performance, and nonextant works demands its own envisaging—this chapter offers one approach speculating on what replication can do. By moving closer to the improvisational impulses of Mexican American material worlds, I offer a virtual platform for these bits and pieces of archival bodies/archival spaces beyond gallery walls and static displays.

Cast culture, I would argue, is closely evocative of the queer futurity of museums. Once a utopian project of museum progress from the mid-nineteenth century, casts glean what José Muñoz calls "the anticipatory illumination of certain objects [as] a kind of potentiality that is open, indeterminate, like the affective contours of hope itself."[21] Casts' anachronistic status as material duplication troubles institutional possession over the original, whole and complete. Much like queer detritus's centrality to the alternative archive formations in this book, the "anticipatory illumination" of materially compromised things organized outside institutional futures yields "a kind of [queer] potentiality" as the cast deviates from traditional life courses for historically valuable art objects and undercuts the burden of proof placed on formal art acquistions.

Consider how Claudia Stein and Roger Cooter have questioned the fraught aesthetic evaluation of AIDS activist posters in museum and archive exhibitions, severed from their circulation on the streets and from AIDS activist communities' demands for medical access and social reforms: "The moment such objects become collectors' items and are stored and/or displayed as artifacts they become epistemologically loaded through the very process of objectification."[22] Virtual approaches to queer archival afterlives challenge the terms of objecthood in white gallery cubes, refusing to deattach the subterranean space shaping the

domestic articulation. Thus, alternative archival formations require new understandings of collection afterlives for the orphaned or unlocated remnants of devastated queer Chicanx worlds. By moving closer to the Hispanophone etymological meaning of *curar* (to care), I propose other trajectories for archival body/archival space that "leaks" beyond traditional preservation assignments. These directions are reimagined sometimes in tension with straighter futures that public historians, cultural heritage professionals, and record administrators prefer. By working in a virtual key, this book's final thoughts return to a language of casts to espouse other ways for the scholar, curator, and activist to make AIDS *matter*.

Museum Queer Futurity

Since the nineteenth century, speculating the future has pervaded national museum building with the cast collection being indicative of this virtuosity. Consider the Metropolitan Museum in New York City, the first universal survey museum in the country, which was established in 1870. It crystalized in a post-Reconstruction era as initial military attention to the Caribbean culminated in the Spanish-American War by century's end.[23] More than being a competing colonial power, the US nation-state also sought a sophisticated language of European antiquities and pillage from hemispheric conquests. However, the nascent museum culture in the United States sought another version of masterworks, duplicates perfected from sculptural and architectural models.[24]

In these civilizing temples, a reciprocal "cast culture" arose between 1874 and 1914. Accordingly, "cast collections were not an oddity or a transient fashion but *the* central attraction of American art museums."[25] For the goal of producing a discerning art public by displaying benchmarks of aesthetic citation, it was thought that the simulacrum "was as good as an original," as US National Museum Director George Brown Goode lauded in his 1889 report, *The Museums of the Future*.[26] For Goode, museum futurity was ingrained in curatorial projects serving publics with "the willing acceptance of copies, casts, impressions, photographs, diagrams, and other surrogates for primary artifacts."[27] A systemic reimagining of the exhibition through oration was another way of narrating artifacts in the dissemination of knowledge. As Barbara Kirshenblatt-Gimblett notes, the "textualize[d] object" and "objectif[ied]

text" emerged to supplant the disappearing "illustrated lecture," using a literary surrogate for the displaced professorial body and rhetorical address.[28] Artifactual literacy grew in importance because "objects were to be read like books"[29]

Connoisseurial attentions to originality, aesthetic distinction, and artistic merit had not yet arrived, and so the resulting trajectory for collection development elevated "copies . . . to play a special role."[30] Reading artifacts usurped the display's power of authenticity. However, the reversal of the pendulum was striking and severe. Goode's projected outcome for a museum future in duplication sharply contrasted with affluent vestiges of art capital, commerce, and collectors. Aesthetic zealots like Boston Museum of Fine Arts director Matthew Prichard took a page from his mentor Bernard Berenson and cast the replicas aside because they "could not communicate the emotion produced by an original."[31] The cast in its apparent affectlessness rendered the copy null and nonreproductive. Like the futures of queer lives, casts were comparative failures discarded and sentenced to an object afterlife in the ruins of museum storerooms, fossilizing a bygone era. But as David Carrier observes, "Much might be learned by explaining why most museums do not any longer exhibit such copies."[32]

In 1954, art writer André Malraux found good use in a related language of casts: photographic duplication. The camera stood in for the clumsy yet authorial replica with a more itinerant option for collection and study. Geoffrey Belknap and Sophie Defrance describe this technological conversion in Charles Darwin's engagement with the nascent medium. His "highly portable photographs became substitutes for museum objects, and by extension, a substitute for museum collections."[33] Surrogating artworks in this way captured the creative potentiality of object reproduction, a photographic flattening of casts thereby emboldening Malraux.

Dreaming of the "le musée imaginaire," or imaginary museum, he reversed course and returned to the duplicate in the diffusion of visual knowledge.[34] A burgeoning art book industry expanded the formats available "in that reproductions allow . . . objects to be 'liberated' from their actual locations and combined at will."[35] A famed 1953 portrait photographed by Maurice Jarnoux picturing Malraux at home depicts him standing over rows of artwork copies, tearsheets representing three

thousand years of artistic wonders. His critical stance is the "means of technological levitation" reordering strands of periods and styles in ways that break from teleological orders, the brick and mortar confines of galleries, and the limitations of positivist museum presentation.[36] Speaking in a virtual mode as Darwin did, Malraux commenced art historical retellings through radical associations of object reproduction, through copies. Using books, he advanced a virtual gallery before the advent of the Internet redrawing art networks across the floor.

Malraux's undoing and reimagining of art-historical knowledge resonate with the image-history work of Aby Warburg decades before. Warburg's *Mnemosyne Atlas* (1924) exposed afterlives for visual forms regenerated in aesthetic repetitions mined from photography, illustration, newsprint, specimens, and paper bits. This rhetorical recurrence links imagery from classical artworks and cosmological archives. His copious comparisons unveiled material, visual, and scientific constellations that "leak" beyond institutional definition. His documentary panels signal their own ends in failure. They were never completed, though they exercised "the uncanny movement and persistence of certain formal tropes that encoded and transmitted affect."[37] Perhaps in defiance of Pritchard's dismissal of the replica's affective impotence, Warburg's photographic duplications feel art history and canon formations differently. According to Grisela Pollock, his atlases parlay a speculative point of inquiry "demonstrat[ing] his other conception of what the history of art might be."[38]

Observing Warburg's work in a past conditional tense, Pollock appeals to a speculative grammar of an art history that could have been.[39] A virtual queer archival lab has a comparable impetus, submitting queer Chicanx visuality not to amend current canon formations or fulfill a more complete American art story but to propose virtual pathways, subterranean fields, and hypothetical associations granting archival bodies/archival spaces afterlives beyond familiar institutions. The reimagined vignettes staged in this chapter "throw off" the singular and autonomous retelling of a straighter, more linear Chicano art and avant-garde history as Chela Sandoval notes in her decolonial musings about the archive.[40] The outcome is particularly urgent for artists like Mundo Meza, who died without a formal estate, who painted to alleviate his social isolation, who sought a future in the magic of his mother's

ceremonial cures, who expressed monochromatic visions as he painted near death, who passed away thinking he was going to get better—who left but didn't want to go.[41]

The virtual queer archival lab proposed here is dialogic, "tracking relations among artworks," as Pollock does in a virtual feminist museum.[42] In the scenes that are about to unfold, I bring together sites emblematic of a failed museum futurity. By reoccupying the improvisational powers of Chicanx material worlds and vernacular stewarding of archival bodies/archival spaces at home, I challenge the emotional defiency of copies as Prichard once charged them. Returning to a language of casts, replicas, and duplications, I favor what affective resonances might afford the obliterated artworks and records ravaged by AIDS. By working through and against the profound domestic ties to these fugitive sources of queer of color knowledges, I engage virtual possibilites in a queer archival lab to challenge the Westernized museum impulse to intervene, rescue, and possess. Rather, I offer other outcomes and possible afterlives for alternative archives in respect to, and not in spite of, queer custodians' future directions for these remains.

In the following site visits, I posit speculative curations for artists linked through AIDS's material impact on queer Chicanx art and avant-gardisms in Southern California. The projected afterlives for the alternative archives of Joey Terrill, Mundo Meza, and Teddy Sandoval share a cast language in three corresponding idioms: the *reprint*, *replication*, and *revisitation*.[43] As these episodes unfold, they "jostle" in time and space, unfurrowing Chicanx art's queer futures and, like Malraux's print copies strewn on the floor, stand to retell the past through a virtual undoing and remaking.[44]

Site 1: Reprinting Maricón Future/Past

The *Los Angeles Times* declared it one of the top five "must see" booths at the 2015 Printed Matter: L.A. Book Art Fair. Edging out more than three hundred exhibitors representing DIY, self-published, and independent print publications from around the world, the Maricón Collective caught the attention of cultural critics, bloggers, and art journalists alike.[45] Donning this offensive moniker in stylish writing printed on uniform black sweatshirts, these "maricón" upstarts attracted even

Artforum, which commented on the group's "feathery graphite cholo erotica," a hybrid aesthetic combining aspects of *Physique Pictorial* magazine with amateur *Pinta* (Spanish for "prison") art and low-rider imagery.[46] Word about this queer quartet traveled around to the more than 30,000 people in attendance.[47] The Maricón Collective announced the rerelease of Joey Terrill's little-known underground magazine *Homeboy Beautiful* (1977–1979), a satirical art and lifestyle digest for the "Homo-Homeboy." As *LA Times* art critic Carolina Miranda warned, "This represents an opportunity to lay your hands on some pretty rare work—only 100 copies will be printed of each."[48]

Media interest in the Maricón Collective was impressive to say the least. The group had formed just one year earlier, in 2014, after Rudi Bleu, a Chicanx *punkero* and DJ, contacted Manuel Paul, the artist behind the queer Cholo pen and ink illustrations posted on social media, to collaborate.[49] When they were joined by Carlos Morales and Michael Rodriguez, the energetic quartet built a following by hosting "happy hour" socials in Silver Lake gay bars, "spinning" at the Tom of Finland erotic art fair and gallery, and organizing outdoor "old school" parties.

The combination of image, sexuality, and wearable art statements declaring oneself "mijo," "daddy," or "maricón" permeated the intermedia atmosphere of "backyard boogie parties" that Bleu organized, perhaps recalling those impromptu hangouts he witnessed as a child.[50] The group's appeal built on that experience of growing up queer and Chicanx in the Southland, relived in the audible soundscape of nostalgic Chicano rock, "throw back" punk, and a cursory trace of that charged question Bleu and Morales remembered from their youths: ¿Que eres Maricón? ("Are you a faggot?").[51] Although spoken with aggressive derision, the question became socially organizing in this context and thus unifying.

"Hailed" as a maricón allows this group to coalesce behind its abjection and, in Muñoz's sense, perform a "disidentifying" recircuitry for queer of color collective ends, perhaps compelling that forward march of the Escandolosa Circle or "the Scans" (as described in chapters 1 and 4 of this book), who strode down Hollywood Boulevard in 1976 with defiant steps.[52] That shaming force of being sexually abject, of being the inverse of *machista* ontological legitimacy, refortifies the maricón marginalia as a powerful social project across media and genre. Mindful of the queer worldmaking proposals of queer Chicanx avant-gardes

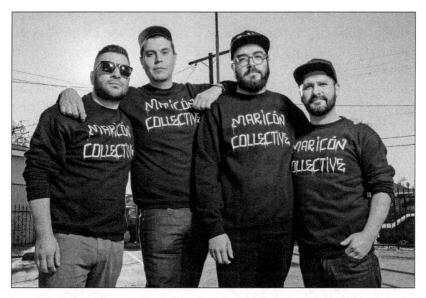

Figure C.1. The Maricón Collective (2015); from left to right: Carlos Morales, Michael Rodriguez, Rudi Bleu, and Manuel Paul, 2015. © Danny Liao Photography.

decades before it, the Maricón Collective curates a mash-up of queer desire, "old school" tunes, barrio street urbanism, and Cholo aesthetics.[53] This visual-aural complex is predicated on an offensive Spanish word made literal on black sweatshirts not unlike those peddled by *vendedores* at the Santa Fe Springs Swap Meet (see figure C.1). For this millennial queer cultural readership, "maricón" is resuscitated as a badge of pride, a call and response to an indomitable collective self.

Despite the expanding media coverage, what remains little recognized is the way this group partakes in a larger visual genealogy anticipated decades earlier and articulated in what I term the "mariconógraphy" actions of the Scans from the mid-1970s.[54] The parallels between the early queer Chicanx avant-garde intervention and the postdisciplinary, poststudio art crew is hard to deny. The revival of mariconógraphy links both collective bodies together, synchronized through a queer iconoclastic tenor and defiant spirit. In fact, as Terrill signs *Homeboy Beautiful* copies at the Printed Matters booth, he uses a rubber stamp from his mail art networks in the 1970s. His printed self-portrait adds yet another maricón certification for the wares sold at the table, making the

collaboration an intergenerational exchange. Furthermore, it entangles maricones of all stripes in a Southern Californian queer creative lineage. An arbiter of all things "homeboy" and "beautiful," the reprint proves successful, and the two-issue limited edition sells out.

In Terrill, the group found an ally, someone who could aid in its sexual reimagining of queer Cholo visuality, someone who could activate a queer archive of the abject maricón, more brazenly homosexual than the Asco collective, more "old school" in sights and sounds, more conversant in the eradicated sexual cultures of pre-AIDS LA. Such conditions set the tone to reactivate a project gone dormant in queer Chicanx art and performance: *Homeboy Beautiful* magazine. To understand the cross-temporal loop restaged and disseminated through the reprint, it is important to unfetter the Scans' visual vocabularies formed in East LA's queer liminality in the 1970s, a brazen improvisation of same-sex desires though accented with premonitory signs of the disaster to come.

Homeboy Beautiful magazine originated in 1977, when Terrill was an undergraduate at Immaculate Heart College. After reading in *New West Magazine* a condescending and patronizing exposé on the "social problem" of East LA juvenile delinquency, introducing California's middle-class readers to the infamous and unseen criminal edges of gangs in the city, Terrill started to wonder: What would happen if the tables were turned and the cholas themselves investigated the affluent dictums of westside elites?[55] At the suggestion of one of his art school classmates, Skot Armstrong, Terrill produced *Homeboy Beautiful* magazine, a parody of *House Beautiful*, featuring glossy page layouts of wealthy home interiors from a maricón's point of view.[56] Using contrived photographic vignettes, didactic thought balloons, and a portrait for each magazine cover, Terrill's *Homeboy Beautiful* embodied his satire and self-image. As the resident "cover girl," he confronted the hypermasculine diatribes of Chicano print media and challenged that pervasive "straight" propaganda of chiseled Aztlán warriors, fraternal photography of barrio *carnales*, and muscular low-riders in car club ephemera with satirical commentary and wit.

Homeboy Beautiful faced the same limitations as other 1970s college and community-based activist networks did in self-publishing their ethnic print media.[57] What Terrill lacked in production materials and equipment, he made up for with a resourcefulness learned from his

immersion in mail art, an art practice forwarded in the 1950s by Black Mountain College alumnus Ray Johnson, who sent what he termed "moticos" or miniature collages anonymously in the mail, activating a federally sanctioned site like the US postal service to exhibit "the co-creative process of art-making in both embodied and disembodied forms" (as described in relationship to Sandoval's conceptual "Butch Gardens School of Art" and "Rosa de la Montaña" in chapter 3).[58] Terrill's handmade aesthetic combined Johnson's postal work with performance art, pressing his body and creative labor into each hand-stapled magazine. As Alison Piepmeier notes, "Paper . . . is a nexus, a technology that mediates the connections not just of 'people' but of bodies."[59]

Terrill innovated queer literary expression and brought it in tandem with Chicanx avant-garde performance and image-text tactics.[60] His work echoed the multidisciplinary thrust of the New Left underground press that combined journalism, propaganda, and political manifestos with visual provocation. Employing mail art's handmade aesthetics, *Homeboy Beautiful* origins were mired in adapted cues from collage, tape adhesive, stenciling, type lettering, rubber stamping, and a handwritten Cholo typography, blending graffiti and Old English writing; advanced its message through Xerox photocopying and color ink reproduction; styled its fashion illustrations after highly lauded Puerto Rican art director and Warholian acolyte Antonio Lopez; and offered all this collated within a hand-stapled packet sold at Chatterton's Bookstore in Silver Lake and, more important, at Soap Plant, an eclectic gift store in Los Feliz. Of course, this was before Soap Plant became the neon-lit and pink-tinted retail palace on trendy Melrose Avenue, located just blocks away from Flip where Meza was dressing windows in the early 1980s.[61] Thus did *Homeboy Beautiful* create the necessary art platform from which the mercurial East LA underground emerged.[62] What Terrill was missing were the homo-homeboys. Enter the Scans.

The Escandalosa Circle—Terrill's queer Chicanx social network cultivated at Cathedral High School, gay discos, and alternative art spaces—supplied the naturally "wild" performers to take on the personae populating his covert underworld (for more see chapter 4). Arguably the apotheosis of his broader mariconographic project, *The Maricón Series* (1975–1976), *Homeboy Beautiful* is indebted to modes of feminist self-creation in performance-text conjunctures like Adrian Piper's racially

indeterminate masculine persona "mythic being" in 1972, which circulated via *Village Voice* and Judy Gerowitz's infamous 1970 *Artforum* ad, where she dubs herself "Judy Chicago," a moniker given textual relief in the sweatshirt she wears in a boxing ring.[63] These women artists enacted their radical personages in the flesh and disseminated them on paper.

Homeboy Beautiful seconded these feminist art strategies by also turning to print media, textual reinscription, photo documentation, and performance art. For example, Terrill adopted the persona Santo, an undercover reporter who bravely voyages into the "homo underground in E.L.A." to prove "What *Really* Happens on Those *Hot* Summer Nights in Geraghty Loma!"[64] Terrill's Santo appropriated investigative journalistic techniques reliant on photography from traditional news outlets—in this case, the *New West Magazine*, a West Coast version of *New York Magazine*. As Santo, he unfolded the events from his night infiltrating the homo-homeboy underground of the Geraghty Loma street gang.[65]

Scan performance actions were photographed and staged inside a trailer that Louis and Eddie Vela's family had in its East LA backyard. The trailer formed the epicenter for Scan expressive play, hosting "everything from *Homeboy Beautiful*, to working out, to parties, orgies, acid, drunken debauchery, music . . . it all took place here," Terrill remembers.[66] That little slice of East LA became a pivotal outlet for queer Chicanx creativity. A generation later, the Maricón Collective's nostalgic "backyard boogie" parties strived to do the same.[67] By featuring the Scans' home base as the interior backdrop, Terrill added another spatial signifier to the "found photo" media aesthetic in the magazine. The photos published in *Homeboy Beautiful* were allegedly "recovered," a false projection of investigative reporting, which was a part of the national consciousness following the box office success of *All the President's Men* (1976) and Woodward and Bernstein's catapult to celebrity around the Watergate Scandal.

But *Homeboy Beautiful* was more consistently on par with *fotonovelas* that presented narratives in photographed vignettes. Each pictorial frame was sequenced, creating the illusion of mass, scale, and, in particular, social reproducibility. Dressed in convincing imitations of Chicano urban gang masculinity, the Scans fill the snapshots, destabilizing an impenetrable *machista* body and rendering it susceptible. Scenes portray Cholos' subversive knowledge of gay male camp, connoisseurship for

all things Judy Garland, and expertise in the "hanky code," that quotidian language of handkerchiefs used to convey sexual practices with corresponding color codes and suggestive self-fashioning.[68] Pointing to a homo-homeboy's bandana removed from his back pocket and placed in a tightly folded wrap around his head, Santo offered a metacommentary to the curious reader: "As you can see the homo-homeboys look perfectly normal on the outside. How deceiving!!!"[69] *Homeboy Beautiful*'s playacting dared to show the machista's masculine façade as a pretense masking queer desires permeating every facet of Cholo gang culture—a truly terrifying realization.

These homo-homeboys appear against a backdrop of graffiti and placas (tags) imitating the harsh barrio landscape that these Scans confronted daily in East LA environs. Reading "VIVA LOS MARICONES," "VIVA LOS HOMO HOME BOYS," and "Puta," the walled replica mirrors the exterior built environment inside the Scan trailer. The graffiti further authenticates the barrio setting accentuated with an urban street aesthetic, rewriting the Cholo's signatory scrawl with a declarative "¡VIVA!" for "LOS HOMO HOME BOYS" at home in East LA (see figure C.2). The barrio's impenetrable heterosexuality crumbles against the weight of male intimacy and play as Scans are pictured deeply kissing, grinding, and simulating copulation. In a photo captioned "2 Exhausted Homo Homeboys!," Terrill and Carrillo pose in postcoital slumber. Although photographed in 1978, HIV trails an innocuous jar of Vaseline, an oil-based lubricant dangerous to the integrity of latex and thus contributing to infection. AIDS haunts the visual field. Of those men appearing in the inaugural issue, all seroconverted. Only Terrill and Carrillo are alive today.[70]

This body count is a dimension of the Maricón Collective's rerelease at the LA Book Art Fair that must not be overlooked. A reprint of Scans' creative expression is ghosted by that Vaseline jar, that viral trace of East LA sexual culture infecting a circle of friends and culminating in their eventual decimation. *Homeboy Beautiful*'s reprint resuscitates not only a queer Chicanx avant-garde project from the mid-1970s, but also the dead, coaxing them to the surface of Xerox pages and behind Mylar wrappings. This reencounter raises questions about how to revisit a collaborative art project from the past when the creative circuits that have constituted it have ceased and now ghost the pages. The Maricón

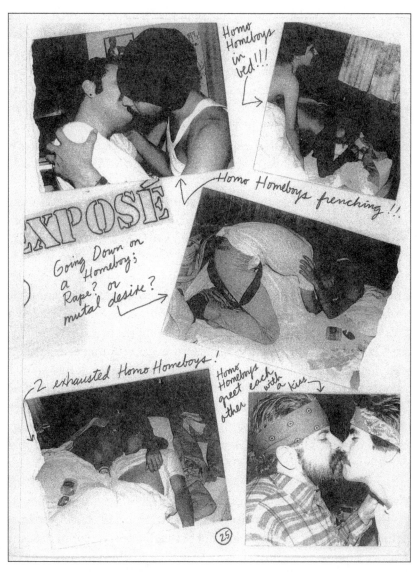

Figure C.2. Teddy Sandoval (upper left) and Louis Vela (upper right) kissing in *Homeboy Beautiful* (1978), photograph mounted on magazine page. Photograph courtesy of Joey Terrill.

Collective's recirculation confronts disjointed mariconographic visual lineages. In reforming around "obsolete technologies" like the art zine, they enfold millennial readers into a posthumous engagement with forgotten queer Chicanx luminaries remediated not by the original but through the radical potential of the reprint.[71] Through Terrill's authentication in hand-punched stapling and personally inscribed stamping and serial numbering, Printed Matter attendees liaison with Maricón bodies—past and present; knowledge about Chicanx AIDS casualties and lost artistic practices is made possible through cross-generational queer stewardship. Like the cast collection, the Maricón Collective's work deviates from art establishment measures of success, skirting the original for the copy. More than recover the zine to objectify and display it apart from the queer circuits of exchange and trade, this contemporary crew of maricón acolytes returns to the reprint, to a queer language of museum failure. In turn, the group's retroactive reversal of terminated timelines and resurrected Scans in the medium appropriate to their reencounter, paper, echoes what J. Jack Halberstam terms "suspect memorialization" by "unleash[ing] new forms of memory that relate more to spectrality than to hard evidence, to lost genealogies than to inheritance, to erasure than to inscription."[72] By getting lost in AIDS phantasmal relations, this reprint commences a cross-temporal loop in which a resurgence of ghosts make possible a reimagining of a maricón past for a maricón future.

Site 2: Replicating Alien Skins

Nonextant artworks and extinguished oeuvres trouble lost/found paradigms in curatorial practice. In the virtual queer archival lab, the following site visit considers a different confrontation with erasure's ineffable consequence for queer of color AIDS art histories: the replica. Resonating with Halberstam's appeal for spectrality over "hard evidence," South African archivist Verne Harris calls for "spectral agency" citing the work of Esther Peeren.[73] He observes that "to pay attention to ghostly authors, voices, narratives, texts, contexts, place and spaces . . . is not easy work. It requires imagination . . . And it is, most often, resisted by structures and systems of power—for attending to ghosts is readily seen by these structures and systems to be (and arguably is)

Figure C.3. Jef Huereque, *Alien Space Drag* (1983/2017), fabric, latex, wire-crusted rocks, plastic piping, and acetate. From *Mundos Alternos: Art and Science Fiction in the Americas*, University of California, Riverside ARTSblock, 2017. Photograph by the author.

subversive."[74] The imaginative approach Harris lauds is "archive banditry" or "los bandidos de la memoria" where it is possible to empower the dead and, in our case, implore visibilities for artworks eradicated, unseen, or otherwise "dead" under Patrick Moore's paradigm.[75] Drawing from curatorial practices exercised by queer custodians who extend archival bodies in surrogate materials and substitutions, we materialize the disappeared and lost in the present. The replica plays a subversive role by refusing to relinquish the inaccessible past and give up the ghost. Like a revenant, it returns from destruction and forgotten milieus and speaks for a corpus omitted from Chicanx art, performance, and avant-garde official archiver.

Consider a sleek black sheath dress with matching skullcap and gloves breathing into a svelte silhouette (see figure C.3). Encrusted space rocks, acetate wire mesh collar, and plastic tubing embellish a glittering

blue chest plate reshaping the body form. An ostentatious vision of extraterrestrial glamour emerges in designer Jef Huereque's recreation of an alien future fashion from 1983. Appearing in the 2017 exhibition *Mundos Alternos: Art and Science Fiction in the Americas* at University of California, Riverside's ARTSblock that I co-curated in conjunction with the Getty Foundation's Pacific Standard Time: LA/LA initiative, a far-reaching exploration of Latin American and Latinx art in dialogue with Los Angeles, Huereque's garment is show stopping.[76] The gown replicates an artistic collaboration from 1983, the traces of which were culled from queer detritus—three scant photographs jogged Huereque's memory of AIDS outbreak in the city. Designing from a place of social alienation, subversion, and life-threatening illness, Huereque coaxes a shadow of the artist Mundo Meza raising it from the dead.

Huereque's personal relationship with the Chicanx window dresser and artist may have ended when he died on February 11, 1985, at age twenty-nine, but the impact of this loss lingered in specters traced to retail and mannequin forms. In October 1988, Huereque opened Modern Objects, a short-lived haberdashery on the east end of Melrose.[77] The *Daily News Record* called it "L.A.'s new sense of Latin chic," a succinct description of its appeal.[78] Converted from a gallery space owned by queer Colombian restaurateur Mario Tamayo, the boutique reimagined the suit maker's shop, presenting men's clothing in antique French chests, armoires, and glass cases surrounded by golden hued walls. Its heavenly ambience was paired with a ceiling mural of parting skies painted by Teddy Sandoval, a close friend, ceramicist, and creative innovator of the interior design company, Artquake. As *LA Times* reporter Barbara Foley observed, "As colorful and nonconformist as the clothes, the store is a monument to contemporary artists."[79] More than this, it was a monument materializing human travesty. Modern Objects was a haberdashery shadowed by trauma and personal loss. The divine allusions accenting the showroom literalized the afterlife. The devastation happening around Huereque reshaped the interior. With Sandoval's palette, his approach to men's visual merchandising was less the "shock theater" resounding in LA retail culture in the 1980s. Instead, his shopping environment resided on a more ethereal plane. His haberdashery perhaps mimicked the incalculable loss he experienced after Meza died.

Mannequins were almost entirely omitted from the shop with the exception of a singular reference. An untitled acrylic painting is a companion piece to Meza's *Portrait Study* (1983) (as described in chapter 2). Like its counterpart, the image depicts a suited self-portrait of the artist. His head substituted with a classic Greco-Roman column. Meza's untitled work is another citation of Picasso's idiomatic influence. *Portrait Study* is painted after he returns from New York City, where he sees *Pablo Picasso: A Retrospective* at the Museum of Modern Art in May 1980 with his ex-lover, friend, and fellow window dresser, Simon Doonan. In his brief postcard correspondence with Robert "Cyclona" Legorreta, he exults in his East Coast excursion. Anticipating the trip to the Picasso retrospective, he "hope[s] they sell slides."[80] Meza was perhaps compelled by what Picasso's cubist vocabulary meant for abstraction and portraiture, as well as by another formal influence: early European mannequin design. Dating to the 1911 Salon d'Automne, when cubism made a splash, an abstract mannequin debuted.[81] Its "surface [was] refracting myriad of tiny broken mirrors," a plastic body remade not from the human form but from the visual vocabulary central to the likes of cubist painters such as Picasso and Jean Metzinger.[82] Meza's geometric perspective galvanized an abstract aesthetic attending to a fashion-forward music video generation while also outlining the haunting language for his personal and social deformity amid his AIDS diagnosis. In effect, Huereque's inclusion of Meza's mannequin surrogate in his retail space staged another afterlife befitting the artist. Ghosts of a queer Chicanx creative community succumbing to the disease occupy Huereque's nexus of French accoutrements, cubist citations, and chic Latinx menswear. Impressions of Meza, Sandoval, and Tamayo "linger" in the retail interior.[83]

Meza's physical deformity, which was a result of Kaposi's sarcoma (KS) lesions scarring his body, was met with discriminatory stares and harassment. As Simon Watney astutely observes, "Throughout the history of the . . . pandemic, questions concerning the proximity of those known or thought to be uninfected to the bodies of people living with HIV or AIDS have played a central role in public discourse."[84] Biospheres emerged in defense of contagion, as geographer Michael Brown suggests, creating spatial distances from gay men as "bodily carriers."[85] Meza entered an alternate reality that was difficult to face. He arranged

a leave of absence from his window-dressing responsibilities at Flip and Melon's on Melrose and took up residency at the Brewery with Huereque on the outskirts of downtown LA.[86]

Like many people living AIDS-symptomatic, Meza found that masking evidence of the disease was critical for his survival. Covering the necrotic traces of KS, tinting complexions, and transforming body surfaces, cosmetics gave gay men the capacity to camouflage during the day and exist at night. Makeup was artillery that Meza knew very well, having exercised it years prior in his experimental performances and gender-defiant avant-garde actions with Robert "Cyclona" Legorreta in LA's urban and coastal landscapes. "He asked me to bring a tin of Pan-Cake makeup. Painstakingly, he sponged it on, covering his swollen face and his lesions," designer Doonan recalls.[87] "Maquillaged, emaciated Mundo somehow looked even stranger than usual like an alien with a beige apple head and a limp rag-doll body."[88] Fashion technology was a temporary escape from terminal illness. Meza's escape from this stagnating social exile required something out of this world.

For an upcoming Halloween party at Palette, a trendy West Hollywood nightclub that attracted the usual crowd—raucous gays, style mavens, and cutting-edge trend connoisseurs—Meza required an outfit that not only disguised the visual signifiers of a disease but could also outwit the discriminating eye of fashion aesthetes. With Huereque, he fabricated an alien drag, a glamorous suit of science fiction seduction: metallic surfaces, plastic piping, wire antennae, and Vulcan ears. Thwarting any suspicion of AIDS, his alien skin allowed him to safely enter a decadent biosphere undetected. For one night, he tasted the "ecstatic" fruits of his refusing to succumb to "the temporal stranglehold [of] . . . straight time."[89] Placing first at the costume contest that night, he celebrated with an expensive bottle of Cristal. "I was out and I came back to the loft," Huereque remembers. "I said, 'Oh, what happened to all the champagne?' and he said, 'Oh, I drank it.' And I said, 'Oh, right on!' Poor man, he was in so much pain."[90] Popping the bottle, Meza was searching for sweet release at the bottom of a glass.

Returning to that moment, Huereque's replica gives flesh to AIDS memory and makes his lover tangible again. Meza's reappearance in the show takes a clandestine flip, fleeing a repressive biosphere alienating him and thus empowers an embodied alien existence. His anachronistic

transport in a costume gallery nearly thirty-five years later reproduces "the negative spaces of the body" with a garment that "[becomes] ghosts or shadows of a performative human form," as Sara Schneider argues.[91] A shadow of him from another time ruptures amnesiac lags in AIDS's post-trauma aftermath. By revisiting an alternative archive drawn from photo detritus, Huereque cuts through the past before Meza died, before his hospitalization, before his boundless creativity ceased. He works on behalf of his ghost and otherwise *drags* the future denied him.[92]

Mitigating the in-between spaces of lost and found, Huereque speaks a language of duplication. His replica sidesteps demands for authentic and unencumbered objects in an art economy of the newly rediscovered, re-collected, and repossessed. From marginalia, Huereque returns Meza to a plastic world of mannequins and cosmic glamor for one last look. We re-member Meza in all his glittering iridescence, casting light flecks over an unknowing art public. His shine infects the museum stage, and for a brief moment, we make AIDS matter.

Site 3: Revisiting Slingback Archaeology

An archival body's disarticulated state demands attention to its dispersion. Trails of ceramics, glimpses of nonextant artworks, and fragments of deceased oeuvres involve renewed emphasis on what Victoria Newhouse considers the "power of [art] placement."[93] While an archival space description and its requisite containers of desire elucidate the significance of privately curated domestic interiors, the queer stewards of these scattered records revisit the past with future purpose. As another mode of duplication, revisitation emphasizes how the built environment might be re-performed, activated in ways reminiscent of museum in-situ exhibitions, which "re-create a virtual world into which the visitor enters."[94] However, those processes of building "virtual worlds" in museum venues give AIDS graphic artists such as Finkelstein reason to pause. AIDS activist posters' codification and recuperation as art objects "become oddly mute" in museum contexts.[95] About these copies he warns, "their social proportion can't be approximated on a gallery wall with any degree of accuracy."[96] Finkelstein demands an "activat[ion] in its performance, in its doing" where the poster is assured

agency that exceeds the authority of wall didactics and label text.[97] And so to curtail the static orientation of museum exhibition objects, Finkelstein proposes a reattachment to these material remains as "lived experience rather than archival material."[98] Perhaps echoing Ann Cvetkovich's "radical archive of emotion," his confrontation with traditional preservation and cultural heritage conveyance requires another spatial and temporal pathway, a reencounter so we may "run loose inside [the artwork's] brain," as he argues.[99] In the virtual queer archival lab, we cruise the architectural ruins of AIDS devastation and revisit these worlds by enacting scenes of spatial replication, a concept energized by Rebecca Schneider's attentive study of reperformance as a "powerful tool for cross- or intra-temporal negotiation."[100] Favoring "the curious inadequacies of the copy, and *what inadequacy gets right about our faulty steps backward*," she challenges "a unidirectional art march toward an empiric future of preservation, time plays forward and backward and sideways" unfolding "the warp and draw of one time in another time— the *theatricality* of time."[101] By re-tracking the footprints of ghosts, we reactivate dwellings, habitations, and treks against the untimely closures of AIDS related death. With "spectral agency," we re-perform "directions not always, or only, *forward*" and thus, we "run loose" in a landscape traced by human loss, memory, and hauntings.[102]

An ordinary tourist snapshot serves as the site from which our initial revisitation occurs. The image documents a couple's trip to the pre-Columbian ruins of the Yucatán (see figure C.4). Teddy Sandoval and Paul Polubinskas pose next to Ian Barrington and Geoffrey Gratz, positioned in the foreground of colossal stone ruins. In a few short years after this vacation, Gratz's partner, Keith Cahoon, would succumb to AIDS complications; Sandoval was next. Their deaths were one week apart. Polubinskas and Gratz experienced twinned tragedies that trail this scene of our final foray in the virtual queer archival lab.

Monuments come in sizes big and small, and Sandoval's final resting place is no exception. Over a period of four months in 1996, Teddy's post-crematorium remains were spread throughout California: the backyard of his Highland Park house on Phillips Way, Huntington Library, and Golden Gate Park. Around a tree in San Francisco, Polubinskas and Gratz merged rings of ash linking terminating lifelines. A granite

Figure C.4. Group trip to Chichén Itzá, Mexico (early 1990s); clockwise: Teddy Sandoval, Paul Polubinskas, Ian Barrington, and Geoffrey Gratz. Photograph courtesy of the Estate of Teddy Sandoval/Paul Polubinskas.

paver from the trunk's base now occupies a corner of Polubinskas' Palm Springs home, cementing this moment and materially reconnecting this deceased circle of friends.[103]

However, this was not the last of Sandoval. The rest of him was left for a monolith built from stone: El Castillo at Chichén Itzá. Taking a trip to Mexico with Gratz, John Ruggles, and Greg Kott, Polubinskas fulfilled his lover's final wishes by returning to a vacation site he adored and homeland he embraced when he was alive.[104] Revisiting the Yucatán, Polubinskas ascended to the top of the ancient warrior temple. Making the ceremonial climb alone with a plastic bag filled with the rest of the remains, he released Sandoval into the Mexican air.[105] With his ashes scattered there, he became a part of the monument, one last performance on a grand pre-Columbian stage. Fine specks settled into the cracks and crevices of the pyramid. Teddy Sandoval, a mischievous trickster, ceramicist, and visual provocateur, became a part of world

history. Polubinskas returned him to ancient Aztec deities *al otro lado* (on the other side).

And yet, Polubinskas was not done. Turning to the sacred cenote at Chichén Itzá, he tossed Sandoval's gold chain into the bottom of the watery pit, handing the rest of him to Mexico. One day Polubinskas thinks the natural pool will be excavated and what archaeologists find amid the limestone bedding will shock.[106] A necklace with a tiny sling-back high heel will be unearthed, giving proof of another great civilization and another glamorous warrior found amongst the ruins.

Polubinskas's return to the Mexican Yucatán retraces footsteps belonging to his deceased lover. He reenacts memorializing body actions continuous with ceremonial rituals and political performances at the apex of the AIDS crisis: candlelight vigils, commemorative walks, and insurgent political funerals where groups such as ACT-UP "carr[ied] the bodies of their dead through the streets," performing "the most spectacular enactment of the [AIDS] movement's conjoining of grief and anger in direct action."[107] Revisitation is a related though private entry closer to the devotional practices of shrine building, pilgrimages, and novenas. "The bygone is not entirely gone by" as Schneider argues, "the dead not completely disappeared nor lost."[108] Polubinskas revisits a movement from the past with future purpose. Disbursing Sandoval's remains, he performs a looking forward to a future archaeology. Imagining an alternative afterlife for Sandoval's things in an ancient place, he also speculates that the process of exhuming a chain with a gold high-heel pendant and a pre-Columbian artifact from a ruin will be one and the same.

Traipsing in the aftermath of personal loss, Polubinskas performs a revisitation with the dead that resembles the speculative underpinnings of director Ira Sachs's elegaic remapping of New York City in the experimental documentary short *Last Address* (2010).[109] Reencountering the last known residencies of twenty-eight artists, the video is a lamenting tour of past haunts. Wandering the city from morning to night, the nocturnal structure of *Last Address* quietly paces the urban landscape. Exterior scenes of buildings, doorways, fire escapes, street-facing windows, and curbside architectural gems are uninterrupted by narration; an eerie calm settles over each stop. Sach's use of diegetic sounds ponder what the artist heard from a bedroom window, what echoed in the alleyway,

what was hummed in the streetscape, what was sung from trees by fluttering birds and voiced in the bustling city by people coming and going.

Artist names and locations are textually superimposed from place to place in brief dissolves. From Keith Haring to Peter Hujar to Robert Mapplethorpe to Reinaldo Arenas (the queer Cuban writer who appears not so coincidentally at dusk before night falls apropos of his memoir's title), Sachs's camera retracks a who's who of contemporary visual, literary, and performing arts.[110] In its essence, *Last Address*'s approach is similar to what Gail Lee Dubrow observes of the "lavender landmarks" heritage movement, which "takes the form of historic houses associated with notable individuals" as a way to "begin remedying the omission and distortions in the presentation of gay and lesbian history."[111] However, unlike the preservation field survey or house tour, Sachs insists on establishing shots. The viewer is never granted access inside the home. Remaining outside the private confines of these addresses, each revisitation is a postmortem remapping of the city, an AIDS archive of place creating intimacy through the ironic distance of exterior scenes. The result is a care of place, for the sanctums from which artists' health declined and the domiciles where creativity eroded. Here, the viewer tarries on the outside and never to look in.

Like Polubinskas's speculative archaeology, *Last Address*'s exterior shots posit a future New York that escapes the dead. After all, the closing epilogue reveals that among the artists featured in the film just four lived past the age of fifty.[112] They never beared witness to New York City of today. Scenes of construction cranes, new developments, building renovations, and, in the case of Vito Russo, demolition shape a gentrifying urban maze and pose the question: Would Klaus Nomi recognize the East Village today? Twisted and turned, the art geography of the AIDS crisis is a portrait of a haunted city, a proverbial ghost tour of what was, what is, what could have been.

Sachs's film catalyzed the "Last Address Tribute Walk" in 2010, inciting promenades to vanished sites in the city, sites either devastated, altered, or bulldozed.[113] Coordinated by the organization Visual AIDS, the city walkthrough reencountered spaces charged with what Ann Cvetkovich calls "a radical archive of emotion" that "must preserve and produce not just knowledge but feeling."[114] Eliciting an emotive experience

of "place-specific memory," publics move in a ghost step with spectral direction.[115] Each stop conjures reflections of deviated life courses, compromised health systems, and spirited memories entangled with the virus, rage, and resiliency. Poetry readings, public dialogues, and shared witness testimony activate each location and serve as stand-ins for headstones or grave markers, which many who died in this plague never received. Embodied transfers of emotion, memory, and recall animate an AIDS archive of place. An artist's last known address sets the stage for the reencounter, a revisitation that does not interfere with the actual interior domains. Rather, each pace is in ghost step retracking deceased footprints and contemplating what ravages these artists once faced, what place memory remains, and what stands to be experienced again. Acting in service of the dead, we exert "the importance of fantasy as a way of creating history from absences" in copying the movements of those who came before.[116]

Following in the dead's tracks, we revisit something that cannot be resolved by institutional mediation arbitrating the original and new. As David Eng and David Kazanjian put it, "a continuous engagement with loss and its remains . . . generates sites for memory and history, for the rewriting of the past as well as the reimagining of the future."[117] The cast and its radical language of duplication does just that, offering a way to rethink the creative potentiality of the revisitation, reimagine the purposes of curation from a project of museum obsolescence, and reencounter afterlives for Chicanx AIDS wreckage in ways that "throw off" the salient historiographies of a straighter, cis-gender Chicanx art and visual culture.[118] Speculative curation speaks in a past conditional tense encouraging a grammar of not "what is" but "what could have been." Like Terrill's acrylic painting *Four Men I Could Have Asked to Marry Me*, the future direction of mainstream LGBTQ civil liberties in the present demand a hypothetical consideration of the AIDS past, a retroactive eye for today (see chapter 4). Terrill's work fits analogously around the lesbian feminist art collective, fierce pussy, and their site-specific installation, *For the Record* (2013). Displaying newsprint ephemera in street-facing windows at Printed Matters in New York, the print textually rehearses the same phrase "if [he/she/they] were alive today."[119] Written like an "incantation," as member Carrie Yamaoka puts it, the recurrent

poetic structure unseals AIDS closure by pondering possibility after loss, conjecturing present timelines for those fallen, betraying the silence endemic to AIDS, and reimagining those lives for now.[120]

The speculative curatorial forms I propose interrogate our assumptions about Chicanx art, its archive, historical actors, and possible futures. Certainly, cast collecting was tantamount to US museum founding, nation-building, and a broader colonial project. However, its end in abandonment, discard, and failure suggests ways to virtually recompose queerer afterlives for archival bodies/archival spaces through the "jostle" of timelines and other constellations.[121] To ask what could have been may upset more institutionally oriented preservation advocates trained to search, recover, and collect. However, the pathways to queer of color alternative archive formations are subterranean, leaky, and, quite often, "disorderly."[122] Required are equally experimental practices that surpass what a museum can activate in terms of its emotional threshold, administrative hold, or physical grounding, looking for ways to preserve and not disturb.

Remains to Be Seen

From the earliest US reports of "gay cancer" in the *Morbidity and Mortality Weekly Report* on June 5, 1981, the seropositive took extraordinary steps for AIDS research advancement in clinical drug trials, organ/tissue donation, and black market buyers' clubs. They endured toxic and exploratory pharmaceutical HIV therapy in desperate efforts to prolong life and discover a cure. As Sean Strub notes, "By making aggressive and experimental treatment choices," the "body [turned] into a virtual lab experiment testing every new treatment."[123] The virtual queer archival lab I am proposing seconds the experimental and provisional impulses undergirding AIDS art, science, and activism. It elucidates a queer museum futurity for archival bodies/archival spaces through what Rebecca Schneider calls the "curious inadequacies of the copy"—in this case, reprints, replicas, and revisitations of architectural ruins.[124] Repudiating lost/found dichotomous logics, we demand queerer vocabularies for these discreet grounds. Working on behalf of the specter of oeuvres and objects long thought destroyed allows us to reimagine curating what refuses to be seen, but like a revenant, stands to reappear.

The virtual scenes imagined here divulge subterranean sites that re-
fuse to turn over the domestic constellation or surrender the affective
charge of queer custodial responsibility from its articulation in a Latinx
material world. As we have seen throughout *Archiving an Epidemic*,
stewards of archival body/archival space care for the afterlives of things,
entrusting their future to the luxuriant surrounds of a designer closet
or the vernacular grounds of a Raisin Bran box. Rather than overturn
these custodial-driven afterlives for the bits and pieces of brief careers
and terminated lifelines, a virtual queer archive lab world-builds with a
speculative impulse.[125] As Eng and Kazajian remind us, "The politics of
mourning might be described as that creative process mediating a hope-
ful or hopeless relationship between loss and history."[126] The imaginative
inroads that speculation and improvisation offer these sites of virtual
reencounter empower a way of seeing possibility in what the antiquated
language of duplication can do.

The late Horacio Roque Ramirez reminds us in his turn to AIDS obit-
uaries as a "gay Latino album of the dead" that "using these unseen and
underused archives as primary sources allows [us] to ground the his-
tory not only of queer Latino everyday *life* in the United States but also
of everyday *death*."[127] More than an obituary, the posthumous oeuvres
of these artists' lives and deaths must necessarily move us closer to that
heterotopic field of debris, that interstitial space of AIDS post-trauma,
bringing experimental laboratories to bear on "identities-in-difference"
that "imagine a world where queer lives, politics, and possibility are rep-
resentable in their complexity," as Muñoz observes.[128] For those of us
immersed in the cultural traffic of alternative archiving, the banditry of
fugitive records, and the spectral powers of queers of color decimated by
AIDS, accessing this (im)material world is complex but also necessary
to transform the terms from which Chicanx art and culture are written
and exhibited. And yet, because Chicanx art history is a nascent terrain,
interpreting its queer past must also refuse the historicist and colonial
compulsion to analyze the "whole," to own the dead, to treasure the rar-
ity, and to dismiss speculative observation all together.

I would be remiss not to recognize how this book's focus on the little-
recognized queer Chicanx avant-gardists will likely stimulate newfound
attention. Because of the domestic frame, archival bodies/archival
spaces are susceptible entities to institutional cooptation, curatorial

agenda setting, and art market cultural brokering eager to own a piece of the new. Traditional curator priorities may also shift, targeting queer remains for formal acquisition reaffirming a conventional artifactual afterlife in object ascendency—a piece of Butch Gardens, a scrap of Le Club for Boys, a trace of Rosa de la Montaña, an original issue of *Homeboy Beautiful*. Monographs, artist retrospectives, catalogs, and symposia are likely to follow. While this collection-building propensity is a familiar response, an ideological shift is demanded. Moving closer to the alternative archival frameworks and virtual curatorial innovations transmits an experience of AIDS's ruin from the fugitive recesses of queer of color cultural knowledge. We must continue to expand the terms and methods for queer Chicanx visual and material cultures, finding radical ways *to make AIDS matter.*

ACKNOWLEDGMENTS

Portions of this manuscript were previously published. Aspects of chapters 1, 3, and 4 appear in "Drawing Offensive/Offensive Drawing: Toward a Theory of Mariconógraphy," *MELUS* 39, no. 2 (Summer 2014): 121–152; they are reproduced courtesy of Oxford University Press. Portions of the introduction and chapter 2 were added from "Drawn from the Scraps: The Finding AIDS of Mundo Meza," *Radical History Review* 122 (May 2015): 70–88; they appear courtesy of Duke University Press. Parts of chapter 1 and the conclusion were drawn from "The Mail/Male Room: Queer Personae of the Chicano Avant-garde," *Aztlán* 42, no. 1 (Spring 2017): 197–216; Thank you to Rebecca Frazier at UCLA Chicano Studies Research Center Press for reproduction permission. Lastly, an portion of chapter 5 comes from "Alien Skins: The Outer Spaces of Transplanetary Performance," eds. Robb Hernández and Tyler Stallings, *Mundos Alternos: Art and Science Fiction in the Americas* (Riverside, CA: UCR ARTSblock and New York: DAP Publishing, 2017), 36–51.

* * *

This journey began with a bit of serendipity or what Teddy Sandoval would call, "a roll of the dice." A chance encounter with experimental performance artist Robert "Cyclona" Legorreta threw me into the eye of the storm. Processing his eclectic array of records at the UCLA Chicano Studies Research Center as a graduate student in 2003 was puzzling and electrifying, and at the prompting of my advisor, Chon A. Noriega, sent me on an unexpected path. Legorreta's outpouring through oral history interviews and cold calls late into the night rang to the dissonant after-effects of AIDS. Undoubtedly, the loss of his collaborator and soul mate, Edmundo "Mundo" Meza (1955–1985), haunted our chats. Saying "I don't have much time left," he stirred my passion for archivally driven recovery projects, to pursue different formats to tell his "controversial truth."

His urgent plea activated a search for remnants of lives extinguished by a plague, the outcome of which you hold in your hands.

As I matriculated into the Ph.D. program in American Studies at the University of Maryland, College Park, I carried the stories of Legorreta and Meza with me, crafting a methodological "toolkit" to more boldly pursue the queer detrital trails and itinerant scatterings in the wake of AIDS. These ruinous pathways grew less bleak under the careful tutelage of my advisor, Mary Corbin Sies, who remained a tireless advocate for salvaging lost neighborhoods, rescuing public histories, and preserving Maryland's ethnic cultural heritage from graver calamity. Her encouraging conversations to innovate a queerer vocabulary for domestic record-keeping emboldened my work and followed me long after graduation into the corners of Maryland diners as we caught up over pie and bottomless cups of coffee.

The range of literatures, critical theory, and methodological acrobatics centering this book owes much of its moxie to a fleet of activist-scholars emboldening my pursuit to overcome frustrating dead ends. Renee Ater, Angel David Nieves, Ana Patricia Rodríguez, Mary Corbin Sies, Martha Nell Smith, and Psyche Williams-Forson were instrumental in this work. Jennifer A. Gonzalez took a chance on me and interjected her brand of precision and visual insight pushing this project to its full realization. It is perhaps surprising that a committee composed of mainly nineteenth-century Americanists incubated the ideas for a research project about post-1960s sexual and gender transgressive aesthetics in the Chicano Art Movement. And yet, I wouldn't have had it any other way. The principal questions I asked about the archive and its alternative form benefited greatly from this audience, and I am grateful for every eye-opening conversation.

Furthermore, receiving the César Chavez Dissertation Fellowship at Dartmouth College in 2010 not only expedited degree completion but also enhanced the Latinx and Latin American art exponents of this project. Writing in the backdrop of the Hanover autumn and the blanket of winter stirred my creativity and inspired neologisms centering this book; words like "mariconógraphy" and "containers of desire" came to me in the desolation of night. My sincerest appreciation to the faculty and students at the Latin American, Latinx And Caribbean Studies Program (LALACS) and in particular, the generosity of Uju Anya, Vincenzo

Bavaro, Rebecca Biron, Mary Coffey, Christina Gomez, Lourdes Gutier-rez Najera, and Silvia Spitta. Israel Reyes was an interlocutor of all things Puerto Rican, queer, and maple-dipped, enriching my all too brief stay in the Upper Valley.

My departure from the East Coast resulted in an unexpected geo-graphic turn: a postdoctoral fellowship at the Center for Mexican American Studies named on behalf of Carlos E Castañeda at the University of Texas at Austin in 2011. There, the Center for Latin American Visual Studies (or CLAVIS) was a sanctuary for the interethnic and hemispheric exchange in the arts I was pursing and offered a platform from which my work on the exhibition practices of VIVA: Lesbian and Gay Latino Artists of Los Angeles and Joey Terrill's *Homeboy Beautiful* magazine was first proposed. Scholarly dialogues with art historians and cultural critics such as Cary Cordova, George Flaherty, Andrea Guinta, Cristobal Jacome, Monica Martinez, John Moran Gonzalez, Deborah Paredes, Domino Perez, Rose Salseda, Cherise Smith, and Luis Vargas Santiago proved invaluable. Reunifying with Tatiana Reinoza, whom I first met at the Smithsonian Latino Center in 2007, resulted in an en-during friendship and shared passion for the arts. In the epicenters of Tejano cultural expression and lengthy drives between Austin, San An-tonio, and Dallas, we found ways to accompany each other, thwarting roadside bumps in careers, archives, and relationships.

The University of Texas served me well and jumpstarted my profes-sional academic career, which began with an assistant professorship in the Department of English at the University of California, Riverside in 2012. There, I found a faculty distinguished in its culture of collabora-tion, interdisciplinary vigor, and reciprocity. I grew under the tutelage of department chairs Deborah Willis, George Haggerty, and David Lloyd. I benefited from the innumerable professional and private advice of for-mer and present colleagues: Steve Axelrod, Andrea Denny Brown, Erica Edwards, John Ganim, Weihsin Gui, Katherine Kinney, Fred Moten, Vorris Nunley, Michelle Raheja, Stephen Sohn, Jim Tobias, Sherryl Vint, Traise Yamamoto, Susan Zieger, and especially the unstoppable Jennifer Doyle, whose tireless cultural work continues to exercise compassion in ways unimaginable. Casting light into the darkest of corners, she models a culture of care that I strive to replicate. At UCR, I was immersed in an undergraduate and graduate student community at the intersection of

all things queer visual, material, and archival with unexpected results. José Alfaro, Mayela Caro, Clarissa Castañeda, Jessica Delgado, Jeshua Enriquez, Ann Garascia, Rudi Kraeher, Josue Landa, Lindsey Potts, Jessica Robertson, and Eric Romero taught me by example and their voices echo in this book. Perla Fabelo, Tina Feldman, Leann Gilmer, Christy Gray, Jennifer Morgan, and Linda Nellany helped sort through department operations, administrative quagmires, and financial hurdles. Their institutional savvy was crucial to the book's completion and to them I am deeply indebted.

Between Austin and Riverside, I completed the monograph, *VIVA Records: Lesbian and Gay Latino Artists of Los Angeles* (2013), unfolding the stories of resiliency that Latinx artists exerted at the apex of the AIDS crisis. There was no better companion in this travail than Joey Terrill. In my attempts to access the queer Chicanx visual pasts from the tumult of post-1960's LA, Terrill was a rare guide into the creative circuits, political histories, and art practices central to this study. Vivacious as he is wise, Terrill offered new insights into activities largely jettisoned from art historical accountings of Southern California and American art, broadly. His maricón visual rehearsals with Teddy Sandoval stimulated innumerable conversations shaping my books, chapters, exhibition catalogue essays, journal articles, as well as sites for further public engagement.

Terrill's stockpile of photographs, slides, and stories opened crucial corridors to the lives and deaths of queer Chicanx artists who walked with me through every sentence, page, and image reproduced in this book. Arnie Araica, Ian Barrington, Victor Durazo, Rick Gildart, Efren Gutierrez, Ray Navarro, Danny Ramirez, Mario Tamayo, Julio Ugay, Jack A. Vargas, and Louis Vela (to name a few) are among those fallen, and although I never had the opportunity to speak to them, I hope this book shines light on their boundless creativity—a little regarded yet key chapter on the arts in LA. In particular, one companion in this decade's long study was Mundo Meza. The mystery surrounding the whereabouts of his vast artistic output and inroads into a burgeoning art, film, and fashion industry electrified every lead, house visit, and unexpected twist and turn. The impact of Meza's creative output is beginning to be realized, though the totality of his work remains elusive and unknown. And yet, no other person had a greater calling to archive an epidemic than he.

The obscurity of Meza and his art collection are unfortunately, all too common. His aftermath sheds insight into the alternative archives formed around AIDS inscrutable and painful resolve in queer Chicanx and Latinx artist communities. Fellow travelers who revisited this period, sharing historical details and exhuming visual and material remnants, included Pablo Alvarez, Rocío Aranda-Alvarado, Barbara Bentley Hale, Ronnie Carrillo, Simon Doonan, Ruben Esparza, Jef Huereque, Greg Kott, Elisa Leonelli, Kevin Martin, Monica May, Mike Moreno, Michael Nava, Roland Palencia, Monica Palacios, John Ruggles, Sara Schneider, Pat Silva, Margaret Tangie, and Eddie Vela. Paul Polubinskas deserves a glittering marquee for his support and hospitality. As the estate executor for Teddy Sandoval (and his life partner), he accomplished unparalleled feats against difficult odds. His rugged determination is laudable, and I am hopeful that some semblance of Teddy's art and life is faithfully executed here.

A project generated in the vicissitudes of little-known artist archives required support, travel, and most importantly, time. A Visiting Faculty Researcher Fellowship from the Institute of American Cultures/UCLA Chicano Studies Research Center, a UCR Regents Faculty Fellowship, a Hellman Foundation Junior Faculty Grant, and a Tyson Scholars Fellowship at Crystal Bridges Museum of American Art were crucial to book revisions and final submission. Additionally, careful readings from New York University Press Sexual Cultures series editors, Tavia Nyong'o, Ann Pellegrini, and Joshua Chambers-Letson, feedback from peer reviewers, and the meticulous attention of Eric Zinner, editor in chief, transformed this manuscript from its original iteration for the better. NYU Press editorial assistants Alicia Nadkarni and Dolma Ombadykow were beacons of hope and stewarded this book to its final stage. The dynamic Lisa Werhle did incalculable acts of copyediting virtuosity. This book's art program was funded in large part by a grant from the College Art Association's Millard Meiss Publication Fund. The illustrious hands of Paul Del Bosque and Eric Romero added final touches to book graphics and art program preparations. I am also grateful for the support I received from the UCR Office of the Dean in the College of Humanities, Arts, and Social Sciences.

A circle of interdisciplinary ethnic and visual culture scholars offered more intensive feedback at different stages of writing and their heroic

acts must be applauded, among them: Renee Ater, Kency Cornejo, Armando Garcia, Marisa Lerer, Mark Minich de Leon, Tatiana Reinoza, Stephen Hong Sohn, and Emily Voelker. More than this, what is a self-proclaimed "Mountain Chicano" without his friends? I am honored to have shared this journey in its many starts and stops with Ademide Adelusi-Adeluyi, Mike Amezcua, Maile Arvin, Elena Beecher, Tom Beecher, Jody Benjamin, Mark Broomfield, Xóchitl Chávez, Gary Coyne, Liz Davis, Donatella Galella, Alberto Gonzalez, Lucian Gomoll, Peter Graham, Georgina Guzman, Covadonga Lamar-Prieto, Mireya Loza, Angel David Nieves, Ricardo Ortiz, Ana M. Perez, Francisco Pedraza, Isabel Quintaña, José Reynoso, Jonathan Ritter, Breanne Robertson Chen, Scott Savage, Roberto Tejada, and Jason Weems. In particular, Joanne Flores who paced numerous museums, urban blocks, city streets, ocean beaches, and Arkansas trails with me always knew the right outfit, soundtrack, and wine pairing for the occasion. Late night layovers with bottles of malbec, tacos, and dragon slaying were a welcome break from the rigors of academia, and Pandito proved to be a perfect companion plotting our escape in a hot tub time machine.

Growing up at the foothills of the Rocky Mountains gives a boy the time to dream, and I did. No one more than my parents, Debbie and Robert, encouraged me to ask for more, take risks, be original, and ask questions even if they were unpopular. Never before did I think that a life existed beyond Boulder's Flatirons, the plum orchard in my grand-mother's backyard, and walnut trees lining my walks to high school. What I discovered was another world that existed beyond the pages of stories I created, the comic books my brother, Lonnie, and I collected, and the VHS tapes I rummaged through in my father's video archive. Despite my first flight away from my mother's nest for graduate school, I found myself returning over and over again for a pep talk, to move forward at all cost, to continue writing for a more equitable world. It is apropos that the final stages of this book reached completion under my parents' roof nourished by home-cooked Mexican food and freshly brewed coffee. I can think of no better sanctuary to bring a devastated queer Chicanx world together than here. Whether facing new obstacles or the temporary relief of good fortune, we confront each new hurdle together with a contagious laughter and optimism making our days a little brighter. For them, I am blessed and dedicate this book.

NOTES

INTRODUCTION

1 The title of this chapter draws its inspiration from "How AIDS Changed American Art," Jonathan Katz's lead curatorial essay for *Art AIDS America* (2016), an ambitious art survey for the Tacoma Art Museum, which featured more than thirty years of artist responses to the AIDS crisis in the face of serious accusations of "whitewashing" and queer of color erasure. I answer his polemic with a Chicanx twist, an intervention I examine more closely in chapter 1. For more on the poetic video epigraph, see Rodríguez, *Your Denim Shirt*.

2 Naming is nothing short of political. Here, "Chicanx" and "Latinx" are used to challenge the polarizing gender dichotomies of language, as I strive to do throughout this book. Equally important is not to erase the feminist prescription of "a" as a strategy of Chicana resistance and intervention. In some cases, I deploy cisgender vocabulary to be concise. "Chicano avant-gardism," "Chicana feminist art," and "Chicano art movement" are used in keeping with art historical conventions. "Chicano" refers to a person of Mexican and/or Mexican American descent who lives in the United States and is a term of ethnic pride. As an anti-assimilationist, nationalist ideology, this political identity is affiliated with the Chicano civil rights movement. For more, see Sanchez, *Becoming Mexican American*; Griswold del Castillo and De Leon, *North to Aztlan*. "Latino" is a broader umbrella term for people of Latin American descent living in the United States. I recognize that this fraught and potentially homogenizing descriptor is used imperfectly. On "Latino," see Gutiérrez, *Columbia History*; Oboler, *Ethnic Labels, Latino Lives*. I apply these terms acknowledging their heteropatriarchal interlocution and flawed articulation. Additionally, I offer "Chicanx avant-gardisms" to rectify queer and gender transgressions ill acknowledged in traditional Chicano art, literary, and cultural studies.

3 Rodríguez, *Your Denim Shirt*.

4 Ibid.

5 Muñoz, *Cruising Utopia*, 81.

6 Rodríguez, *Your Denim Shirt*.

7 Aldarondo, *Memories of a Penitent Heart*.

8 Ibid.

9 Victorian "half-drag" is discussed in Adams, *Sideshow U.S.A*, 97.

10 For more, see Hernández, *Fire of Life*.

11 Noriega, "Queer Archive 2006 Hour 1." In my interview with Meza's ex-lover Jef Huereque, he confirmed Noriega's claims, noting: "They took most of the stuff. . . . And their anger was that I'm alive and their son died" (Jef Huereque, interview by author, video recording, August 23, 2007, Los Angeles, California).

12 Muñoz, *Cruising Utopia*, 65.

13 Ibid.

14 On "structures of feeling," see Williams, *Marxism and Literature*, 128. Legorreta as quoted by Sternad, "Cyclona and Early Chicano Performance Art," 481.

15 "Berserk" is Legorreta's term. See photocopy of Legorreta's Biographical Sketch, undated, in "Cyclona" (unpaginated booklet of autobiographical materials and press kit compiled by Robert Legorreta); undated, The Fire of Life: The Robert Legorreta–Cyclona Collection, Chicano Studies Research Center, University of California, Los Angeles.

16 For example, consider Chavoya and Gonzalez, *Asco: Elite of the Obscure*. Asco's relationship to exhibition and art-historical discourse is elucidated in chapter 1 of this book.

17 Muñoz, *Cruising Utopia*, 22. See also, Boellstorff, "When Marriage Falls," 229–30. Their intervention is clearly indebted to J. Jack Halberstam's "a queer time and place." See Halberstam, *In a Queer Time and Place*, 4–6, where queer temporality refuses hegemonic norms of life maturation and destabilizes the "natural" attainments of the heteronormative Westernized human subject oriented outside "reproductive" life cycles, which conflate queer existence with such pejorative societal objections as immaturity, indulgence, or incompleteness.

18 Muñoz, *Cruising Utopia*, 7.

19 O'Driscoll and Bishop, "Archiving 'Archiving,'" 6.

20 On the development of the "golden age" of archive theory, see T. Cook, "What Is Past Is Prologue." For debate regarding the intersection of archivist and historian, with attention to Jenkinson's early theorizations of archive record administration, see Blouin and Rosenberg, *Processing the Past*.

21 For example, Sweeney, "Ambiguous Origins."

22 Ibid., 197.

23 Blouin and Rosenberg, *Processing the Past*, 30–31.

24 Consider Derrida, *Archive Fever*. See also, Schwartz and Cook, "Archives, Records, and Power."

25 Edelman, *No Future*, 2.

26 Caswell, *Archiving the Unspeakable*, 13.

27 An, "Integrated Approach to Records Management," 25. Also, consider McKemmish, "Placing Records."

28 Kennedy and Schauder, *Records Management*.

29 I use the term "queer kinship" to signal specific allegiances to key works on the matter. See Freeman, "Queer Belongings."

30 Aldarondo, *Memories of a Penitent Heart*.

31 Cox, "Romance of the Document."
32 Ibid., 12.
33 Gilliland and Cifor, "Affect and the Archive," 2.
34 Cox, "Romance of the Document," 1.
35 Ibid., 12.
36 Ibid., 1.
37 Danbolt, "Touching History," 36.
38 See Muñoz, "Ephemera as Evidence." See also Cvetkovich, *Archive of Feelings*, 227; Schneider, *Performance Remains*; Román, *Performance in America*, 137.
39 Muñoz, *Cruising Utopia*, 81.
40 Ibid., 65.
41 See Cvetkovich, *Archive of Feelings*.
42 Auslander, "Performativity of Performance Documentation," 9.
43 Jones, "Lost Bodies," 117.
44 Ibid.
45 Ibid.
46 Ibid.
47 Muñoz, *Cruising Utopia*, 81.
48 Eichhorn, *Archival Turn in Feminism*, 9.
49 For more on *fotoesculturas*, see Garza, "Secular *Santos*." See also, Ricciardi, "Building Altars"; Turner, *Beautiful Necessity*.
50 Turner, "Mexican American Home Altars," 318.
51 González, "Autotopographies."
52 Mesa-Bains, "'Domesticana,'" 161.
53 González, "Windows and Mirrors," 38.
54 Pérez, *Chicana Art*, 6.
55 Davalos, "Poetics of Love and Rescue," 95.
56 Pérez, *Chicana Art*, 7.
57 Ybarra-Frausto's classic essay has circulated in different formats and print generations over the years beginning with its publication by the Movimiento Artistico del Rio Salado in 1989. His line regarding the "tattered, shattered and broken" is a late addition to his catalog essay for the groundbreaking exhibition *Chicano Art: Resistance and Affirmation, 1965–1985* (or CARA), and I am moved by its inclusion in the 1991 version published at the height of the AIDS crisis. See Ybarra-Frausto, "Rasquachismo" (1991), 156.
58 Turner, "Mexican American Home Altars," 315.
59 Pérez, *Chicana Art*, 6.
60 Ybarra-Frausto, "Rasquachismo" (1991), 156.
61 Andriote, *Victory Deferred*, 71.
62 Strub, *Body Counts*, 352.
63 Groff, "The Curious Closets of Barton Benes."
64 Muñoz, "'Chico,'" 441.

65 For more on Puerto Rican settlement in Philadelphia, see Whalen, *From Puerto Rico to Philadelphia*. Another important primer is Whalen and Vasquez, *Puerto Rican Diaspora*.

66 My sense of social death is indebted to Cacho, *Social Death*.

67 Moon, "Memorial Rags."

68 Ibid., 239.

69 Rodríguez, *Queer Latinidad*, 36.

70 *Gilbert's Altar* (2001) is reproduced in Epstein, *Laura Aguilar: Show and Tell*, 93.

71 Yarbro-Bejarano, "Laying It Bare," 300, 288.

72 Ibid.

73 Doyle, *Hold It against Me*, 138.

74 Goldman, "Iconography of Chicano Self-Determination," 167.

75 For a powerful investigation of "la familia" cultural discourse, see Rodriguez, *Next of Kin*.

76 Barnett-Sanchez, "Chicano/a Critical Practices," 77.

77 For more on "LA art," see Whiting, *Pop L.A.*; Plagens, *Sunshine Muse*; Drohojowska-Philp, *Rebels in Paradise*. On LA's queer creative bohemia, see Hurewitz, *Bohemian Los Angeles*.

78 Jackson, *Chicana and Chicano Art*, 174. See also, McGrew and Phillips, *It Happened at Pomona*, 112.

79 See Danbolt, "Touching History," 36.

80 Mundy, *Lost Art*, 12. For more on vandalism as it relates to memorials and monuments, see Doss, *Memorial Mania*, as well as chapter 1 of this book.

81 Ibid., 17.

82 DeSilvey, "Observed Decay," 324.

83 Muñoz, *Cruising Utopia*, 81.

84 Cvetkovich, *Archive of Feelings*, 271, emphasis added.

85 Fisher, "In Search of a Theory," 4.

86 For example, see Crimp and Ralston, *AIDS DemoGraphics*, 13; Stein and Cooter, "Visual Objects and Universal Meanings."

87 For more on General Idea, see Decter, "Infect the Public Domain."

88 Joey Terrill, interview by author, video recording, August 23, 2007, Los Angeles, California.

89 Cairns and Silverman, *Treasures*, vii.

90 Belk, "Possessions and the Extended Self," 159. See also Ulrich et al., *Tangible Things*, 164.

91 J. González, *Subject to Display*, 4, 5.

92 Enwezor, *Archive Fever*, 18.

93 Banting, "Archive as a Literary Genre," 120.

94 Lowenthal, *Past Is a Foreign Country*, 143.

95 Ibid., 147.

96 Halberstam, *Queer Art of Failure*, 3.

97 Ibid., 2.

98 Cvetkovich, *Archive of Feelings*, 245.
99 Halberstam, *In a Queer Time and Place*, 2 (emphasis added).
100 Foucault, "On Other Spaces," 24.
101 Punzalan, "Archival Diasporas," 332.
102 Doyle, "Queer Wallpaper," 391.
103 Newhouse, *Art and the Power of Placement*, 8.
104 For example, see Pearce, *Interpreting Objects and Collections*.
105 Bachelard, *Poetics of Space*, 78.
106 Ibid., 86.
107 Ibid., 78.
108 Latina Feminist Group, *Telling to Live*, 1.
109 Bechdel, *Fun Home*, 100–101.
110 Lerer, *Prospero's Son*, 24.
111 See Miller, "Possessions."
112 Bille and Sørensen, "Anthropology of Luminosity," 280.
113 For the work of gay Chicago imagist artist Roger Brown, see Rosenberg, "Roger Brown"; Mcgath, "Tour a Landmark Art Show."
114 Photocopy of Legorreta's Biographical Sketch, undated, in "Cyclona" (unpaginated booklet of autobiographical materials and press kit compiled by Robert Legorreta); undated, The Fire of Life: The Robert Legorreta–Cyclona Collection, Chicano Studies Research Center, UCLA, University of California, Los Angeles.
115 "Jostle" is from Pollock, *Encounters*, 9.
116 This concept is furthered in the conclusion of this book. See Harris, "Hauntology, Archivy and Banditry."

CHAPTER 1. THE ICONOCLASTS OF QUEER AZTLÁN

1 Zugazagoitia, foreword and acknowledgments, 7.
2 *Arte No Es Vida*.
3 Ibid.
4 Kirshenblatt-Gimblett, *Destination Culture*, 18.
5 R. Smith, "When the Conceptual Was Political."
6 Santillano, "Asco," 118 (emphasis added).
7 Davalos, *Chicana/o Remix*, 49.
8 Ibid., 50.
9 Noriega, "Orphans of Modernism," 24.
10 Asco remains paradigmatic in Chicano avant-garde theory and criticism. Although other dimensions of the group were evident during the 1980s in the "Asco B" period, the group's canonization has been predicated on its relationship to the four founders, a master narrative recited in scholarship, exhibitions, popular press, and video documentaries. At least ten major exhibitions over the last ten years spanning museums across the United States, Mexico, England, Netherlands, and France repeat a narrative in which Asco has a central relationship to the four founders. Art media and press discourse reproduce this narrative, reducing the

queer creative agents shaping Chicanx avant-gardisms. See the documentary pre-sentation of the collective, *Asco: Is Spanish for Nausea*; Parra, *The Asco Interviews*.

11 Santillano, "Asco."

12 Hernández, *Fire of Life*, 18.

13 Ibid., 20.

14 I am riffing on the "Hit and Run" media tactics proffered by Harry Gamboa Jr. See Gamboa, "No Phantoms," 15.

15 Hernández, *Fire of Life*, 6.

16 Sternad, "Cyclona and Early Chicano Performance Art," 482.

17 For more on "barbarian/beatnik," see Hernández, *Fire of Life*, 6; Sternad, "Cyclona and Early Chicano Performance Art."

18 Sternad, "Cyclona and Early Chicano Performance Art."

19 These performances are mentioned in Hernández, *Fire of Life*, 8.

20 Carr, "Just Another Painter," 18.

21 Jones, "'Traitor Prophets,'" 135.

22 Moraga, "Queer Aztlán," 147; emphasis in original. In "Jotería Studies, or the Political Is Personal" Michael Hames-García observes that the word jotería is used "to describe a group of people of Chicana/o or Mexicana/o descent whose lives include dissident practices of gender and sexuality" (139).

23 Doss, "Process Frame," 408, 403.

24 Mundy, *Lost Art*, 11.

25 Román, *Acts of Intervention*, 83.

26 Ibid.

27 Meyer, *Outlaw Representation*, 13.

28 Raul V. Romero, "Chicanarte: A Major Exposition of California Arts," *Neworld* (Fall 1975), 22, box 6, folder 16, Tomás Ybarra-Frausto research material, 1964–2004, Archives of American Art, Smithsonian Institution (hereafter cited as Smithsonian Archives).

29 *New Language for a New Society—28 Samples* is nonextant; only ephemera and oral history records remain. See "Jack Vargas," 18; Comité Chicanarte, *Chicanarte*. See also, Harry Gamboa Jr., interview by Jeffrey Rangel, audio recording, April 1–16, 1999, Smithsonian Archives. On "la-la's," see Jack A. Vargas to Ronnie Carrillo, September 20, 1977 (postmarked October 28, 1977), 2; Jack A. Vargas digital ar-chive (in process). Further analysis of Vargas and Carrillo is based on the private letters, ephemera, and unpublished prose sent to the author by Carrillo for study and digitization at the University of California, Riverside, in 2014. The outcome will be the Jack A. Vargas digital archive (in process).

30 Jack A. Vargas to Ronnie Carrillo, September 20, 1977 (postmarked October 28, 1977), 4; Jack A. Vargas digital archive (in process).

31 Gamboa, interview by Rangel. Gamboa's recollection restores Chicano public responses to the work, although his reference to the "tar pits" is misleading, perhaps confusing Vargas's poetic device from *Chicanarte* at Barnsdall Park with his experimental video art submission, "Breakfast with Evaristo Altamirano,"

which screened at *Chicanismo en el Arte* (1975) at LACMA. The La Brea Tar Pits are natural oil reserves pooling behind the LA County Museum of Art in nearby Hancock Park.

32 Gamboa, "Renegotiating Race, Class, and Gender," 93.

33 Ibid.

34 Crane, "Definition of Correspondence Art," 20.

35 Longstreth, "Epistolary Follies," 32.

36 Jack A. Vargas to Ronnie Carrillo, December 30, 1976 (postmarked January 1977), 1.

37 Ronnie Carrillo to Jack A. Vargas, July 18, 1977 (postmarked August 6, 1977), 3.

38 Ibid.

39 Piepmeier, "Why Zines Matter," 220.

40 "Fleshy debris" is Carrillo's euphemism for the incidental "meat market" tricking with anonymous men. Ronnie Carrillo to Jack A. Vargas, September 16, 1977 (postmarked December 5, 1977), 3. "Ancient but familiar beasts" is another Vargas textual reference to cruising.

41 Harry McCann, "The Wall/Las Memorias Builds Momentum," clipping from *Update: Southern California's Gay & Lesbian Newspaper*, February 9, 1994, A-5, box 2, folder 22, The Fire of Life: Cyclona Collection, Chicano Studies Research Center Library, University of California, Los Angeles (hereafter cited as Cyclona Collection). Also, Ronnie Carrillo, email message to the author, December 5, 2014.

42 Davalos, *Chicana/o Remix*, 71.

43 Gabrielle Malta and Marcus Lito, "LH AIDS Wall Fight Goes On, But Is It Too Late?," clipping from the *Observer*, August 29–September 12, 2003, 11, box 76, folder 9–11, Shifra M. Goldman Papers, CEMA 119, Department of Special Collections, UC Santa Barbara Library, University of California, Santa Barbara (hereafter cited as Goldman Papers).

44 Ibid.

45 Letters to the editor prove quite informative in this regard. Consider "AIDS Wall Story Stirs Debate: Supports and Detractors Wage Cyber-War," clipping from the *Observer*, August 29–September 12, 2003, NP, box 76, folder 9–11, Goldman Papers.

46 "Do You Know about The Wall–Las Memorias Project?" flyer, box 76, folder 9–11, Goldman Papers.

47 "AIDS Wall Story Stirs Debate: Supports and Detractors Wage Cyber-War," clipping from the *Observer*, August 29–September 12, 2003, NP, box 76, folder 9–11, Goldman Papers.

48 Alex Alferov Proposal for the Wall–Las Memorial Project, box 76, folder 9–11, Goldman Papers.

49 Lively, Ackerman, and Cody to Lorraine Bradley and Rev. Rabbi Allen I. Frehling, October 10, 2003 (digitally stamped December 5, 2003), correspondence, box 76, folder 9–11, Goldman Papers.

50 Alferov details in his email to Goldman, "When Sister Karen was alive I had someone that I could go for counseling and constructive dialogue. I am hoping

that you can provide some of this badly needed comfort" (Alex Alferov to Shifra Goldman, December 12, 2003, email, box 76, folder 9–11, Goldman Papers).

51 Goldman, "Mexican-Latino Connection," 5.

52 Shifra Goldman to Alex Alferov, December 19, 2003, email, box 76, folder 9–11, Goldman Papers.

53 Goldman's relationship to contemporary Latinx art, queerness, and AIDS visibility is a surprising contradictory aspect of her work. Joey Terrill details his views on Goldman's discomfort with overt images of same-sex desire in *VIVA: Lesbian and Gay Latino Artist of Los Angeles*. See also Hernández, *VIVA Records*, 45–46.

54 Gaspar de Alba and López, *Our Lady of Controversy*, 2.

55 López, "Artist of *Our Lady*," 14.

56 Ibid.

57 Pérez, *Chicana Art*, 264.

58 For more on Moreno in relationship to VIVA, see Hernández, *VIVA Records*, 42.

59 See Meyer, "Alex Donis"; Johnson, "Alex Donis."

60 Donis, "How to Make a Paint Bomb," 70.

61 Rivas, "Gay Cholo Mural Gets Defaced." Terrill was involved in public mediation around this incident. See C. Gonzales, *Mission Local*; Sayed, "Artist Shocked."

62 Doss, "Process Frame," 411.

63 Vargas, *Contemporary Chican@ Art*, 7.

64 Ibid., 11.

65 Almaraz, "Artist as a Revolutionary," 50.

66 Ibid.

67 Ibid.

68 Almaraz's tone is surprising but not unusual for dogmatic writings of the period. Almaraz's sexuality was the subject of rumor and conversation. Though married to Chicana artist Elsa Flores, his affairs with other men are a part of the public record, as is his AIDS-related death in 1989. Consider Dan Guerrero's one-man show, *¡GayTino!*, which premiered in 2006. Produced by the LA-based Center Theater Group, Guerrero's show has been staged at multiple performance venues including the Kennedy Center in Washington, DC, Kirk Douglas Theatre, and Highways Performance Space in LA. Also, consult chapter 4 of this book for Almaraz's relationship with Joey Terrill.

69 Whereas Chicano murals are often conflated with male bravado, public space, and exercises in athleticism, Chicanas are a critical part of this medium's constitution and popular vocabularies. Women muralists broke through misogynist barriers and forwarded incipient discourses in third world feminisms and political praxis. See LaTorre, *Walls of Empowerment*; Cordova, "Hombres y Mujeres Muralistas."

70 Terrill, "E.L.A. Terrorism!"

71 This particular mural is discursively appended to the Asco corpus, a point made permanent when the artist painted his third mural in the same alleyway in 2011. His new addition commemorated Asco's 1972 street intervention, *Walking Mural*, a performance on Whittier Boulevard where Herrón, Gronk, and Valdez embod-

ied romantic figures escaping the static conditions of concrete and brick mortar. See Gamboa, "In the City of Angels," 75, 77; Knight, "Permanent Asco Mural."

72 See Muñoz, *Disidentifications*.

73 Puar, *Terrorist Assemblages*, 2, xxiv, xiii.

74 Almaraz, "Artist as a Revolutionary," 50.

75 Meyer, *Outlaw Representation*, 12.

76 Ibid., 14.

77 Muñoz, "Feeling Brown," 70.

78 "Newsline: L.A. Parade Melee," 21.

79 Vaserfirer, "(In)Visibility," 619.

80 Mulvey, "Visual Pleasure and Narrative Cinema," 11.

81 Almaraz, "Artist as a Revolutionary," 50.

82 Williams, *Marxism and Literature*, 128.

83 I would be remiss not to acknowledge that *maricón* is a historically specific and culturally varied term. While much of this chapter foregrounds its visual imaginings from a Mexican standpoint, in no way is it representative of the image's rich cultural antecedents in different Latin American contexts. *Mariposa, marica, pato, loca,* and *joto* are among several other linguistic vernaculars and pseudonyms deserving of additional study in relationship to national, political, and social formations. See La Fountain-Stokes, "Translocas"; Peña, *Oye Loca*.

84 Manrique, *Eminent Maricones*, 112.

85 Ibid., 114.

86 Meyer, *Outlaw Representation*, 10.

87 Pérez, "Entre Machos y Maricones," 143.

88 Smith, *Photography on the Color Line*, 11.

89 Ibid.

90 Irwin, "Centenary of the Famous 41," 169.

91 For more about Legorreta's use of the phrase "live art artist," see photocopy of Legorreta's Biographical Sketch, undated, in "Cyclona" (unpaginated booklet of autobiographical materials and press kit compiled by Robert Legorreta), undated, Cyclona Collection.

92 The "cockroach" as an offensive Chicana/o cultural allegory anticipates Acosta's *Revolt of the Cockroach People*.

93 The origin of this performance is as amorphous as the personalities behind it. In a 1986 interview with Linda Burnham in *High Performance* magazine, Gronk discusses Patssi's participation. Despite reports that Gronk knew her from art classes at Garfield High School, he suggests that he had "seen her on the street and she looked so great I invited her to be in it." In the group's mythology, Gronk, Legorreta, and Meza shared a similar first run-in, though the playwright minimizes this encounter in the *High Performance* interview. Meza is omitted, and Legorreta is briefly referred to by his nickname "Bob," a *chola* drag queen from *Caca-Roaches Have No Friends*. Legorreta is treated as a drag impresario eclipsing his practice in live art experimentation. For more, see Linda Burnham, "Gronk," *High*

Performance 9, no. 3 (1986): 57, box 13, folder 54, Tomás Ybarra-Frausto research material, 1964–2004, Smithsonian Archives.

94 Robert "Cyclona" Legorreta, interview by author, tape recording, September 15, 2004, Los Angeles, California.

95 Hernández, *Fire of Life*, 8.

96 For more on their performance as "unnatural disunity," see Hernández, *Fire of Life*, 8–9. The "Cyclona" mural is now lost—"whitewashed soon after its completion" as Harry Gamboa Jr. remembers ("In the City of Angels," 75). *Regeneración* was instrumental in sealing the union of Gamboa, Gronk, Herrón, and Valdez according to many art historical accounts and thus catalyzed the formation of Asco. According to Colin Gunckel, an invitation to Meza was declined by the painter-ingénue ("'We Were Drawing'").

97 Hernández, *Fire of Life*, 11.

98 Brown and Crist, "Gronk" interview.

99 Benavidez, *Gronk*, 36.

100 Ibid.

101 Ibid.

102 Jones, "'Traitor Prophets.'"

103 Jones, *Self/Image*, 83.

104 Legorreta is a part of Friedkin's "female impersonator" series. See Cox, *Gay Essay*, 77; Gronk, "Cockroaches Have No Friends #3," illustration from *El Playano* (1973), 1, box 9, folder 4, Harry Gamboa Jr. Papers, M0753, Department of Special Collections, Stanford University Libraries, Stanford, California; Castellanos, "La Aportacion de la Mujer a la Cultura," 16. See also Dreva/Gronk 1968–78: 10 Years of Art and Life (1978), exhibition announcement poster, box 2, folder 7, Tomás Ybarra-Frausto research material, 1964–2004, Smithsonian Archives.

105 Hernández, *Fire of Life*, 14.

106 Gamboa, "Gronk: Off-the-Wall Artist," 35.

107 See Chavoya and Gonzalez, *Asco*, 78–79.

108 Legorreta's complex history between competing university archives, one LGBTQ and the other Chicana/o, is relayed in Morales, "Liberating," 60–61. Dan Cameron's lengthy account of Legorreta's Fire of Life Collection is a worthy read on these archival politics. Legorreta is the only participating artist in the catalog without a supplementary exhibition history attached. See Cameron, "Robert Legorreta," 110–13.

109 For more, see Putnam, *Art and Artifact*. See also Enwezor, *Archive Fever*; J. González, *Subject to Display*; Corrin, "Mining the Museum."

110 Cameron, "Robert Legorreta."

111 Consider Morales, "Liberating," 60–61. See also, Hernández, *Fire of Life*, 29–31.

112 The redacted *Asco: Elite of the Obscure* (2013) catalog is an unprocessed part of the Legorreta collection at ONE: National Gay and Lesbian Archive, Los Angeles, California.

113 Sternad, "'Your Identity Is Somewhere Else,'" 105.

114 Hernández, *Fire of Life*, 4.

CHAPTER 2. LOOKING FOR MUNDO MEZA

1 Hackford, *Against All Odds.*

2 Wallace, "Transformation," 2. For more on the ball, see Rourke, "They're Flipping Out," G22.

3 "Lingering" is Muñoz's conception of the way ephemerality confounds historical evidence in queer gesture. See Muñoz, *Cruising Utopia,* 65.

4 Hallas, *Reframing Bodies,* 186.

5 Ibid., 3.

6 Ibid.

7 Ibid., 4.

8 Key works in the area include Dyer, *White*; Berger, *Sight Unseen*; and Abel, *Signs of the Times.*

9 Smith, *Edge of Sight,* 14.

10 Ibid., 8.

11 See Francis, "Introduction and Overview," 9.

12 Boime, *Art of Exclusion,* 16.

13 Harris, *Colored Pictures,* 40.

14 Ibid., 41.

15 Craig and O'Toole, "Looking at Archives in Art," 98.

16 Ibid., 125.

17 Ibid., 98.

18 Foucault, *Power/Knowledge,* 81.

19 Atlas, *The Legend of Leigh Bowery.*

20 Muñoz, *Cruising Utopia,* 65.

21 Atlas, *The Legend of Leigh Bowery.*

22 Urbach, "Closets, Clothes, disClosure," 64.

23 Moreland, "At $2 Billion," 1.

24 Doonan, *Confessions,* 33.

25 Ibid.

26 Moreland, "At $2 Billion," 3.

27 Irwin, "West Hollywood, 1980."

28 Ibid.

29 Kent, "Drama Department," 85.

30 Harry Gamboa Jr., interview by author (with Tyler Stallings), March 9, 2015, Los Angeles, California.

31 Margaret Tangie, interview by author, June 13, 2012, Crested Butte, Colorado.

32 Robert Legorreta, "Ed-Mundo Meza," Biographical Statement, 1989, unprocessed papers, The Gay Chicanismo in El Arte Cyclona Art Collection, 1964–2004, The ONE National Gay and Lesbian Archives. Also, Woo, "Fred Slatten Dies at 92."

33 "Insane" is Doonan's term. See Doonan, *Beautiful People,* 241.

34 An example of the window is found in Doonan, *Confessions,* 42–43.

35 Ibid., 40.

36 Timm and Baker, "History of Urban Coyote Problems," 273.

37 Kelly, "Caution Urged around Coyotes."

38 Moreland, "At $2 Billion," 3.

39 For more on these performance actions, see Hernández, *Fire of Life*, 6–16.

40 Drohojowska-Philp, *Rebels in Paradise*, 165.

41 Sandberg, *Living Pictures Missing Persons*, 10.

42 Ibid,

43 Merkert, "Ed Kienholz," 20.

44 Phelan, "Coyote Politics," 135.

45 Flores-Turney, "Howl," 11.

46 Ibid., 41.

47 Doonan, *Beautiful People*, 242.

48 See *Jonathan Adler and Simon Doonan*.

49 Simon Doonan, phone interview by author, June 13, 2012.

50 Doonan, *Beautiful People*, 241.

51 Doonan, *Confessions*, 149.

52 This moment is vividly revisited in Ola d'Aulaire and Ola d'Aulaire, "Mannequins," 73–74, based on the archives of mannequin historian Marsha Bentley Hale.

53 Doonan, *Confessions*, 191.

54 Kent, "Drama Department," 84.

55 Ibid., 85.

56 Ibid.

57 Sudler-Smith, *Ultrasuede*.

58 Kent, "Drama Department," 85.

59 Johnson, *Art of Living*, 182. And, Hager, *Art After Midnight*, 31.

60 Johnson, *Art of Living*, 182.

61 For an example, see *Klaus Nomi and Joey Arias Dancing*.

62 Johnson, *Art of Living*, 183.

63 Londoño, "Barrio Affinities," 545.

64 Ibid.

65 Kent, "Drama Department," 82.

66 Ibid.

67 For more, see Phelan, *Live Art in LA*.

68 Schneider, *Vital Mummies*, 147.

69 The image in question is in Schneider, *Vital Mummies*, 6.

70 Tangie joined the Huntington Park High School faculty in 1969. Her courses were regularly criticized as "too advanced" and her personable demeanor as "unprofessional." She recalls that Meza, her flamboyantly dressed student prodigy adorned in rhinestones and feathered boas, took to her lesson plans "like a sponge." He duplicated still-lifes from her slide library with stunning precision, incorporating them into his early paintings. Escher was particularly influential. She vividly remembers that he showed great interest in her book about the artist. Despite the criticism of Tangie, her mentorship of Meza parlayed his first-place prize at a juried LA District

Unified art contest, which led to a scholarship to Otis-Parsons School of Art. Her support of Meza continued after his graduation in 1973. For a brief time, she rented him the guesthouse behind her family residence in Santa Monica. Even Doonan recalls this living arrangement with his teacher, a "groovy bohemian chick," before Meza moved to Hollywood at the Fontenoy with him around 1980. Margaret Tangie, interview by author, June 13, 2012, Crested Butte, Colorado.

71 Pietschmann, "Melrose," 228.
72 Ibid.
73 See Doonan, *Confessions*, 27. Note: The window is identified as "Bottom row far left: The original Maxfield store, 1980."
74 Schneider, *Vital Mummies*, 147.
75 Recent scholarship has attributed "Frozen Art" to Legorreta. It is not clear whether this term was retroactively prescribed by him through handwritten assignments on extant slides. As a custodian of and actor in this work, I attribute this coinage to Legorreta though acknowledging its ambiguity. An early essay by Amelia Jones also cites Legorreta in this regard, though it eschews the performance practice's fluency with window display idioms so central to Meza's art practice at that time; Jones, "'The Artist in Present,'" 27.
76 Doonan frequently relays the story of lying about his homosexuality to get a green card in media interviews and university lectures, as well as in Doonan, *Confessions*, 36.
77 Doonan, *Beautiful People*, 239.
78 Ibid.
79 Ibid., 235.
80 Ibid., 239.
81 Ibid., 240.
82 Jef Huereque, interview by author, audio recording, June 10, 2014, Los Angeles, California.
83 Pietschmann, "Melrose," 228.
84 The Veil, the Fake, and Club Lingerie are listed among Meza's and Doonan's favorite Hollywood nightspots. See Doonan, *Beautiful People*, 240; Ingram, *Punk*, 55; Voight, ". . . But Rockers Shine," B-6.
85 Tucker, "Adam and the Ants," B-1.
86 Ibid.; see also, Voight, ". . . But Rockers Shine," B-6.
87 Miles, *London Calling*, 378.
88 Lewis, "Music and Fashion," 525.
89 Cole, *Don We Now*, 158.
90 Miles, *London Calling*, 380.
91 Lewis, "Music and Fashion," 525.
92 Doonan, *Beautiful People*, 239.
93 Pietschmann, "Melrose," 256.
94 Voight, ". . . But Rockers Shine," B-6.

95 Ingram, *Punk*, 28.
96 Rourke, "They're Flipping Out," G22.
97 Monica May, interview by author, audio recording, May 27, 2017, Los Angeles, California.
98 Ibid.
99 Woo, "Glass Menagerie."
100 These neighborhood tensions are reviewed in Pietschmann, "Melrose," 226–32, 256. See also Wallace, "Transformation from 'Dead Street,' pt. II, 1–2.
101 May, interview by author.
102 Jef Huereque, interview by author.
103 Ibid.
104 Ibid.
105 Rourke, "They're Flipping Out," G22.
106 Ibid.
107 Doonan, *Beautiful People*, 240.
108 At this time, other Chicanx artists were intermingling within the diverse ethnic soundscape of LA. For instance, Chicano printmaker Richard Duardo collaborated with Mark Mothersbaugh of DEVO fame and later immersed himself into a burgeoning "hardcore punk scene" in Hollywood and Chinatown in the early 1980s. See Richard Duardo, Interview with Karen Mary Davalos. The broader role of Chicanx punk and, most important, feminist assessments of Chicana rockers such as Alice Bag and Teresa Covarrubias elucidate the intersections of art, music, and fashion. However, the post-punk era of New Romantics, Hi-NRG, and New Wave Synthpop in the production of queer Chicanx aesthetics and overlapping English sensibilities in the 1980s is still nascent. For an excellent rendition of Chicana punk scene in East LA, see Bag, *Violence Girl*. See also, Gunckel and Tompkins Rivas, *Vexing*; Habell-Pallan, *Loca Motion*.
109 Doonan, *Beautiful People*, 240.
110 Schneider, *Vital Mummies*, 4.
111 Straw, "Scales of Presence," 125.
112 Doonan, *Beautiful People*, 239.
113 Ibid., 240.
114 For more on Steven Arnold and Meza's collaborations, see Weiermair, *Steven Arnold*.
115 Hale, "Body Attitudes," 49. On Siqueiros's relationship to Chicanx muralism in LA, see Indych-López, *Judith F. Baca*, 47–48.
116 Doonan, *Beautiful People*, 235.
117 Ibid., 240.
118 Ibid., 244.
119 In my phone interview of Doonan, June 13, 2012, referred to the iconic article that first reported a "rare cancer" among gay men as the *Village Voice*. He may have been recalling a column that ran on July 4 rebutting the historic Lawrence Altman piece in the *New York Times* entitled "Rare Cancer Seen in 41 Homosexuals,"

which appeared on July 3, 1981. The columnist vilified the *Times* article, calling it "the despicable attempt . . . to wreck the July 4 holiday break for every homosexual in the Northeast." See Altman, "Recollections," M10. Also, Doonan cites the *Village Voice* in *Beautiful People*, 244–45. Doonan relayed Meza's comment during my interview as well.

120 Huereque, interview by author, video recording, August 23, 2007, Los Angeles, California.

121 Doonan outlines the general panic surrounding gay men with AIDS around 1984. See Doonan, *Beautiful People*, 248.

122 For the character's name change, see "Murphy on for 'Cop.'" On Murphy's portrayal, see Wilmington, "'Beverly Hills Cop,'" 1.

123 Russo, *Celluloid Closet*, 5.

124 Schickel, "Eddie Goes to Lotusland," 92.

125 Best, *Beverly Hills Cop*.

126 London, "Film Clips," M10.

127 Ibid.

128 Savage, *Standing Soldiers, Kneeling Slaves*, 52.

129 Schneider, *Vital Mummies*, 144.

130 Reed, *Art and Homosexuality*, 219.

131 For more on "neon light" in retail, see Woo, "Glass Menagerie." Avram Finkelstein references the neon in relationship to pornographic adult shop windows (*After Silence*, 81).

132 Finkelstein, *After Silence*, 81.

133 Watney, "Acts of Memory," 167.

134 Ibid.

135 Doonan, phone interview by author.

136 Doonan, *Beautiful People*, 250 (emphasis in original). Also, Huereque, interview by author, June 9, 2016, Los Angeles, California.

137 Hale was a friend and colleague who curated "Fashion Mannequin" in December 1981 at Security Pacific National Bank in downtown LA. Doonan and Meza were commissioned to create an extensive site-specific installation for the show. Their collaborative design draped exceptional examples of these "silent salespersons" in custom-made newsprint silk swaths, declaring, "City Overtaken by 'Mannequin Madness.'" The installation alluded to nudity and created the impression of Greco-Roman revelry and orgiastic ritual on a sundeck platform modeled after Doonan's backyard veranda in Hollywood. In their site-specific display, bathhouse meets LA's version of Wall Street. For more, see Crane, "Fashion's 'Silent Sales Persons,'" M10; Hale, personal communication with author, n.d.

138 On "lingering," see Muñoz, *Cruising Utopia*, 65.

139 Viladas, "That 70's House."

140 Ibid.

141 Barker, "At Home."

142 Doonan, *Confessions*, 47–48.

143 Storms, "Fine Romance."
144 *Ten Things.*
145 Ibid.
146 Ibid.
147 Doonan, *Beautiful People*, 239.
148 Media attention to their lavish home life was further propagated by their renovation of a midcentury modern retreat on Shelter Island. The results were featured in *USA Today*, *Architectural Digest*, and a cover story in *Dwell*. For more, see Doonan, "True to Form"; Rubinstein, "Top Grades"; Barker, "At Home."
149 Urbach, "Closets, Clothes, disClosure," 63.
150 Lewis, "Clothing Closets," 58.
151 Edwards and Hart, "Introduction," 5.

CHAPTER 3. A ROLL/ROLE OF THE DICE

1 Tony Perez, "Reyes Joins Community to Dedicate Southwest Museum Station," press release, http://www.lacity.org/council/cd1/ (accessed April 1, 2007).
2 "Chusien Chang: Wheels of Change."
3 These awards and commendations belong to the private collection of Paul Polubinskas on behalf of the Estate of Teddy Sandoval.
4 "Memory of Teddy Sandoval," City of Los Angeles Resolution, LA City Council, June 7, 1996, Estate of Teddy Sandoval.
5 Paul Polubinskas, interview by author, video recording, May 13, 2011, Palm Springs, California.
6 Punzalan, "Archival Diasporas," 332.
7 Ibid, 329.
8 Consider Terrill's collection from the "archive elicitation" activity from the introduction of this book. See also John Ruggles, interview by author, April 21, 2017, Los Angeles, California.
9 For evidence of Sandoval's in-situ display within the Canales home, see Noriega, *East of the River*, 22.
10 Sturken, *Tangled Memories*, 185. See slso Butler, "Embracing AIDS," 106.
11 Castiglia and Reed, *If Memory Serves*, 90.
12 Watney, "'Likelife,'" 194.
13 Castiglia and Reed, *If Memory Serves*, 90.
14 Román, "Remembering AIDS," 282.
15 While it has significance in the United States, the NAMES project is not a "nationally" recognized AIDS memorial. This federal designation belongs to the National AIDS Memorial Grove, a seven-acre contemplative garden in San Francisco Golden Gate Park. See Wilson, *The Grove*; Hawkins, "Naming Names," 764.
16 Sturken, *Tangled Memories*, 185.
17 Ibid., 185, 197.
18 Hawkins, "Naming Names," 766.

19 Sturken, *Tangled Memories*, 192; Hawkins, "Naming Names," 755.
20 Hawkins, "Naming Names," 760.
21 This historical context is presented by Sturken, *Tangled Memories*, 184. Juxtaposition between media and material is made by Hawkins, "Naming Names," 765.
22 Queer vicissitudes of quilt-making is brilliantly taken up in Sturken, *Tangled Memories*, 205.
23 See, for example, George Segal's *Gay Liberation Monument* (1980/1992) or Maya Lin's *Vietnam Veterans Memorial* (1982).
24 See Doonan, "Nancy Turned Her Back."
25 Morris, "ACT UP 25," 52, 51.
26 Doonan, "Nancy Turned Her Back."
27 Danto, "Vietnam Veterans Memorial," 152.
28 Morris, "ACT UP 25," 52; see also, Sturken, *Tangled Memories*, 196.
29 Román, "Remembering AIDS," 282.
30 Butler, "Embracing AIDS," 106.
31 Castiglia and Reed, *If Memory Serves*, 91.
32 Julio Ugay memorial altar installation photography, June 19, 1993, box 1, folder 2, *VIVA Records, 1970–2000: Lesbian and Gay Latino Artists of Los Angeles*, Chicano Studies Research Center Library, University of California, Los Angeles.
33 Cordova, *Heart of the Mission*, 225.
34 Paul Polubinskas, interview by author, audio recording, March 6, 2015, Palm Springs, California.
35 R. Rodríguez, "Queering the Homeboy Aesthetic," 128.
36 Ibid.
37 "Barrio Baroque" is Sandoval's term. See *VIVA!*'s Mexico exhibition price list, September 15, 1991, box 3, folder 6, *VIVA Records, 1970–2000: Lesbian and Gay Latino Artists of Los Angeles*, Chicano Studies Research Center Library, University of California, Los Angeles.
38 Ybarra-Frausto, "Rasquachismo" (1989), 7, 5.
39 Paul Polubinskas, interview by author, May 13, 2011, Palm Springs, California.
40 Ibid.
41 Ibid.
42 Youmans, "Elsa Gidlow's Garden," 102.
43 Castiglia and Reed, *If Memory Serves*, 84–85.
44 J. González, "Autotopographies," 146.
45 Kott made at least three visits to Polubinskas's Palm Springs home between 2011 and 2014. On May 8, 2015, Gregory Henry Kott passed away from health complications related to HIV. He was sixty-eight.
46 Barnett-Sanchez, "Chicano/a Critical Practices," 78–81.
47 Ironically, art critic Hunter Drohojowska-Philp opens her post-factum review of the emergent LA art scene with Warhol's debut of Elvis silkscreens at Ferus Gallery. See Drohojowska-Philp, *Rebels in Paradise*, 1, 3.
48 Levin, *Gay Macho*, 61.

49 Approximately 180 Chicanx artists were included in this national show. Although an international tour to Mexico City and Madrid did not come to pass, nine US venues supported the exhibition: Los Angeles, Albuquerque, San Antonio, San Francisco, Fresno, Tucson, Denver, Washington, and the Bronx. See Gaspar de Alba, "From CARA to CACA"; the exhibition history and public reception is well detailed in Gaspar de Alba, *Chicano Art Inside/Outside*.

50 John Ruggles, interview by author, April 21, 2017, Los Angeles, California.

51 Ibid. "Nasty" is Ruggles's term for Sandoval's underwear vocabulary.

52 This performance is further explored in Benavidez, *Gronk*, 52.

53 R. González, "Frida, Homeboys," 320.

54 Polubinskas, interview by author, May 13, 2011.

55 "Contact zone" is Mary Louise Pratt's term for the spatial interception of cultures. For more, see *Imperial Eyes*.

56 Polubinskas, interview by author, May 13, 2011.

57 Ibid.

58 John Valadez, a Chicanx photo-realist painter and muralist, also attended CSULB. He earned his BFA in 1986 after Sandoval graduated. Like Sandoval, he grew up in Boyle Heights in East LA in the 1950s.

59 *Chicanismo en el Arte.*

60 This story is recounted in Joey Terrill, interview by author, video recording, August 23, 2007, Los Angeles, California.

61 Muñoz, "Ephemera as Evidence," 10.

62 Ibid.

63 Polubinskas, interview by author, May 13, 2011.

64 Ibid.

65 Ibid. Roth's employment was a bit ironic given that Circus Disco was founded in response to anti-Black and anti-Latinx sentiment at Studio One in West Hollywood. Faderman and Timmons, *Gay L.A.*, 288.

66 Polubinskas, interview by author, May 13, 2011.

67 Ibid.

68 Gere, "T-Shirts and Holograms," 51.

69 As noted in chapter 2, Mundo Meza and Simon Doonan were producing avant-garde windows for trendy fashion boutiques like Maxfield Bleu, Melon's, and Flip and thereby furthering the imprint of queer Chicanx creativity enveloping this particular cultural enclave. By the early 1980s, East LA barrio figures like Sandoval and Meza found a critical outlet for experimental art expression in the window medium. Long after Ron's Records had closed, Meza's lover and Sandoval's CSULB colleague and friend, Jef Huereque, opened Modern Objects across the street, a Latinx twist on the haberdashery. Sandoval's hand-painted mural of heavenly skies and his color scheme adorned the interior. Even after it closed, Sandoval's designs could be observed from the shop's windows. See Kissel, "Ole L.A.," 27.

70 "Lisa—Rocket to Your Heart (Single Mix)."

71 Levin, *Gay Macho*, 59.

72 The advertisement for Ron's Records appears in the *San Francisco Policeman* newsletter, October 1985, 9. By publishing in this venue, Roth and Sandoval may have been soliciting the attention of gay policemen or possibly an audience of readers interested in uniform fetishism and leather play.

73 Gamson, *Fabulous Sylvester*, 144.

74 Ibid., 206.

75 Lawrence, *Life and Death*, 228.

76 Ibid., 229.

77 Sandoval returned to LA after opening the shop where, according to Polubinskas, he likely contracted HIV. The boom in the San Francisco sound was quickly besieged by loss. Cowley, the synthesizer ingénue, died from GRID (gay-related immune deficiency) in 1983 before completing Sarah Dash's LP; by 1984, seven of the ten staff members of Moby Dick Records perished, along with others from Megatone. Quoting John Hedges, a DJ and Cowley collaborator, Joshua Gamson writes, "It killed our customers, it killed our artists, it killed out founders. . . . It was kind of a three-year or four-year blur, and then everybody was gone" (*Fabulous Sylvester*, 247). For mention of Moby Dick Records and AIDS, see Corliss, "How Artists Respond to AIDS," 63. Note also Polubinskas, interview by author, May 13, 2011.

78 His mail art was also exhibited in 1978 as part of the *Lightworks Envelope* show in Ann Arbor, Michigan, though under another pseudonym: Teddy.

79 De Salvo, "Correspondences," 20.

80 Crane, "Definition of Correspondence Art," 20.

81 In contemporary Chicanx art criticism, Butch Gardens is mistakenly confused with the gay bar of the same name in Silver Lake. Unlike the Faultline or Score Bar in downtown, which hosted queer art and performances like the infamous *Terrill/Gronk* show in 1984, Sandoval's Butch Gardens was more reverent. These claims are made in Benavidez, *Gronk*, 52; Noriega, "Your Art Disgusts Me." Others sometimes refer to it as a gay art collective of which Sandoval and Terrill belonged. This is similarly misleading. See R. Rodriguez, "Being and Belonging," 488n15.

82 Joey Terrill, interview by author, August 23, 2007, Los Angeles, California.

83 Levin, *Gay Macho*, 62.

84 Ybarra-Frausto, "Rasquachismo" (1989), 7.

85 See Terrill, "E.L.A. Terrorism!," 40. For more on Dowd, see Editors, "Exhibitions: John Dowd."

86 Gronk addressed a napkin drawing to "Rosie de la Montaña, 521 S. Central Ave. Los Angeles, CA 90021," the art studio Sandoval had shared with John Ruggles since September 1976. Gronk's inscription purposefully evoked the name of Sandoval's alter ego. Gronk Napkin Illustration, ca. 1976, Teddy Sandoval Papers, Estate of Teddy Sandoval.

87 *Corazón Herido* featured the work of Joey Terrill, Bill Hernandez, Claudine Anderson, Jack Vargas, and S. Zaneta Kosiba-Vargas. For more, see *Corazón Herido*, Flier, September 15, 1979, Estate of Teddy Sandoval.

88 Gangadharan, "Mail Art," 286.

89 See Bourriaud, *Relational Aesthetics*.

90 Muñoz, *Disidentifications*.

91 For more, see Hopkins, *Dada's Boys*.

92 Jones, "'Clothes Make the Man,'" 22.

93 Ibid.

94 This is not to overstate a heteropatriarchal address in Chicano muralism. Women artists and queers were developing imagery simultaneously. Consider the work on Chicana feminist mural projects in Cordova, "Hombres y Mujeres Muralistas"; see also, LaTorre, *Walls of Empowerment*. While little has been written about queer Chicanx mural art in the 1970s, consider Joey Terrill's "queer terrorist" action at Willie Herrón's *The Wall that Cracked Open*, as well as Sandoval's compatriots, Robert "Cyclona" Legorreta, Mundo Meza, and Gronk's "Cyclorama" performance against a mural backdrop at California State University, Los Angeles, in 1972, all discussed in chapter 1 of this book. Moreover, Self-Help Graphics cofounder Carlos Ibanez y Bueno inscribed his East LA murals with the combined last name of himself (Ibanez) and his lover, Antonio Bueno. For more, see Hernández, "Archival Body/Archival Space."

95 For more on Tormenta, see Benavidez, *Gronk*, 61–71.

96 Vincent, "Part II: The 1970s Revisited."

97 Polubinskas, interview by author, May 13, 2011.

98 Abdollah, "Magnitude 4.6 Temblor."

99 Polubinskas, interview by author, May 13, 2011.

100 Knight, "How L.A. Missed the Train."

101 Ibid.

102 Muchnic, "Fare Includes Art and History."

103 Ibid.

104 Schrank, *Art and the City*, 8.

105 Knight, "How L.A. Missed the Train."

106 Ibid.

107 There were several architectural firms attached to the project. The chief designer, Wallace Bartelt from McLean & Schultz, also employed other architects charged with different fabrication components for the station. Paul Polubinskas, e-mail to author, July 19, 2017.

108 Letter from Alan Nakagawa to Teddy Sandoval, March 31, 1994, Estate of Teddy Sandoval.

109 Wilson and Falkenstein-Doyle, 88.

110 Schrank, *Art and the City*, 27. On the staircase see, Wilson and Falkenstein-Doyle, "Charles Fletcher Lummis," 89.

111 See Wilson and Falkenstein-Doyle, "Charles Fletcher Lummis," 76–77.

112 Wilson and Falkenstein-Doyle, "Charles Fletcher Lummis," 83.

113 Ibid., 85. Also, ceramics held an esteemed place among the relics. His attraction followed a stay in Santa Fe, where friends of New Mexican congressman and rancher Amado Chavez gifted him pottery from the Acoma Pueblo. See Ibid., 78.

114 Padget, "Travel, Exoticism," 448–49.

115 Polubinskas, interview by author, May 13, 2011.

116 Quoting Lummis, according to Wilson and Falkenstein-Doyle, "Charles Fletcher Lummis," 89.

117 For more on this, see Parrot, *Arts of Assyria*, 27.

118 Wyllie, "Mural Paintings of El Zapotal," 218.

119 Schrank, *Art and the City*, 32.

120 This architectural relic was offered to Sandoval by La Canada Design Group on behalf of the Highland Park Arts Committee on March 25, 1994. Lance Bird, "La Canada Design Group Project Note," March 25, 1994, Estate of Teddy Sandoval, Item 32.6, pg. 2.

121 Tongson, *Relocations*, 116–17; emphasis in original. Though Tongson is speaking in the context of Riverside, California, her observations also pertain to the "queer suburbia" of the Highland Park/Mt. Washington neighborhood in Los Angeles.

122 Deverell, *Whitewashed Adobe*, 138.

123 Ibid.

124 Winter, *Batchelder*, 18, 38, 67, 68.

125 Winter's monograph is invaluable to this tile history; for exceptional documentations of Mayan-inspired craftwork, see ibid., 74–75.

126 For more on the Dutch Chocolate Shop, see ibid., 63–67; for a fantastic journalistic overview, see Arnold, "Quest to Save."

127 Winter, *Batchelder*, 80–83.

128 Images of these sculptural muses can be seen in ibid., 82.

129 On Burt Williams Johnson and Simons brickyard, see Wallach, "Fine Arts Building."

130 For more on Batchelder's school of art and craft in the Arroyo Seco, see Winter, *Batchelder*, 31.

131 Polubinskas, interview by author, May 13, 2011.

132 Paul Polubinskas, interview by author, audio recording, March 7, 2015, Palm Springs, California.

133 Polubinskas, interview by author, May 13, 2011.

134 "Hispanic Ceramic Artists," 14.

135 For more, see Gavin, Pierce, and Pleguezuelo, *Cerámica y Cultura*.

136 Knight, "How L.A. Missed the Train."

137 Morris, "ACT UP 25," 52.

138 "Teddy Sandoval, Highland Park Gateway."

139 Polubinskas, interview by author, May 13, 2011. Sandoval's relationship with Meza was parlayed through a close friendship with Jef Huereque and his brother, Marcos, men whom Sandoval grew fond of from his days at CSULB.

140 Letter from Paul Polubinskas to Alan Nakagawa, March 8, 1996, private collection of Paul Polubinskas.

141 Sterngold, "Museum Joins with Tribe," 20.

142 "Teddy Sandoval, Highland Park Gateway."

143 This independent art-literary text ran for five issues and included photography and illustrations from members, such as visual artists Huereque, Terrill, Laura Aguilar, and Mike Moreno, among others. See Hernández, *VIVA Records*, 36–47.

144 Ibid., 8.

145 Huyssen, *Twilight Memories*, 250.

146 Cvetkovich, *An Archive of Feelings*, 7.

147 Muñoz, "Ephemera as Evidence," 10.

CHAPTER 4. VIRAL DELAY/VIRAL DISPLAY

1 Hawkins, "Naming Names."

2 Ibid., 760.

3 The HBO cinematic adaptation of Larry Kramer's polemic AIDS play uses Tommy Boatwright's Rolodex to materialize an AIDS body count and manage a record of its wreckage. See Murphy, *Normal Heart*. For more on Strub and his coming of age during this plague, see Strub, *Body Counts*, 124. Relatedly, Strub also briefly discusses the phenomenon of the "Rolo-dead file" as an alternative recordkeeping practice ordering AIDS devastation (ibid., 191). "Checkmarks" are laced through Brad Gooch's memoir of men consequential to his life, career, and creative circle, such as the *Nation* editor, Duncan Stalker, who died from AIDS (Gooch, *Smash Cut*, 163–64).

4 This term is drawn from Strub's dual uses of it in *Body Counts* as he calculates communal devastation and survival at the height of the AIDS crisis.

5 Born in Hawthorne, California, on October 6, 1964, Navarro graduated from Otis-Parson School of the Arts and California Institute of the Arts, where he did more than mingle with queer Chicanx avant-gardists. For a brief time, he and Joey Terrill were lovers. They visited New York in 1988, where Terrill undoubtedly thrived showing the young artist-ingénue a city influential to his own visual art practice, sexual expression, and creativity. Later, Navarro was admitted to the prestigious Whitney Museum of American Art Independent Study program, where he met future collaborators Alex Juhasz, Gregg Bordowitz, and Ellen Spiro, among others, extending his reach in New York. For more, see R. Rodríguez, "Being and Belonging," 490n24.

6 For more on the foundational debates in testimonio literature, see Beverly, *Testimonio*.

7 Yúdice, "*Testimonio* and Postmodernism," 17.

8 Castiglia and Reed, *If Memory Serves*, 9; Beverly, "Margin at the Center," 94.

9 Foucault, *Power/Knowledge*, 81.

10 Gorman-Murray, "Reconciling Self," 2.

11 Davalos, *Chicana/o Remix*, 158.

12 For more on paratexts, see Genette, *Paratexts*.

13 Ketelaar, "Tacit Narratives," 133.

14 Joey Terrill, interview by author, video recording, August 23, 2007, Los Angeles, California.

15 Ibid.

16 R. Rodríguez, "Being and Belonging," 473.

17 Ibid.

18 Joey Terrill, interview by author, video recording, August 28, 2010, Los Angeles, California.

19 Bryan-Wilson, "To Move, to Dress," 201.

20 Gamson, *Fabulous Sylvester*, 58.

21 Ibid., 108

22 Ibid.

23 Terrill, interview by author, August 28, 2010.

24 My thinking is indebted to Shawn Michelle Smith's observations regarding how photo albums, vernacular recordkeeping, and public displays have *countered* scientific and racist discourses of Black inferiority since W. E. B. DuBois's photographic exhibition at the Paris Exposition in 1900. She argues that "the archive is a vehicle of memory, and as it becomes the trace on which an historical record is founded, it makes some people, places, things, ideas and events visible, while relegating others, through its signifying absences, to invisibility" (*Photography on the Color Line*, 7). Such resiliency underlines the counter-archive and thus, interconnects the critical work on race and memory shared by Chicanx and Latinx feminists and queer Chicanx cultural carriers.

25 Aldama, *Disrupting Savagism*, 114.

26 Latina Feminist Group, "Introduction: *Papelitos Guardados*," 8.

27 Terrill, interview by author, August 28, 2010.

28 "Newsline: L.A. Parade Melee," 21.

29 Bojórquez, "Stroke as Identity," 6.

30 For more on the "body-placa" as it relates to Terrill and Sandoval's collaborative verve, see Hernández, "Drawing Offensive/Offensive Drawing," 143.

31 Muñoz, "Feeling Brown," 70.

32 Gunckel, "'I Was Participating and Documenting,'" 8.

33 Referring to the photography of Oscar Castillo, Gunckel notes, "Documentation of a woman executing gang graffiti in the era is rare enough; indeed some regard Chicana graffiti writers to be exceedingly scarce, perhaps even nonexistent" (ibid., 7).

34 Escandalosa's gallery announcement, December 18, 1975, box 3, folder 3, The Fire of Life: Cyclona Collection, UCLA Chicano Studies Research Center Library, University of California, Los Angeles.

35 "Coca-Cola, 1971."

36 For more on the "Maricón Series" as it relates to the queer Latina/o aesthetics of "mariconógraphy," see Hernández, "Drawing Offensive/Offensive Drawing," 121–52.
37 Bourriaud, *Relational Aesthetics*, 15.
38 Bishop, *Artificial Hells*, 2.
39 Ibid.
40 Jackson, *Social Works*, 14.
41 Eddie Vela, interview by author, audio recording, October 20, 2015, Los Angeles, California.
42 "Punctum" is Barthes's term for "that accident which pricks me (but also bruises me, is poignant to me)" (*Camera Lucida*, 27).
43 Jackson, *Social Works*, 14. For more on relational aesthetics and social practice, see Bourriaud, *Relational Aesthetics*
44 Gugelberger and Kearney, "Voices for the Voiceless," 4.
45 Latina Feminist Group, "Introduction," 13.
46 Ibid., 20.
47 Cvetkovich, *Archive of Feelings*, 241.
48 Terrill, interview by author, August 28, 2010.
49 For more on the racial politics of genre painting and the work of Johnson, see Berger, *Sight Unseen*. On Brooks, see Latimer, *Women Together/Women Apart*.
50 Joey Terrill, interview by author, audio recording, October 18, 2015, Los Angeles, California.
51 Gugelberger and Kearney, "Voices for the Voiceless," 5.
52 Steven Fregoso also attended Cathedral Catholic High School but was an older student who graduated in the class of 1971. Later, he became an extension of the Escandalosa Circle in its purest form as a Cathedral alumnus and lover of Terrill's. This was conveyed by Terrill, interview by author, October 18, 2015.
53 Ibid.
54 Foucault, "Sexual Choice, Sexual Act," 297.
55 Livingstone, "Private Face of a Public Art," 17.
56 Whiting, *Pop L.A.*, 119.
57 Huff, "Reading as Re-Vision," 507. Also, Terrill, interview by author, August 28, 2010.
58 Whiting, *Pop L.A.*, 114.
59 Ibid., 119.
60 For more, see Rechy, *City of Night*.
61 Whiting, *Pop L.A.*, 121.
62 Ibid.
63 Terrill, interview by author, August 28, 2010.
64 Relatedly, Terrill was given the opportunity to paint Isherwood's portrait in 1982. *Portrait of Christopher Isherwood* depicts another example of a flat and nondescript hand intervening in the canvas to disclose a black and white photograph of his parents. He reveals competing sources for his visual expressions, embedding

Chicanx historical and gay British subject matter among his art historical influences, creative genealogy, and self-identification.

65 Clothier, "Don Bachardy," 7.
66 Ibid.
67 Halberstam, *In a Queer Time*, 10.
68 Ibid.
69 Dean, "Bareback Time," 78–79.
70 Ibid., 79.
71 "HIV+ Latino Uses His Art for Activism."
72 Ibid.
73 "HIV+ Latino Uses His Art for Activism."
74 Hirsch and Spitzer, "Testimonial Objects," 355.
75 Ibid.
76 Productive tensions similarly shape his home. Arguably, it is a domesticity of oppositional relations. Contrasts of race, generation, and serostatus yield a dichotomous house environment that even splits along geographical lines. The couple shares time between Northern and Southern California. Their recent purchase of a pied-á-terre in Palm Springs allows for an arid retreat, a gay couple's sanctuary in the sweltering low desert of Riverside County. Michael Nava, interview by author, video recording, December 14, 2014, Daly City, California.
77 See Monette, *Borrowed Time*, 271.
78 Nava, interview by author, December 14, 2014.
79 With regard to "structure of feeling," see Williams, *Marxism and Literature*, 128. Also, Nava, interview by author, December 14, 2014.
80 Nava, interview by author, December 14, 2014.
81 Hirsch and Spitzer, "Testimonial Objects," 360.
82 Bruhm, "Still Here," 318 (quoting Gere, *How to Make Dances*).
83 Terrill, interview by author, August 28, 2010.
84 Chambers-Letson, "Contracting Justice," 559.
85 Strub, *Body Counts*, 182.
86 Gaytán, "Tequila Talk," 66.
87 Gonzales, "Anatomy of Learning," 219.
88 Ibid.
89 Nava, interview by author, December 14, 2014.
90 Ibid.
91 Ibid.
92 Mesa-Bains, "'Domesticana,'" 163, 160, 163.
93 Ibid., 163.
94 Cvetkovich, *Archive of Feelings*, 157; see also Mesa-Bains, "'Domesticana,'" 163.
95 Genova, "The Story behind the Colorization."
96 Ibid.
97 Sturken, *Tangled Memories*, 171.

98 The "sissy" archetype is a critical trope in carefully coded mainstream representation of gay men in film. See Russo, *Celluloid Closet*.

99 Looby, "Flowers of Manhood," 145.

100 Ibid.

101 Eddie Vela, interview by author, audio recording, October 20, 2015, Los Angeles, California. Like Danny Ramirez, Jef Huereque worked in flower arrangement. Horticultural study was a common theme that linked Geoffrey Gratz with his close friend Teddy Sandoval. They used to travel to Mexico visiting gardens and also collected horticultural specimens across the US border. John Ruggles, interview by author, April 21, 2017, Los Angeles, California.

102 Vela, interview by author, October 20, 2015.

103 Ibid.

104 Reed, *Art and Homosexuality*, 223. For more on the way Mapplethorpe's death affected Chicanx queer art practices in Los Angeles, see Hernández, *VIVA Records*, 68–70.

105 Asen, "Appreciation and Desire," 50.

106 Richard Meyer writes masterfully about censorship in relationship to the work of Mapplethorpe and David Wojnarowicz in *Outlaw Representation*. See also Reed, *Art and Homosexuality*, 207–28.

107 See *Robert Mapplethorpe: Flowers*.

108 Meyer, "Mapplethorpe's Living Room," 295.

109 Schultz, "Robert Mapplethorpe's Flowers," 86.

110 Asen, "Appreciation and Desire," 59.

111 Schultz, "Robert Mapplethorpe's Flowers," 85.

112 Asen, "Appreciation and Desire," 59.

113 In addition to Terrill and Reyes, participating artists were Alex Alferov, Alex Donis, Ruben Esparza, Jef Huereque, Rigo Maldonado, Luciano Martinez, Hector Silva, and Paul Sweeney.

114 Self-Help Graphics was founded in East LA in 1972 under the aegis of Sister Karen Boccalero, a socially conscious art advocate, practitioner, and Franciscan nun, who was an icon venerated at the crossroads of three major pillars of Chicana/o cultural identity—community building, political activism, and the Catholic Church. Cofounders of Self-Help Graphics included Carlos and Antonio Ibanez y Bueno. These men were not only fellow artists and colleagues of Sister Karen's, but also same-sex lovers. This couple's last name is a combination of surnames certifying their partnership. The name appeared on Carlos's urban street murals. More than this, Carlos is frequently cited for being the first to produce a Self-Help print in an East LA garage in 1970. *Homobre L.A.* revisited this genealogy, explicating Self-Help's hitherto unexplained but pivotal queer past. Kristen Guzman documents the couple's critical role in the organization in *Self Help Graphics & Art*. See also, Woo, "Carlos Bueno, 60"; Saldivar, "Self-Help Graphics."

115 Terrill, interview by author, October 18, 2015.

116 Jef Huereque, interview by author, audio recording, June 10, 2014, Los Angeles, California

117 Terrill, interview by author, October 18, 2015.

118 Bruhm, "Still Here," 319.

119 See Cherry, "Sweet Memories."

120 Chambers-Letson, "Contracting Justice," 560.

121 Gere, *How to Make Dances*, 97.

122 Castiglia and Reed, *If Memory Serves*, 9.

123 Ibid., 10.

124 Ibid.

125 Ibid.

126 Arreola, "Mexican American Housescapes," 300.

127 Ibid., 300, 308–9.

128 See Hilderbrand, "Retroactivism."

129 Camille, "Editor's Introduction," 163–64.

130 Gorman-Murray, "Reconciling Self," 2.

131 Castiglia and Reed, *If Memory Serves*, 10.

CONCLUSION

1 Strub, *Body Counts*, 182.

2 Mossinghoff, "AIDS Medicines in Development," 4.

3 The dates of these artists' seroconversion were related in the following: Joey Terrill, interview by author, audio recording, October 18, 2015, Los Angeles, California; Jef Huereque, interview by author, audio recording, June 10, 2014, Los Angeles, California; Patricia Navarro, interview by Mcgrath, "County Residents."

4 Gere, "T-Shirts and Holograms," 52.

5 *Future Safe*, 4.

6 Ibid., 2.

7 Moore, *Beyond Shame*, 192.

8 White, "Mining the Forgotten," 238.

9 Pérez, *Decolonial Imaginary*, 5.

10 Stevens, "Remembering Lost Paintings," 250.

11 Tyburczy, *Sex Museums*, 3–4.

12 Avram Finkelstein, interview by Cynthia Carr, April 25–May 23, 2016, audio recording, Archives of American Art, Smithsonian Institution.

13 For more on the art museums and censorship in the 1990s, see Kester, *Art, Activism, and Oppositionality*.

14 Finkelstein, *After Silence*, 77.

15 Wallach, *Exhibiting Contradiction*, 6.

16 Pollock, *Encounters*, 10; see also Muñoz, *Cruising Utopia*, 7.

17 Pollock, *Encounters*, 9.

18 Ibid.

19 C. Sandoval, *Methodology of the Oppressed*, 53; see also Pollock, *Encounters*, 9.

20 Pollock, *Encounters*, 9; see also Finkelstein, *After Silence*, 2.

21 Muñoz, *Cruising Utopia*, 7.

22 Stein and Cooter, "Visual Objects and Universal Meanings," 105.

23 Duncan and Wallach, "Universal Survey Museum," 465.

24 A. Wallach, *Exhibiting Contradiction*, 46.

25 Ibid.

26 "Simulacrum" comes from Baudrillard, *For a Critique*; Goode as cited in Kirshenblatt-Gimblett, *Destination Culture*, 31.

27 Kirshenblatt-Gimblett, *Destination Culture*, 31.

28 Ibid., 31, 32.

29 Ibid.

30 Ibid.

31 Ibid., 52.

32 Carrier, *Museum Skepticism*, 9.

33 Belknap and Defrance, "Photographs as Scientific and Social Objects," 144.

34 Pollock, *Encounters*, 10.

35 Grasskamp, *Book on the Floor*, 3.

36 Ibid.

37 Pollock, *After-Affects | After-Images*, 60.

38 Pollock, *Encounters*, 18.

39 Certainly, Pollock's feminist project is skeptical of Malraux's and Warburg's models of memory and encounter. Under her assessment, Malraux perpetuates museum categories and methodological "orders and relations defined by superimposed art historical logics." However, Warburg is lauded for "traversing extended historical times and transcultural dispersion" in his practice. Differences aside, I am interested in the ways Warburg and Malraux reoccupy a language of failed museum futurity, reimagining virtual afterlives for duplications mapped in the clutter of object storerooms, the stretch of a parlor floor, or the static remove of piecemeal assemblages. Pollock, *Encounters*, 10, 18.

40 C. Sandoval, *Methodology of the Oppressed*, 53.

41 As described in Doonan, *Beautiful People*, 247.

42 Pollock, *Encounters*, 10.

43 Ibid., *Encounters*, 9.

44 "Jostle" is a term from Pollock, *Encounters*, 9.

45 Miranda, "Five Must-See Booths."

46 Martinez, "Third Time's a Charm."

47 This attendance estimate was forwarded by organizer Shannon Michael Cane, as noted in Miranda, "Five Must-See Booths."

48 Ibid.

49 These origins are conveyed in Villarreal, "Maricón Art."

50 See ibid.

51 Villarreal, "Owning Slurs."

52 Muñoz, *Disidentifications*, 31. "Hailing" appears in Althusser, "Ideology," 162–63.

53 Rudi Bleu compares the maricón sweatshirt to the Santa Fe Springs Swap Meet in Fernandez, *Artist's Talk*.

54 For more on mariconógraphy, see Hernández, "Drawing Offensive/Offensive Drawing."

55 Although Terrill cites a *New West Magazine* story on Chicana social delinquents as a key influence in his artistic intervention, I could not locate any such article prior to the release of his first issue of *Homeboy Beautiful* in 1978. *New West* did publish an exploitation story entitled "La Vida Loca: Girls in the Gangs of East L.A." in its January 29, 1979 issue. However, it follows the first run of *Homeboy Beautiful*, contradicting Terrill's claims. In keeping with the artist's memory and the mythology surrounding the art publication's production, I preserve it here despite its awkward relationship to his self-narrative. For more, see Johnston, "La Vida Loca."

56 Armstrong's role was conveyed by Joey Terrill, personal communication with author, August 26, 2012.

57 The material limitations for Chicana feminist print media productions is effectively conveyed in Blackwell, "Contested Histories." See also consider Ontiveros, "Antennas and Mimeograph Machines."

58 Gangadharan, "Mail Art," 285–86.

59 Piepmeier, "Why Zines Matter," 220.

60 Rodríguez links Terrill's *Homeboy Beautiful* to the "literature and other expressive forms" generated by queer Latino men "before and during the 1980s" ("Latino/a Queer Expression," 34).

61 For more on Soap Plant's place in trendy Melrose of the 1980s, see Woo, "Glass Menagerie."

62 Terrill also approached the owner of Papa Boch, a famous westside bookstore renowned for its high-end and pseudo-intellectual art publications and journals. After perusing *Homeboy Beautiful*, the owner balked at the issue and decried its artistic merit. This was conveyed to the author by Joey Terrill in personal communication, August 26, 2012.

63 See C. Smith, *Enacting Others*. For more on Chicago, see Gerhard, "Judy Chicago," 594.

64 Joey Terrill, "What *Really* Happens on Those *Hot* Summer Nights," 14.

65 Geraghty Loma is one of many historic East Los Angeles gangs that included East Side Clover, Cypress Park Boys, The Avenues, El Chemo, Whitefence, 18th Street, among others. These gangs are specifically evoked in the pages of *Homeboy Beautiful*, further exposing the unseen homo-homeboy underground.

66 The Vela brothers—Louis and Eddie—were the only male siblings among a group of sisters and thus, lived on this other property in the backyard. According to Vela, the trailer often traded hands because each brother had his own uncompromising tolerance for the other. Eddie preferred order, cleanliness, and housekeeping to his older brother's inverse likings. Joey Terrill, interview by author, June 13,

2015. Also, Eddie Vela, interview by author, audio recording, October 20, 2015, Los Angeles, California.

67 Villarreal, "Maricón Art."

68 Scenes of listening to Judy Garland's "Trolley Song" are used for comic effect. However, the irony is that they were not props but actual records from Louis Vela's collection. Terrill, interview by author, June 13, 2015.

69 Terrill, "What *Really* Happens on Those *Hot* Summer Nights in Geraghty Loma!," 23.

70 As stated in chapter 4, Teddy Sandoval, Efren Valadez, and Louis Vela passed away from AIDS-related complications in the early 1990s. Although not appearing in the inaugural issue, Eddie Vela, who gave use of the trailer for the photo shoot, survived his older brother and joined Terrill and Ronnie Carrillo as custodians of Scans cultural memory.

71 Thomas, "Value and Validity," 27.

72 Halberstam, *Queer Art of Failure*, 15.

73 Harris, "Hauntology, Archivy and Banditry," 21.

74 Ibid.

75 Ibid., 21, 23.

76 See Hernández and Stallings, *Mundos Alternos*.

77 Foley, "Modern Object Lesson."

78 Kissel, "Ole L.A.," 30.

79 Foley, "Modern Object Lesson."

80 Mundo Meza to Robert Legorreta, postcard dated 1980, box 7, folder 4, The Fire of Life: The Robert Legorreta–Cyclona Collection, Chicano Studies Research Center Library, University of California, Los Angeles.

81 Schneider, *Vital Mummies*, 127.

82 Ibid.

83 Muñoz, *Cruising Utopia*, 65

84 Watney, "'Lifelike,'" 192.

85 Brown, "Ironies of Distance," 161.

86 Simon Doonan, phone interview by author, June 13, 2012, Austin, Texas.

87 Doonan, *Beautiful People*, 249.

88 Ibid.

89 Muñoz, *Cruising Utopia*, 32.

90 Jef Huereque, interview by author, audio recording, June 9, 2016, Los Angeles, California.

91 S. Schneider, *Vital Mummies*, 142.

92 My double entendre is indebted to what Elizabeth Freeman terms "temporal drag" (*Time Binds*, 62).

93 See Newhouse, *Art and the Power of Placement*.

94 Kirshenblatt-Gimblett, *Destination Culture*, 4.

95 Finkelstein, *After Silence*, 5.

96 Ibid., 5.

97 Ibid.

98 Ibid.

99 Ibid. See also Cvetkovich, *An Archive of Feelings*, 241.

100 R. Schneider, *Performance Remains*, 31.

101 Ibid., 6 (emphasis in original).

102 Harris, "Hauntology, Archivy and Banditry," 21; Schneider, *Performance Remains*, 11; Finkelstein, *After Silence*, 5.

103 Polubinskas, interview by author, March 7, 2015, Palm Springs, California.

104 Ibid.

105 Details of this story are similarly conveyed by Ruggles, interview by author, April 21, 2017.

106 Polubinskas, interview by author, March 7, 2015.

107 Gould, *Moving Politics*, 233.

108 Schneider, *Performance Remains*, 15.

109 Sachs, *Last Address*.

110 For more, see Arenas, *Before Night Falls*.

111 Dubrow, "Blazing Trails," 286, 285.

112 Sachs, *Last Address*.

113 An exhibition entitled *Last Address*, organized at New York University's Kimmel Center, April 9–May 31, 2010, featured translucent photograph overlays on thirteen windows.

114 Also, Cvetkovich, *Archive of Feelings*, 241.

115 Hayden, *Power of Place*, 13.

116 Cvetkovich, *Archive of Feelings*, 271.

117 Eng and Kazanjian, "Introduction: Mourning Remains," 4.

118 Sandoval, *Methodology of the Oppressed*, 53.

119 Yamaoka recounts *For the Record* in Carrie Yamaoka, interview by Alex Fialho, July 26–27, 2016, audio recording, Archives of American Art, Smithsonian Institution.

120 Ibid.

121 Again, "jostle" references Pollock, Encounters, 9.

122 Based on Pollock, *Encounters*, 9. See also Finkelstein on "disorderly truths," *After Silence*, 2.

123 Strub, *Body Counts*, 374.

124 R. Schneider, *Performance Remains*, 6.

125 My thoughts on queer of color worldmaking are indebted to the late José Esteban Muñoz, who defines it as "the ways in which performances—both theatrical and everyday rituals—have the ability to establish alternate views of the world" (Disidentifications, 195).

126 Eng and Kazanjian, "Introduction: Mourning Remains," 2.

127 Roque-Ramirez, "Gay Latino Histories," 104 (emphasis in original).

128 Muñoz, *Disidentifications*, 7, 1.

BIBLIOGRAPHY

Abdollah, Tami. "Magnitude 4.6 Temblor Rattles Plates and Nerves." *Los Angeles Times*, August 10, 2007. http://articles.latimes.com/2007/aug/10/local/me-earthquake10.

Abel, Elizabeth. *Signs of the Times: The Visual Politics of Jim Crow*. Berkeley: University of California Press, 2010.

Acosta, Oscar Zeta. *The Revolt of the Cockroach People*. San Francisco: Straight Arrow Books, 1973.

Adams, Rachel. *Sideshow U.S.A.: Freaks and the American Cultural Imagination*. Chicago: University of Chicago Press, 2001.

Aldama, Arturo. *Disrupting Savagism: Intersecting Chicana/o, Mexican Immigrant, and Native American Struggles for Self-Representation*. Durham, NC: Duke University Press, 2001.

Aldarondo, Cecilia, dir. *Memories of a Penitent Heart*. Troy, NY: Blackscrackle Films, 2016. DVD.

Almaraz, Carlos. "The Artist as a Revolutionary." *Chismearte* 1, no. 1 (1976): 50.

Althusser, Louis. "Ideology and Ideological State Apparatuses (Notes towards an Investigation)." In *Lenin and Philosophy, and Other Essays*, translated by Ben Brewster, 121–80. New York: Monthly Review Press, 1971.

Altman, Lawrence. "Recollections on the Age of AIDS." *New York Times*, July 3, 2001, M10.

An, Xiaomi. "An Integrated Approach to Records Management." *Information Management Journal* 37, no. 4 (2003): 24–30.

Andriote, John-Manuel. *Victory Deferred: How AIDS Changes Gay Life in America*. Chicago: University of Chicago Press, 1999.

Anzaldúa, Gloria. *Borderlands/La Frontera: The New Mestiza*. San Francisco: Aunt Lute Books, 1987.

Arenas, Reinaldo. *Before Night Falls*, translated by Dolores M. Koch. New York: Viking, 1993.

Arnold, Liz. "The Quest to Save LA's Century-Old Batchelder Tile Masterpiece." *Curbed Los Angeles*, July 9, 2014, https://la.curbed.com/2014/7/9/10078288/the-quest -to-save-las-centuryold-batchelder-tile-masterpiece.

Arreola, Daniel. "Mexican American Housescapes." *Geographical Review* 78, no. 3 (1988): 299–315.

Arte No Es Vida: Actions by Artist of the Americas, 1960–2000. Didactic wall panel text, exhibition files. New York: El Museo del Barrio, 2008 .

Asco: Is Spanish for Nausea. Filmed 1994; released 2014. YouTube video, 12:47, posted by Auraria Library, February 12, 2014. https://www.youtube.com/watch?v =fSQSekn7Ihg.

Asen, Robert. "Appreciation and Desire: The Male Nude in the Photography of Robert Mapplethorpe." Text and Performance Quarterly 18, no. 1 (1998): 50–62.

Atlas, Charles, dir. The Legend of Leigh Bowery. 2002. New York: Palm Pictures, 2004. DVD.

Auslander, Phillip. "The Performativity of Performance Documentation." PAJ: A Journal of Performance and Art 28, no. 3 (2006): 1–10.

Bachelard, Gaston. The Poetics of Space. Boston: Beacon Press, 1994.

Bag, Alice. Violence Girl: East LA Rage to Hollywood Stage, A Chicana Punk Story. Port Townsend, WA: Feral House, 2011.

Banting, Pamela. "The Archive as a Literary Genre: Some Theoretical Speculations." Archivaria 23 (Winter 1986–1987): 119–22.

Barker, Olivia. "At Home: Creative Couple, Doonan and Adler, Build Monument to Their Talent." USA Today, January 1, 2008. http://usatoday30.usatoday.com/life/life style/home/2008-01-10-athome-adler-doonan_N.htm.

Barnett-Sanchez, Holly. "Chicano/a Critical Practices: Reflections on Tomás Ybarra-Frausto's Concept of Rasquachismo." In Pop Art and Vernacular Cultures, edited by Kobena Mercer, 56–87. Cambridge, MA: MIT Press, 2007.

Barthes, Roland. Camera Lucida: Reflections on Photography. Translated by Richard Howard. New York: Hill and Wang, 1981.

Baudrillard, Jean. For a Critique of the Political Economy of the Sign. St. Louis, MO: Telos Press, 1981.

Bechdel, Alison. Fun Home: A Family Tragicomic. Boston: Mariner, 2006.

Belk, Russell W. "Possessions and the Extended Self." Journal of Consumer Research 15, no. 2 (1988): 139–68.

Belknap, Geoffrey, and Sophie Defrance. "Photographs as Scientific and Social Objects in the Correspondence of Charles Darwin." In Photographs, Museums, Collections: Between Art and Information, edited by Elizabeth Edwards and Christopher Morton, 139–56. New York: Bloomsbury Academic, 2015.

Benavidez, Max. Gronk. Minneapolis: University of Minnesota Press, 2007.

Berger, Martin. Sight Unseen: Whiteness and American Visual Culture. Berkeley: University of California Press, 2005.

Best, Martin, dir. Beverly Hills Cop. 1984; Hollywood: Paramount Pictures, 2001. DVD.

Beverly, John. Testimonio: On the Politics of Truth. Minneapolis: University of Minnesota Press, 2004.

———. "The Margin at the Center: On Testimonio (Testimonial Narrative)." In De/Colonizing the Subject: The Politics of Gender in Women's Autobiography, edited by Sidonie Smith and Julia Watson, 91–114. Minneapolis: University of Minnesota Press, 1992.

Bille, Mikkel, and Tim Flohr Sørensen. "An Anthropology of Luminosity: The Agency of Light." Journal of Material Culture 12, no. 3 (2007): 263–84.

Bishop, Claire. *Artificial Hells: Participatory Art and the Politics of Spectatorship.* London: Verso, 2012.

Blackwell, Maylei. "Contested Histories: *Las Hijas de Cuauhtemoc*, Chicana Feminisms, and Print Culture in the Chicano Movement, 1968–1973." In *Chicana Feminisms: A Critical Reader*, edited by Gabriela Arredondo, Aída Hurtado, Norma Klahn, Olga Nájera-Ramírez, and Patricia Zavella, 59–89. Durham, NC: Duke University Press, 2004.

Blouin, Francis X., Jr., and William G. Rosenberg. *Processing the Past: Contesting Authority in History and the Archives.* Oxford: Oxford University Press, 2011.

Boellstorff, Tom. "When Marriage Falls: Queer Coincidences in Straight Time." *GLQ: A Journal of Lesbian and Gay Studies* 13, nos. 2–3 (2007): 227–48.

Boime, Albert. *The Art of Exclusion: Representing Blacks in the Nineteenth Century.* Washington, DC: Smithsonian Institution Press, 1990.

Bojórquez, Chaz. "Stroke as Identity." In *Cholo Writing: Latino Gang Graffiti in Los Angeles*, edited by Francois Chastanet, 6–7. Arsta, Sweden: Dokument, 2009.

Bourriaud, Nicolas. *Relational Aesthetics.* Paris: Les Presses du Reel, 2002.

Brown, Michael. "Ironies of Distance: An Ongoing Critique of the Geographies of AIDS." *Environment and Planning D: Society and Space* 13 (1995): 159–83.

Bruhm, Steven. "Still Here: Choreography, Temporality, AIDS." In *Queer Times, Queer Becomings*, edited by E. L. McCallum and Mikko Tuhkanen, 315–32. Albany: State University of New York Press, 2011.

Bryan-Wilson, Julia. "To Move, to Dress, to Work, to Act: Playing Gender and Race in 1970s California Art." In *State of Mind: New California Art Circa 1970*, edited by Constance M. Lewallen and Karen Moss, 196–216. Berkeley: University of California Press, 2011.

Butler, Paul. "Embracing AIDS: History, Identity, and Post-AIDS Discourse." *jac* 24, no. 1 (2004): 93–111.

Cacho, Lisa Marie. *Social Death: Racialized Rightlessness and the Criminalization of the Unprotected.* New York: New York University Press, 2012.

Cairns, Kathleen, and Eliane Leslau Silverman. *Treasures: The Stories Women Tell about the Things They Keep.* Calgary: University of Calgary Press, 2004.

Camille, Michael. "Editor's Introduction." *Art History* 24, no. 2 (2001): 163–68.

Carr, Elston. "Just Another Painter from East L.A." *LA Weekly*, March 18–24, 1994, 16–21.

Carrier, David. *Museum Skepticism: A History of the Display in Public Galleries.* Durham, NC: Duke University Press, 2006.

Castellanos, Rosario. "La Aportacion de la Mujer a la Cultura." *Regeneración* 2, no. 4 (1974–75): 16.

Castiglia, Christopher, and Christopher Reed. "Mourning Militancy: Remembering AIDS Activism." In *Art AIDS America*, edited by Rock Hushka and Jonathan D. Katz, 82-89. Tacoma, WA: Tacoma Art Museum, 2015.

———. *If Memory Serves: Gay Men, AIDS, and the Promise of the Queer Past.* Minneapolis: University of Minnesota Press, 2012.

Caswell, Michelle. *Archiving the Unspeakable: Silence, Memory, and the Photographic Record in Cambodia*. Madison: University of Wisconsin Press, 2014.

Chambers-Letson, Josh Takano. "Contracting Justice: The Viral Strategy of Felix Gonzalez-Torres." *Criticism* 51, no. 4 (2009): 559–87.

Chavoya, C. Ondine, and Rita Gonzalez, eds. *Asco: Elite of the Obscure: A Retrospective, 1972–1987*. Ostfildern, Germany: Hatje Cantz, 2011.

———. "Asco and the Politics of Revulsion." In *Asco: Elite of the Obscure*, edited by Ondine C. Chavoya and and Rita Gonzalez, 56–62. Ostfildern, Germany: Hatje Cantz, 2011.

Cheng, Jih-Fei. "How to Survive: AIDS and Its Afterlives in Popular Media." *WSQ: Women's Studies Quarterly* 44, nos. 1 & 2 (2016): 73–92.

Cherry, Deborah. "Sweet Memories: Encountering the Candy Spills of Félix González-Torres." Paper presented at Encuentro II: Migratory Politics Symposium, University of Amsterdam, 2007.

Chicanismo en el Arte. Los Angeles: Los Angeles County Museum of Art, 1975.

"Chusien Chang: Wheels of Change." *Going for the Gold: California Stories on the Los Angeles Metro Gold Line: Communities, Public Art, and Placement*. http://usc.v1 .libguides.com/gold_line (accessed April 27, 2017).

Clothier, Peter. "Don Bachardy: Pictures of Christopher." In *Don Bachardy: Christopher Isherwood Portraits, 1953–1985*. Fullerton: California State University, Fullerton Main Art Gallery, 2001.

"Coca-Cola, 1971—'Hilltop' | 'I'd Like to Buy the World a Coke.'" YouTube video, posted March 6, 2012. https://www.youtube.com/watch?v=1VM2eLhvsSM.

Cole, Shaun. *"Don We Now Our Gay Apparel": Gay Men's Dress in the Twentieth Century*. New York: Berg, 2000.

Comité Chicanarte. *Chicanarte: An Exhibition Organized by the Comité Chicanarte with the Cooperation of the Los Angeles Municipal Art Gallery*. Los Angeles: Comité Chicanarte, 1976.

Cook, Matt. *Queer Domesticities: Homosexuality and Home Life in Twentieth-Century London*. New York: Palgrave Macmillan, 2014.

Cook, Terry. "What Is Past Is Prologue: A History of Archival Ideas Since 1898, and the Future Paradigm Shift." *Archivaria* 43 (1997): 17–63.

Cordova, Cary. *The Heart of the Mission: Latino Art and Politics in San Francisco*. Philadelphia: University of Pennsylvania Press, 2017.

———. "Hombres y Mujeres Muralistas on a Mission: Painting Latino Identities in 1970s San Francisco." *Latino Studies* 4, no. 4 (2006): 356–80.

Corliss, Richard. "Show Business: How Artists Respond to AIDS." *Time*, July 27, 1987.

Corrin, Lisa. "*Mining the Museum*: Artists Look at Museums, Museums Look at Themselves." In *Mining the Museum: An Installation by Fred Wilson*, edited by Lisa G. Corrin, 1–22. Baltimore: Contemporary, 1994.

Cox, Julian, ed. *The Gay Essay*. San Francisco: Fine Arts Museums of San Francisco, 2014.

Cox, Richard J. "The Romance of the Document." *Records and Information Management Report* 22, no. 1 (2006): 1–13.

Craig, Barbara L., and James M. O'Toole. "Looking at Archives in Art." *American Archivist*, Spring/Summer 2000, 97–125.

Crane, Michael. "A Definition of Correspondence Art." In *Correspondence Art: Source Book for the Network of International Postal Art Activity*, edited by Michael Crane and Mary Stofflet, 3–38. San Francisco: Contemporary Arts, 1984.

Crane, Tricia. "Fashion's 'Silent Sales Persons' Convene." *Valley Green Sheet*, December 25, 1981, M10.

Crimp, Douglas, and Adam Ralston. *AIDS DemoGraphics*. Seattle: Bay Press, 1990.

Cruz, David Antonio. *The Arts Featured Speaker: David Antonio Cruz*. YouTube video, 1:08:11, posted by Delaware County Community College, April 12, 2017. https://www.youtube.com/watch?v=2KV7HKtIPWI.

Cvetkovich, Ann. *An Archive of Feelings: Trauma, Sexuality, and Lesbian Public Cultures*. Durham, NC: Duke University Press, 2003.

Danbolt, Mathias. "Touching History: Archival Relations in Queer Art and Theory." In *Lost and Found: Queerying the Archive*, edited by Mathias Danbolt, Jane Rowley, and Louise Wolthers, 27–45. Nikolaj: Copenhagen Contemporary Art Center, 2009.

Danto, Arthur. "The Vietnam Veterans Memorial." *Nation*, August 31, 1985.

Davalos, Karen Mary. *Chicana/o Remix: Art and Errata since the Sixties*. New York: New York University Press, 2017.

——. "A Poetics of Love and Rescue in the Collection of Chicana/o Art." *Latino Studies* 5 (2007): 76–103.

Dean, Tim. "Bareback Time." In *Queer Times, Queer Becomings*, edited by E. L. McCallum and Mikko Tuhkanen, 75–99. Albany: State University of New York Press, 2011.

Decter, Joshua. "Infect the Public Domain with an Imagevirus: General Idea's AIDS Project." *Afterfall: A Journal of Art, Context, and Enquiry* 15 (Spring/Summer 2007): 96–105.

Derrida, Jacques. *Archive Fever*. Translated by Eric Prenowitz. Chicago: University of Chicago Press, 1998.

De Salvo, Donna. "Correspondences." In *Ray Johnson: Correspondences*, edited by Donna De Salvo and Catherine Gudis, 15–29. Columbus: Wexner Center for the Arts, 1999.

DeSilvey, Caitlin. "Observed Decay: Telling Stories with Mutable Things." *Journal of Material Culture* 11, no. 3 (2006): 318–38.

Deverell, William. *Whitewashed Adobe: The Rise of Los Angeles and the Remaking of Its Mexican Past*. Berkeley: University of California Press, 2004.

Donis, Alex. "How to Make a Paint Bomb: Alex Donis Recalls *My Cathedral* and *WAR*." *QED: A Journal in GLBTQ Worldmaking* 2, no. 3 (2015): 68–74.

Doonan, Simon. "Nancy Turned Her Back." Slate.com, March 15, 2016. http://www.slate.com/news-and-politics/2018/03/republicans-hope-hillary-clinton-still-scares-red-state-voters.html.

——. "True to Form." *Architectural Digest*, July 2012, 112–19.

——. *Beautiful People: My Family and Other Glamorous Varmints*. New York: Simon and Schuster, 2005.

———. *Confessions of a Window Dresser: Tales from a Life in Fashion.* New York: Penguin Studio, 1998.

Doss, Erika. "The Process Frame: Vandalism, Removal, Re-Siting, Destruction." In *A Companion to Public Art*, edited by Cher Krause Knight and Harriet F. Senie, 403–21. Malden, MA: Wiley Blackwell, 2016.

———. *Memorial Mania: Public Feeling in America.* Chicago: University of Chicago Press, 2010.

Doyle, Jennifer. *Hold It against Me: Difficulty and Emotion in Contemporary Art.* Durham, NC: Duke University Press, 2013.

———. "Queer Wallpaper." In *The Art of Art History: A Critical Anthology*, edited by Donald Preziosi, 391–401. Oxford: Oxford University Press, 2009.

Drohojowska-Philp, Hunter. *Rebels in Paradise: The Los Angeles Art Scene and the 1960s.* New York: Henry Holt, 2011.

Duardo, Richard. Interview by Karen Mary Davalos. November 5, 8, and 12, 2007, Los Angeles. CSRC Oral Histories Series, no. 9. Los Angeles: UCLA Chicano Studies Research Center Press, 2013.

Dubrow, Gail Lee. "Blazing Trails with Pink Triangles and Rainbow Flags: Improving the Preservation and Interpretation of Gay and Lesbian Heritage." In *Restoring Women's History through Historic Preservation*, edited by Gail Lee Dubrow and Jennifer B. Goodman, 281–99. Baltimore, MD: Johns Hopkins University Press, 2003.

Duncan, Carol, and Alan Wallach. "The University Survey Museum." *Art Journal* 3, no. 4 (1980): 465.

Dyer, Richard. *White: Essays on Race and Culture.* New York: Routledge, 1997.

Edelman, Lee. *No Future: Queer Theory and the Death Drive.* Durham, NC: Duke University Press, 2004.

Editors. "Exhibitions: John Dowd." *Art in America*, May 4, 2017.

Edwards, Elizabeth, and Janice Hart. "Introduction: Photographs as Objects." In *Photographs Objects Histories: On the Materiality of Images*, edited by Elizabeth Edwards and Janice Hart, 1–15. New York: Routledge, 2004.

Eichhorn, Kate. *The Archival Turn in Feminism: Outrage in Order.* Philadelphia: Temple University Press, 2013.

Eng, David L. and David Kazanjian. "Introduction: Mourning Remains." In *Loss: The Politics of Mourning*, edited by David K. Eng and David Kazanjian, 1-25. Berkeley: University of California Press, 2002.

Enwezor, Okwui, ed. *Archive Fever: Uses of the Document in Contemporary Art.* Götlingen, Germany: Steidl/ICP, 2008.

Epstein, Rebecca, ed. *Laura Aguilar: Show and Tell.* Los Angeles: UCLA Chicano Studies Research Center Press, 2017.

Faderman, Lillian, and Stuart Timmons. *Gay L.A.: A History of Sexual Outlaws, Power Politics, and Lipstick Lesbians.* New York: Basic Books, 2006.

Feldman, Paul. "Struggling Artists Find New Colony Downtown." *Los Angeles Times*, May 30, 1988. http://articles.latimes.com/1988-05-30/local/me-2486_1_artist-colony -downtown.

Fernandez, Juan. *Artist's Talk: Maricón Collective.* May 21, 2015. YouTube video, 0:42:51, posted by UCLA Chicano Studies Research Center, June 15, 2015. https://www.youtube.com/watch?v=FX4yXOZ2pE4.

Finkelstein, Avram. *After Silence: A History of AIDS through Its Images.* Oakland: University of California Press, 2018.

Fisher, Rob. "In Search of a Theory of Private Archives: The Foundational Writings of Jenkinson and Schellenberg Revisited." *Archivaria* 67 (Spring 2009): 1–24.

Flores-Turney, Camille. "Howl: The Artwork of Luis Jiménez." In *Howl: The Artwork of Luis Jiménez,* edited by Arnold Vigil, 11–67. Santa Fe: New Mexico Magazine, 1997.

Foley, Barbara. "A Modern Object Lesson: How Mario Tamayo and Jef Huereque Brought High Style to the Lower Reaches of Melrose Avenue." *Los Angeles Times,* June 25, 1989. http://articles.latimes.com/1989-06-25/magazine/tm-6041_1_fashion-designer-jef-huereque-cha-cha-cha-clothing-store.

Foster, Hal. "An Archival Impulse." *October* 110 (2004): 3–22.

Foucault, Michel. "On Other Spaces." *Diacritics 16, no. 1* (1986): 22–27.

———. "Sexual Choice, Sexual Act: Foucault and Homosexuality." In *Politics, Philosophy, Culture: Interviews and Other Writings, 1977–1984,* edited by Lawrence Kritzman, 286–306. New York: Routledge, 1988.

———. *Power/Knowledge: Selected Interviews and Other Writings, 1972–1977.* Edited by Colin Gordon. New York: Pantheon Books, 1980.

France, David, dir. *How to Survive a Plague.* 2012. New York: Public Square Films; Ninety Thousand Words; Ted Snowden Foundation, 2012. DVD.

Francis, Jacqueline. "Introduction and Overview." *American Art* 17, no. 1 (2003): 2–10.

Freeman, Elizabeth. "Queer Belongings: Kinship Theory and Queer Theory." In *A Companion to Lesbian, Gay, Bisexual, Transgender and Queer Studies,* edited by George Haggerty and Molly McGarry, 293–314. Malden, MA: Blackwell, 2008.

———. *Time Binds: Queer Temporalities, Queer Histories.* Durham, NC: Duke University Press, 2010.

Future Safe: The Present Is the Future. New York: Estate Project for Artists with AIDS, 1997.

Gamboa, Harry, Jr. "Renegotiating Race, Class, and Gender: Street Works, Performance Art, and Alternative Space." In *MEX/L.A.: "Mexican" Modernism(s) in Los Angeles, 1930–1985,* edited by Ruben Ortiz-Torres, 90–101. Long Beach, CA: Museum of Latin American Art, 2011.

———. "In the City of Angels, Chameleons, and Phantoms: Asco, a Case Study of Chicano Art in Urban Tones (or, Asco Was a Four-Member Word)." In *Urban Exile: Collected Writings of Harry Gamboa Jr.,* edited by Chon A. Noriega, 71–87. Minneapolis: University of Minnesota Press, 1998.

———. "No Phantoms." *High Performance,* 4, no. 2 (1981): 15.

———. "Gronk: Off-the-Wall Artist." *Neworld* 6, no. 4 (1980): 33–43.

Gamson, Joshua. *The Fabulous Sylvester: The Legend, the Music, the Seventies in San Francisco.* New York: Picador, 2005.

Gangadharan, Seeta Peña. "Mail Art: Networking without Technology." *New Media and Society* 11, nos. 1–2 (2009): 279–98.

Garza, Monica. "Secular *Santos*." *Aztlán* 28, no. 1 (2003): 163–71.

Gaspar de Alba, Alicia. "From CARA to CACA: The Multiple Anatomies of Chicana/o Art at the Turn of the New Century." *Aztlán* 26, no. 1 (2001): 205–31.

———. *Chicano Art Inside/Outside the Master's House: Cultural Politics and the CARA Exhibition.* Austin: University of Texas Press, 1998.

Gaspar de Alba, Alicia, and Alma López, eds. *Our Lady of Controversy: Alma López's "Irreverent Apparition."* Austin: University of Texas Press, 2011.

Gavin, Robin Farwell, Donna Pierce, and Alfonso Pleguezuelo, eds. *Cerámica y Cultura: The Story of Spanish and Mexican Mayólica.* Albuquerque: University of New Mexico Press, 2003.

Gaytán, Marie Sarita. "Tequila Talk: Consumption, Gender and the Transnational Terrain of Cultural Identity." *Latino Studies* 9, no. 1 (2011): 62–86.

Genette, Gérard. *Paratexts: Thresholds of Interpretation.* Translated by Jane E. Lewis. New York: Cambridge University Press, 1997.

Genova, Alexandra. "The Story Behind the Colorization of a Controversial Benetton AIDS Ad." *Time Magazine*, December 13, 2016. http://time.com/4592061/colorization -benetton-aids-ad/.

Gere, David. *How to Make Dances in an Epidemic: Tracking Choreography in the Age of AIDS.* Madison: University of Wisconsin Press, 2004.

———. "T-Shirts and Holograms: Corporeal Fetishes in AIDS Choreography, c. 1989." *Theatre Journal* 54, no. 1 (2002): 45–62.

Gerhard, Jane. "Judy Chicago and the Practice of 1970s Feminism." *Feminist Studies* 37, no. 3 (2011): 591–618.

"Gil Cuadros; Poet, Essayist Tackled AIDS Subject." *Los Angeles Times*, September 10, 1996. http://articles.latimes.com/1996-09-10/news/mn-42302_1_gil-cuadros.

Gilliland, Anne J., and Marika Cifor. "Affect and the Archive, Archives and Their Affects: An Introduction to the Special Issue." *Archival Science* 16 (2016): 1–6.

Goldman, Shifra. "The Mexican-Latino Connection: The Effective and Affective Representations of AIDS." In *Arte Mexicano: Imágenes en el Siglo del SIDA/Mexican Art: Images in the Age of AIDS*, edited by Michael Crane, 5–27. Boulder: University of Colorado, 1994.

———. "The Iconography of Chicano Self-Determination: Race, Ethnicity, and Class." *Art Journal* 49, no. 2 (1990): 167–73.

Gonzales, Carlos (Kookie). *Mission Local.* July 25, 2015. Vimeo video, 0:02:21. https:// vimeo.com/134675968.

Gonzales, Patrisia. "Anatomy of Learning: Yauhtli, Peyotzin, Tobacco and Maguey." In *Fleshing the Spirit: Spirituality and Activism in Chicana, Latina, and Indigenous Women's Lives*, edited by Elisa Facio and Irene Lara, 218–40. Tucson: University of Arizona Press, 2014.

González, Jennifer. *Subject to Display: Reframing Race in Contemporary Installation Art.* Cambridge, MA: MIT Press, 2008.

———. "Windows and Mirrors: Chicano Art Collectors at Home." In *East of the River: Chicano Art Collectors Anonymous*, edited by Chon A. Noriega, 38–41. Santa Monica: Santa Monica Museum of Art, 2000.

———. "Autotopographies." In *Prosthetic Territories: Politics and Hypertechnologies*, edited by Gabriel Brahm Jr. and Mark Driscoll, 133–50. Boulder, CO: Westview Press, 1995.

González, Rita. "Frida, Homeboys, and the Butch Gardens School of Fine Art." In *Asco: Elite of the Obscure*, edited by Ondine C. Chavoya and and Rita Gonzalez, 318–25.

Gooch, Brad. *Smash Cut: A Memoir of Howard & Art & the 70s & the 80s*. New York: Harper, 2015.

Gorman-Murray, Andrew. "Reconciling Self: Gay Men and Lesbians Using Domestic Materiality for Identity Management." In *Queer Spaces: Centres and Peripheries*, edited by N. Stead and J. Prior, 1–7. Sydney, Australia: University of Technology Sydney, 2007.

Gould, Deborah. *Moving Politics: Emotion and ACT UP's Fight Against AIDS*. Chicago: The University of Chicago Press, 2009.

Grasskamp, Walter. *The Book on the Floor: André Malraux and the Imaginary Museum*. Los Angeles: Getty Research Institute, 2016.

Griswold del Castillo, Richard, and Arnoldo De Leon. *North to Aztlan: A History of Mexican Americans in the United States*. New York: Twayne, 1996.

Groff, "The Curious Closets of Barton Benes." *POZ.com*, August 1, 1999. https://www.poz.com/article/The-Curious-Closets-of-Barton-Benes-11353-4477.

"Gronk." Interview by Julia Brown and Jacqueline Crist. *Summer 1985*. Los Angeles: Museum of Contemporary Art, 1985.

Gugelberger, Georg, and Michael Kearney. "Voices for the Voiceless: Testimonial Literature in Latin America." *Latin American Perspectives* 18, no. 3 (1991): 3–14.

Gunckel, Colin. "'I Was Participating and Documenting': Chicano Art through the Photography of Oscar Castillo." In *The Oscar Castillo Papers and Photograph Collection*, edited by Colin Gunckel, 1–17. Los Angeles: UCLA Chicano Studies Research Center Press, 2011.

———. "'We Were Drawing and Drawn into Each Other': Asco's Collaboration through *Regeneración*." In *Asco: Elite of the Obscure*, edited by Ondine C. Chavoya and and Rita Gonzalez, 151–67.

Gunckel, Colin, and Pilar Tompkins Rivas, eds. *Vexing: Female Voices from East L.A. Punk*. Claremont, CA: Claremont Museum of Art, 2008.

Gutiérrez, David G. "Background and Gestation: New Mexico Reinvented: Charles Fletcher Lummis and the Orientalization of New Mexico." In *Nuevomexicano Cultural Legacy: Forms, Agencies, and Discourse*, edited by Francisco A. Lomelí, Víctor A. Sorell, and Genaro M. Padilla, 11–27. Albuquerque: University of New Mexico Press, 2002.

———, ed. *The Columbia History of Latinos in the United States Since 1960*. New York: Columbia University Press, 2004.

Guzman, Kristen. *Self Help Graphics & Art: Art in the Heart of East Los Angeles*. Los Angeles: UCLA Chicano Studies Research Center, 2005.

Habell-Pallan, Michelle. *Loca Motion: The Travels of Chicana and Latina Popular Culture*. New York: New York University Press, 2005.

Hackford, Taylor, dir. *Against All Odds*. 1984. Hollywood: Columbia Pictures, 2010. DVD.

Hager, Steven. *Art after Midnight: The East Village Scene*. New York: St. Martin's Press, 1986.

Halberstam, J. Jack. *The Queer Art of Failure*. Durham, NC: Duke University Press, 2011.

———. *In a Queer Time and Place*. New York: New York University Press, 2005.

Hale, Marsha Bentley. "Body Attitudes." *Visual Merchandising & Store Design* 114, no. 8 (1983): 47–52.

Hallas, Roger. *Reframing Bodies: AIDS, Bearing Witness, and Moving Image Media*. Durham, NC: Duke University Press, 2013.

Hames-García, Michael. "Jotería Studies, or the Political Is Personal." *Aztlán* 39, no. 1 (2014): 135-141.

Harris, Michael D. *Colored Pictures: Race and Visual Representation*. Chapel Hill: University of North Carolina Press, 2003.

Harris, Verne. "Hauntology, Archivy and Banditry: An Engagement with Derrida and Zapiro." *Critical Arts: South-North Cultural and Media Studies* 29, no. 1 (2015): 13–27.

Hawkins, Peter S. "Naming Names: The Art of Memory and the NAMES Project AIDS Quilt." *Critical Inquiry* 19 (Summer 1993): 752–79.

Hayden, Dolores. *The Power of Place: Urban Landscapes as Public History*. Cambridge, CA: MIT Press, 1995.

Hernández, Robb. "Drawing Offensive/Offensive Drawing: Toward a Theory of Mariconóngraphy." *MELUS* 39, no. 2 (2014): 121–52.

———. *VIVA Records: Lesbian and Gay Latino Artists of Los Angeles*. Los Angeles: UCLA Chicano Studies Research Center Press, 2013.

———. "Archival Body/Archival Space: Queer Remains of the Chicano Avant-Garde in Los Angeles, 1969–2009." PhD diss., University of Maryland, College Park, 2011.

———. *The Fire of Life: The Robert Legorreta–Cyclona Collection*. Los Angeles: UCLA Chicano Studies Research Center Press, 2009.

Hernández, Robb, and Tyler Stallings, eds. *Mundos Alternos: Art and Science Fiction in the Americas*. Riverside: University of California, ARTSblock, 2017.

Hilderbrand, Lucas. "Retroactivism." *GLQ: A Journal of Lesbian and Gay Studies* 12 no. 2 (2006): 303–17.

Hirsch, Marianne, and Leo Spitzer. "Testimonial Objects: Memory, Gender, and Transmission." *Poetics Today* 27, no. 2 (2006): 353–83.

"Hispanic Ceramic Artists Los Angeles: Teddy Sandoval." *Studio Potter* 17, no. 2 (1989): 13–14.

"HIV+ Latino Uses His Art for Activism." Changing America with Maria Teresa Kumar. MSNBC TV video, 0:07:35, June 16, 2015. http://www.msnbc.com/changing-america/watch/hiv—latino-uses-his-art-for-activism-465534019694.

Hopkins, David. *Dada's Boys: Masculinity After Duchamp*. New Haven, CT: Yale University Press, 2007.

Huff, Cynthia A. "Reading as Re-Vision: Approaches to Reading Manuscript Diaries." *Biography* 23, no. 3 (2000): 505–23.

Hurewitz, Daniel. *Bohemian Los Angeles and the Making of Modern Politics*. Berkeley: University of California Press, 2007.

Huyssen, Andreas. *Twilight Memories: Marking Time in a Culture of Amnesia*. New York: Routledge, 1995.

Indych-Lopez, Anna. *Judith F. Baca*. Minneapolis: University of Minnesota Press, 2018.

Ingram, Billy. *Punk*. San Bernardino, CA: TVParty! Books and CreateSpace Independent Publishing Platform, 2012.

Irwin, Robert McKee. "The Centenary of the Famous 41." In *The Famous 41: Sexuality and Social Control in Mexico, 1901*, edited by Robert McKee Irwin, Edward J. McCaughan, and Michelle Nasser, 169–92. New York: Palgrave, 2008.

Jackson, Carlos Francisco. *Chicana and Chicano Art: ProtestArte*. Tucson: University of Arizona Press, 2009.

Jackson, Shannon. *Social Works: Performing Art, Supporting Publics*. New York: Routledge, 2011.

"Jack Vargas." *Artes Virtuales* 29 (June 1981): 18.

Jenkinson, Sir Hilary. *A Manual of Archive Administration*. Oxford: Clarendon Press, 1922.

Johnson, Dominic. *The Art of Living: An Oral History of Performance Art*. London: Palgrave, 2015.

Johnson, Kaytie. "Alex Donis." In *Contemporary Chicana and Chicano Art: Artists, Works, Culture, and Education*, edited by Gary D. Keller, Mary Erickson, Kaytie Johnson, and Joaquín Alvarado, 1:174–76. Tempe: Bilingual Press, 2002.

Johnston, Tracey J. "La Vida Loca: Girls in the Gangs of East L.A." *New West Magazine*, January 29, 1979, 38–46.

Jonathan Adler and Simon Doonan: On Happy Chic, Eccentric Glam, and Other Stories . . . YouTube video, 1:07:10, posted by CasaItalianaNYU, April 5, 2013. https://www.youtube.com/watch?v=GCyqHnVkdDY.

Jones, Amelia. "Lost Bodies: Early 1970s Los Angeles Performance Art in Art History." In *Live Art in LA: Performance in Southern California*, edited by Peggy Phelan, 115–84. New York: Routledge, 2012.

———. "'The Artist Is Present': Artistic Re-enactments and the Impossibility of Presence." *TDR: The Drama Review* 55, no. 1 (2011): 16–45.

———. "'Traitor Prophets': Asco's Art as a Politics of the In-Between." In *Asco: Elite of the Obscure*, edited by Ondine C. Chavoya and and Rita Gonzalez, 107–41. Ostfildern, Germany: Hatje Cantz, 2011.

———. *Self/Image: Technology, Representation, and the Contemporary Subject*. New York: Routledge, 2006.

———. "'Clothes Make the Man': The Male Artist as a Performative Function." *Oxford Art Journal* 18, no. 2 (1995): 18–32.

Juhasz, Alexandra. "Video Remains: Nostalgia, Technology, and Queer Archive Activism." *GLQ: A Journal of Lesbian and Gay Studies* 12, no. 2 (2006): 319–28.

Katz, Jonathan David. "How AIDS Changed American Art." In *Art AIDS America*, edited by Rock Hushka and Jonathan D. Katz, 24–45. Tacoma: Tacoma Art Museum, 2015.

Kelly, David. "Caution Urged around Coyotes." *Los Angeles Times*, May 8, 2008. http://articles.latimes.com/2008/may/08/local/me-coyotes8.

Kennedy, Jay, and Cherryl Schauder. *Records Management: A Guide to Corporate Recordkeeping*, 2nd ed. South Melbourne: Longman, 1998.

Kent, Rosemary. "Drama Department: Comedy, Sex, and Violence in Store Windows." *New York Magazine*, May 24, 1976, 85.

Kester, Grant H., ed. *Art, Activism, and Oppositionality: Essays from Afterimage*. Durham: Duke University Press, 1998.

Ketelaar, Eric. "Tacit Narratives: The Meanings of Archives." *Archival Science* 1 no. 2 (2001): 131–41.

Kirshenblatt-Gimblett, Barbara. *Destination Culture: Tourism, Museums, and Heritage.* Berkeley: University of California Press, 1998.

Kissel, William. "Ole L.A." *DNR: Daily News Record*, March 6, 1989, 28–32.

Klaus Nomi and Joey Arias Dancing in Fiorucci Windows NYC—Real People. YouTube video, December 16, 2009. https://www.youtube.com/watch?v=G-pMwDzK8uw.

Knight, Christopher. "A Permanent Asco Mural Is Slated for City Terrace." *Culture Monster* (blog), *Los Angeles Times*, September 12, 2011.

———. "How L.A. Missed the Train." *Los Angeles Times*, June 25, 2000.

La Fountain-Stokes, Lawrence. "Translocas: Migration, Homosexuality, and Transvestism in Recent Puerto Rican Performance." *E-Misférica* 8, no. 1, n.d. http://hemisphericinstitute.org/hemi/en/e-misferica-81/lafountain.

Latimer, Tirza True. *Women Together/Women Apart: Portraits of Lesbian Paris.* New Brunswick, NJ: Rutgers University Press, 2005.

Latina Feminist Group. "Introduction. *Papelitos Guardados*: Theorizing *Latinidades* through *Testimonio*." In *Telling to Live: Latina Feminist Testimonios*, edited by Latina Feminist Group, 1–24. Durham, NC: Duke University Press, 2001.

———, ed. *Telling to Live: Latina Feminist Testimonios.* Durham, NC: Duke University Press, 2001.

LaTorre, Guisela. *Walls of Empowerment: Chicana/o Indigenist Murals of California.* Austin: University of Texas Press, 2008.

Lawrence, Tim. *Life and Death on the New York Dance Floor, 1980–1983.* Durham, NC: Duke University Press, 2016.

Leonelli, Elisa. "Just Looking." *Los Angeles Herald Examiner*, August 30, 1981, 24.

Lerer, Seth. *Prospero's Son: Life, Books, Love and Theater.* Chicago: University of Chicago Press, 2013.

Levin, Martin P. *Gay Macho: The Life and Death of the Homosexual Clone.* New York: New York University Press, 1998.

Lewis, Julia. "Clothing Closets." *House Beautiful*, May 2014, 58.

Lewis, Van Dyk. "Music and Fashion." In *The Berg Companion to Fashion*, edited by Valerie Steele, 522–27. New York: Berg, 2010.

"Lisa—Rocket to Your Heart (Single Mix)." YouTube video, posted August 2, 2013. https://www.youtube.com/watch?v=WZA1gsehdRA.

Livingstone, Marco. "The Private Face of a Public Art." In *David Hockney Portraits*, edited by Sarah Howgate and Barbara Stern Shapiro, 16–19. New Haven, CT: Yale University Press, 2006.

London, Michael. "Film Clips." *Los Angeles Times*, December 21, 1984, M10.

Londoño, Johana. "Barrio Affinities: Transnational Inspiration and the Geopolitics of Design." *American Quarterly* 66, no. 3 (2014): 529–48.

Longstreth, Galen Goodwin. "Epistolary Follies: Identity, Conversation, and Performance in the Correspondence of Ellen Terry and Bernard Shaw." *Shaw* 21 (2001): 27–40.

Looby, Christopher. "Flowers of Manhood: Race, Sex and Floriculture from Thomas Wentworth Higginson to Robert Mapplethorpe." *Criticism* 37, no. 1 (1995): 109–56.

López, Alma. "The Artist of *Our Lady* (April 2, 2001)." In *Our Lady of Controversy: Alma López's "Irreverent Apparition,"* edited by Alicia Gaspar de Alba and Alma López, 13–17. Austin: University of Texas Press, 2011.

Lowenthal, David. *The Past Is a Foreign Country*. Cambridge: Cambridge University Press, 1985.

Manrique, Jaime. *Eminent Maricones: Arenas, Lorca, Puig, and Me*. Madison: University of Wisconsin Press, 1999.

Martinez, Christina Catherine. "Third Time's a Charm." *Artforum*, February 4, 2015. http://artforum.com/diary/id=50099.

Mcgath, Carrie. "Tour a Landmark Art Show on AIDS & America in a Converted Bank Building." *Chicagoist*, December 9, 2016. http://chicagoist.com/2016/12/09/a_cultural _survey_of_the_aids_epide.php#photo-1.

Mcgrath, Rachel. "County Residents Talk about Their Experiences Living with HIV, AIDS." *Ventura County Star*, December 2, 2009. http://www.vcstar.com/news/county -residents-talk-about-their-experiences-living-with-hiv-aids-ep-370387938–350355401 .html.

McGrew, Rebecca, and Glenn Phillips, eds. *It Happened at Pomona: Art at the Edge of Los Angeles, 1969–1973*. Claremont, CA: Pomona College Museum of Art, 2011.

McKemmish, Sue. "Placing Records Continuum Theory and Practice." *Archival Science* 1, no. 4 (2001): 333–59.

McKemmish, Sue, and Frank Upward. "Somewhere beyond Custody." *Archives & Manuscripts* 22, no. 1 (1994): 136–49.

Merkert, Jorn. "Ed Kienholz and the Language of Objects." In *Edward Kienholz: Volksempfangers*, 20–53. Berlin: Nationalgalerie Berlin: Staatliche Museen Preubischer Kulturbesitz, 1977.

Mesa-Bains, Amalia. "'Domesticana': The Sensibility of Chicana Rasquache." *Aztlán* 24, no. 2 (1999): 157–67.

Meyer, Richard. "Alex Donis: An Introduction." *Theatre Journal* 55, no. 3 (2003): 581–83.

———. *Outlaw Representation: Censorship and Homosexuality in Twentieth Century American Art*. Boston: Beacon Press, 2002.

———. "Mapplethorpe's Living Room: Photography and the Furnishing of Desire." *Art History* 24, no. 2 (2001): 292–311.

Miles, Barry. *London Calling: A Counterculture History of London since 1945*. London: Atlantic Books, 2011.

Miller, Daniel. "Possessions." In *Home Possessions: Material Culture behind Closed Doors*, edited by Daniel Miller, 107–21. New York: Berg, 2001.

Miranda, Carolina A. "Five Must-See Booths at the L.A. Art Book Fair." *Los Angeles Times*, January 29, 2015. http://www.latimes.com/books/jacketcopy/la-et-jc-la-art-book-fair-laabf-booths-20150128-story.html.

Monette, Paul. *Borrowed Time: An AIDS Memoir*. New York: Harcourt Brace, 1988.

Moon, Michael. "Memorial Rags." In *Professions of Desire: Lesbian and Gay Studies in Literature*, edited by George Haggerty and Bonnie Zimmerman, 233–40. New York: Modern Language Association, 1995.

Moore, Patrick. *Beyond Shame: Reclaiming the Abandoned History of Radical Gay Sexuality*. Boston: Beacon Press, 2004.

Moraga, Cherríe. "Queer Aztlán: The Re-Formation of Chicano Tribe." In *The Last Generation: Prose and Poetry*, 145–74. Boston: South End Press, 1993.

Morales, Frank. "Liberating Unleashed Latino/Gay-Themed Artifacts." *Orange County and Long Beach Blade*, July 2004, 60–61.

Moreland, Pamela. "At $2 Billion, It's More than Window Dressing." *Los Angeles Times*, March 24, 1980, E1.

Morris, Charles E. "ACT UP 25: HIV/AIDS, Archival Queers, and Mnemonic World Making." *Quarterly Journal of Speech* 98, no. 1 (2012): 49–53.

Mossinghoff, Gerald J. "AIDS Medicines in Development." *AIDS Patient Care*, October 1989.

Muchnic, Suzanne. "Fare Includes Art and History." *Los Angeles Times*, June 6, 1999.

Mulvey, Laura. "Visual Pleasure and Narrative Cinema." *Screen* 16, no. 3 (1975): 6–18.

Mundy, Jennifer. *Lost Art: Missing Artworks of the Twentieth Century*. London: Tate, 2013.

Muñoz, José Esteban. *Cruising Utopia: The Then and There of Queer Futurity*. New York: New York University Press, 2009.

———. "'Chico, What Does It Feel Like to Be a Problem?': The Transmission of Brownness." In *A Companion to Latino Studies*, edited by Juan Flores and Renato Rosaldo, 441–51. Oxford: Blackwell, 2007.

———. "Feeling Brown: Ethnicity and Affect in Ricardo Bracho's *The Sweetest Hangover (and Other STDs)*." *Theatre Journal* 52, no. 1 (2000): 67–79.

———. *Disidentifications: Queers of Color and the Performance of Politics*. Minneapolis: University of Minnesota Press, 1999.

———. "Ephemera as Evidence: Introductory Notes to Queer Acts." *Women and Performance* 8, no. 2 (1996): 5–16.

"Murphy on for 'Cop' as Part of 5-Film Par Deal." *Hollywood Reporter*, April 1984.

Murphy, Ryan, dir. *The Normal Heart*. New York: HBO Pictures, 2014. DVD.

"My Cathedral—1997." In *Los Angeles Gay and Lesbian Latino Arts Anthology, 1988–2000*, edited by Luis Sampaio, 13. Los Angeles: VIVA: Lesbian and Gay Latino Artists of Los Angeles, 2000.

Newhouse, Victoria. *Art and the Power of Placement*. New York: Monacelli Press, 2005.

"Newsline: L.A. Parade Melee." *Advocate*, July 28, 1976, 21.

Noriega, Chon, A., ed. "Queer Archive 2006 Hour 1: Queering the Archive, Or Archiving the Queer." UCLA Chicano Studies Research Center. Audio podcast, March 18, 2011. https://itunes.apple.com/us/itunes-u/chicano-studies-research-center-content/id434142405?mt=10.

———. "Your Art Disgusts Me: Early Asco 1971–75." *East of Borneo*, November 18, 2010.

———. "The Orphans of Modernism." In *Phantom Sightings, Art After the Chicano Movement*, edited by Rita Gonzalez, Howard Fox, and Chon Noriega, 24–45. Berkeley: University of California Press, 2008.

———. *East of the River: Chicano Art Collectors Anonymous*. Santa Monica: Santa Monica Museum of Art, 2000.

Oboler, Suzanne. *Ethnic Labels, Latino Lives: Identity and the Politics of (Re)presentation in the United States*. Minneapolis: University of Minnesota Press, 1995.

O'Driscoll, Michael, and Edward Bishop, "Archiving 'Archiving.'" *English Studies in Canada* 30, no. 1 (2004): 1–16.

Ola d'Aulaire, Emily, and Per Ola d'Aulaire. "Mannequins: Our Fantasy Figures of High Fashion." *Smithsonian Magazine*, 22, no. 1 (1991): 66–77.

Ontiveros, Randy. "Antennas and Mimeograph Machines: Postwar Mass Media and the Chicano/a Street Press." In *In the Spirit of a New People: The Cultural Politics of the Chicano Movement*, 44–85. New York: New York University Press, 2014.

Padget, Martin. "Travel, Exoticism, and the Writing of Region: Charles Fletcher Lummis and the 'Creation' of the Southwest." *Journal of the Southwest* 37, no. 3 (1995): 421–49.

Parra, Alvaro, dir. *The Asco Interviews*. 2013. YouTube video, 25:29, posted by Nottingham Contemporary, February 28, 2014. https://www.youtube.com/watch?v=iyFViWGU06I.

Parrot, André. *The Arts of Assyria*. Edited by André Malraux and Georges Salles. New York: Golden Press, 1961.

Pearce, Susan M., ed. *Interpreting Objects and Collections*. London: Routledge 1994.

Peña, Susana. *Oye Loca: From the Mariel Boatlift to Gay Cuban Miami*. Minneapolis: University of Minnesota Press, 2013.

Pérez, Daniel Enrique. "Entre Machos y Maricones: (Re)Covering Chicano Gay Male (Hi)Stories." In *Gay Latino Studies: A Critical Reader*, edited by Michael Hames-García and Ernesto Javier Martínez, 141–46. Durham, NC: Duke University Press, 2011.

Pérez, Emma. *The Decolonial Imaginary: Writing Chicanas into History*. Bloomington: Indiana University Press, 1999.

Pérez, Laura. *Chicana Art: The Politics of Spiritual and Aesthetic Altarities*. Durham, NC: Duke University Press, 2006.

Phelan, Peggy, ed. *Live Art in LA: Performance in Southern California*. New York: Routledge, 2012.

Piepmeier, Alison. "Why Zines Matter: Materiality and the Creation of Embodied Community." *American Periodicals* 18, no. 2 (2008): 213–38.

Pietschmann, Richard J. "Melrose: Is It the Sunset Strip of the '80s?" *Los Angeles Magazine*, October 1983, 228.

Plagens, Peter. *Sunshine Muse: Art on the West Coast, 1945–1970*. Berkeley: University of California Press, 2000.

Pollock, Griselda. *After-Affects / After-Images: Trauma and Aesthetic Transformation in the Virtual Feminist Museum*. Manchester: Manchester University Press, 2013.

———. *Encounters in the Virtual Feminist Museum: Time, Space and the Archive*. London: Routledge, 2007.

Pratt, Mary Louise. *Imperial Eyes: Travel Writing and Transculturation*. New York: Routledge, 1992.

Puar, Jasbir K. *Terrorist Assemblages: Homonationalism in Queer Times*. Durham, NC: Duke University Press, 2007.

Punzalan, Ricardo L. "Archival Diasporas: A Framework for Understanding the Complexities and Challenges of Dispersed Photographic Collections." *American Archivist* 77, no. 2 (2014): 326–49.

Putnam, James. *Art and Artifact: The Museum as Medium*. New York: Thames and Hudson, 2001.

Rechy, John. *City of Night*. New York: Grove Press, 1963.

Reed, Christopher. *Art and Homosexuality: A History of Ideas*. New York: Oxford University Press, 2011.

Reynolds, Christopher. "Southwest Museum's Future at Heart of Tussle." *Los Angeles Times*, June 26, 2006, E6.

Ricciardi, Gabriella. "Building Altars: Mexican American Women's Altars in Oregon." *Oregon Historical Quarterly* 107, no. 4 (2006): 536–52.

Rivas, Jorge. "Gay Cholo Mural Gets Defaced in San Francisco after Online Threats." *Fusion*, June 17, 2015. http://fusion.net/story/151882/maricon-collective-gay-cholo-mural-galeria-de-la-raza-san-franciscos-mission/.

"Robert Legorreta." In *2013 California-Pacific Triennial*, edited by Dan Cameron, 110–13. New York: Delmonico Books and Prestel, 2013.

Robert Mapplethorpe: Flowers. Tokyo: Galerie Watari, 1983.

Rodríguez, Juana María. *Queer Latinidad: Identity Practices, Discursive Spaces*. New York: New York University Press, 2003.

Rodríguez, Richard T. "Latino/a Queer Expression." In *Latino/a Literature in the Classroom: 21st Century Approaches to Teaching*, edited by Frederick Luis Aldama, 32–40. New York: Routledge, 2015.

———. "Being and Belonging: Joey Terrill's Performance of Politics." *Biography* 34, no. 3 (2011): 467–91.

———. *Next of Kin: The Family in Chicano/a Cultural Politics*. Durham, NC: Duke University Press, 2009.

———. "Queering the Homeboy Aesthetic." *Aztlán* 31, no. 2 (2006): 127–37.

Rodríguez, Samuel, dir. *Your Denim Shirt*. 2001. YouTube video, 11:35, posted by CDHLab UCR, April 2, 2015. https://www.youtube.com/watch?v=54y8y3FrGE0.

Román, David. "Remembering AIDS: A Reconsideration of the Film *Longtime Companion*." *GLQ: A Journal of Lesbian and Gay Studies* 12, no. 2 (2006): 281–301.

———. *Performance in America: Contemporary U.S. Culture and the Performing Arts*. Durham, NC: Duke University Press, 2005.

———. *Acts of Intervention: Performance, Gay Culture, and AIDS*. Bloomington: Indiana University Press, 1998.

Roque-Ramirez, Horacio. "Gay Latino Histories/Dying to be Remembered: AIDS Obituaries, Public Memory, and the Queer Latino Archive." In *Beyond El Barrio: Everyday Life in Latina/o America*, edited by Adrian Burgos, Frank Guridy, and Gina M. Pérez, 103–28. New York: New York University Press, 2010.

Rosenberg, Max. "Roger Brown." *Art in America*, October 6, 2015. http://www.artinamericamagazine.com/reviews/roger-brown/.

Rourke, Mary. "They're Flipping Out on Melrose Avenue." *Los Angeles Times*, September 10, 1982, G22.

Rubinstein, Dan. "Top Grades." *Dwell*, March 2014, 90–97.

Russo, Vito. *The Celluloid Closet: Homosexuality in the Movies*. New York: Harper and Row, 1985.

Sachs, Ira, dir. *Last Address*. 2010. YouTube video, 8:35, April 27, 2010. https://www.youtube.com/watch?v=YKKeWsMyDXQ.

Saldivar, Reina Alejandra Prado. "Self-Help Graphics: A Case Study of a Working Space for Arts and Community." *Aztlán* 25, no. 1 (2000): 167–81.

Sanchez, George. *Becoming Mexican American: Ethnicity, Culture, and Identity in Los Angeles, 1900–1945*. New York: Oxford University Press, 1995.

Sandberg, Mark B. *Living Pictures Missing Persons: Mannequins, Museums, and Modernity*. Princeton, NJ: Princeton University Press, 2003.

Sandoval, Chela. *Methodology of the Oppressed*. Minneapolis: University of Minnesota Press, 2000.

Santillano, Dianna Marisol. "Asco." In *Phantom Sightings: Art After the Chicano Movement*, edited by Rita Gonzalez, Howard Fox, and Chon Noriega, 118. Berkeley: University of California Press, 2008.

Savage, Kirk. *Standing Soldiers, Kneeling Slaves: Race, War, and Monument in Nineteenth-Century America*. Princeton, NJ: Princeton University Press, 1997.

Sayed, Khaled. "Artist Shocked by Arson on Gay Mural." *Bay Area Reporter*, July 30, 2015. http://ebar.com/news/article.php?sec=news&article=70782.

Schickel, Richard. "Eddie Goes to Lotusland." *Time*, December 10, 1984, 92.

Schneider, Rebecca. *Performance Remains: Art and War in Times of Theatrical Reenactment*. London: Routledge, 2011.

Schneider, Sara K. *Vital Mummies: Performance Design for the Show-Window Mannequin*. New Haven, CT: Yale University Press, 1995.

Schrank, Sarah. *Art and the City: Civic Imagination and Cultural Authority in Los Angeles.* Philadelphia: University of Pennsylvania Press, 2009.

Schultz, Peter. "Robert Mapplethorpe's Flowers." *History of Photography* 22, no. 1 (1998): 84–89.

Schwartz, Joan, and Terry Cook. "Archives, Records, and Power: The Making of Modern Memory." *Archival Science* 2 (2002): 1–19.

Smith, Cherise. *Enacting Others: Politics of Identity in Eleanor Antin, Nikki S. Lee, Adrian Piper, and Anna Deavere Smith.* Durham, NC: Duke University Press, 2011.

Smith, Roberta. "When the Conceptual Was Political." *New York Times*, February 1, 2008. http://www.nytimes.com/2008/02/01/arts/design/01vida.html?scp=1&sq=Museo+del+Barrio&st=nyt.

Smith, Shawn Michelle. *Edge of Sight.* Durham, NC: Duke University Press, 2014.

———. *Photography on the Color Line: W. E. B. Du Bois, Race, and Visual Culture.* Durham, NC: Duke University Press, 2004.

Stein, Claudia, and Roger Cooter. "Visual Objects and Universal Meanings: AIDS Posters and the Politics of Globalisation and History." *Medical History* 55 (2011): 85–108.

Sternad, Jennifer Flores. "Cyclona and Early Chicano Performance Art: An Interview with Robert Legorreta." *GLQ: A Journal of Lesbian and Gay Studies* 12, no. 3 (2006): 475–90.

Sternad, Jennifer Flores, with Ricardo Bracho. "'Your Identity Is Somewhere Else': Cyclona as Perception, as Polemic." In *MEX/L.A.: "Mexican" Modernism(s) in Los Angeles, 1930–1985*, edited by Ruben Ortiz-Torres, 103–5. Ostfildern, Germany: Hatje Cantz, 2011.

Sterngold, James. "Museum Joins with Tribe to Expand Exhibits." *New York Times*, May 16, 2002, 20.

Stevens, Bethan. "Remembering Lost Paintings: Vanessa Bell's *The Nursery.*" *Memory Studies* 3, no. 3 (2010): 242–52.

Storms, Sarah. "A Fine Romance." *Lonny Magazine*, September 2013. http://www.lonny.com/magazine/September+2013/ARuTSe8JRKq/1#82.

Straw, Will. "Scales of Presence: Bess Flowers and the Hollywood Extra." *Screen* 52, no. 1 (2011): 121–27.

Strub, Sean. *Body Counts: A Memoir of Politics, Sex, AIDS, and Survival.* New York: Scribner, 2014.

Sturken, Marita. *Tangled Memories: The Vietnam War, the AIDS Epidemic, and the Politics of Remembering.* Berkeley: University of California Press, 1997.

Sudler-Smith, Whitney, dir. *Ultrasuede: In Search of Halston.* New York: Tribeca Film, 2012. DVD.

Sweeney, Shelley. "The Ambiguous Origins of the Archival Principle of 'Provenance.'" *Libraries and the Cultural Record* 43, no. 2 (2008): 193–213.

"Teddy Sandoval, Highland Park Gateway." *Going for the Gold: California Stories on the Los Angeles Metro Gold Line: Communities, Public Art, and Placement.* http://usc.v1.libguides.com/gold_line (accessed April 19, 2015).

Terrill, Joey. "Artist Statement: Mother and Son." *Frontiers: A Journal of Women Studies* 35, no. 1 (2014): 211–13.

———. "E.L.A. Terrorism!," *Homeboy Beautiful*, Spring 1979, 15–31.

———. "What *Really* Happens on Those *Hot* Summer Nights in Geraghty Loma!," *Homeboy Beautiful*, Spring 1978, 14-26.

Thomas, Robert McG., Jr. "Gene Moore, 88, Window Display Artist, Dies." *New York Times*, November 26, 1998. http://www.nytimes.com/1998/11/26/nyregion/gene-moore-88-window-display-artist-dies.html.

Thomas, Susan E. "Value and Validity of Art Zines as an Art Form." *Art Documentation* 28, no. 2 (2009): 27–38.

Timm, Robert M., and Rex O. Baker. "A History of Urban Coyote Problems." In *Proceedings of the 12th Wildlife Damage Management Conference*, edited by D. L. Nolte, W. M. Arjo, and D. H. Stalman, 272–86. Lincoln, NE: Center for Wildlife Damage Management, 2007.

Tongson, Karen. *Relocations: Queer Suburban Imaginaries*. New York: New York University Press, 2011.

Tucker, Ken. "Adam and the Ants Colonize the Roxy." *Los Angeles Herald Examiner*, April 15, 1981, B-1.

Turner, Kay. *Beautiful Necessity: The Art and Meaning of Women's Altars*. New York: Thames and Hudson, 1998.

———. "Mexican American Home Altars: Towards Their Interpretation." *Aztlán* 13, no. 1–2 (1982): 309–26.

Tyburczy, Jennifer. *Sex Museums: The Politics and Performance of Display*. Chicago: University of Chicago Press, 2016.

Ulrich, Laurel Thatcher, Ivan Gaskell, Sara Schnechner, and Sarah Anne Carter. *Tangible Things: Making History through Objects*. Oxford: Oxford University Press, 2015.

Urbach, Henry. "Closets, Clothes, disClosure." *Assemblage*, August 1996, 62–73.

Vargas, George. *Contemporary Chican@ Art: Color & Culture for a New America*. Austin: University of Texas Press, 2010.

Vaserfirer, Andrew. "(In)Visibility in Lesbian and Gay Student Organizing: The Case of Gay Student Services." *Journal of Homosexuality* 59 (2012): 610–27.

Viladas, Pilar. "That 70's House." *New York Times*, February 13, 2005. http://www.nytimes.com/2005/02/13/magazine/that-70s-house.html?_r=0.

Villarreal, Yezmin. "Owning Slurs and Battling Hate: All in a Day's Work to Maricón Collective." *Advocate*, September 20, 2015. http://www.advocate.com/arts-entertainment/2015/9/30/owning-slurs-and-battling-hate-all-days-work-maricón.

———. "Maricón Art and DJ Collective Celebrates Queer Chicano Culture." *LA Weekly*, January 20, 2015. http://www.laweekly.com/music/maric-n-art-and-dj-collective-celebrates-queer-chicano-culture-5342502.

Vincent, Philip. "Part II: The 1970s Revisited: Biron on Robert Opel, Camille O'Grady, Jerry Dreva, Robert Mapplethorpe, Gronk, Teddy, Jorge Caraballo, Clemente Padin,

Guglielmo Achille Cavellini and Other Artists." Lionel A. Biron Interview. http://
www.photos-biron.com/words/intervo1b.htm (accessed February 22, 2016).

Voight, Becky. ". . . But Rockers Shine Best as Fashion Plates." *Los Angeles Herald Examiner*, April 15, 1981, B-6.

Wallace, Charles P. "Transformation from 'Dead Street' to Trendy Commercial Spot Alienates Longtime Neighbors." *Los Angeles Times*, July 31, 1983, pt. II, 2.

Wallach, Alan. *Exhibiting Contradiction: Essays on the Art Museum in the United States.* Amherst: University of Massachusetts Press, 1998.

Wallach, Ruth. "Fine Arts Building." *Public Art in LA*, July 2011. http://www.publicartinla
.com/Downtown/FineArts/.

Watney, Simon. "Acts of Memory." In *Imagine Hope: AIDS and Gay Identity*, edited by Simon Watney, 163–68. New York: Routledge, 2000.

———. "'Lifelike': Imagining the Bodies of People with AIDS." In *Imagine Hope: AIDS and Gay Identity*, edited by Simon Watney, 192–98. New York: Routledge, 2000.

West Hollywood, 1980. 2016. YouTube video, 4:52, posted by Lew Irwin, March 9, 2019. https://www.youtube.com/watch?v=QkZHZoLqsqg.

Whalen, Carmen. *From Puerto Rico to Philadelphia: Puerto Rican Workers and Postwar Economies.* Philadelphia: Temple University Press, 2001.

Whalen, Carmen, and Victor Vasquez, eds. *Puerto Rican Diaspora: Historical Perspectives.* Philadelphia: Temple University Press, 2005.

White, Deborah Gray. "Mining the Forgotten: Manuscript Sources for Black Women's History." *Journal of American History* 74, no. 1 (1987): 237–42.

Whiting, Cécile. *Pop L.A.: Art and the City in the 1960s.* Berkeley: University of California Press, 2008.

Williams, Raymond. *Marxism and Literature.* Oxford: Oxford University Press, 1977.

Wilmington, Michael. "'Beverly Hills Cop' Hits the Mark in Zany Caper." *Los Angeles Times*, December 5, 1984, 1.

Wilson, Andy Abrahams, dir. *The Grove.* San Rafael, CA: Open Eye Pictures, 2011. DVD.

Wilson, Thomas H., and Cheri Falkenstein-Doyle. "Charles Fletcher Lummis and the Origins of the Southwest Museum." In *Collecting Native America, 1870–1960*, edited by Shepard Krech III and Barbara A. Hail, 74–104. Washington, DC: Smithsonian Institution Press, 1999.

Winter, Robert. *Batchelder: Tilemaker.* Los Angeles: Balcony Press, 1999.

Woo, Elaine. "Fred Slatten Dies at 92; Kind of Crazy-High Heels and Platform Shoes." *Los Angeles Times*, July 23, 2015. http://www.latimes.com/local/obituaries/la-me-fred-slatten-20150723-story.html.

———. "Carlos Bueno, 60; L.A. Art Pioneer." *Los Angeles Times*, September 5, 2001, B10.

———. "The Glass Menagerie: Melrose Avenue Leads the Way in the Neon Renaissance." *Los Angeles Times*, February 24, 1985. http://articles.latimes.com/1985-02-24
/news/we-24831_1_local-neon-sign.

Wyllie, Cherra. "The Mural Paintings of El Zapotal, Veracruz, Mexico." *Ancient Mesoamerica* 21 (2010): 209–27.

Yarbro-Bejarano, Yvonne. "Laying It Bare: The Queer/Colored Body in Photography by Laura Aguilar." In *Living Chicana Theory*, edited by Carla Trujillo, 277–305. Berkeley, CA: Third Woman Press, 1998.

Ybarra-Frausto, Tomás. "Rasquachismo: A Chicano Sensibility." In *Chicano Art: Resistance and Affirmation, 1965–1985*, edited by Shifra Goldman et al., 156. Los Angeles: Wight Art Gallery, 1991.

———. "Rasquachismo: A Chicano Sensibility." In *Chicano Aesthetics: Rasquachismo*, 5–8. Phoenix: Movimiento Artistico del Rio Salado, 1989.

Youmans, Greg. "Elsa Gidlow's Garden: Plants, Archives, and Queer History." In *Out of the Closet into the Archives: Researching Sexual Histories*, edited by Amy L. Stone and Jaime Cantrell, 99–123. Albany: State University of New York Press, 2016.

Yúdice, George. "*Testimonio* and Postmodernism." *Latin American Perspectives* 18, no. 3 (1991): 15–31.

Zugazagoitia, Julian. Foreword and acknowledgments to *Arte No Es Vida: Actions by Artists of the Americas, 1960–2000*, edited by Deborah Cullen, 6–11. New York: El Museo del Barrio, 2008.

INDEX

Robb Hernández is Associate Professor of English at the University of California, Riverside. His work examines the impact of AIDS in Latinx contemporary art, performance, museum studies, and archival theory and practice. He is the co-curator of *Mundos Alternos: Art and Science Fiction in the Americas* for the Getty Foundation's Pacific Standard Time: LA/LA Initiative.

CPSIA information can be obtained
at www.ICGtesting.com
Printed in the USA
LVHW081938050220
645949LV00005B/66